Graphis Inc. is committed to celebrating exceptional work in Design, Advertising, Photography, & Art/Illustration internationally.

Published by **Graphis** | Publisher & Creative Director: **B. Martin Pedersen**

Chief Visionary Officer: **Patti Judd** | Design Director: **Hee Ra Kim** | Senior Designer: **Hie Won Sohn**

Associate Editor: **Colleen Boyd** | Publisher's Assistant/Designer: **Yuan Zhuang** | Account/Production: **Bianca Barnes**

Interns: **Samantha Cai, Charlotte Cooper, Maggie Herrera, Eli Hiscott, Sam Mayer, Ella York**

Graphis Design Annual 2025

Published by:
Graphis Inc.
389 Fifth Avenue, Suite 1105
New York, NY 10016
Phone: 212-532-9387
www.graphis.com
help@graphis.com

ISBN 13: 978-1-954632-34-9

We extend our heartfelt thanks to
the international contributors
who have made it possible to publish
a wide spectrum of the best work
in Design, Advertising, Photography,
and Art/Illustration.
Anyone is welcome to submit
work at www.graphis.com.

Printed in China

Contents

In Memoriam

AMERICAS

Iris Apfel
American Interior Designer
& Fashion Designer
1921 – 2024

George Baird
Canadian Architect, Scholar,
& Architectural Educator
1939 – 2023

Julie Robinson Belfonte
American Costume Designer
& Actress
1928 – 2024

Burkey Belser
American Graphic Designer
1947 – 2023

Juli Lynne Charlot
American Fashion Designer
& Actress
1922 – 2024

Pamela Cluff
British-Canadian Architect
1931 – 2023

Wesley P. Dahlberg
American Car Designer
1917 – 2023

Henry Dunay
American Jewelry Designer
1935 – 2023

April Ferry
American Costume Designer
1932 – 2024

Leonard Everett Fisher
American Children's Book
Illustrator
1924 – 2024

Dærick Gröss Sr.
American Illustrator, Writer,
Editor, & Art Director
1947 – 2023

May "Nonny" Hogrogian
American Illustrator
& Writer
1932 – 2024

Adolpho Lindenberg
Brazilian Architect,
Civil Engineer, & Writer
1924 – 2024

Jerome Markson
Canadian Architect
1929 – 2023

Petra Mathers
German-American
Illustrator & Writer
1945 – 2024

Laralyn McWilliams
American Game Designer
& Video Game Producer
1965 – 2024

Raymond Moriyama
Canadian Architect
1929 – 2023

Leo Narducci
American Fashion Designer
1932 – 2023

Robert Andrew Parker
American Illustrator
1927 – 2023

Harriet Pattison
American Landscape
Architect
1928 – 2023

Dallas Penn
American Fashion Designer
& Internet Personality
1970 – 2024

Antoine Predock
American Architect
1936 – 2024

REX
American Illustrator
& Visual Artist
1943 – 2024

Carrie Robbins
American Costume Designer
1943 – 2024

Barbara Stauffacher Solomon
American Graphis Designer
& Landscape Architect
1928 – 2024

Mike Thaler
American Illustrator
& Author
1936 – 2024

Shawna Trpcic
American Costume Designer
1966 – 2023

George Tscherny
Hungarian-American
Designer & Educator
1924 – 2023

James M. Ward
American Game Designer
& Author
1951 – 2024

Beverly Willis
American Architect
1928 – 2023

EUROPE & AFRICA

Roser Amadó
Spanish Architect
1944 – 2023

Adele Änggård
Swedish-British Stage
& Costume Designer
1933 – 2023

Bryan Ansell
British Game Designer
1955 – 2023

Marc Bohan
French Fashion Designer
1926 – 2023

Andrea Branzi
Italian Architect & Designer
1938 – 2023

Hermann Brede
German Architect
1923 – 2023

Günter Brus
Austrian Painter, Graphic
Artist, & Writer
1938 – 2024

John Byrne
Scottish Designer, Artist,
& Writer
1940 – 2023

Ennio Calabria
Italian Illustrator & Painter
1937 – 2024

Susan Campbell
British Illustrator
1931 – 2024

Roberto Cavalli
Italian Fashion Designer
1940 – 2024

Étienne Delessert
Swiss Graphic Artist
& Illustrator
1941 – 2024

Jacqueline Duhême
French Illustrator & Writer
1927 – 2024

József Finta
Hungarian Architect
1935 – 2024

Marcello Gandini
Italian Car Designer
1938 – 2024

Gerhard Gepp
Austrian Graphic Designer,
Illustrator, & Painter
1940 – 2024

N. John Habraken
Dutch Architect, & Educator
1928 – 2023

Christopher Hobbs
British Production Designer
& Actor
1941 – 2024

Rob Krier
Luxembourgish Architect
& Urban Designer
1938 – 2023

Peter Kulka
German Architect
1937 – 2024

Lisa Larson
Swedish Designer
& Ceramicist
1931 – 2024

Juha Leiviskä
Finnish Architect
& Designer
1936 – 2023

Jacques Lucan
French Architect & Historian
1947 – 2023

Antoni Martí
Andorran Architect
1963 – 2023

Bertus Mulder
Dutch Architect
1929 – 2024

Pat Nebo
Nigerian Production
Designer & Art Director
1959 – 2023

Lucien Pellat-Finet
French Fashion Designer
1945 – 2024

Maria Pergay
French Furniture Designer
1930 – 2023

Gaetano Pesce
Italian Architect
1939 – 2024

Paolo Pininfarina
Italian Designer, Engineer,
& Manager of Pininfarina
S.p.A
1958 – 2024

Davide Renne
Italian Fashion Designer
1977 – 2023

Lorenzo Riva
Italian Fashion Designer
1938 – 2023

Italo Rota
Italian Architect
1953 – 2024

Hideki Seo
Japanese-French Fashion
Designer & Artist
1974 – 2024

Heinz Tesar
Austrian Architect
1939 – 2024

Trini Tinturé
Spanish Illustrator
& Cartoonist
1935 – 2024

John F.C. Turner
British Architect & Theorist
1927 – 2023

Tone Vigeland
Norwegian Jewellery
Designer
1938 – 2024

Stanislav Žalud
Czech Architect & Politician
1932 – 2023

ASIA & OCEANIA

Alan Choe
Singaporean Architect
& Urban Planner
1931 – 2024

Shib Narayan Das
Bangladeshi Designer
& Vexillographer
1946 – 2024

Mutsumi Inomata
Japanese Illustrator
& Animator
1960 – 2024

Yumi Katsura
Japanese Fashion Designer
1930 – 2024

Fumihiko Maki
Japanese Architect
1928 – 2024

Yoshitaka Murayama
Japanese Game Designer,
Game Director,
& Game Producer
1969 – 2024

Hisaya Nakajo
Japanese Manga Artist,
Character Designer, & Writer
1973 – 2023

Akira Toriyama
Japanese Manga Artist
& Character Designer
1955 – 2024

THE AMERICAS

**A+D Architecture
& Design Museum**
www.aplusd.org
170 S. La Brea Ave., Suite 102
Los Angeles, CA 90036
United States

Carnegie Museum of Art
www.carnegieart.org
4400 Forbes Ave.
Pittsburgh, PA 15213
United States
Tel +1 412 622 3131

**Cooper Hewitt, Smithsonian
Design Museum**
www.cooperhewitt.org
2 E. 91st St.
New York, NY 10128
United States
Tel +1 212 849 8400

**Cummer Museum
of Art & Gardens**
www.cummermuseum.org
829 Riverside Ave.
Jacksonville, FL 32204
United States
Tel +1 904 356 6857

Design Exchange
www.designexchangetoronto.
com
234 Bay St.
Toronto, ON M5K 1B2
Canada
Tel +1 647 933 2919

Gregg Museum of Art & Design
www.gregg.arts.ncsu.edu
1903 Hillsborough St.
Raleigh, NC 27607
United States
Tel +1 919 515 3503

Harvard Art Museums
www.harvardartmuseums.org
32 Quincy St.
Cambridge, MA 02138
United States
Tel +1 617 495 9400

Lima Art Museum
www.mali.pe
Parque de la Exposición
Ave. 9 de Diciembre 125
Lima 15046
Peru
Tel +51 969 046 254

Montreal Museum of Fine Arts
www.mbam.qc.ca
1380 Sherbrooke St. W
Montreal, QB H3G 1J5
Canada
Tel +1 514 285 2000

Museo de Arte Contemporáneo
www.mac.uchile.cl
464 Ave. Matucana
Santiago 8350452
Chile
Tel +56 229 771 765

Museo del Objeto del Objeto
www.elmodo.mx/en
Colima 145 N. Roma
Cuauhtémoc, 06700 Ciudad de
México, CDMX
Mexico
Tel +52 55 5533 9637

**Museum of Art of São Paulo
Assis Chateaubriand**
www.masp.org.br/en
1578 Paulista Ave.
São Paulo, SP 01310-200
Brazil
Tel +55 11 3149 5959

**Museum of Contemporary
Art & Design**
www.madc.cr
3rd Ave. & 15th St.
San José
Costa Rica
Tel +506 2257 7202

**Museum of Contemporary
Art Cleveland**
www.mocacleveland.org
11400 Euclid Ave.
Cleveland, OH 44106
United States
Tel +1 216 421 8671

Museum of Craft & Design
www.sfmcd.org
2569 3rd St.
San Francisco, CA 94107
United States
Tel +1 415 773 0303

Museum of Design Atlanta
www.museumofdesign.org
1315 Peachtree St. NE
Atlanta, GA 30309
United States
Tel +1 404 979 6455

Museum of Image & Sound
www.mis-sp.org.br
158 Ave. Europa
São Paulo, SP 01449-000
Brazil
Tel +55 11 2117 4777

**Museum of Modern Art
of São Paulo**
www.mam.org.br/en
Pedro Alvares Cabral Ave., s/n°
Vila Mariana, São Paulo, SP
04094-000
Brazil
Tel +55 11 5085 1300

Museum of the City of New York
www.mcny.org
1220 5th Ave.
New York, NY 10029
United States
Tel +1 212 534 1672

National Gallery of Art
www.nga.gov
6th & Constitution Ave. NW
Washington, DC 20565
United States
Tel +1 202 737 4215

Pérez Art Museum Miami
www.pamm.org/en
1103 Biscayne Blvd.
Miami, FL 33132
United States
Tel +1 305 375 3000

Philadelphia Museum of Art
www.philamuseum.org
2600 Benjamin Franklin Parkway
Philadelphia, PA 19130
United States
Tel +1 215 763 8100

Poster House
www.posterhouse.org
119 W. 23rd St.
New York, NY 10011
United States
Tel +1 917 722 2439

**San Francisco Museum
of Modern Art**
www.sfmoma.org
151 3rd St.
San Francisco, CA 94103
United States
Tel +1 415 357 4000

Seattle Art Museum
www.seattleartmuseum.org
1300 1st Ave.
Seattle, WA 98101
United States
Tel +1 206 654 3100

The Art Institute of Chicago
www.artic.edu
111 S. Michigan Ave.
Chicago, IL 60603
United States
Tel +1 312 443 3600

**The Museum of Contemporary
Art Los Angeles**
www.moca.org
250 S. Grand Ave.
Los Angeles, CA 90012
United States
Tel +1 213 626 6222

The Wynnwood Walls
www.thewynwoodwalls.com
2516 NW. 2nd Ave.
Miami, FL 33127
United States
Tel +1 305 576 3334

Vizcaya Museum & Gardens
www.vizcaya.org
3251 S. Miami Ave.
Miami, FL 33129
United States
Tel +1 305 250 9133

**Whitney Museum
of American Art**
www.whitney.org
99 Gansevoort St.
New York, NY 10014
United States
Tel +1 212 570 3600

EUROPE & AFRICA

Barbican
www.barbican.org.uk
Barbican Centre, Silk St.
London, EC2Y 8DS
United Kingdom
Tel +44 20 7638 8891

Design Museum Arabia
www.designmuseum.fi/en/mu
seums
Korkeavuorenkatu 23
00130 Helsinki
Finland
Tel +358 9 6220 540

Design Museum Denmark
www.designmuseum.dk
68 Bredgade
København 1260
Denmark
Tel +45 33 18 56 56

Die Neue Sammlung
www.die-neue-sammlung.de/en
Barer Str. 40
München 80333
Germany
Tel +49 89 23805 360

Direktorenhaus
www.direktorenhaus.com
2 Am Krögel
Berlin 10179
Germany
Tel +49 30 48491929

**Estonian Museum of Applied
Art & Design**
www.etdm.ee/en
Lai 17
Tallinn 10133
Estonia
Tel +372 627 4600

Galleria Campari
www.campari.com/it-it/galleria-
campari
161 Viale Gramsci
Sesto San Giovanni, MI 20099
Italy
Tel +39 02 62251

Gropius Bau
www.berlinerfestspiele.de/gro
pius-bau
7 Niederkirchnerstraße
Berlin 10963
Germany
Tel +49 30 254 86 0

Guggenheim Museum Bilbao
www.guggenheim-bilbao.eus/en
2 Abandoibarra Etorbidea
Bilbao, Bizkaia 48009
Spain
Tel +34944359080

Gutenberg Museum
www.mainz.de/microsite/guten
berg-museum
5 Liebfrauenplatz
Mainz 55116
Germany
Tel +49 6131 122503

Horta Museum
www.hortamuseum.be/en
27 Rue Américaine
Bruxelles 1060
Belgium
Tel +32 2 543 04 90

Klingspor Museum
www.offenbach.de/klingspor-
museum
80 Herrnstraße
Offenbach 63065
Germany
Tel +49 69 80652164

**Marta Herford Museum for Art,
Architecture, & Design**
www.marta-herford.de/en
2–10 Goebenstraße
Herford 32052
Germany
Tel +49 5221 9944300

Moderna Museet
www.modernamuseet.se
4 Exercisplan
Stockholm 111 49
Sweden
Tel +46 8 520 235 00

Montebello Design Centre
www.montebello.co.za
31 Newlands Ave.
Newlands, Cape Town 7700
South Africa
Tel +27 21 685 6445

Musée de l'Imprimerie
www.imprimerie.lyon.fr
13 Rue de la Poulaillerie
Lyon 69002
France
Tel +33 4 78 37 65 98

Museum Angewandte Kunst
www.museumangewandtekunst.
de/en
17 Schaumainkai
Frankfurt 60594
Germany
Tel +49 69 212 44539

**Museum Boijmans
Van Beuningen**
www.boijmans.nl/en
18 Museumpark
Rotterdam CX 3015
Netherlands
Tel +31 010 44 19 400

**Museum of Contemporary
Art Kiasma**
www.kiasma.fi/en
Mannerheiminaukio 2
Helsinki, FIN-00100
Finland
Tel +358 294 500 501

National Museum
www.nasjonalmuseet.no/en
3 Brynjulf Bulls Plass
Oslo 0250
Norway
Tel +47 21 98 20 00

**National Museum of Ireland -
Decorative Arts & History**
www.museum.ie/en-IE/Museums/
Decorative-Arts-History
Collins Barracks, Benburb St.
Dublin, D07 XKV4
Ireland
Tel +353 1 6777444

Pavillon de l'Arsenal
www.pavillon-arsenal.com/en
21 Blvd. Morland
Paris 75004
France
Tel +33 1 42 76 33 97

Röhsska Museum
www.rohsska.se/en
39 Vasagatan
Göteborg 411 37
Sweden
Tel +46 31 368 31 50

The Centre Pompidou
www.centrepompidou.fr
Place Georges-Pompidou
Paris 75004
France
Tel +33 1 44 78 12 33

The Design Museum
www.designmuseum.org
224-238 Kensington High St.
London, W8 6AG
United Kingdom
Tel +44 20 3862 5900

The Douglas Hyde
www.thedouglashyde.ie
Trinity College Dublin
Dublin, 2D02 PN40
Ireland
Tel +353 1 896 1116

The Model, Sligo.
www.themodel.ie
The Model, The Mall, Slig.
F91 TP20
Ireland
Tel +353 7191 41405

**The Temporary Bauhaus-Archiv
/ Museum für Gestaltung**
www.bauhaus.de
1 Knesebeckstraße
Berlin-Charlottenburg 10623
Germany
Tel +49 0 30 254002 0

The Wilson
www.cheltenhammuseum.org.uk
51 Clarence St.
Cheltenham GL50 3JT
United Kingdom
Tel +44 1242 528764

Triennale di Milano
www.triennale.org/en
6 Viale Emilio Alemagna
Milano, MI 20121
Italy
Tel +39 02 724341

ASIA & OCEANIA
Art Gallery of New South Wales
www.artgallery.nsw.gov.au
Art Gallery Road
Sydney, NSW 2000
Australia
Tel +61 02 9225 1700

Arte Museum Dubai
www.dubai.artemuseum.com
SF-159, Level 2, The Dubai Mall
Downtown Dubai
United Arab Emirates
Tel +971 4 570 7084

Australian Museum
www.australian.museum
1 William St.
Darlinghurst, NSW 2010
Australia
Tel +61 2 9320 6000

Dongdaemun Design Plaza
www.ddp.or.kr
281 Eulji-ro
Jung-gu, Seoul
South Korea
Tel +82 2 2153 0000

Hong Kong Museum of Art
www.hk.art.museum/en/web/ma/
home.html
10 Salisbury Road
Tsim Sha Tsui, Kowloon
Hong Kong
Tel +852 2721 0116

Illusion City Dubai
www.illusioncity.ae
EC011, The Wharf Mall
Bluewaters Island, Dubai
United Arab Emirates
Tel +971 0 4 529 7880

**International Design
Centre Nagoya**
www.idcn.jp
3-18-1 Sakae
Naka-ku, Nagoya 460-0008
Japan
Tel +81 52 265 2105

M+
www.mplus.org.hk/en
38 Museum Drive
West Kowloon Cultural District
Hong Kong
Tel +852 2200 0217

Metropolitan Museum of Manila
www.metmuseum.ph
MK Tan Centre
30th Street,
Bonifacio Global City
The Philippines
Tel +63 917 160 9667

**Museum of Contemporary
Art & Design Manila**
www.mcadmanila.org.ph
G/F De La Salle – College of
Saint Benilde Design and Arts
Campus, Dominga St.
Malate, Manila 1004
Philippines
Tel +632 8230 5100

**Museum of Contemporary
Art Bangkok**
www.mocabangkok.com
499 Kamphaengphet 6 Road
Ladyao, Chatuchak,
Bangkok 10900
Thailand
Tel +66 2 016 5666

Museum of the Future
www.museumofthefuture.ae/en
67CP+H4Q Sheikh Zayed Road
Dubai
United Arab Emirates
Tel +971 800 2071

National Art Center Tokyo
www.nact.jp/english/index.html
7-22-2 Roppongi
Minato-ku, Tokyo 106-8558
Japan
Tel +81 50 5541 8600

National Gallery of Victoria
www.ngv.vic.gov.au
180 St. Kilda Road
Melbourne, VIC 3006
Australia
Tel +61 3 8620 2222

**National Museum of Modern
& Contemporary Art Seoul**
www.mmca.go.kr/eng
30 Samcheong-ro
(Sogyeok-dong)
Jongno-gu, Seoul 03062
South Korea
Tel +82 2 3701 9500

National Museum of Qatar
www.nmoq.org.qa/en
Museum Pk St.
7GQX+8P Doha
Qatar
Tel +974 4452 5555

**National Taiwan Museum
of Fine Arts**
www.ntmofa.gov.tw/en
No. 2, Section 1,
Wuquan W. Road
West District,
Taichung City 403414
Taiwan
Tel +886 04 2372 3552

Red Dot Design Museum
www.museum.red-dot.sg
11 Marina Blvd.
Singapore 018940
Singapore
Tel +65 6514 0111

Seoul Museum of Art
www.sema.seoul.go.kr/en/index
61, Deoksugung-gil
Jung-gu, Seoul 04515
South Korea
Tel +82 2 2124 8800

ADDITIONAL MUSEUMS:
If you are a museum that collects
posters and are not listed above,
please contact us for inclusion in our
next Annual at help@graphis.com.

Eduardo Aires | Studio Eduardo Aires | **Founder & Art Director**
Biography: Eduardo Aires (Ph.D) is the founder and artistic director of Studio Eduardo Aires. From visual identity, territorial branding, and packaging and labeling to editorial design, postage stamps, and circulation coins, the Studio's portfolio is broad in range. Their clients include companies and institutions such as Esporão, the Portuguese Mint and Official Printing Office, the CTT (Portuguese Post Office), the Calouste Gulbenkian Foundation, and the Amorim Group. One of the Studio's most notable projects is the visual identity for the city of Porto, which has been in use since 2014. Studio Eduardo Aires is represented in Taschen's *History of Graphic Design* (2018), *History of Portuguese Design* (2016), and in specialized publications such as Novum and Graphis. The Studio's work has won awards from Graphis, Red Dot, Pentawards, D&AD, the European Design Awards, and the Bienal Iberoamericana de Diseño. Eduardo has developed several self-initiated projects merging editorial and product design, such as the Past and Future calendars. He is also an associate professor for the faculty of fine arts at the University of Porto.
Commentary: We live in a world full of increasingly powerful images and messages, and this saturation often makes us think we've seen it all. However, analyzing the Graphis Design Awards' submissions can still offer a surprise. Year after year, projects have been consolidating at an excellent level, a sign that design is crucial in the habitat of contemporary man. At the end of the judging process, Graphis sets a milestone of what was done best and designed worldwide. For designers and the practice of design, this award is a symbol of international peer recognition, in addition to valuing the absolute merit of the effort of each designer and studio. And it's always wonderful to be rewarded with such a prize.

Jennifer Morla | Morla Design | **Designer**
Biography: Since opening Morla Design in 1984, Jennifer Morla has paired wit and elegance on everything from motion graphics and branding to retail environments and textiles. She is the recipient of the two most honored awards in graphic design: the Cooper Hewitt National Design Award and the AIGA Medal. Jennifer's work is included in numerous museum collections, including MoMA, SFMoMA, LACMA, and the Smithsonian. She lectures and judges internationally and taught at California College of the Arts for over 20 years. *Morla: Design*, published by Letterform Archive, offers insight into her creative process and features 150 of her studio's projects.
Commentary: Packaging was a stand-out category. Unlike recent years, where over-the-top embellishments were pervasive, many of this year's entries displayed a return to the beauty of simplicity.

Brendán Murphy | Lippincott | **Global Creative Director & Senior Partner**
Biography: Brendán Murphy is a global creative director and a senior partner based in Lippincott's New York office. A native of Dublin, Brendán has led and designed programs for various clients, including Aer Lingus, Samsung, *The New Yorker*, Toys "R" Us, and many more. His work has been featured in Graphis, *Design Management Journal*, *Metropolis*, Novum, PRINT, and *The Wall Street Journal*. His work has won awards from the SEGD and the Type Directors Club of New York and exhibited at the Type Directors Club and the Oireachtas in Dublin. Brendán holds an EC certificate in advertising from the College of Commerce, Dublin, a BS in printing from Pittsburg State University, Kansas, and an MDes in design from the University of Cincinnati.
Commentary: Seeing the global diversity of thinking and breadth of projects is always fantastic. Year after year, it's refreshing to see how the design world and aesthetics evolve. CGI certainly made a mark with some fantastical, if not honest, packaging. Those that stood out continue to push our craft with crisp thinking and imaginative storylines, all within the confines of type, line, scale, and imagery. The winners will no doubt evoke the deadly sin of envy.

Richard Poulin | Poulin + Morris Inc. | **Former Principal, Co-founder, & Design Director**
Biography: Richard Poulin is a designer, educator, author, and artist living in Palm Springs, California. Throughout his career, he has focused on a generalist approach to all design aspects, including graphic, interior, experiential, and exhibition design, dividing his time between professional practice and academia. For over 30 years, he was a creative director and managing partner of Poulin + Morris Inc., which he co-founded in New York City in 1989. As a highly respected educator, he taught at Cooper Union and the School of Visual Arts for over two decades. He is a recipient of a research grant in design history from the Graham Foundation for Advanced Studies in the Fine Arts and a recipient of a Fellow from the Society of Experiential Graphic Design (the profession's highest honor). His work is in the permanent design collections of the Denver Museum of Art, Letterform Archive, Library of Congress, and the Los Angeles County Museum of Art (LACMA). Richard is also the author of several books on graphic design, typography, and design history. His new book is a comprehensive monograph on the life and work of mid-century modernist designer Rudolph de Harak—*Rational Simplicity: Rudolph de Harak: Graphic Designer*—published by Thames & Hudson (London). As an artist, his multi-media collage constructions have been exhibited throughout the United States and are in the collections of several private collectors.
Commentary: Our physical world or cultural divides no longer limit us. The language of visual communications is universal and one of the primary vehicles for sharing information. Since the industrial revolution, the adage "every picture tells a story" was conventionally applied to products and their advertising. Today, a similar statement can be made for practically every aspect of our daily lives—"everything can tell a story." Globalization, fueled by the internet and social media, allows designers worldwide to communicate on a level we have never experienced before. New and innovative technologies are being quickly embraced and inevitably empower us to gain more control over the realization and transmission of our ideas. The results are evident in the 2025 Graphis Design Awards.

Toshiaki & Hisa Ide | IF Studio | **Co-founders**
Biography: Toshiaki and Hisa Ide are an award-winning father and daughter team leading the creative vision at IF Studio. After graduating with honors from SVA in 2010, Hisa joined Toshiaki as the creative director and co-founder of IF Studio. The pair has won numerous publications and awards since then. Toshiaki's 30 years of experience with agencies such as Wells Rich Greene, Grey Advertising, and Bates USA on accounts including Estée Lauder, Olay, IBM, AT&T, and American Express are complemented by Hisa's fresh and sophisticated aesthetic as design director.
Commentary: This year's design entries are a stunning display of creativity and technical skill and a true testament to the boundless potential of design. From innovative branding campaigns to thought-provoking illustrations, the competition showcased the power of design and its ability to move us, challenge us, and leave a lasting impression. It is always a privilege to be part of a community that constantly pushes visual communication boundaries.

Titles: White Studio - Magistra, The Pop Collection | **Clients:** Esporão, Livraria Lell

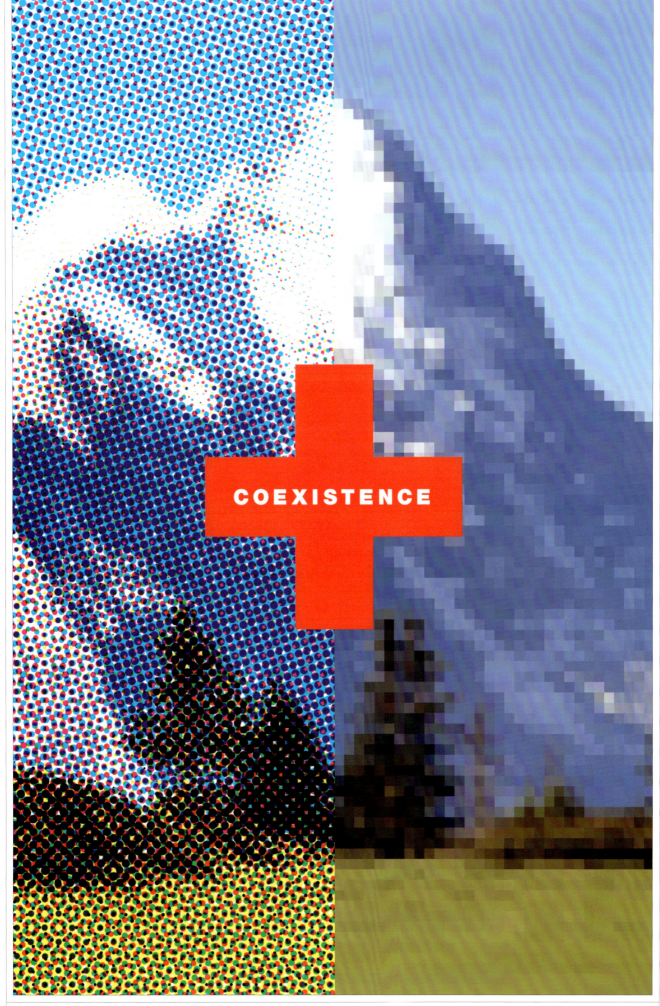

Title: Alliance Graphique Internationale 2015 "Coexistence" Poster | **Client:** Alliance Graphique International

Titles: Aer Lingus: Renewing an Irish Icon, Reimagining Play for a New Generation of Parents | **Clients:** Aer Lingus, Toys"R"Us

Titles: Convent of the Sacred Heart Athletics and Wellness Center, Rational Simplicity: Rudolph de Harak, Graphic Designer
Clients: Convent of the Sacred Heart, Thames & Hudson Ltd.

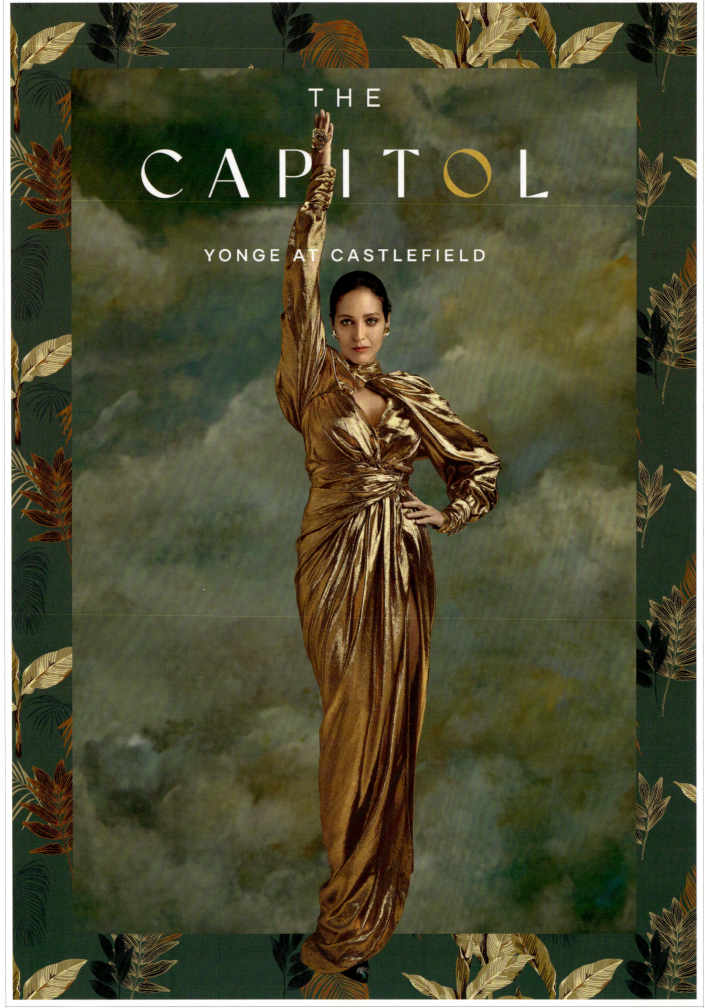

Title: The Capitol Brochure | **Client:** Madison Group

Delfin | **Studio DelRey** | Graphic Designer | Page: **20** | www.studiodelrey.com.br
Biography: Delfin is a writer, journalist, editor, and an acclaimed graphic designer with a remarkable career. Notably, he has received prestigious national and international awards for his outstanding editorial design work from the likes of the Brazil Design Awards (BDA), Graphis, and the Society for New Design (SND). Delfin has also left his mark in literature, having translated works by renowned authors and being a published writer himself. His fiction includes the short story books *Kreuzwelträtsel* and *If I Had an Axe*, the novelettes *All I See Is Our Love* and *The Death of Maximo Condor*, and contributions to various anthologies. Furthermore, his professional journey spans from working in local newspapers to assuming key editorial roles at prominent media outlets and pop culture websites. Delfin's multifaceted expertise also extends to the realms of broadcasting and cine-clubbing, where he remains an influential figure in the cultural scene of his hometown.

Kit Hinrichs | **Studio Hinrichs** | Principal & Creative Director | Pages: **21, 221** | www.studio-hinrichs.com
Biography: Kit Hinrichs studied at the ArtCenter College of Design in Los Angeles, California. He served as principal in several design offices in New York and San Francisco and spent 23 years (1986–2009) as a partner of Pentagram before opening Studio Hinrichs in 2009. His work is included in the permanent collections of the Museum of Modern Art (New York and San Francisco), the Los Angeles County Museum of Art, the Denver Museum of Design, and the Letterform Archive. In addition to *Narrative Design*, he is the co-author of five books, including *Typewise*, *Long May She Wave*, and *The Pentagram Papers*. Kit co-founded the magazine *@issue: The Journal of Business and Design*, chaired the AIGA California Show, and co-chaired the AGI San Francisco Congress. Kit is a recipient of the prestigious AIGA medal and a member of the Alliance Graphique Internationale. Recently, he was commissioned to design an American flag exhibit, Broad Stripes/Bright Stars, at the Nevada Museum of Art and a major American flag book in celebration of the 250th anniversary of the United States.

Anna and Elena Balbusso | **Balbusso Twins Artist Duo** | Artists & Illustrators | Page: **22** | www.balbussotwins.com
Biography: Anna and Elena Balbusso, also known as the Balbusso Twins, are an award-winning Italian artist duo based in Milan who work internationally in the fields of illustration, art, and design. Their works have been published by major publishers and companies worldwide. Their clients include newspapers and magazines such as *The Economist*, *The New Yorker*, *The New York Times*, *Reader's Digest*, and *Corriere Della Sera*. They have illustrated over 50 books and won over 100 international prestigious awards and honors, including several gold and silver medals from the Society of Illustrators New York, SILA Los Angeles, Graphis, and 3x3. The Norman Rockwell Museum included the Balbusso Twins in the history of illustration among "The Illustrators of the Decade: 2010–2020." In 2023, Graphis featured the artist duo in *The Graphis Journal* issue #377.

Vishal Vora | **Sol Benito** | Founder & Designer | Page: **23** | www.solbenito.com
Biography: Sol Benito is an award-winning packaging design studio based in Mumbai and is headed by founder and designer Vishal Vora. He studied graphic design form at the I.S. College of Fine Arts. He has intrinsic creative talent and over 20 years of multi-disciplinary and multi-sector experience in design direction, management, and implementation in India and overseas. Vishal has worked in various markets in Europe, America, and GCC. With a keen eye for quality design and profound experience in applying graphic principles to produce innovative designs for any media, he would describe his approach to design as emotional, intuitive, and aspirational. His inclination lies in branding, packaging, product, and exhibition design.

Globalization allows designers to communicate in new ways, and new technologies empower us to gain more control over our ideas.

The results are completely evident in the 2025 Graphis Design Awards.

Richard Poulin, *Former Principal, Co-founder, & Design Director, Poulin + Morris Inc.*

Ivan Bell | **Stranger & Stranger** | Group MD & CEO | Pages: **24, 25** | **www.strangerandstranger.com**
Biography: Ivan started his career as a multidisciplinary graphic designer in London back in the 80s and became fascinated with consumer brand packaging for alcoholic beverages. For the past 23+ years, he has worked alongside Kevin Shaw, founder of Stranger & Stranger, in building the award-winning packaging consultancy (from three to 40+ people) and overseeing design from their locations in London, New York, and San Francisco. Stranger's client base is diverse, from well-known global brands to new start-ups. Ivan is passionate about brands that disrupt and stand out. Ivan also regularly serves as a jury member for trade and international design awards and undertakes speaking engagements on the power of good design.

Chong-Wen Chen | **National Kaohsiung University of Science and Technology (NKUST)** | Professor, Designer, & Animator
Page: **26** | **www.nkust.edu.tw**
Biography: Chong-Wen Chen is a professor in the Department of Cultural and Creative Industries at the National Kaohsiung University of Science and Technology in Taiwan. He is also a graphic and product designer and a 3D animator who brings expertise and innovation to his work, having earned multiple patents and international awards. Chong-Wen is passionate about leveraging design thinking and methodologies to drive sustainable development and higher education innovation. He is committed to exploring the potential of design language to enhance cross-cultural communication. With over a decade of experience in interdisciplinary studies and design, his research and visual works have been published in renowned top-ranking journals, including *Sustainable Development*, *Sustainable Cities and Society*, *Visual Studies*, *Design Journal*, and *Design and Culture*. Chong-Wen received his Ph.D in industrial design from the National Cheng Kung University and holds an MS in visual design and a BS in fine art from the National Kaohsiung Normal University.

Hoon-Dong Chung | **Dankook University** | Professor & Designer | Page: **27** | **www.dankook.ac.kr**
Biography: Hoon-Dong Chung is a professor (Ph.D in design) at Dankook University in South Korea. His works have been shown in international exhibitions and received over 200 awards, including the German Design Award, the Red Dot Design Award, the iF Design Award, the Design Award of the Federal Republic of Germany, the Good Design Award, the K-Design Award, and more. He also received a commendation from the president of South Korea at the Korea Design Award, known as "Korea's Highest Honor in Design." Furthermore, his works are in the collections of the Design Museum Munich, the Museum für Kunst und Gewerbe in Hamburg, the Museum für Gestaltung, the Musée de la Publicité, the National Museum in Poznan, the Poster Museum at Wilanów, the Dansk Plakat Museum, the Museum House of Humour and Satire, the Ogaki Poster Museum, and more.

Xiaowei Zhang | **33 and Branding** | Founder, Designer, & Art Director | Page: **28** | **www.33andbranding.com**
Biography: Xiaowei Zhang is an award-winning designer and art director specializing in graphic design, branding, packaging, multimedia, immersive experiences, and other cross-disciplinary work. He was invited to be the visual effects director for the opening ceremony of the 24th Beijing Winter Olympics in 2022 and was the lead designer for the Olympic torch snowflake installation. His works span traditional and popular culture, significantly promoting the development of Chinese design. Xiaowei has won hundreds of awards, including the NY ADC, D&AD, One Show, Clios, Cannes Lions, and CA awards.

Eunjin Yu | **EJ Communication Studio** | Designer, PR Director, & Professor | Page: **29**
Biography: Eunjin Yu majored in visual design at Dankook University and completed her doctoral coursework there in 2013. Since 2011, she has lectured on editorial and graphic design at various universities. Since 2021, she has been the PR director of BI Gallery, strengthening the brand. Currently, she is an adjunct professor in the Department of Design and Visual Arts at Baekseok University and the chief designer at Hexain Inc., working on brand marketing projects. She has received several awards, including the Minister's Award at the Korea Design Exhibition in 2022 and grand prizes in visual design (It-Award, 2021), spatial environmental design (2021), and package design (2019). She has held 11 solo exhibitions, including K-Module Talk'in Hungary, Window to Turkey in Turkey, and Continuetus in Beijing.

Media.Work | Page: **221** | **www.media.work**
Biography: Media.Work is a collective of innovators, designers, artists, and creators who are exploring visual ways to convey ideas in collaboration with ambitious, independent organizations. Creating cross-disciplinary experimental projects, the company is trusted by brands such as Nike, Sony, Chanel, Google, Microsoft, Pinterest, OPPO, BMW, Volvo, Adidas, IKEA, Jimmy Choo, and many others that aim to be bold and challenge the normal. Being explorers at heart, the studio depends on a significant amount of time for self-initiated projects, opening up a new perspective on the essence and properties of tangible things and intangible entities.

Visit our Credits & Commentary section in the back of the book to read the full assignments, approaches, and results from this year's Platinum Winners.

Title: Tesla: A Vida e a Loucura Do Gênio que Iluminou o Mundo | **Client:** Editora Globo
Design Firm: Studio DelRey | **P235:** Credit & Commentary

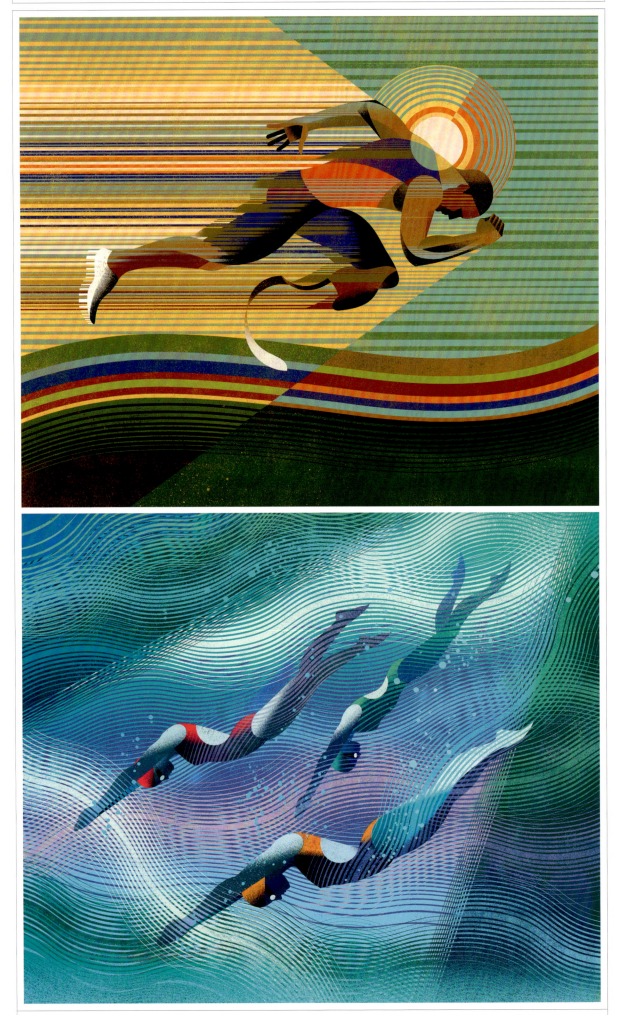

Title: Epson Calendar Spectacular Limited Edition | **Client:** Epson | **Design Firm:** The Balbusso Twins
P235: Credit & Commentary | Images 1, 2 of 7

Title: SDGs Messages Trilogy | Client: NKUST College of Innovation and Design
Design Firm: National Kaohsiung University of Science and Technology | P235: Credit & Commentary | Image 1 of 3

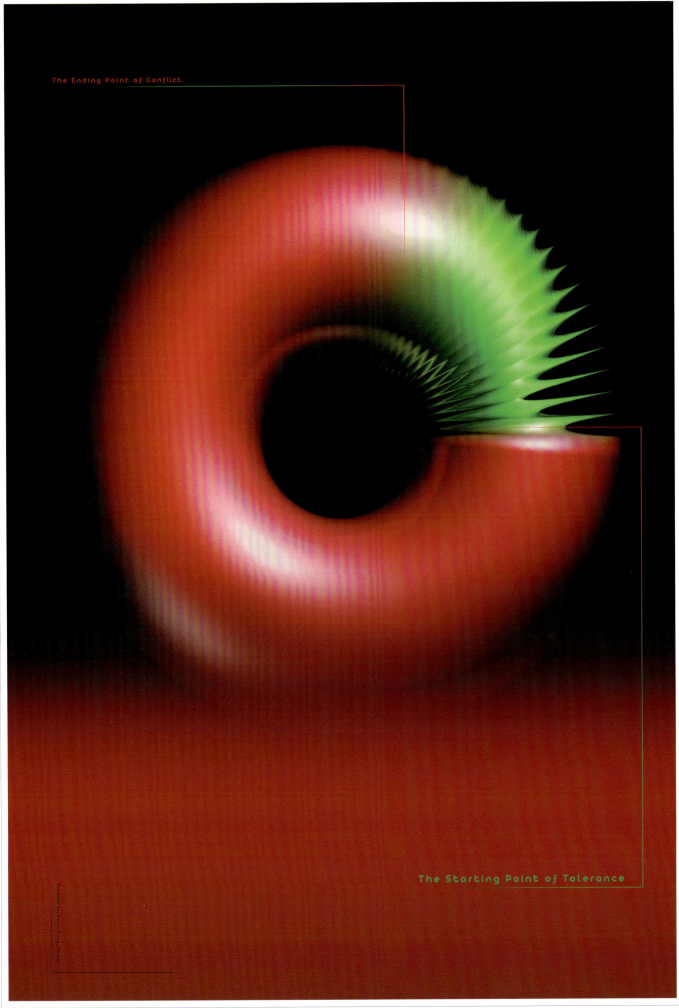

The Ending Point of Conflict

The Starting Point of Tolerance

木卿御品

BUTTERFLYEFFECT

What happens if there are no butterflies?
If butterflies did disappear completely from our shores – this along with a much more troubling list of changes would signal an end to the way we currently live our lives as our weather could become shockingly extreme. Climate change drives mountaine butterflies towards the summits

What is the butterfly concept?
In chaos theory, the butterfly effect is the sensitive dependence on initial conditions in which a small change in one state of a deterministic nonlinear system can result in large differences in a later state.

Title: Butterfly Effect | **Client:** Information and Communication Technology Division
Design Firm: EJ Communication Studio | **P235:** Credit & Commentary

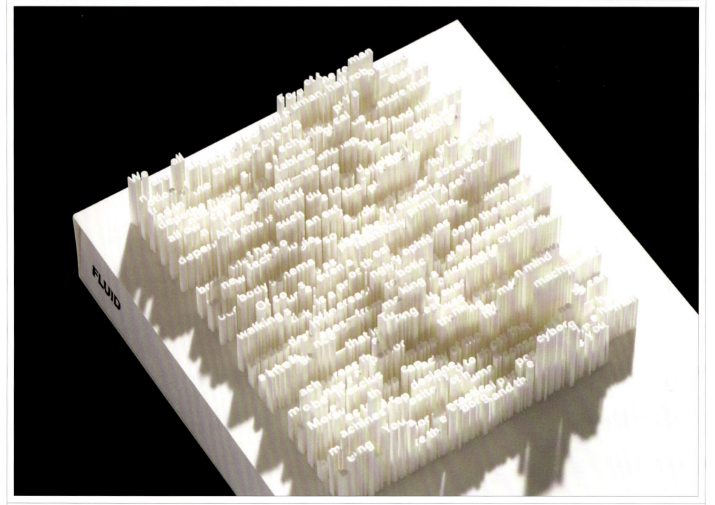

Title: Fluid Dimensions | **Client:** Berkeley Center for New Media
Design Firm: Jocelyn Zhao Design | **P235:** Credit & Commentary | Images 1, 2 of 7

Title: Noir Bar: Cocktails Inspired by the World of Film Noir | **Clients:** Running Press Book Publishers, Turner Classic Movies
Design Firm: Headcase Design | **P236:** Credit & Commentary | **Images 1-3 of 7**

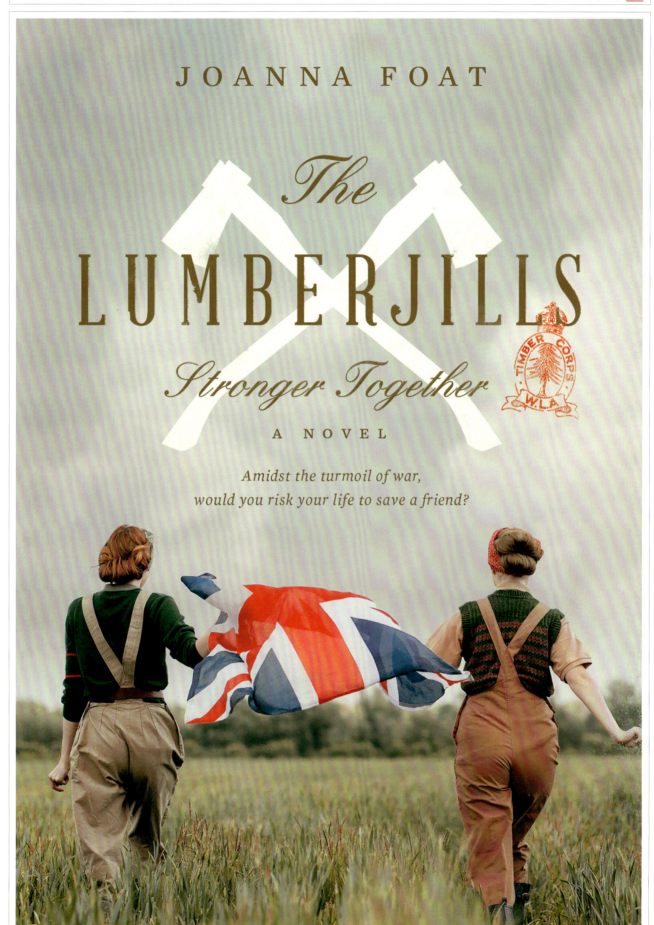

P236: Credit & Commentary **Title:** The Lumberjills | **Client:** Merrow Downs Press | **Design Firm:** Richard Ljoenes Design LLC

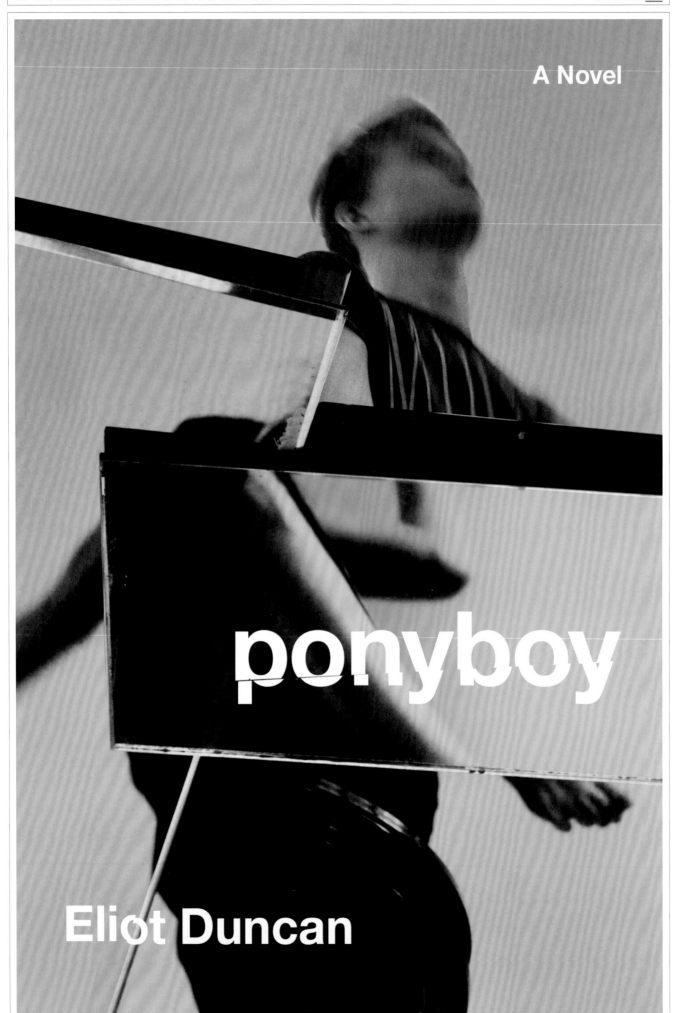

A Novel

ponyboy

Eliot Duncan

Title: Toledo Museum of Art Rebrand | **Clients:** Toledo Museum of Art, Adam Levine, Gary Gonya, Mark Yappueying, Aly Krajewski, Crystal Phelps
Design Firm: Lafayette American | **P236:** Credit & Commentary | Images 1, 2 of 7

Title: Eco Fusion - Branding | **Client:** Eco Fusion | **Design Firm:** Viva & Co.

Title: Michi Japanese Kitchen Branding | **Clients:** Michi Japanese Kitchen, Michiyo Wilson
Design Firm: Arcana Academy | **P237:** Credit & Commentary | Images 1, 2 of 7

Title: Unifonic Rebrand | **Client:** Unifonic
Design Firm: Pendo | **P237:** Credit & Commentary | Images 1, 2 of 7

Title: Wert&Co. Brand Identity: Every Creative's Career Follows a Unique Path | **Client:** Wert&Co.
Design Firm: Stitzlein Studio | **P237:** Credit & Commentary | Images 1, 2 of 7

Elevate your dining experience.

RESERVATIONS: UPSTAIRS@DIVINO.COM

Upstairs at Divino | Dec 1

UPSTAIRS@DIVINO.COM

P237: Credit & Commentary **Title:** 7UP Onam 2023 | **Client:** Self-initiated | **Design Firm:** PepsiCo Image 1 of 5

This year's Graphis Design competition entries are a stunning display of creativity and technical skill and a true testament to the boundless potential of design.

Ranging from innovative branding and ad campaigns to thought-provoking illustrations, the competition showed us the power of design and its ability to move us, challenge us, and leave a lasting impression.

Toshiaki & Hisa Ide, *Co-founders, IF Studio*

We offer
cross-border product
design and trade.

Title: Gangwon State CI | **Clients:** Gangwon State, Kim Jin-Tae, Kim Yong-Kyun, Bak Ho, Choi Nak-young, Choi In-Sook, Choi Yong-Sun, Shin Kyoung-Cheol, Jang Aeri, Lee Mi-Kyung, Choi Jung-Won, Park Young-Jo | **Design Firm:** DAEKI and JUN | **P237:** Credit & Commentary | Images 1, 2 of 7

Title: 65th Monterey Jazz Festival Identity | **Client:** Monterey Jazz Festival
Design Firm: *Trace Element | **P237:** Credit & Commentary | Image 1 of 4

2024 CALENDAR
LIFE with LIGHTS

Title: 2024 CALENDAR LIFE with LIGHTS | **Clients:** Electric Works Company, Panasonic Corporation
Design Firm: TOPPAN INC. | **P237:** Credit & Commentary | Images 1-6 of 7

Title: 2024 CALENDAR FUSION Nature & Technology | **Client:** KOMORI Corporation
Design Firm: TOPPAN INC. | **P238:** Credit & Commentary | Images 1-6 of 7

THE

OF INNOCENCE

PURE, PEACEFUL AND ALWAYS IN VOGUE, WHITE IS THE COLOR DU JOUR FOR OUR WEE MODELS.
PHOTOGRAPHY BY ZOE ADLERSBERG • STYLING BY MARIAH WALKER

Eliza is wearing
a cardigan by
Bonpoint and
collar by **Noralee**.

P238: Credit & Commentary **Title:** The Age of Innocence | **Client:** Earnshaw's Magazine | **Design Firm:** Wainscot Media

TREVETT MCCANDLISS, NANCY CAMPBELL **GOLD**

EDITORIAL

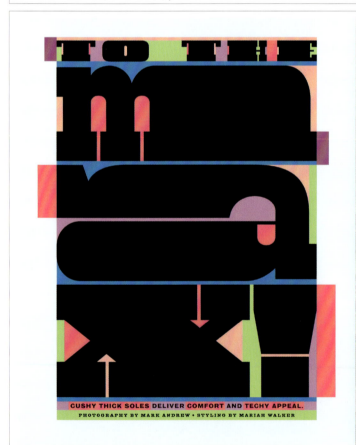

CUSHY THICK SOLES DELIVER COMFORT AND TECHY APPEAL.
PHOTOGRAPHY BY MARK ANDREW • STYLING BY MARIAH WALKER

Maximum EVA sole joggers with
built-in arch support by **Aetrex**.

P238: Credit & Commentary **Title:** To the Max! | **Client:** Footwear Plus Magazine | **Design Firm:** Wainscot Media

Title: Dazzle Jazz Club: Branding, Environmental Graphics, and Signage | **Client:** Dazzle Jazz
Design Firm: ArtHouse Design | **P238:** Credit & Commentary | Images 1, 2 of 7

P238: Credit & Commentary **Title:** Another Year | **Client:** Self-initiated | **Design Firm:** UP-Ideas

Title: 21 Covers for Margaret Atwood's Masterpieces | **Client:** Corriere Della Sera
Design Firm: The Balbusso Twins | **P238:** Credit & Commentary | Image 1 of 7

Title: Ghost Army Congressional Gold Medal and Bronze Medal | **Client:** The United States Mint
Design Firm: Justin Kunz Art & Design | **P239:** Credit & Commentary

JAY JOSUE

GAMESQUARE

P239: Credit & Commentary **Title:** Gamesquare Logo | **Client:** Gamesquare | **Design Firm:** Arcana Academy

JIAYU MA, LINLAN LI

CURATING AND
THE COMMONS

P239: C & C **Title:** Curating & The Commons Logo | **Clients:** Independent Curators International, Scott Campbell | **Design Firm:** Big House Studio

EL PASO, GALERÍA DE COMUNICACIÓN

P239: Credit & Commentary **Title:** La Pernía Beer | **Client:** José R. García | **Design Firm:** El Paso, Galería de Comunicación

ANDRÉ DE WAAL

P239: Credit & Commentary **Title:** Birchden Vineyards Logo | **Client:** Birchden Vineyards | **Design Firm:** Idle Hands

PHIL MARSHALL

P239: Credit & Commentary **Title:** ORYX Outdoor Clothing | **Client:** OpSec | **Design Firm:** Mischievous Wolf Image 1 of 4

DAICHI TAKIZAWA ●

P239: Credit & Commentary **Title:** EAT DRINK SLEEP RUN / HEART Logo | **Client:** Runtrip, Inc. | **Design Firm:** Daichi Takizawa

DANIEL PETTIT

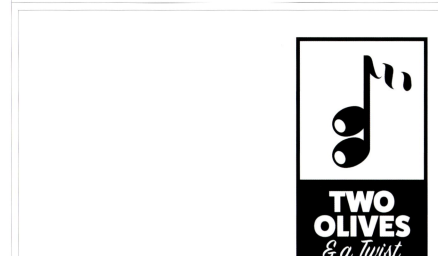

P239: C & C **Title:** Two Olives & A Twist Logo | **Clients:** Two Olives & A Twist, Clark Germain | **Design Firm:** Arcana Academy

ANTON TIELEMANS

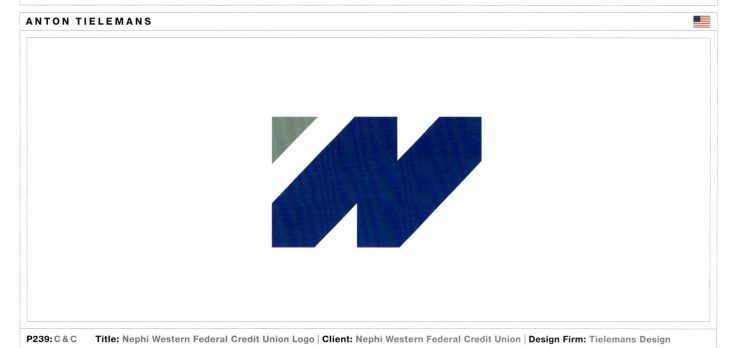

P239: C & C **Title:** Nephi Western Federal Credit Union Logo | **Client:** Nephi Western Federal Credit Union | **Design Firm:** Tielemans Design

REGGIE LONDON

P239: Credit & Commentary | **Title:** New York Pavements | **Client:** New York Pavements | **Design Firm:** Reggie London | Image 1 of 6

LERMA/

P240: Credit & Commentary | **Title:** Rebel Chef Logo Design | **Client:** Rebel Dreads Corp, LLC. | **Design Firm:** LERMA/

JOE ROSS

P240: Credit & Commentary | **Title:** Aerospike Logo | **Client:** Aerospike | **Design Firm:** Traina

SHARON LLOYD MCLAUGHLIN

P240: Credit & Commentary | **Title:** Flaming6 Logomark | **Client:** Flaming6 | **Design Firm:** Mermaid, Inc.

LAURA GANG

P240: Credit & Commentary | **Title:** Madison Nightmares Identity | **Client:** Madison Nightmares | **Design Firm:** Planet Propaganda | Image 1 of 7

KIT HINRICHS

P240: Credit & Commentary **Title:** CL!KS Digital Identity | **Client:** CL!KS Digital | **Design Firm:** Studio Hinrichs

JEFF BARFOOT

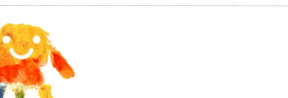

P240: Credit & Comm. **Title:** Octopus Garden Preschool Trademark | **Client:** Octopus Garden Preschool | **Design Firm:** *Trace Element

JOHANN TERRETTAZ

P240: Credit & Commentary **Title:** MAZE Logo | **Client:** MAZE | **Design Firm:** Johann Terrettaz

JOHN BALL, DAVID ALDERMAN

P240: Credit & Commentary **Title:** Shakira Pastry Logo | **Client:** Shakira Pastry | **Design Firm:** MiresBall

SHADIA OHANESSIAN

P240: Credit & Commentary **Title:** SEXELS | **Client:** SEXELS | **Design Firm:** Shadia Design Image 1 of 7

Title: Raffles Boston's Signature Restaurant, Amar: Menus | **Client:** Raffles Hotels and Resorts
Design Firm: Toolbox Design | **P240:** Credit & Commentary | Images 1, 2 of 7

P241: Credit & Commentary **Title:** Hotel Tango Pride 2023 | **Client:** Hotel Tango Distillery | **Design Firm:** Young & Laramore

OMDESIGN GOLD **PACKAGING** 🇵🇹

P241: Credit & Commentary **Title:** Chronicle Whisky | **Client:** The Auld Alliance | **Design Firm:** Omdesign

Lagg Distillery
Isle of Arran
167 Square Miles
Firth of Clyde
Scotland

LAGG

Single Malt
Scotch Whisky

Kilmory Edition
100% ex-Bourbon Barrel

Non Chill Filtered
Natural Colour

46%Vol 70cl.e

Product of Scotland

Title: Stonestreet Bourbon | **Clients:** Stonestreet Whiskey, Jackson Family Wines
Design Firm: Chad Michael Studio | **P242:** Credit & Commentary

Title: Belvedere 10 Vodka | Client: LVMH | Design Firm: Stranger & Stranger

PIN DROP
CARIBBEAN RUM
AGED 10 YEARS
IN OAK BARRELS

BLENDED & BOTTLED
AT JOHN WATLING'S
DISTILLERY, NASSAU,
THE BAHAMAS

PRODUCT OF
THE BAHAMAS

GOVERNMENT WARNING: (1)
ACCORDING TO THE SURGEON
GENERAL, WOMEN SHOULD NOT
DRINK ALCOHOLIC BEVERAGES
DURING PREGNANCY BECAUSE OF
THE RISKS OF BIRTH DEFECTS.
(2) CONSUMPTION OF ALCOHOLIC
BEVERAGES IMPAIRS YOUR ABILITY
TO DRIVE A CAR OR OPERATE
MACHINERY, AND MAY CAUSE
HEALTH PROBLEMS.

IMPORTED BY
PIN DROP RUM LLC
JERSEY CITY, NJ

ENJOY RESPONSIBLY

HARBOUR ISLAND, BAHAMAS

PIN
DROP
RUM

40% ALC/VOL·750mL

10
YEARS

Title: CONFESSION® Straight Bourbon Whiskey | Client: Burnt Church Distillery
Design Firm: Thoroughbred Spirits Group | P242: Credit & Commentary | Images 1, 2 of 7

Title: Robert's No. 1 American Dry Gin | **Client:** Oak House Distillery
Design Firm: CF Napa Brand Design | **P242:** Credit & Commentary

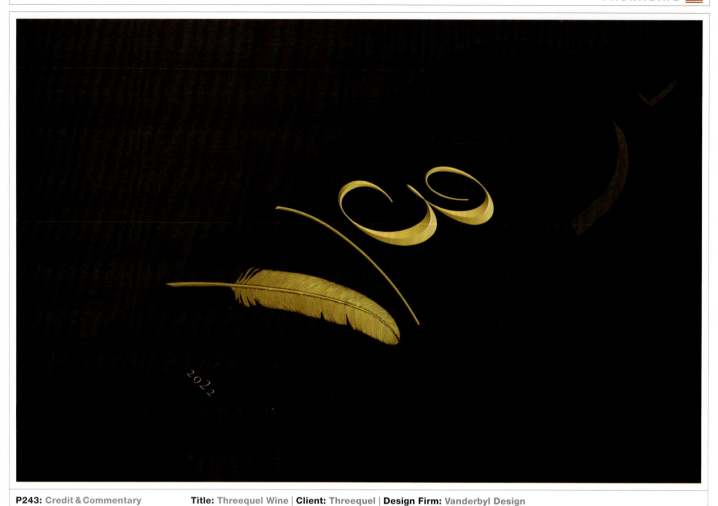

P243: Credit & Commentary **Title:** Threequel Wine | **Client:** Threequel | **Design Firm:** Vanderbyl Design

SEAN FREEMAN, EVE STEBEN *GOLD* **PACKAGING** 🇬🇧

P243: Credit & Commentary **Title:** LIKKLE MORE | **Clients:** Likkle More Chocolate, Nadine Burie | **Design Firm:** THERE IS STUDIO Image 1 of 5

Title: Café Olimpico - Heritage Tin | **Client:** Café Olimpico
Design Firm: STNMTL (Station Montréal Design Bureau) | **P243:** Credit & Commentary | Images 1, 2 of 5

P244: Credit & Commentary **Title:** Casabella | **Client:** Emper Perfumes | **Design Firm:** Sol Benito

JOHN VANNELLI, MAUD GAUDREAU GOLD

PACKAGING

Title: Cioccolato | **Clients:** Café Olimpico, État de Choc.
Design Firm: STNMTL (Station Montréal Design Bureau) | **P244:** Credit & Commentary | Image 1 of 5

Title: Margaret River Natural Spring Water | **Client:** Margaret River Natural Spring Water
Design Firm: Dessein | **P244:** Credit & Commentary | Image 1 of 7

Title: Genesis Motors G90 Gifting Campaign | **Client:** Genesis Motors
Design Firm: Premier Communications Group | **P244:** Credit & Commentary | Images 1, 2 of 7

Title: Wrapping the Opportunity of a Lifetime — 1963 Ferrari 250 GTO s/n 3765GT Presented by RM Sotheby's | **Client:** RM Sotheby's
Design Firms: Affinity Creative Group, Kabookaboo | **P244:** Credit & Commentary

P244: Credit & Commentary **Title:** Epicure Popcorn Tins | **Client:** Self-initiated | **Design Firm:** Neiman Marcus Brand Creative

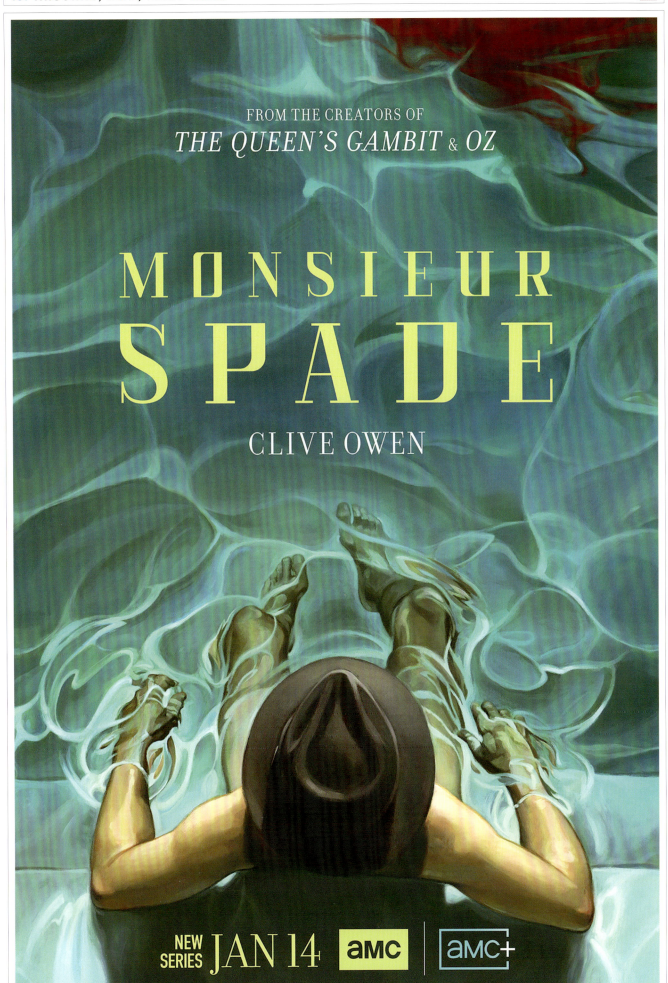

Title: Monsieur Spade | **Clients:** AMC, AMC+
Design Firm: ARSONAL | **P244:** Credit & Commentary

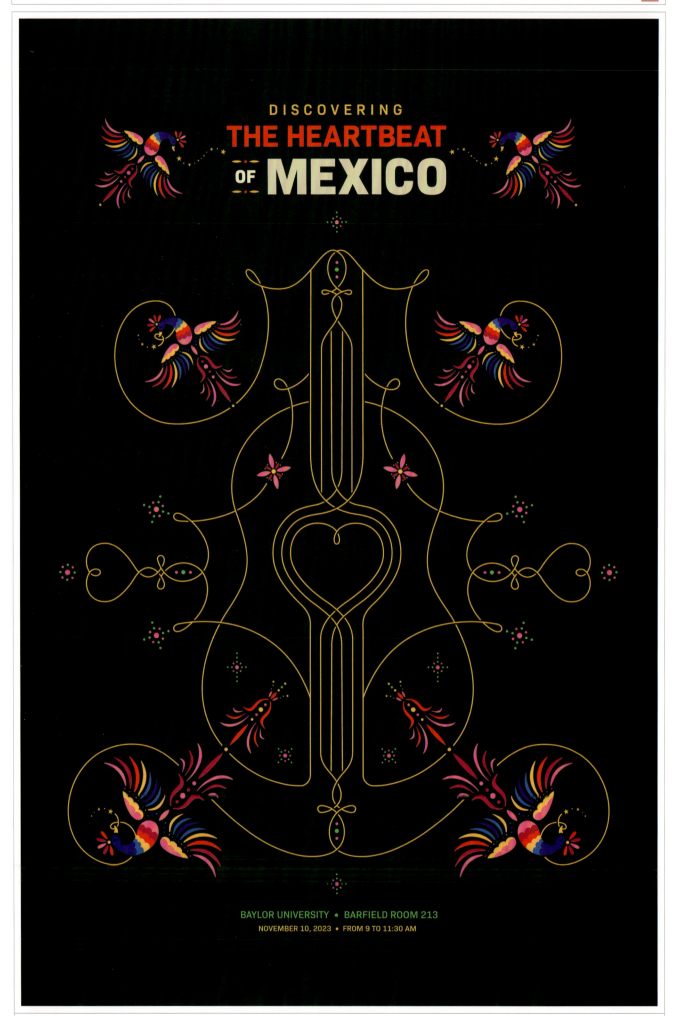

Title: The Heartbeat of Mexico | **Client:** Department of Modern Languages and Cultures at Baylor University
Design Firm: Legacy79 | **P245:** Credit & Commentary

¹Generation

Recognizing the diversity of experiences and perspectives within feminist movements schools and seeking to build coalitions across differences

²Generative

Generating innovative ideas and adaptable approaches to address the unique challenges facing women in diverse situations

A multifaceted creative framework enabling feminist activists to advocate for their rights.

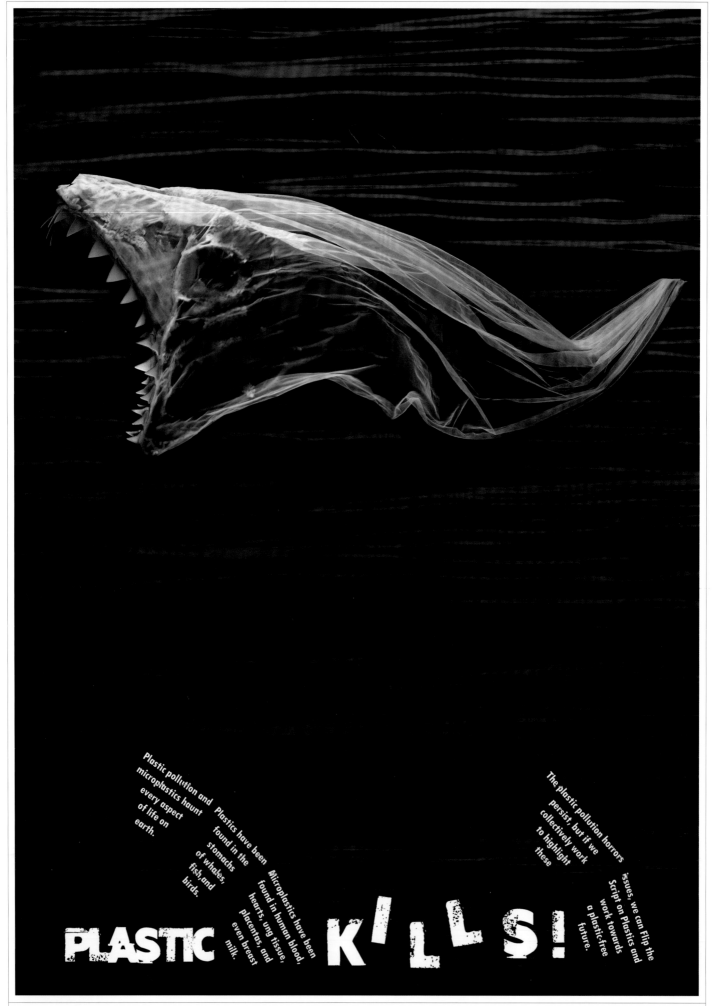

PLASTIC KILLS!

Plastic pollution and microplastics haunt every aspect of life on earth.

Plastics have been found in the stomachs of whales, fish, and birds.

Microplastics have been found in human blood, hearts, ung tissue, placentas, and even breast milk.

The plastic pollution horrors persist, but if we collectively work to highlight these issues, we can flip the script on plastics and work towards a plastic-free future.

Title: Plastic Kills | **Client:** Marine Environment Management Department of the Ministry of Ecology and Environment of China
Design Firm: Sun Design Production | **P245:** Credit & Commentary

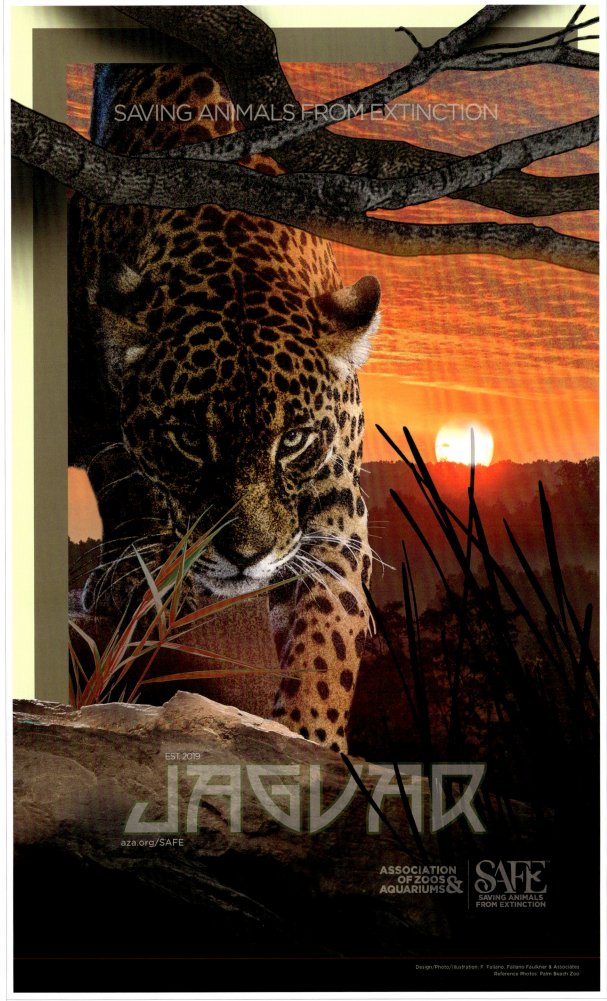

POSTER EVERY DAY 2024

INNER LIGHT

INTERNATIONAL DESIGN POSTER EXHIBITION

Title: Inner Light | **Client:** Poster Every Day 2024 International Design Poster Exhibition
Design Firm: Carmit Design Studio | **P245:** Credit & Commentary | Image 1 of 4

HUMAN SHADOW ETCHED IN STONE

AUGUST 6, 1945, HIROSHIMA

AUGUST 6, 1945, 8:15 AM. A HAUNTING REMINDER OF ATOMIC TRAGEDY, SILENTLY LINGERING ON THE SURFACE,
A TESTAMENT TO PEACE, RESONATING DEEPLY, ETERNAL SYMBOL OF HOPE, WHISPERING PRAYERS FOR PEACE.

Title: HUMAN SHADOW ETCHED IN STONE | **Client:** Japan Graphic Designers Association Hiroshima
Design Firm: Tsushima Design | **P245:** Credit & Commentary | Image 1 of 2

The TYPE TEXT KOREA exhibition in 2023 is a thematic event in the Medium Gallery, Warsaw, Poland 17.06-26.06.2023

Created by Hoon-Dong Chung in Dankook University

| TYPE TEXT KOREA | Typography Poster Exhibition |
Thematic event accompanying the 28th Poster Biennale in Warsaw

시옷 — 이응

히읗 — 치읓

IMAGERY OF 4 CONSONANTS

Title: Imagery of 4 Consonants | Client: 'TYPE TEXT KOREA' Typography Poster Exhibition
Design Firm: Dankook University | P245: Credit & Commentary

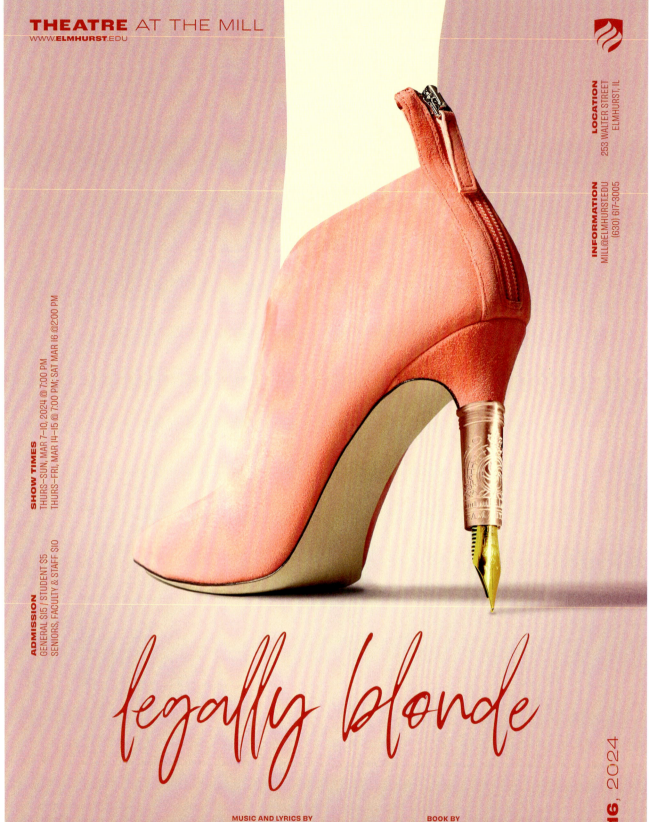

THEATRE AT THE MILL
WWW.ELMHURST.EDU

LOCATION
253 WALTER STREET
ELMHURST, IL

INFORMATION
MILL@ELMHURST.EDU
(630) 617-3005

SHOW TIMES
THURS–SUN, MAR 7–10, 2024 @ 7:00 PM
THURS–FRI, MAR 14–15 @ 7:00 PM; SAT MAR 16 @2:00 PM

ADMISSION
GENERAL $15 / STUDENT $5
SENIORS, FACULTY & STAFF $10

legally blonde

MARCH 7 — 16, 2024

MUSIC AND LYRICS BY
LAURENCE O'KEEFE and NELL BENJAMIN

BOOK BY
HEATHER HACH

BASED ON THE NOVEL BY AMANDA BROWN
AND THE METRO-GOLDWYN-MAYER MOTION PICTURE

DIRECTED BY
ERIK WAGNER

MUSIC DIRECTION BY
SCOTT UDDENBERG

CHOREOGRAPHY BY
AMY LYN MCDONALD

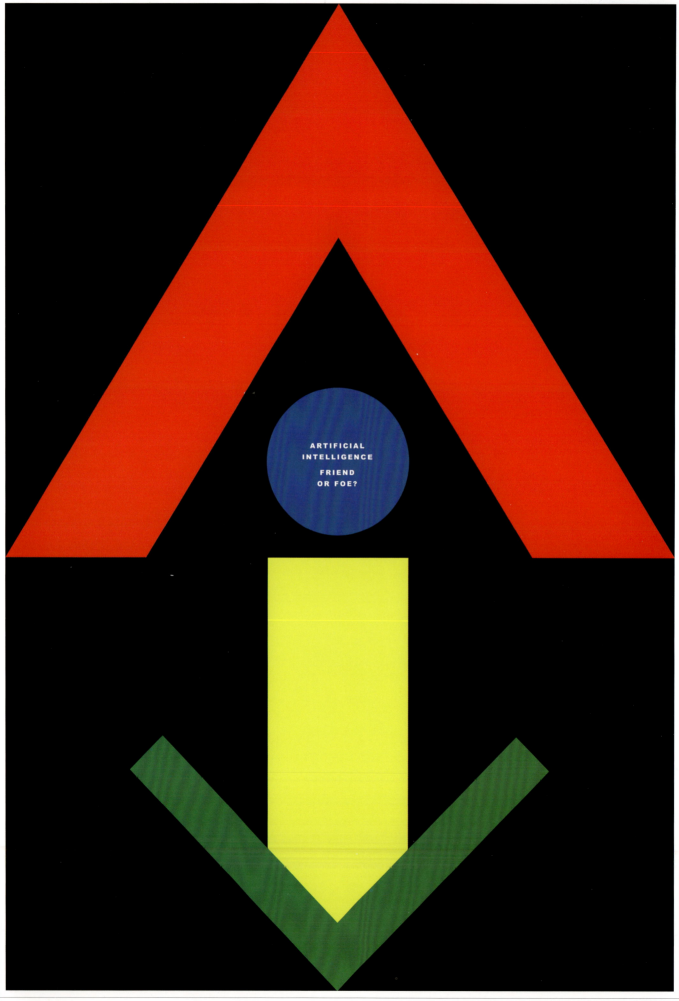

ARTIFICIAL
INTELLIGENCE

FRIEND
OR FOE?

Title: Artificial Intelligence: Friend or Foe? | **Client:** Borderless Graphic Designer's Group Artificial Intelligence International Competition
Design Firm: Goodall Integrated Design | **P245: Credit & Commentary**

Title: FALL | Client: FALL | Design Firm: HEHE DESIGN

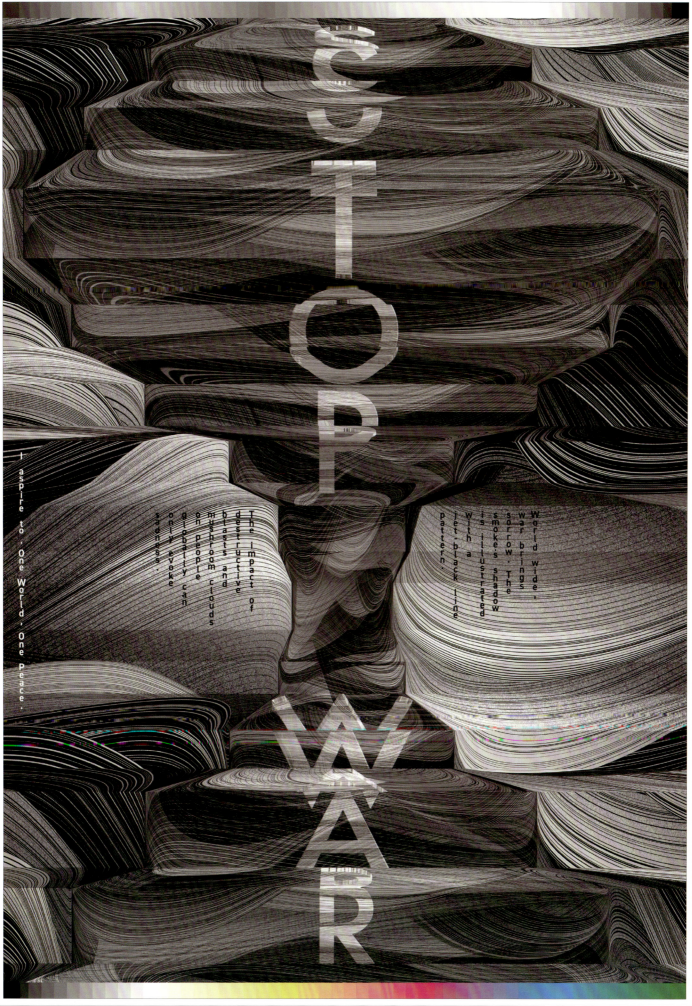

P246: Credit & Commentary **Title:** STOP WAR | **Client:** Taiwan Poster Design Association | **Design Firm:** Tsushima Design

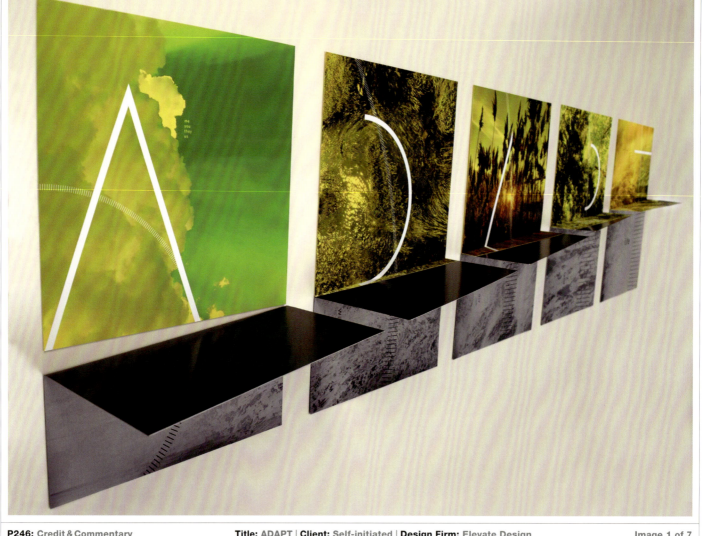

P246: Credit & Commentary **Title:** ADAPT | **Client:** Self-initiated | **Design Firm:** Elevate Design Image 1 of 7

P246: Credit & Commentary **Title:** HOUSE OF THE DRAGON | **Client:** HBO | **Design Firm:** ARSONAL

P246: Credit & Commentary | Title: No Country for Old Men | Client: Self initiated | Design Firm: Collective Turn

Seeing the global diversity of thinking and breadth of projects is always fantastic.

Brendán Murphy, *Global Creative Director & Senior Partner, Lippincott*

MICROSOFT BRAND STUDIO, MCCANN NEW YORK 🇺🇸🇺🇦

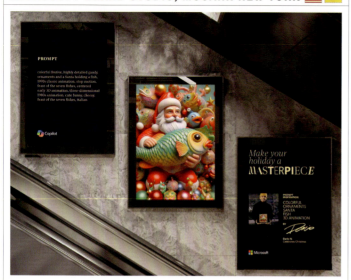

Title: Make Your Holiday A Masterpiece
Client: Microsoft
Design Firms: Microsoft Brand Studio, McCann New York, O0 Design

BRUCE POWER 🇨🇦

Title: The Future is Nuclear, 2023: Bruce Power Annual Review and Energy Report | **Client:** Self-inititated
Design Firm: Bruce Power Creative Strategy

YSLETA DEL SUR PUEBLO 🇺🇸

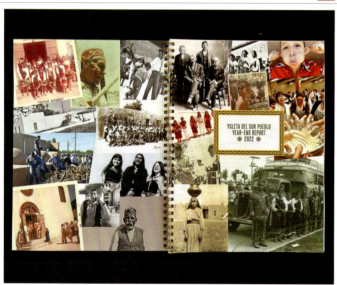

Title: Ysleta del Sur Pueblo 2022 Year-End Report | **Clients:** Ysleta del Sur Pueblo, Helix Solutions | **Design Firm:** Anne M. Giangiulio Design

PAUL BARTLETT 🇺🇸

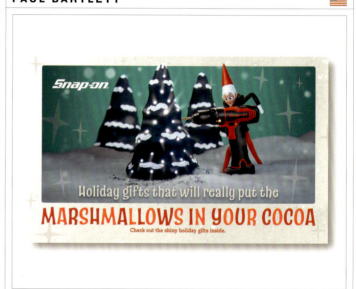

Title: Gnome With the Chrome | **Client:** Snap-on Tools
Design Firm: Traction Factory

NICK SCHMITZ 🇺🇸

Title: BlackRock 2022 Annual Report
Client: BlackRock
Design Firm: Addison

ATELIER NUNES E PÃ, LDA 🇵🇹

Title: RAR Seen By... | **Client:** RAR - Sociedade de Controle Holding, S.A.
Design Firm: Atelier Nunes e Pã, Lda

KRISTIN GLICK 🇺🇸

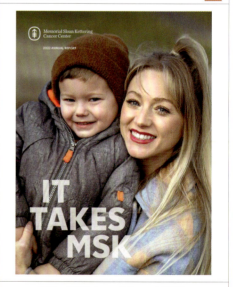

Title: MSK Annual Report 2022
Client: Self-initiated
Design Firm: Memorial Sloan Kettering

STEPHANIE MORRISON

Title: Life Less Scary - Billboard Series
Client: Grow Financial Federal Credit Union | **Design Firm:** Dunn&Co.

DESIGN BY OOF

Title: There's Always a Plan B | **Client:** Braga 25 Portuguese Capital of Culture | **Design Firm:** Design by OOF

C&G PARTNERS LLC, TRO ESSEX MUSIC GROUP

Title: TRO Essex Music Group Anniversary Booklet
Client: TRO Essex Music Group | **Design Firm:** C&G Partners LLC

HEADCASE DESIGN

Title: Johnny Cash: The Life in Lyrics
Clients: Voracious, Little Brown | **Design Firm:** Headcase Design

CLAUDIA NERI

Title: Art Catalogue for Damien Hirst "To Live Forever (For A While)"
Exhibit | **Client:** Rizzoli International | **Design Firm:** Teikna Design

EMILY DICARLO

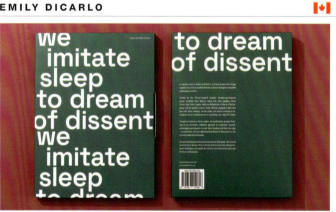

Title: We Imitate Sleep to Imitate Dissent
Client: FADO Performance Art Centre | **Design Firm:** Studio Castrodale

HOWARD SCHATZ, BEVERLY ORNSTEIN

Title: PAIRS: A Book of Photographs | **Client:** Lawrence Richard Publishing
Design Firm: Schatz Ornstein Studio

YUQIN NI

Title: The Exiled | **Client:** Bizarrely Basic
Design Firm: Studio XXY

JAN ŠABACH

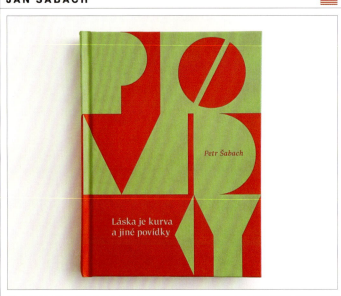

Title: Láska je Kurva a Jiné Povídky (Love is a Whore and Other Short Stories) | **Client:** Paseka Publishing House | **Design Firm:** Code Switch

JULIET ROBERTS

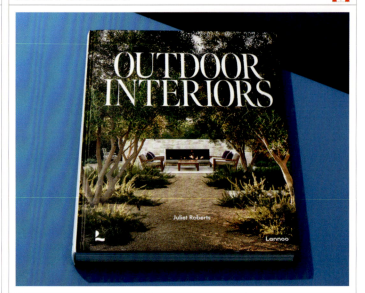

Title: Outdoor Interiors | **Client:** Lannoo
Design Firm: Studio Castrodale

ATELIER NUNES E PÃ, LDA

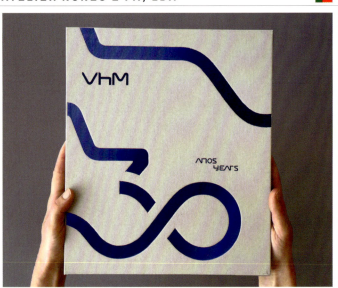

Title: 30 Years VHM | **Client:** VHM – Coordenação e Gestão de Projectos, Lda
Design Firm: Atelier Nunes e Pã, Lda

STILL ROOM STUDIO, JESSICA FLEISCHMANN

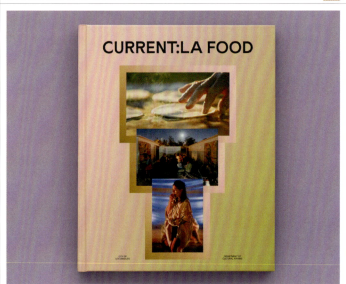

Title: CURRENT: LA FOOD | **Client:** City of Los Angeles Department of Cultural Affairs | **Design Firm:** Still Room Studio

EDUARDO AIRES

Title: Backstage | **Client:** Self-initiated
Design Firm: Studio Eduardo Aires

ANDY SWIST

Title: A Certain Magical Index: The Old Testament Omnibus Edition
Client: Yen On | **Design Firm:** Yen Press

HANNAH GASKAMP 🇺🇸

Title: The West Texas Power Plant that Saved the World Revised Edition | **Client:** Self-initiated **Design Firm:** Texas Tech University Press

FACEOUT STUDIO, ELISHA ZEPEDA 🇺🇸

Title: Shake It Up, Baby! **Client:** Pegasus Books **Design Firm:** Faceout Studio

JARED DORSEY 🇺🇸

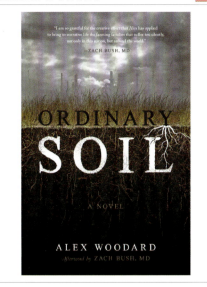

Title: Ordinary Soil **Client:** Alex Woodard **Design Firm:** Greenleaf Book Group

NEIL GONZALEZ 🇺🇸

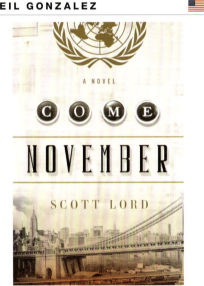

Title: Come November **Client:** Scott Lord **Design Firm:** Greenleaf Book Group

PEPSICO 🇺🇸

Title: PepsiCo Design x Rizzoli Design Book 2023 **Client:** Self-initiated **Design Firm:** PepsiCo

HANNAH GASKAMP 🇺🇸

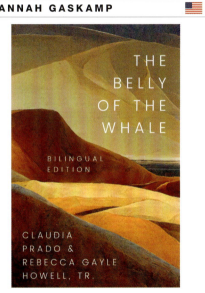

Title: The Belly of the Whale **Client:** Self-initiated **Design Firm:** Texas Tech University Press

FACEOUT STUDIO, MOLLY VON BORSTEL 🇺🇸

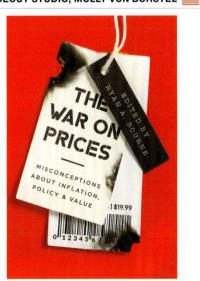

Title: The War on Prices **Client:** Cato Institute **Design Firm:** Faceout Studio

RICHARD LJOENES DESIGN LLC 🇺🇸

Title: Chasing the Panther **Client:** HarperCollins Publishers **Design Firm:** Richard Ljoenes Design LLC

HANNAH GASKAMP 🇺🇸

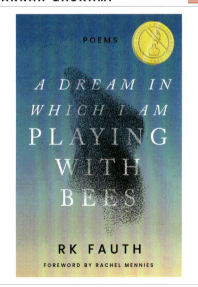

Title: A Dream in Which I Am Playing with Bees **Client:** Self-initiated **Design Firm:** Texas Tech University Press

RICHARD LJOENES DESIGN LLC 🇺🇸

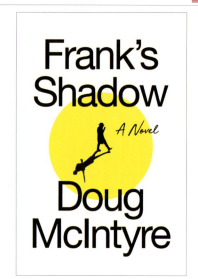

Title: The Leaving Season
Client: W. W. Norton
Design Firm: Richard Ljoenes Design LLC

CAMERON STEIN 🇺🇸

Title: Frank's Shadow
Client: Doug McIntyre
Design Firm: Greenleaf Book Group

HANNAH GASKAMP 🇺🇸

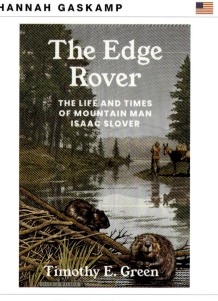

Title: The Edge Rover
Client: Self-initiated
Design Firm: Texas Tech University Press

FACEOUT STUDIO, TIM GREEN 🇺🇸

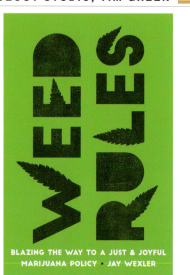

Title: Weed Rules
Client: University of California Press
Design Firm: Faceout Studio

RICHARD LJOENES DESIGN LLC 🇺🇸

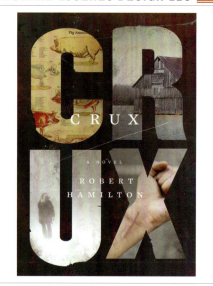

Title: Crux
Client: Troutpond Creative Partners
Design Firm: Richard Ljoenes Design LLC

HANNAH GASKAMP 🇺🇸

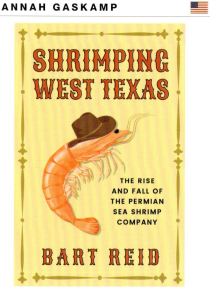

Title: Shrimping West Texas
Client: Self-initiated
Design Firm: Texas Tech University Press

FACEOUT STUDIO, SPENCER FULLER 🇺🇸

Title: The Policing Machine
Client: University of Chicago Press
Design Firm: Faceout Studio

FACEOUT STUDIO, SPENCER FULLER 🇺🇸

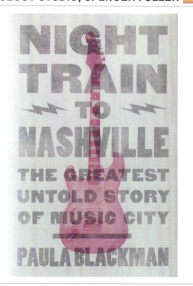

Title: Night Train to Nashville
Client: HarperCollins Christian Publishing
Design Firm: Faceout Studio

STILL ROOM STUDIO, JESSICA FLEISCHMANN 🇺🇸

Title: Follow the Artist: 20 Years of CalArts Center for New Performance | **Client:** CalArts Center for New Performance | **Design Firm:** Still Room Studio

ANNA FARKAS 🇭🇺

Title: Irene Solà | **Client:** Magvető
Design Firm: Anagraphic

LAURA MAY TODD 🇨🇦

Title: Walls: The Revival of Wall Decoration | **Client:** Lannoo
Design Firm: Studio Castrodale

MICHAEL VANDERBYL 🇺🇸

Title: Lail Vineyards Brand Book | **Client:** Lail Vineyards
Design Firm: Vanderbyl Design

S. AREVALOS, M. BALDWIN, M. COVINGTON, L. GARCIA, J. OVIEDO 🇺🇸

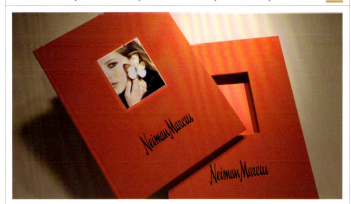

Title: The Book, Fall 2023 | **Client:** Self-initiated
Design Firm: Neiman Marcus Brand Creative

ANNA FARKAS, ÁBEL SZALONTAI 🇭🇺

Title: Badacsony | **Client:** Ábel Szalontai
Design Firm: Anagraphic

1/4 STUDIO

Title: Embalado em 9/4/21 | Consumir até 12/11/22
Client: Galeria Ocupal | **Design Firm:** 1/4 Studio

SPIRE AGENCY 🇺🇸

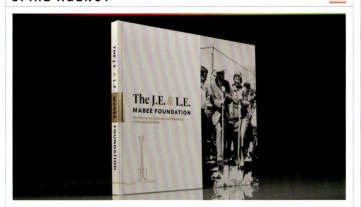

Title: Mabee Foundation Coffee Table Book
Client: The J.E. & L.E. Mabee Foundation | **Design Firm:** Spire Agency

TOSHIYUKI KOJIMA 🇯🇵

Title: y HANYU YUZURU PHOTO BOOK | **Client:** The Sports Nippon
Newspapers | **Design Firm:** Kojima Design Office Inc.

KIT HINRICHS 🇺🇸

Title: Raffi's Superpowers
Client: Joline Godfrey
Design Firm: Studio Hinrichs

FACEOUT STUDIO, SPENCER FULLER 🇺🇸

Title: Crown, Cloak, and Dagger
Client: Georgetown University Press
Design Firm: Faceout Studio

SIENA SCARFF DESIGN 🇺🇸

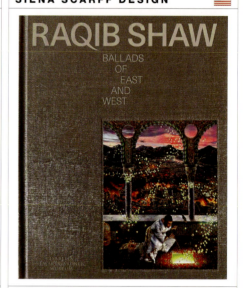

Title: Raqib Shaw: Ballads of East and West
Client: Isabella Stewart Gardner Museum
Design Firm: Siena Scarff Design

FACEOUT STUDIO, TIM GREEN 🇺🇸

Title: Fashion Killa
Client: Simon & Schuster
Design Firm: Faceout Studio

FACEOUT STUDIO, TIM GREEN 🇺🇸

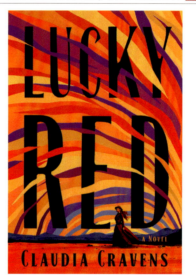

Title: Lucky Red
Client: Penguin Random House
Design Firm: Faceout Studio

LAURIE MACQUEEN 🇺🇸

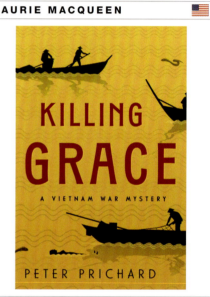

Title: Killing Grace
Client: Peter Prichard
Design Firm: Greenleaf Book Group

ABRAHAM BURICKSON 🇺🇸

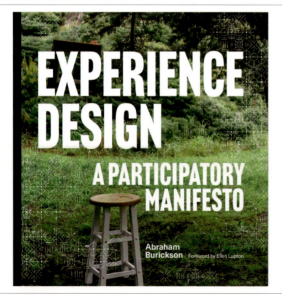

Title: Experience Design: A Participatory Manifesto
Client: Yale University Press | Design Firm: Erica Holeman

ATHARVA SUDARSHAN BARAPATRE 🇵🇭

Title: Greatness of Spirit: Stories of Love, Courage, and Service
Client: Ramon Magsaysay Award Foundation | Design Firm: Gentry Press OPC

ELMWOOD LONDON 🇬🇧

Title: WHISKAS | **Client:** Mars Petcare
Design Firm: Elmwood London

GRAY HAUSER 🇺🇸

Title: Ollion Rebrand | **Client:** Ollion
Design Firm: Matchstic

JOE ROSS 🇺🇸

Title: Aerospike ReBrand | **Client:** Aerospike
Design Firm: Traina

STUDIO PGEROSSI 🇬🇧

Title: Keywords Studios Brand Refresh | **Client:** Keywords Studios
Design Firm: Studio Pgerossi

MARK DEROSE 🇺🇸

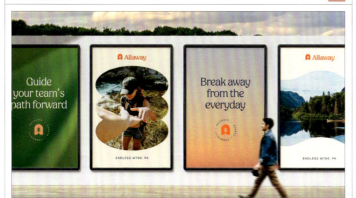

Title: Allaway Brand | **Client:** Allaway
Design Firm: Traina

DAVID SIEREN 🇺🇸

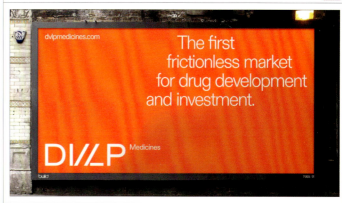

Title: DVLP Medicines | **Client:** DVLP Medicines
Design Firm: One Design Company

STACEY CHUN YU, CHRIS CHUNG 🇹🇼

Title: Chroma | **Client:** Chroma ATE Inc.
Design Firm: RedPeak Global

ELMWOOD LONDON 🇬🇧

Title: The AA | **Client:** The AA
Design Firm: Elmwood London

MEGHAN MURRAY 🇺🇸

Title: Rain Bird Rebrand | **Client:** Rain Bird
Design Firm: Matchstic

INNERSPIN MARKETING 🇺🇸

Title: The Encinitan Hotel & Suites | **Client:** The Encinitan Hotel & Suites
Design Firm: Innerspin Marketing

TEST MONKI 🇺🇸

Title: The Tooth Co. Brand Identity & Website | **Client:** The Tooth Co.
Design Firm: Test Monki

R. CLOCKER, E. SERRATE, I. CAREY, K. BOUTWELL, S. MAILHOT 🇺🇸

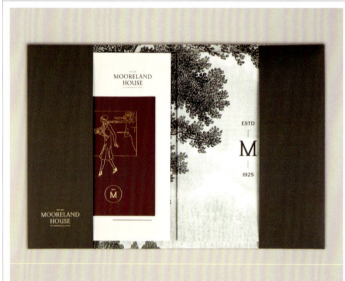

Title: Mooreland House Visual Identity | **Clients:** Sea-Dar Real Estate,
CNW Capital Partners | **Design Firm:** Hacin

CODY BASS 🇺🇸

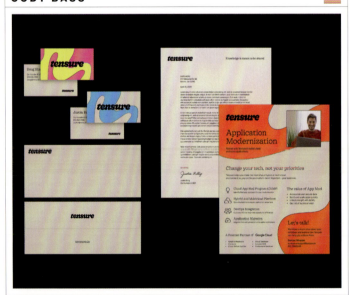

Title: Tensure Rebrand | **Client:** Tensure
Design Firm: Matchstic

TEIGA, STUDIO. 🇪🇸

Title: Espazo Isaura Gómez | **Client:** Concello de Tomiño
Design Firm: Teiga, Studio.

BRANDON TUSHKOWSKI 🇺🇸

Title: Milwaukee Admirals Autism Acceptance
Client: Milwaukee Admirals | **Design Firm:** Traction Factory

THACKWAY MCCORD 🇺🇸

Title: MN8: You Got Power
Client: MN8 Energy | **Design Firm:** Thackway McCord

LAFAYETTE AMERICAN 🇺🇸

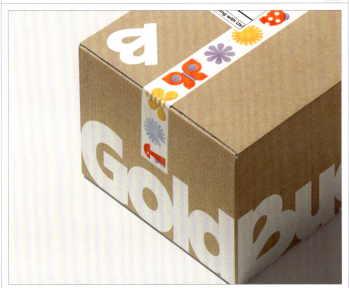

Title: GoldBug Branding | **Client:** GoldBug
Design Firm: Lafayette American

MEGHAN MURRAY 🇺🇸

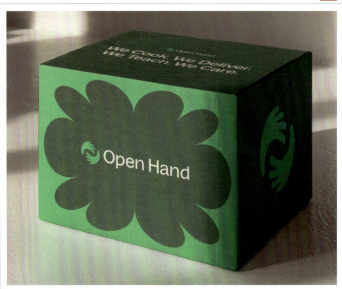

Title: Open Hand and Good Measure Meals Rebrand | **Client:** Open Hand
Design Firm: Matchstic

DAVID SIEREN 🇺🇸

Title: Kinetic | **Client:** Kinetic
Design Firm: One Design Company

ROLANDO CASTILLO 🇺🇸

Title: Umanzor Laundry Management | **Clients:** Carlos Umanzor,
Melissa Umanzor | **Design Firm:** Rolando Castillo

LINLAN LI, JIAYU MA 🇺🇸

Title: Yulin Tofu Visual Identity
Client: Yulin Tofu | **Design Firm:** Big House Studio

M. GUERIN, B. MURPHY, L. HARRIS, J. SIKMA, W. FERGUSON, D. SAGER 🇺🇸

Title: Bombardier: Piloting a New Future for Business Aviation
Clients: Bombardier, Ève Laurier, Maria Pagano | **Design Firm:** Lippincott

PHILLIPS 🇺🇸

Title: Living the Avant-Garde—The Triton Collection Foundation
Client: Self-initiated | **Design Firm:** Phillips Marketing Department

JANG WON LEE 🇰🇷

Title: Wecan Kids Club: Visual Brand Identity Design
Client: Wecan Kids Club | **Design Firm:** Whimsical Studio

ANTHONY WELBORN 🇺🇸

Title: San Antonio Stock Show & Rodeo – 75th Anniversary Identity
Client: Self-initiated | **Design Firm:** San Antonio Stock Show & Rodeo

HOUSE OF CURRENT, WENDY LOWDEN 🇺🇸

Title: Fenton This is the Life | **Client:** Hines
Design Firm: House of Current

DIMITRI SCHEBLANOV 🇺🇸

Title: DRG Branding Series | **Client:** DRG
Design Firm: BrandTuitive

GRIFFIN ORSER 🇺🇸

Title: HALLØJ | **Client:** Stauning Whisky
Design Firm: Sidecar

JOCELYN WONG, TONY HIRD, MATT BIELBY

Title: Lindsay Siu Branding | **Client:** Lindsay Siu
Design Firm: Here Be Monsters

TIMOTHY KING, PETER LADD

Title: Trulioo Rebrand | **Client:** Trulioo
Design Firm: Pendo

SASHA VIDAKOVIC, JOEY LAU

Title: EXPO2027 Brand Identity | **Clients:** Government of Serbia,
BIE - Bureau International des Expositions | **Design Firm:** SVIDesign

TIMOTHY KING, PETER LADD

Title: Lux Rebrand
Client: Lux Insights | **Design Firm:** Pendo

GAETANO GRIZZANTI, GIANCARLO TOSONI

Title: Absurd / Against Beauty
Client: ABSURD Group S.r.l. Società Benefit | **Design Firm:** Univisual SRL

V. TANVIS, G. GULTOM, N. CHRISTABEL, F. AUSTIN, R. ASHLEY

Title: The Playlist
Client: Self-initiated | **Design Firm:** Krit Design Club

PAULO MARCELO

Title: UÍMA - ECOSSISTEMA FLUVIAL
Client: Município de Santa Maria da Feira | **Design Firm:** PMDESIGN

EDUARDO AIRES

Title: Portuguese Government New Visual Identity
Client: Government of Portugal | **Design Firm:** Studio Eduardo Aires

PLAY, OPENAI

Title: DevDay | **Client:** OpenAI
Design Firm: Play

ALBAN OROZ

Title: Building Success Together: Redefining AMG's Brand of
Partnership | **Client:** AMG | **Design Firm:** Sequel Studio

MIKE BASSE

Title: Cynergy™ Series Ratchet Launch | **Client:** Snap-on Tools
Design Firm: Traction Factory

LISA SIRBAUGH CREATIVE

Title: Bankabox Branding | **Client:** Bankabox
Design Firm: Lisa Sirbaugh Creative

BALLOON INC.

Title: FICCT Branding Project
Client: Osaka University | **Design Firm:** Balloon Inc.

TEST MONKI

Title: Howdy Pediatric Dental Studio Brand Identity
Client: Howdy Pediatric Dental Studio | **Design Firm:** Test Monki

DAVID SIEREN

Title: Confronting Design | **Client:** Chicago Graphic Design Club
Design Firm: One Design Company

CLAIRE ZOU

Title: Brand Identity for YY Project | **Client:** YY Project
Design Firm: Claire Zou

ARIEL FREANER 🇺🇸

Title: OES Be Prepare Emerg. Disaster Full Adv. Campaign | Clients: San Diego County Office of Emerg. Svcs., Daniel Vasquez | Design Firm: Freaner Creative & Design

NEXT BRAND 🇦🇺

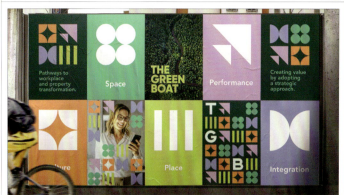

Title: The Green Boat | Client: The Green Boat
Design Firm: Next Brand

ROSE 🇬🇧

Title: The Royal Parks Half | Client: The Royal Parks Half
Design Firm: Rose

MINKWAN KIM 🇺🇸

Title: YouTube Music Recap 2022 | Client: Self-initiated
Design Firms: Google, YouTube Music

ARIEL FREANER 🇺🇸

Title: Red Cross Binational Donation Campaign | Clients: Red Cross of Tijuana, Jorge Astiazaran | Design Firm: Freaner Creative & Design

SEAN JONES 🇺🇸

Title: Casinos.com Rebrand | Client: Casinos.com
Design Firm: Matchstic

MICROSOFT BRAND STUDIO, FRANKLINTILL, PANTONE 🇺🇸🇬🇧

Title: Colorful to Color-Thoughtful | Client: Microsoft
Design Firms: Microsoft Brand Studio, FranklinTill, Pantone

CONNIE KOCH, DENISE SOMMER 🇺🇸

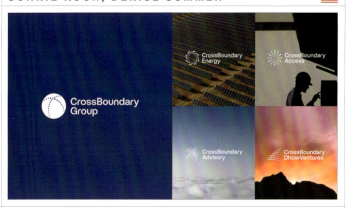

Title: CrossBoundary Group Branding | Client: CrossBoundary Group
Design Firm: Ahoy Studios

GO WELSH 🇺🇸

Title: Wayzgoose 2023 | **Clients:** Hamilton Wood Type & Printing Museum, Stephanie Carpenter, Erin Beckloff | **Design Firm:** Go Welsh

NEXT BRAND 🇦🇺

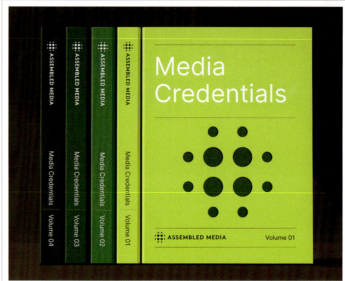

Title: Assembled Media | **Client:** Assembled Media
Design Firm: Next Brand

TEIGA, STUDIO. 🇪🇸

Title: Praza Cultura Branding
Client: Concello de Tomiño
Design Firm: Teiga, Studio.

C&G PARTNERS LLC 🇺🇸

Title: Opticat
Client: Optica
Design Firm: C&G Partners LLC

LAFAYETTE AMERICAN 🇺🇸

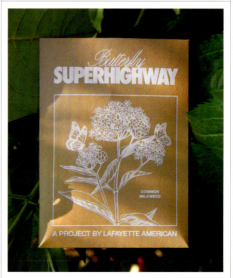

Title: Butterfly Superhighway
Client: Self-initiated
Design Firm: Lafayette American

CLAIRE ZOU 🇺🇸

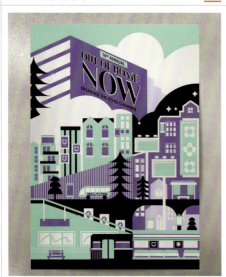

Title: Ads and the City: Out-of-Home
Event Branding | **Client:** The Advertising Club
of New York | **Design Firm:** Claire Zou

BALLOON INC. 🇯🇵

Title: Quastella Branding Project
Client: Quastella Inc.
Design Firm: Balloon Inc.

MOUSER ELECTRONICS CREAT. DESIGN TEAM 🇺🇸

Title: Industrial Automation Clock Ad
Client: Self-initiated
Design Firm: Mouser Electronics

CRAIG CUTLER 🇺🇸

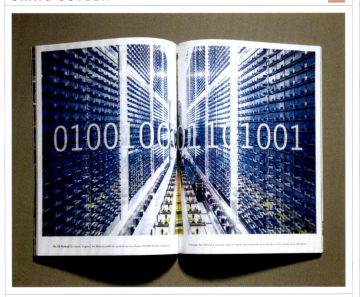

Title: Observations
Client: Self-initiated | **Design Firm:** CutlerBremner

RICH WALLACE 🇺🇸

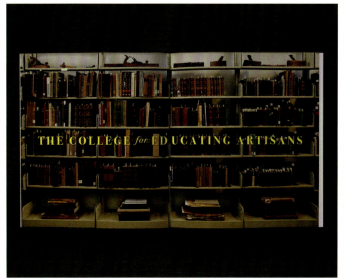

Title: American College of the Building Arts Brochure
Client: American College of the Building Arts | **Design Firm:** Not William

MICHAEL VANDERBYL 🇺🇸

Title: Teknion Kiosk Brochure | **Client:** Teknion
Design Firm: Vanderbyl Design

VIVA & CO. 🇨🇦

Title: Butterfield & Robinson Brochure | **Client:** Butterfield & Robinson
Design Firm: Viva & Co.

WOLFGANG GAST 🇩🇪

Title: VHS Magazine | **Client:** VHS Langenfeld/Rhld.
Design Firm: Gastdesign

CAROLINE CALDWELL 🇺🇸

Title: A World of Clubs and Fences | **Client:** Self-initiated
Design Firm: White & Case LLP

MASAHIRO AOYAGI 🔴

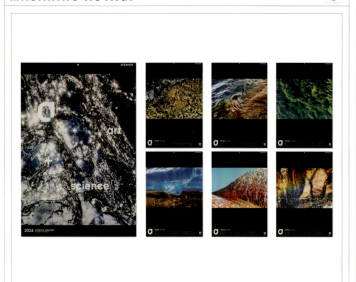

Title: 2024 artience Calendar "Art+Science"
Client: artience Co., Ltd. | **Design Firm:** TOPPAN INC.

MASAHIRO AOYAGI 🔴

Title: 2024 CALENDAR CITYSCAPES -Memories-
Client: Obayashi Corporation | **Design Firm:** TOPPAN INC.

ALIRA HRABAR BEKAR, DUŠAN BEKAR 🇭🇷

Title: Calendar 4 Keeps | **Client:** HRVATSKA POŠTANSKA BANKA
Design Firm: BEKAR HAUS D.O.O.

STUDIO 5 DESIGNS INC. (MANILA) 🇵🇭

Title: BRIDGES OF PROGRESS | **Clients:** Alcantara Group of Companies,
Sylvia Duque, Anna Alcantara | **Design Firm:** Studio 5 Designs Inc.

JEFF BARFOOT 🇺🇸

Title: Central Market Foodie Trading Cards | **Client:** Central Market
Design Firm: *Trace Element

CONNIE KOCH, DENISE SOMMER 🇺🇸

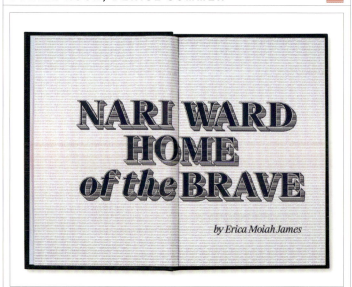

Title: Nari Ward – Home of the Brave Catalog and Exhibition Design
Client: Vilcek Foundation | **Design Firm:** Ahoy Studios

MIKE BASSE 🇺🇸

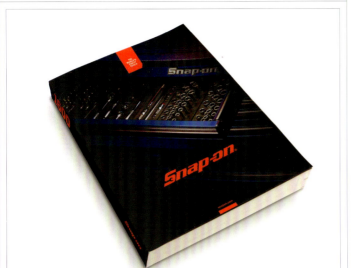

Title: Snap-on Tools Catalog | **Client:** Snap-on Tools
Design Firm: Traction Factory

LISA GARCIA, DEVIN HALL 🇺🇸

Title: Bejeweled Mailer | **Client:** Self-initiated
Design Firm: Neiman Marcus Brand Creative

CRAIG BYERS 🇺🇸

Title: The Moderns That Matter: Sarasota 100 Publication
Client: Architecture Sarasota | **Design Firm:** Studio Craig Byers

SAVANNAH COLLEGE OF ART & DESIGN 🇺🇸

Title: SCAD Admission Catalog 2023-24
Client: Self-initiated | **Design Firm:** Savannah College of Art & Design

SAVANNAH COLLEGE OF ART & DESIGN 🇺🇸

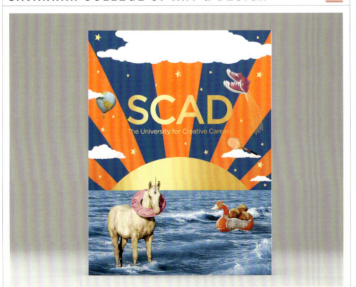

Title: SCAD Academic Catalog 2022-23 | **Client:** Self-initiated
Design Firm: Savannah College of Art & Design

LINGOU LI 🇺🇸

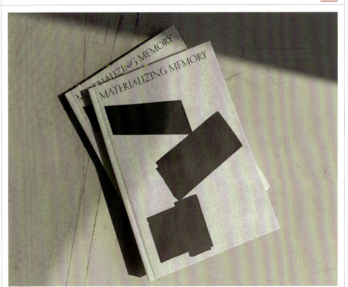

Title: Materializing Memory | **Client:** Self-initiated
Design Firm: Lingou Li

NIKKEISHA, INC.

Title: Make This Year the Greatest. | **Client:** Self-initiated
Design Firm: Nikkeisha, Inc.

MICROSOFT BRAND STUDIO, MICROSOFT DESIGN STUDIO

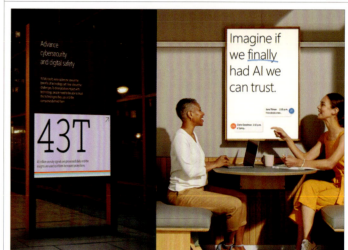

Title: Our Commitments | **Client:** Self-initiated
Design Firms: Microsoft Brand Studio, Microsoft Design Studio

DAICHI TAKIZAWA

Title: Honki Factory Visual Identity
Client: Honki Factory Co., Ltd | **Design Firm:** Daichi Takizawa

DAWN JASPER

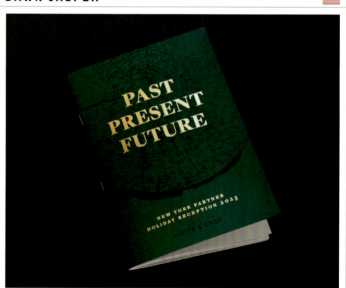

Title: 2023 White & Case Partner Holiday Celebration Program Cover
Client: Self-initiated | **Design Firm:** White & Case LLP

MICROSOFT BRAND STUDIO, KOTO STUDIO

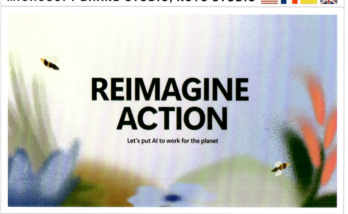

Title: Reimagine Action: Let's Put AI to Work for the Planet
Client: Microsoft | **Design Firms:** Microsoft Brand Studio, Koto Studio, O0 Design, Alexis Jamet

JG DEBRAY

Title: Papa Johns ESG Report
Client: Papa Johns
Design Firm: Addison

TREVETT MCCANDLISS

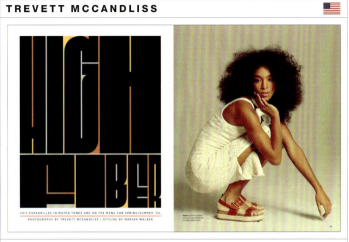

Title: **High Fiber** | Client: **Footwear Plus Magazine**
Design Firm: **McCandliss and Campbell**

TREVETT MCCANDLISS, NANCY CAMPBELL

Title: **Generation Next** | Client: **Earnshaw's Magazine**
Design Firm: **McCandliss and Campbell**

NANCY CAMPBELL, TREVETT MCCANDLISS

Title: **A Perfect Ken** | Client: **Footwear Plus Magazine**
Design Firm: **Wainscot Media**

NANCY CAMPBELL, TREVETT MCCANDLISS

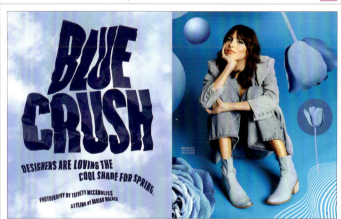

Title: **Blue Crush** | Client: **Footwear Plus Magazine**
Design Firm: **McCandliss and Campbell**

NANCY CAMPBELL, TREVETT MCCANDLISS

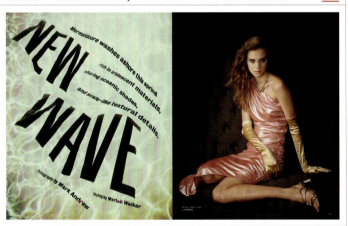

Title: **New Wave** | Client: **Footwear Plus Magazine**
Design Firm: **Wainscot Media**

TREVETT MCCANDLISS, NANCY CAMPBELL

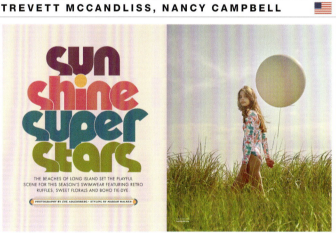

Title: **Sunshine Superstars** | Client: **Earnshaw's Magazine**
Design Firm: **Wainscot Media**

LAURA LATHAM, LELA JOHNSON, MINJUNG LEE 🇺🇸

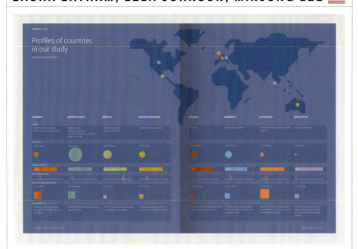

Title: Global Climate Action Survey 2023 | **Client:** Self-initiated
Design Firm: Gensler Research Institute

TREVETT MCCANDLISS, NANCY CAMPBELL 🇺🇸

Title: Zach Weiss is Everywhere | **Client:** MR Magazine
Design Firm: Wainscot Media

JAN ŠABACH 🇺🇸

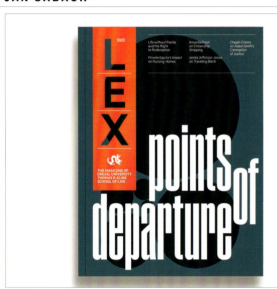

Title: LEX Magazine 2023 | **Client:** Thomas R. Kline School of Law
at Drexel University | **Design Firm:** Code Switch

COLE MELANSON 🇺🇸

Title: Wayfare Magazine Issues 1, 2, 3 | **Client:** Faith Matters Foundation
Design Firm: TopoGraphic Studio

ARIEL FREANER 🇺🇸

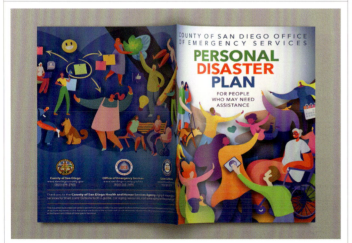

Title: OES Personal Disaster Plan
Client: San Diego County Agricultural Weights and Measures
Design Firm: Freaner Creative & Design

ARIEL FREANER 🇺🇸

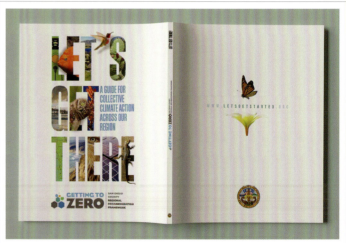

Title: Let's Get There Getting 2 Zero - San Diego County Decarbonization
Framework | **Client:** San Diego County Land Use & Environment
Design Firm: Freaner Creative & Design

KATHY MUELLER 🇺🇸

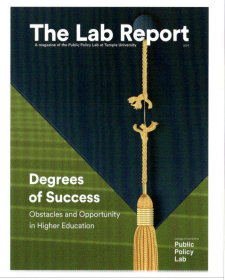

Title: The Rise in U.S. Gun Violence
Client: The Public Policy Lab at Temple University
Design Firm: Kathy Mueller Design, LLC

KATHY MUELLER 🇺🇸

Title: Degrees of Success
Client: The Public Policy Lab at Temple University
Design Firm: Kathy Mueller Design, LLC

RANDY CLARK 🇨🇳

Title: Socrates is Dead
Client: Spark
Design Firm: Randy Clark Graphic Design

MATT MCKEVENY 🇺🇸

Title: Eye Opener Sessions Campaign | **Client:** Association of Schools and Colleges of Optometry (ASCO)
Design Firm: Truth Collective

KINDAI UNIVERSITY 🔴

Title: Art Thinking & Design Thinking
Client: KINDAI University
Design Firm: Kiyoung An Graphic Art Course Laboratory

KINDAI UNIVERSITY 🔴

Title: Cooperation Activities for GA Course's
"TEAM Expo 2025" | **Client:** KINDAI University
Design Firm: Kiyoung An Graphic Art Course Laboratory

JOHN GRAVDAHL 🇺🇸

Title: Walk Across Italy with CSU!
Client: International Programs at Colorado
State University | **Design Firm:** Gravdahl Design

MICROSOFT BRAND STUDIO, STERLING

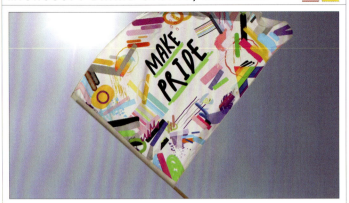

Title: Make Pride | Client: Microsoft
Design Firms: Microsoft Brand Studio, Sterling, O0 Design, Atypic

ELMWOOD NEW YORK

Title: The Economic Justice Partnership Brand Identity
Client: The Economic Justice Partnership | **Design Firm:** Elmwood New York

ROBERT SHAW WEST

Title: Fayetteville State University Poster Campaign
Client: Fayetteville State University | **Design Firm:** The Republik

AIRSPACE

Title: The Breeze
Client: Hudson Companies | **Design Firm:** Airspace

AIRSPACE

Title: Lyft East Coast Headquarters | **Client:** Lyft
Design Firm: Airspace

JANSWORD ZHU

Title: Hyatt Centric Gaoxin Xi'an Art Murals | **Client:** Hyatt
Design Firm: Jansword Design

ASTERISK

Title: Designed by Data | **Client:** NI
Design Firm: Asterisk

AIRSPACE

Title: Nice-Pak Headquarters | **Client:** Nice-Pak
Design Firm: Airspace

AIRSPACE

Title: Pier 57 | **Client:** Jamestown
Design Firm: Airspace

PEPSICO

Title: Pepsi 125 Diner | **Client:** Self-initiated
Design Firm: PepsiCo

3D-IDENTITY

Title: Junior Achievement: Free Enterprise Center
Client: Junior Achievement Rocky Mountain | **Design Firm:** 3D-Identity

SARAH NORTHCUTT

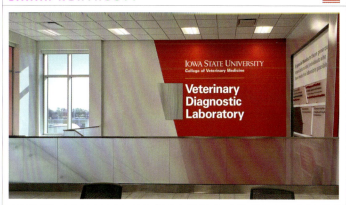

Title: Veterinary Diagnostic Laboratory Donor Wall | **Client:** College of
Veterinary Medicine at Iowa State University | **Design Firm:** Bailey Lauerman

VOLUME INC.

Title: 650 Townsend Wayfinding and Environmental Graphics
Client: Beacon Capital | **Design Firm:** Volume Inc.

PLAY, OPENAI

Title: DevDay | **Client:** OpenAI
Design Firm: Play

ENTRO

Title: BMO Place | **Client:** Bank of Montreal (BMO)
Design Firm: Entro

AIRSPACE

Title: St. Francis College | **Client:** St. Francis College
Design Firm: Airspace

CRAIG BYERS 🇺🇸

Title: The Moderns That Matter: Sarasota 100 Exhibition
Client: Architecture Sarasota | **Design Firm:** Studio Craig Byers

SIENA SCARFF 🇺🇸

Title: Presence of Plants in Contemporary Art | **Client:** Isabella Stewart Gardner Museum | **Design Firm:** Siena Scarff Design

VOLUME INC. 🇺🇸

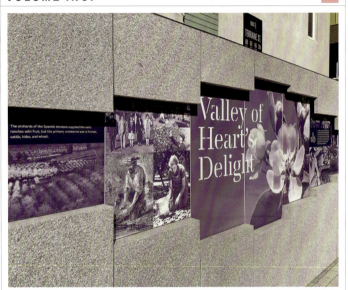

Title: Pellier Park Interpretive Program
Client: The City of San Jose | **Design Firm:** Volume Inc.

RALPH APPELBAUM ASSOCIATES 🇺🇸

Title: Richard Gilder Center for Science, Education, & Innovation | **Client:** American Museum of Natural History | **Design Firm:** Ralph Appelbaum Associates

AMERICAN MUSEUM OF NATURAL HISTORY - EXHIBITIONS DEPARTMENT 🇺🇸

Title: Invisible Worlds Pre-Show | **Client:** Self-initiated
Design Firm: American Museum of Natural History - Exhibitions Department

AMERICAN MUSEUM OF NATURAL HISTORY - EXHIBITIONS DEPARTMENT 🇺🇸

Title: The Secret World of Elephants | **Client:** Self-initiated
Design Firm: American Museum of Natural History - Exhibitions Department

C&G PARTNERS LLC

Title: "Uprooted: An American Story" | **Client:** The California Museum
Design Firm: C&G Partners LLC

C&G PARTNERS LLC

Title: What a Wonderful World | **Client:** The Louis Armstrong
House Museum | **Design Firm:** C&G Partners LLC

AMERICAN MUSEUM OF NATURAL HISTORY - EXHIBITIONS DEPARTMENT

Title: Louis V. Gerstner, Jr. Collections Core | **Client:** Self-initiated
Design Firm: American Museum of Natural History - Exhibitions Department

AMERICAN MUSEUM OF NATURAL HISTORY - EXHIBITIONS DEPARTMENT

Title: Susan and Peter J. Solomon Family Insectarium | **Client:** Self-initiated
Design Firm: American Museum of Natural History - Exhibitions Department

CONNIE KOCH, DENISE SOMMER

Title: 50 Years Germany in the United Nations Exhibit | **Client:** Permanent
Mission of Germany to the United Nations | **Design Firm:** Ahoy Studios

JENIFER LEHKER, JAMES ATKINS, AURELIO SAIZ (+6)

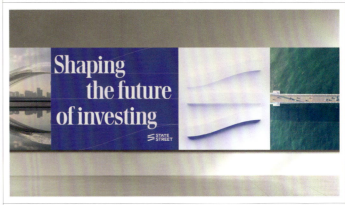

Title: State Street: A New Chapter for a Storied Financial Institution
Client: State Street | **Design Firm:** Lippincott

ELMWOOD NEW YORK

Title: Stori: Building Stability and Confidence for LATAM's
Unbanked Millions | **Client:** Stori Card | **Design Firm:** Elmwood New York

ELMWOOD NEW YORK

Title: Re-imagining CFA Institute | **Client:** CFA Institute
Design Firm: Elmwood New York

AFFINITY CREATIVE GROUP 🇺🇸

Title: Revitalizing Paul Hobbs Winery's Packaging for Modern Excellence | **Client:** Paul Hobbs Winery
Design Firm: Affinity Creative Group

DUFFY & PARTNERS 🇺🇸

Title: Red Locks Irish Whiskey
Client: Red Locks Irish Whiskey
Design Firm: Duffy & Partners

OMDESIGN 🇵🇹

Title: Menin D. Beatriz
Client: Menin Douro Estates
Design Firm: Omdesign

CHASE DESIGN GROUP 🇺🇸

Title: Black Chalk Still Wine
Client: Black Chalk Wine
Design Firm: Chase Design Group

CHIKAKO OGUMA 🇯🇵

Title: TOKYO SPICE GIN
Client: Tokyo Hachioji Distillery
Design Firm: Chikako Oguma

ANDRÉ DE WAAL 🇿🇦

Title: The Honey Thief
Client: Black Elephant Vintners & Co.
Design Firm: Idle Hands

AFFINITY CREATIVE GROUP 🇺🇸

Title: Acidity Trip Packaging Design
Client: Acidity Trip Wines
Design Firm: Affinity Creative Group

TEIGA, STUDIO. 🇪🇸

Title: Sainas Packaging
Client: Sainas
Design Firm: Teiga, Studio.

TRISH WARD 🇺🇸

Title: Eterno Verano Tequila
Client: Grain and Barrel Spirits
Design Firm: HOOK

DAEKI SHIM, HYOJUN SHIM, JUNSEOK KIM 🇰🇷

Title: Tommarrow BI | **Clients:** Tommarrow, Gangwon Institute of Design Promotion (+8) | **Design Firm:** DAEKI and JUN

ELMWOOD LONDON 🇬🇧

Title: Dolmio | **Client:** Mars
Design Firm: Elmwood London

TRISH WARD 🇺🇸

Title: Wild Tonic Rebrand | **Client:** Wild Tonic
Design Firm: HOOK

JEFF ROGERS 🇺🇸

Title: Oak Cliff Brewing Co. Packaging | **Client:** Oak Cliff Brewing Co.
Design Firm: *Trace Element

ELMWOOD NEW YORK, HORIZON ORGANIC 🇺🇸

Title: Horizon Organic Brand Refresh | **Client:** Horizon Organic
Design Firm: Elmwood New York

ELMWOOD NEW YORK 🇺🇸

Title: Revl Fruits Brand Identity | **Client:** Revl Fruits
Design Firm: Elmwood New York

JEFF ROGERS 🇺🇸

Title: Lavazza China Coffee Packaging | **Client:** Lavazza
Design Firm: *Trace Element

OMDESIGN 🇵🇹

Title: Adamus Signature Edition 2023 | **Client:** Adamus
Design Firm: Omdesign

EARTH CORPORATION

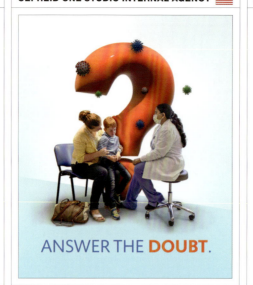

Title: Act For Life.
Client: Earth Corporation
Design Firms: PEACE Inc., Fujimino Design

CEPHEID ONE STUDIO INTERNAL AGENCY

Title: Answer The If Campaign
Client: Self-initiated | **Design Firm:** Cepheid One Studio Internal Agency

JOHN GRAVDAHL

Title: The Year of the Dragon
Client: Self-initiated
Design Firm: Gravdahl Design

SPIRE AGENCY

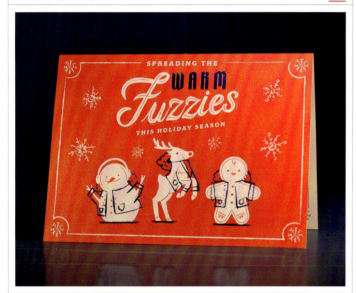

Title: Spreading the Warm Fuzzies | **Client:** Self-initiated
Design Firm: Spire Agency

ROBERT TALARCZYK

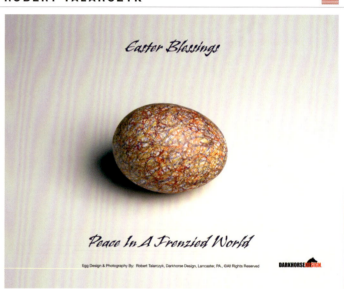

Title: Easter Blessings | **Client:** Self-initiated
Design Firm: Darkhorse Design, LLC

JOHANN TERRETTAZ

Title: Johann Terrettaz - Twice2 - Atelier de Graphisme & Typographie Greetings Card
Client: Self-initiated | **Design Firm:** Twice2 - Atelier de Graphisme & Typographie

GIZZELE DELOS SANTOS-EUSTAQUIO

Title: Flowers of the Philippines: A Selection of Botanical Illustrations
Client: ASEAN Centre for Biodiversity | **Design Firm:** Gentry Press OPC

ŠTORKÁN

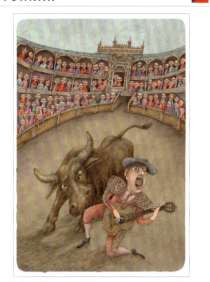

Title: Corrida
Client: Self-initiated
Design Firm: Štorkán

WILLIAM JOHNSTONE

Title: Tender Embrace
Client: Self-initiated
Design Firm: ArtCenter College of Design

WHITNEY HOLDEN

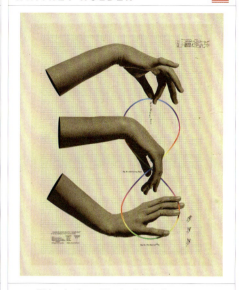

Title: Autism: The Invisible Spectrum
Client: Self-initiated
Design Firm: Studio Holden

MARK BORGIONS

Title: #twocolorcharacter | **Client:** Self-initiated
Design Firm: HandMade Monsters

SPIRE AGENCY

Title: Slacktoberfest Illustrations | **Client:** Slack Davis Sanger
Design Firm: Spire Agency

SÉRGIO DUARTE

Title: Café D'Ouro "O Piolho" | **Client:** Café Ancora d'Ouro
Design Firm: Duas Faces Design

MINJUNG LEE, LELA JOHNSON, LAURA LATHAM 🇺🇸

Title: City Pulse 2023: The Future of Central Business Districts
Client: Self-initiated | **Design Firm:** Gensler Research Institute

MINJUNG LEE, LELA JOHNSON, LAURA LATHAM 🇺🇸

Title: Global Workplace Survey 2024
Client: Self-initiated | **Design Firm:** Gensler Research Institute

MINJUNG LEE, LELA JOHNSON, LAURA LATHAM 🇺🇸

Title: Global Workplace Survey Comparison 2023
Client: Self-initiated | **Design Firm:** Gensler Research Institute

MINJUNG LEE, LELA JOHNSON, LAURA LATHAM 🇺🇸

Title: The Return of the City: A 2024 Retrospective of the City Pulse
Client: Self-initiated | **Design Firm:** Gensler Research Institute

SPIRE AGENCY 🇺🇸

Title: Slacktoberfest Invitation
Client: Slack Davis Sanger | **Design Firm:** Spire Agency

JEWEL MASTRODONATO 🇺🇸

Title: Monroe Community College Foundation Gold Star Gala Invitations
Client: Monroe Community College Foundation | **Design Firm:** Dixon Schwabl + Company

DANA NIXON 🇺🇸

Title: Crystal Bridges Letterhead | **Client:** Crystal Bridges Museum
of American Art | **Design Firm:** *Trace Element

CONNIE LIGHTNER 🇺🇸

Title: Trinity Episcopal Cathedral Stationery
Client: Trinity Episcopal Cathedral | **Design Firm:** Lightner Design

VANESSA RYAN

Title: TechFoundry Identity
Client: TechFoundry
Design Firm: SML Design

LAURA GANG

Title: Musicnotes Logo
Client: Musicnotes
Design Firm: Planet Propaganda

CRAIG BYERS

Title: Philip Hanson Hiss Award Identity
Client: Architecture Sarasota
Design Firm: Studio Craig Byers

MARK DEROSE

Title: Allaway Logo
Client: Allaway
Design Firm: Traina

NEXT BRAND

Title: Seeding Trade
Client: Australia Africa Chamber of Commerce
Design Firm: Next Brand

RIESLING DONG

Title: Spudnik Press Logo
Client: Spudnik Press
Design Firm: Riesling Dong

ROBERT FROEDGE

Title: Common Grace Pottery Logo
Client: Common Grace Pottery
Design Firm: Lewis Communications

RUIQI SUN

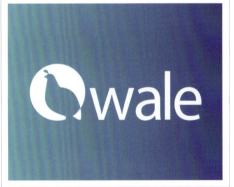

Title: Revitalized Brand Identity of Qwale
Client: Qwale
Design Firm: Ruiqi Sun Design

XIAOWEI ZHANG

Title: FITTBUZZ
Client: FITTBUZZ
Design Firm: 33 and Branding

G.D. ALLEN

Title: Pulitzer on the Road
Client: The Pulitzer Prizes
Design Firm: Columbia University

SPIRE AGENCY

Title: Mabee Foundation 75th Anniversary Logo
Client: The J.E. & L.E. Mabee Foundation
Design Firm: Spire Agency

DAVID BROWN

Title: WaterSAFE MKE
Client: Milwaukee Fire Department
Design Firm: Traction Factory

STJEPKO ROŠIN

Title: Salona Yachts
Client: Salona Group Ltd.
Design Firm: Stjepko Rošin

JOHN BALL, DAVID ALDERMAN

Title: San Diego Tijuana International Jazz
Festival | **Client:** San Diego Tijuana International
Jazz Festival | **Design Firm:** MiresBall

MARK ALLEN

Title: Accessology Logo
Client: Accessology
Design Firm: RedCape

JOHN BALL, DAVID ALDERMAN

Title: SunCoast Market Food Co-op Logo
Client: SunCoast Market Food Co-op
Design Firm: MiresBall

EL PASO, GALERÍA DE COMUNICACIÓN

Title: JMG Taller de Forja y Afilado
Client: JMG Taller de Forja y Afilado
Design Firm: El Paso, Galería de Comunicación

ANGELIQUE MARKOWSKI

Title: Possibility Partners Logo
Client: Possibility Partners LLC
Design Firm: Angelique Markowski

SHARON LLOYD MCLAUGHLIN

Title: Restorative Housing Logomark
Client: Restorative Housing
Design Firm: Mermaid, Inc.

KIRA CSAKANY

Title: Keeper Icon and Wordmark
Client: Keepr
Design Firm: Partners + Napier

STEWART JUNG

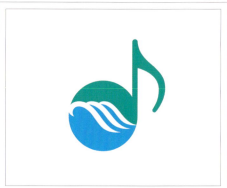

Title: Oceanside Music Logo
Client: Parksville & District Musical Association
Design Firm: AG Creative Group

XIE YANGUANG

Title: TATC Logo
Client: Tmall Autocare Tuning Center
Design Firm: Yanguan

ARIEL FREANER

Title: Tijuana Red Cross 80º Anniversary
Clients: Red Cross of Tijuana, Jorge Astiazaran
Design Firm: Freaner Creative & Design

LOUIS YIU

Title: A.S.M.D. Logo
Client: Self-initiated
Design Firm: A.S.M.D. Creations

ANTON TIELEMANS 🇺🇸

Title: Kabob Shack Logo
Client: Kabob Shack
Design Firm: Tielemans Design

CAMILLA MARSTRAND GOLDEN 🇺🇸

Title: Sag Harbor Press Logo
Client: Sag Harbor Press
Design Firm: Camilart

CHAK KIN JEFF POON 🇭🇰

Title: Metahub Logo
Client: Wenzhou-Kean University
Design Firm: UNISAGE

ROGER ARCHBOLD 🇦🇺

Title: Chewton Cemetery Logo
Client: Chewton General Cemetery
Design Firm: Roger Archbold

SÉRGIO DUARTE 🇵🇹

Title: Clube de Minigolfe do Porto
Client: André Campos
Design Firm: Duas Faces Design

LEVEL GROUP 🇺🇸

Title: DOC Logo
Client: DOC
Design Firm: Level Group

AG CREATIVE GROUP 🇨🇦

Title: First District Mechanical Logo
Client: First District Mechanical
Design Firm: AG Creative Group

DERWYN GOODALL 🇨🇦

Title: Quince Flowers Logo
Client: Quince Flowers
Design Firm: Goodall Integrated Design

KEVIN WOODS 🇺🇸

Title: Nature's Earth Products Logo
Client: Nature's Earth Products
Design Firm: Kevin Woods Creative

LISA SIRBAUGH CREATIVE 🇺🇸

Title: Bankabox Logo
Client: Bankabox
Design Firm: Lisa Sirbaugh Creative

HYUNGJOO A. KIM 🇺🇸

Title: PATTeRN | **Client:** Print Bay in the John
Martinson Honors College at Purdue University
Design Firm: Hyungjookim Designlab

ROGER ARCHBOLD 🇦🇺

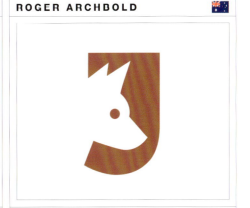

Title: Jirrahlinga Logo
Client: Jirrahlinga Wildlife Sanctuary
Design Firm: Roger Archbold

SMOG DESIGN, INC.

Title: FOR THE BIRDS: The Birdsong Project | **Clients:** National Audubon Society, The Birdsong Project | **Design Firm:** SMOG Design, Inc.

NOW NOW

Title: The Abyss EP | **Client:** Tenet Recordings
Design Firm: Now Now

PRIMOZ ZORKO

Title: Nima Smisla - Balans (LP) | **Client:** Balans
Design Firm: Primoz Zorko

CHARMIE SHAH

Title: Craft Class | **Client:** Dropbox
Design Firm: Charmie Shah

SHANTANU SUMAN

Title: Non-Solo Sarang Vinyl Cover
Client: Non-Solo
Design Firm: Shantanu Suman

ROZI ZHU, XIZHE WANG

Title: Accents of Love
Client: Vivian Fang Liu
Design Firm: Rozi Zhu

MARK BORGIONS

Title: Joystick Jazz Vol. 2
Client: iam8bit
Design Firm: HandMade Monsters

PEPSICO 🇺🇸

Title: Mirinda Plus Restage | **Client:** Self-initiated
Design Firm: Pepsico

PEPSICO 🇺🇸

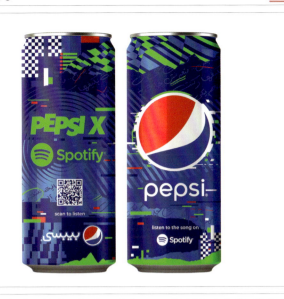

Title: Pepsi x Spotify Can Design + Influencer Kit | **Client:** Self-initiated
Design Firm: Pepsico

CF NAPA BRAND DESIGN 🇺🇸

Title: TK Mulligan | **Client:** TK Mulligan
Design Firm: CF Napa Brand Design

MICHAEL HESTER 🇺🇸

Title: Manhattan Coffee Roasters | **Client:** Manhattan Coffee Roasters
Design Firm: Pavement

TRACY KENWORTHY 🇦🇺

Title: Lavosh, Biscuits and Crackers | **Client:** Knutsford Gourmet
Design Firm: Dessein

NEXT BRAND 🇦🇺

Title: Pure Love | **Client:** Loving Earth
Design Firm: Next Brand

MICHAEL HESTER 🇺🇸

Title: Northcross Irish Whiskey
Client: Latitude Beverage Company
Design Firm: Pavement

STRANGER & STRANGER 🇺🇸 🇬🇧

Title: Isle of Raasay Gin
Client: R&B Distillers LTD
Design Firm: Stranger & Stranger

SHENZHEN EX. BRAND DES. CON. CO., LTD. 🇨🇳

Title: Ice Lake | **Client:** Ice Lake
Design Firm: Shenzhen Excel Brand Design
Consultant Co., Ltd.

OUR MAN IN HAVANA 🇺🇸

Title: Our Man In Havana
Client: Boyd & Blair
Design Firm: Our Man In Havana

SHENZHEN EX. BRAND DES. CON. CO., LTD. 🇨🇳

Title: Medal One | **Client:** Medal One
Design Firm: Shenzhen Excel Brand Design
Consultant Co., Ltd.

AFFINITY CREATIVE GROUP 🇺🇸

Title: Reinterpreting Old Soul
Client: Oak Ridge Winery
Design Firm: Affinity Creative Group

CF NAPA BRAND DESIGN 🇺🇸

Title: Hypothesis
Client: Roots Run Deep
Design Firm: CF Napa Brand Design

CF NAPA BRAND DESIGN 🇺🇸

Title: Turks Head
Client: Main Line Wine Company
Design Firm: CF Napa Brand Design

CF NAPA BRAND DESIGN 🇺🇸

Title: Rebrook Cellars
Client: Rebrook Cellars
Design Firm: CF Napa Brand Design

STRANGER & STRANGER

Title: Glenglassaugh Highland Single Malt Scotch Whisky
Client: Brown-Forman Corporation | **Design Firm:** Stranger & Stranger

STRANGER & STRANGER

Title: The Hearach Scotch Whisky
Client: Isle of Harris Distillers Ltd. | **Design Firm:** Stranger & Stranger

AFFINITY CREATIVE GROUP

Title: Authentico Organic Tequila Packaging Design | **Client:** Freshie
Design Firm: Affinity Creative Group

CF NAPA BRAND DESIGN

Title: Giulio Straccali | **Client:** Palm Bay International
Design Firm: CF Napa Brand Design

CF NAPA BRAND DESIGN

Title: Head High Wines Shoreline Series | **Client:** Head High Wines
Design Firm: CF Napa Brand Design

STRANGER & STRANGER

Title: Element[AL] Wines | **Client:** Bogle Vineyards & Winery
Design Firm: Stranger & Stranger

STRANGER & STRANGER

**Title: Neverstill Wines | Client: Bayberry Lane Investors
Design Firm: Stranger & Stranger**

STRANGER & STRANGER

**Title: Starward Australian Whiskey | Client: New World Whisky
Distillery Pty Ltd | Design Firm: Stranger & Stranger**

NEIL GRUNDY

**Title: Force & Grace - Brand Creation
Client: Deutsch Family Wine & Spirit | Design Firm: forceMAJEURE**

HARCUS DESIGN

**Title: Beelu Forest Distilling Co. Saprock
Client: Beelu Forest Distilling Co. | Design Firm: Harcus Design**

MICHAEL HESTER

**Title: Coterra Wines | Client: Cote West Winery
Design Firm: Pavement**

ELMWOOD LONDON

**Title: Old Mout | Client: Heineken
Design Firm: Elmwood London**

LAFAYETTE AMERICAN

**Title: Scorpion Rosé
Client: Self-initiated | Design Firm: Lafayette American**

AFFINITY CREATIVE GROUP

**Title: Electrifying Elegance: Force and Grace Sizzle Kits
Client: Deutsch Family Wine & Spirit | Design Firm: Affinity Creative Group**

BOXER BRAND DESIGN 🇺🇸

Title: 2023 McCafé Holiday Cups
Client: McDonald's USA | **Design Firm:** Boxer Brand Design

ALICE ZENG, RACHEL SANVIDO 🇨🇦

Title: Not Too Sweet Craft Soda Rebranding, Brand Identity, Packaging
Client: Not Too Sweet | **Design Firm:** Toolbox Design

LEGIS DESIGN 🇺🇸

Title: Amanatsu Candy | **Client:** Hirano Farm
Design Firm: Legis Design

SUBIN YUN 🇺🇸

Title: El Cadejo Coffee Packaging | **Client:** Self-initiated
Design Firm: Subin Yun

MATT BIELBY, TONY HIRD, JOCELYN WONG 🇨🇦

Title: Nothing for the Holidays | **Client:** Self-initiated
Design Firm: Here Be Monsters

KENNETH CHIEM 🇺🇸

Title: Bath & Body Works AAPI Candle Collection | **Client:** Self-initiated
Design Firm: Bath & Body Works

A.S.M.D. CREATIONS, SINTEN COFFEE ROASTERY 🇹🇼

Title: SinTen Coffee Roastery Packaging Design
Client: SinTen Coffee Roastery | **Design Firm:** A.S.M.D. Creations

BUD SNOW 🇺🇸

Title: Ain't Normal Coffee
Client: Ain't Normal Cafe | **Design Firm:** Pavement

PEPSICO

Title: Quaker Bowl of Growth | **Client:** Self-initiated
Design Firm: Pepsico

PEPSICO

Title: Lays Dungeons and Dragons | **Client:** Self-initiated
Design Firm: Pepsico

STEPHEN AREVALOS

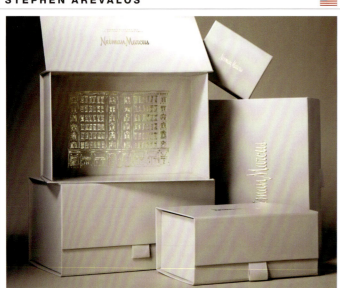

Title: Neiman Marcus Holiday Gift Boxes | **Client:** Self-initiated
Design Firm: Neiman Marcus Brand Creative

ZAC NEULIEB

Title: Bit-O-Honey Rebrand | **Client:** Spangler Candy
Design Firm: Young & Laramore

MICHAEL HESTER

Title: No. 8 | **Client:** No. 8 Health
Design Firm: Pavement

MAYUMI KATO

Title: Rice Packaging | **Client:** Ikeda Farm
Design Firm: Legis Design

PEPSICO 🇺🇸

Title: Frito Lay Super Bowl LVII Compostable Bags 2023
Client: Self-initiated | **Design Firm:** PepsiCo

PEPSICO 🇺🇸

Title: Natuchips Redesign
Client: Self-initiated | **Design Firm:** PepsiCo

TRACY KENWORTHY 🇦🇺

Title: Yoni | **Client:** Yoni Pleasure Palace
Design Firm: Dessein

SOL BENITO 🇮🇳

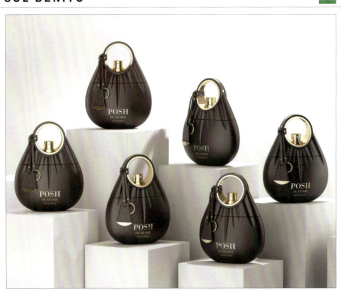

Title: POSH Eau de Parfum by Camara | **Client:** Elite Brands
Design Firm: Sol Benito

EMILY FUNCK 🇺🇸

Title: Aavrani Updated Branding and New Hair Care Line | **Clients:** Aavrani,
Nancy Lan, Rooshy Roy, Samantha Strauss | **Design Firm:** Dear Fellow Design Studio

BIANCA GARAVAGLIA 🇮🇹

Title: Packaging System Polaramin | **Client:** Bayer
Design Firm: Tangram Strategic Design

MI-JUNG LEE

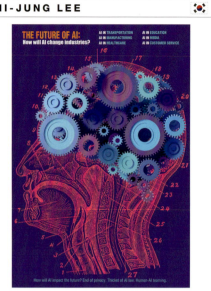

Title: The Future of AI: How Will AI Change Industries? | **Client:** Ministry of Science and ICT
Design Firm: Namseoul University

ROBERT SHAW WEST

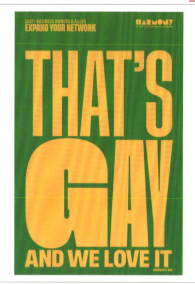

Title: Harmony LGBT-Poster Campaign
Clients: Harmony LGBT, Allied Chamber of Commerce | **Design Firm:** The Republik

WU QIXIN

Title: GOD
Client: GOD
Design Firm: HEHE DESIGN

ARSONAL, STARZ

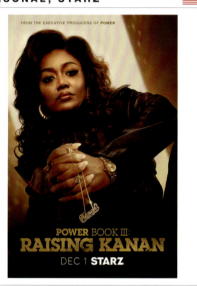

Title: RAISING KANAN
Client: STARZ
Design Firm: ARSONAL

ZHONGJUN YIN

Title: Pray for Peace
Client: Mankind
Design Firm: Dalian RYCX Design

DERWYN GOODALL

Title: Be Lie Ve (Don't Believe the Lies)
Client: Self-initiated
Design Firm: Goodall Integrated Design

DERWYN GOODALL

Title: Happy 200th Birthday Anton Bruckner
Client: Self-initiated
Design Firm: Goodall Integrated Design

ARSONAL, HBO MAX

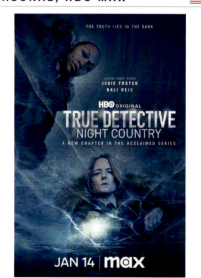

Title: True Detective Night Country
Client: HBO Max
Design Firm: ARSONAL

BARLOW.AGENCY

Title: The Desert Said Dance Teaser Key Art
Client: Mojave Pictures
Design Firm: Barlow.Agency

ARSONAL, NETFLIX

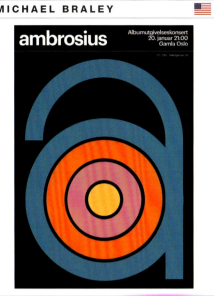

Title: **UNFROSTED**
Client: **Netflix**
Design Firm: **ARSONAL**

MICHAEL BRALEY

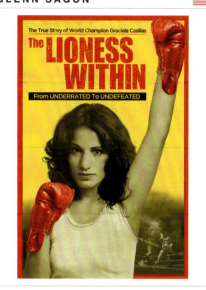

Title: **Ambrosius: Album Release Concert Poster**
Client: **Ambrosius**
Design Firm: **Braley Design**

GLENN SAGON

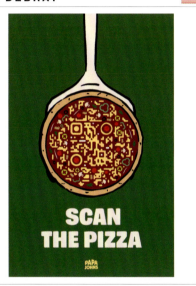

Title: **The Lioness Within**
Client: **Casillas Inc.**
Design Firm: **Sagon-Phior**

JG DEBRAY

Title: **Papa Johns ESG Posters**
Client: **Papa Johns**
Design Firm: **Addison**

TEIGA, STUDIO.

Title: **Sainas Posters**
Client: **Sainas**
Design Firm: **Teiga, Studio.**

HAJIME TSUSHIMA

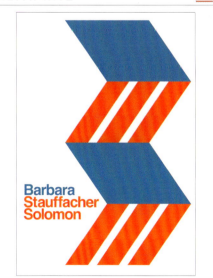

Title: **COP28**
Client: **Emirates International Poster Festival**
Design Firm: **Tsushima Design**

KEITH KITZ

Title: **Barbara Stauffacher Solomon**
Client: **Self-initiated**
Design Firm: **Keith Kitz Design**

ARIEL FREANER

Title: **ZETA Poster Anniversary History
and Timeline | Client: ZETA Weekly**
Design Firm: **Freaner Creative & Design**

ARSONAL, HBO MAX

Title: **True Detective Night Country**
Client: **HBO Max**
Design Firm: **ARSONAL**

DOUGLAS MAY 🇺🇸

Title: Solar Eclipse
Client: Self-initiated
Design Firm: May & Co.

DANIEL SOUSA 🇵🇹

Title: As Aves Capitals
Client: Pixbee
Design Firm: Duas Faces Design

WU QIXIN 🇨🇳

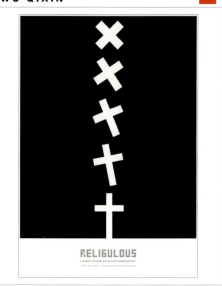

Title: RELIGULOUS
Client: RELIGULOUS
Design Firm: HEHE DESIGN

DO GYUN KIM 🇺🇸

Title: Promoting Rueff School Posters
Client: Rueff School at Purdue University
Design Firm: Do Kim Design

ARIEL FREANER 🇺🇸

Title: Red Cross 80° Anniversary Poster Series
Clients: Red Cross of Tijuana, Jorge Astiazaran
Design Firm: Freaner Creative & Design

ARIEL FREANER 🇺🇸

Title: Eclipse Advertising Ads Campaign
Clients: Fujitsu Ten, Eclipse Mobile Entertainment
Design Firm: Freaner Creative & Design

CARMIT DESIGN STUDIO 🇺🇸

Title: Toxic Society Leaves Toxic Scars
Client: Self-initiated
Design Firm: Carmit Design Studio

DERWYN GOODALL 🇨🇦

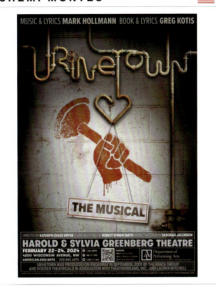

Title: Design for Tomorrow 2023 | **Client:** The Earth International Poster Art Festival in Taiwan
Design Firm: Goodall Integrated Design

CHEMI MONTES 🇺🇸

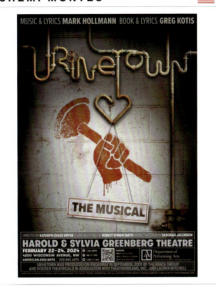

Title: Urinetown: The Musical | **Client:** Department of Performing Arts at American University
Design Firm: Chemi Montes Design

MICHAEL BRALEY 🇺🇸

Title: Rachmaninoff 150
Clients: The Golden Bee Biennale, Self-initiated
Design Firm: Braley Design

JOVANEY HOLLINGSWORTH 🇺🇸

Title: Minnesota Twins History Poster
Client: Minnesota Twins
Design Firm: DLR Group

KELLY SALCHOW MACARTHUR 🇺🇸

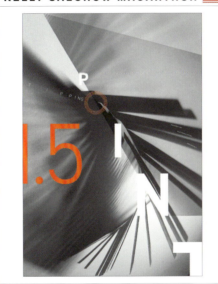

Title: Tipping Point
Client: Self-initiated
Design Firm: Elevate Design

WU QIXIN 🇨🇳

Title: Believe
Client: HUMAN
Design Firm: HEHE DESIGN

BARLOW.AGENCY 🇦🇺

Title: Key The Boys Short Film Key Art
Client: Stefan Hunt Films
Design Firm: Barlow.Agency

DELFIN 🇧🇷

Title: Festival de Ideias (Festival of Ideas)
Client: Conexão Quilombo Amarais Hub
Design Firm: Studio DelRey

ARSONAL, AMC 🇺🇸

Title: INTERVIEW WITH THE VAMPIRE S2
Client: AMC
Design Firm: ARSONAL

ARIEL FREANER 🇺🇸

Title: ZETA 42 Years Anniversary Poster
Client: ZETA Weekly
Design Firm: Freaner Creative & Design

GRAVDAHL DESIGN 🇺🇸

Title: Study Abroad with CSU!
Client: Colorado State University
Design Firm: Gravdahl Design

DERWYN GOODALL 🇨🇦

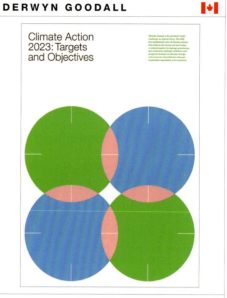

Title: Climate Action 2023
Client: Emirates International Poster Festival
Design Firm: Goodall Integrated Design

JOHN SPOSATO 🇺🇸

Title: Summer 2023
Client: Self-inititated
Design Firm: John Sposato Design & Illustration

CHRIS CORNEAL 🇺🇸

Title: The Love You Take/Make
Client: Self-inititated
Design Firm: Symbiotic Solutions

RANDY CLARK 🇨🇳

Title: Accountability
Client: Self-inititated
Design Firm: Randy Clark Graphic Design

CRISTINA MOORE 🇺🇸

Title: Central Market Catch Hatch Campaign | **Client:** Central Market
Design Firm: *Trace Element

ROBERT SHAW WEST 🇺🇸

Title: Dilworth Coffee Poster Campaign | **Client:** Dilworth Coffee
Design Firm: The Republik

ANDREW SOBOL 🇺🇸

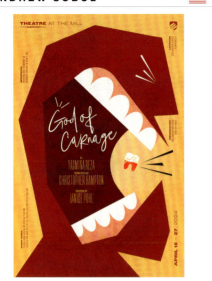

Title: God of Carnage
Client: Theatre at the Mill
Design Firm: Andrewsobol.com

NORIYUKI KASAI ●

Title: Ekoda Metaverse Innovation
Client: Nihon University College of Art
Design Firm: Noriyuki Kasai

ANDREA SZABÓ 🇭🇺

Title: Borderless | **Client:** Association
of Hungarian Fine and Applied Artists
Design Firm: Andrea Szabó

MICHAEL BRALEY 🇺🇸

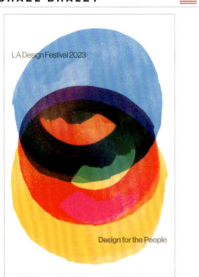

Title: LA Design Festival 2023: Design
for the People | **Client:** LA Design Festival 2023
Design Firm: Braley Design

CASEY STOKES 🇺🇸

Title: Full. Half.
Client: Lincoln Track Club
Design Firm: Bailey Lauerman

ARIEL FREANER 🇺🇸

Title: Red Cross Corporate Campaign Poster Series
Clients: Red Cross of Tijuana, Jorge Astiazaran
Design Firm: Freaner Creative & Design

JAN ŠABACH 🇺🇸

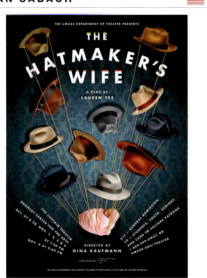

Title: The Hatmaker's Wife | **Client:** The Theatre
Department at the University of Massachusetts-
Amherst | **Design Firm:** Code Switch

MIRKO ILIC 🇺🇸

Title: Corruption
Client: Lincoln Center Theater
Design Firm: Spotco NYC

ARSONAL, NGC 🇺🇸

Title: BOBI WINE
Client: NGC
Design Firm: ARSONAL

MATT LEMKE 🇺🇸

Title: Delta Diner Branding
Client: Delta Diner
Design Firm: Traction Factory

JAN ŠABACH 🇺🇸

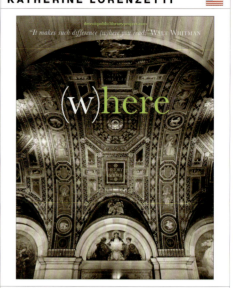

Title: Rachmaninoff 150
Client: The Golden Bee Biennale
Design Firm: Code Switch

KATHERINE LORENZETTI 🇺🇸

Title: Where You Read
Client: Detroit Public Library
Design Firm: Studio Lorenzetti

DANA NIXON 🇺🇸

Title: Central Market Passport Portugal | **Client:** Central Market
Design Firm: *Trace Element

ARIEL FREANER 🇺🇸

Title: Red Cross | **Clients:** Red Cross of Tijuana, Jorge Astiazaran
Design Firm: Freaner Creative & Design

ARIEL FREANER 🇺🇸

Title: ZETA 2022 Advertising Poster | **Client:** ZETA Weekly
Design Firm: Freaner Creative & Design

JOHN SPOSATO 🇺🇸

Title: New York Times Promo | **Client:** New York Times
Design Firm: John Sposato Design & Illustration

DAEKI SHIM, HYOJUN SHIM 🇰🇷

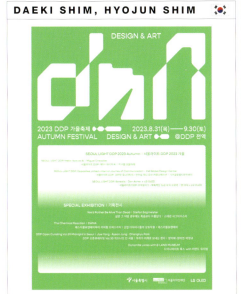

Title: DDP dnA: Design & Art | **Clients:** Seoul Metropolitan Government, Se-Hoon Oh, Dongdaemun Design Plaza, Seoul Design Foundation, (+7) | **Design Firm:** DAEKI and JUN

LEILA SINGLETON 🇨🇦

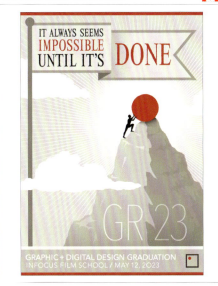

Title: InFocus Graphic + Digital Design Graduation 2022–2023: Key Visuals | **Client:** InFocus Film School | **Design Firm:** L.S. Boldsmith

ARSONAL, NETFLIX 🇺🇸

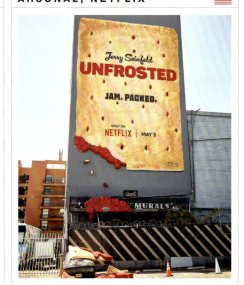

Title: UNFROSTED
Client: Netflix
Design Firm: ARSONAL

STACEY CHAPMAN 🇺🇸

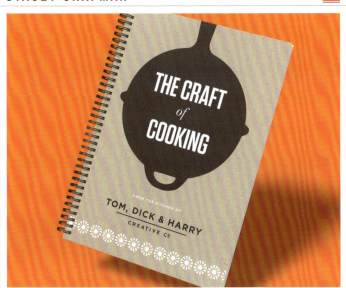

Title: TDH Cookbook | **Client:** Self-initiated
Design Firm: Tom, Dick & Harry Creative

ERIC TAGGART 🇺🇸

Title: 414 Day Promotion | **Client:** Milwaukee Admirals
Design Firm: Traction Factory

ARIEL FREANER 🇺🇸

Title: Tijuana Iluminada Mugs - Promotional Items
Client: City of Tijuana | **Design Firm:** Freaner Creative & Design

HANYUE SONG 🇺🇸

Title: Coffee Wristband
Client: I'M NOT A BARISTA | **Design Firm:** HANYUE DESIGN STUDIO

SHANTANU SUMAN 🇺🇸

Title: Ammi NYC | **Client:** Jimmy Rizvi
Design Firm: Shantanu Suman

DAVID SIEREN 🇺🇸

Title: Truth Be Told, | **Clients:** Study Hotels, Truth Be Told
Design Firm: One Design Company

STEPHEN AREVALOS 🇺🇸

Title: Neiman Marcus Gift Notecard | **Client:** Self-initiated
Design Firm: Neiman Marcus Brand Creative

UNDERLINE STUDIO 🇨🇦

Title: Canada Post Willie O'Ree Stamp | **Client:** Canada Post
Design Firm: Underline Studio

ETHEL KESSLER 🇺🇸

Title: Love (2023) | **Client:** US Postal Service
Design Firm: Kessler Design Group

GREG BREEDING 🇺🇸

Title: Thinking of You | **Client:** US Postal Service
Design Firm: Journey Group

ETHEL KESSLER 🇺🇸

Title: Ruth Bader Ginsburg | **Client:** US Postal Service
Design Firm: Kessler Design Group

DERRY NOYES 🇺🇸

Title: Snow Globes | **Client:** US Postal Service
Design Firm: Derry Noyes

JEFF ROGERS 🇺🇸

Title: Coca-Cola Southwest Beverages San Antonio Mural
Client: Coca-Cola Southwest Beverages | **Design Firm:** *Trace Element

MITCHELL GOODRICH 🇺🇸

Title: Life Less Scary - Alphabet
Client: Grow Financial Federal Credit Union | **Design Firm:** Dunn&Co.

DESIGN BY OOF 🇵🇹

Title: Laboratório da Paisagem Website
Client: Laboratório da Paisagem | **Design Firm:** Design by OOF

SHARON LLOYD MCLAUGHLIN 🇺🇸

Title: iPark 87 Website
Client: iPark 87 | **Design Firm:** Mermaid, Inc.

KIT HINRICHS EXHIBIT

Title: Designing Peace: Origami Dove
Client: Museum of Craft and Design
Design Firm: Studio Hinrichs
P255: Credit & Commentary

MEDIA.WORK HEALTH/PHARMA

Title: SkinCeuticals Brand Assets
Client: SkinCeuticals
Design Firm: Media.Work
P255: Credit & Commentary

MEDIA.WORK BRANDING

Title: PlayStation Productions Branding Identity
Client: PlayStation Studios
Design Firm: Media.Work
P255: Credit & Commentary

ROBERT SHAW WEST EDUCATION

Title: Fayetteville State University - Anything Really Can Happen
Client: Fayetteville State University
Design Firm: The Republik
P255: Credit & Commentary

PHILLIPS LOGO

Title: DROPSHOP
Client: Self-initiated
Design Firm: Phillips Marketing Department
P255: Credit & Commentary

AFFINITY CREATIVE GROUP, KABOOKABOO

Title: "Don't Blink" Teaser — 1963 Ferrari 250 GTO s/n 3765GT Presented by RM Sotheby's
Client: RM Sotheby's
Design Firms: Affinity Creative Group, Kabookaboo
P255: Credit & Commentary

MEDIA.WORK

Title: Volvo Safety In Mind
Client: Volvo
Design Firm: Media.Work
P255: Credit & Commentary

MEDIA.WORK

Title: Nike Invincible 3
Client: Nike
Design Firm: Media.Work
P255: Credit & Commentary

ROBERT SHAW WEST

$193 BILLION IN RESEARCH AND STILL NO CURE.

Title: Fayetteville State University
- We Could Use Your Help
Client: Fayetteville State University
Design Firm: The Republik

ALYSA BRAGA

Spike Protein

ACE2 Cell Receptor

Title: COVID-19 3D Medical Animation
Client: Self-initiated
Design Firm: MJH Life Sciences

ERIN HUGHES

Title: Patient Stories
Client: CURE
Design Firm: MJH Life Sciences

HAJIME TSUSHIMA

Title: HUMAN SHADOW ETCHED IN STONE
Client: Japan Graphic Designers
Association Hiroshima
Design Firm: Tsushima Design

LEE BRADLEY

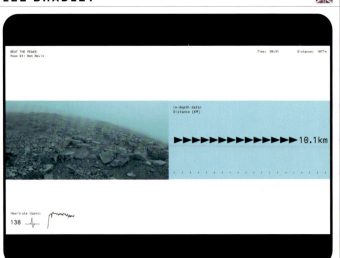

Title: Beat the Peaks
Client: Self-intiated
Design Firm: B&W Studio

ARIEL FREANER

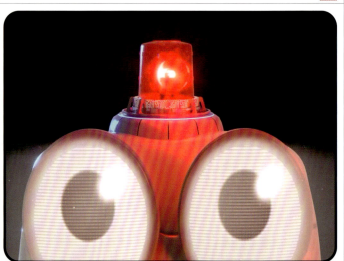

Title: Red Cross Binational Donation Campaign
Clients: Red Cross of Tijuana, Jorge Astiazaran
Design Firm: Freaner Creative & Design

MJH Life Sciences

Spire Agency

Addison

Mischievous Wolf

PepsiCo

BEKAR HAUS D.O.O.

Elmwood London

Addison

Partners + Napier

Freaner Creative & Design

Sydney Saneun Hwang

MJH Life Sciences

Design by OOF

Test Monki

Meng Lan

Botond Vörös

Traina

White & Case LLP

Neiman Marcus Brand Creative

Freaner Creative & Design

Big House Studio

MJH Life Sciences

TOPPAN INC.

Underline Studio

Addison

BroadcastMed

BroadcastMed

***Trace Element**

Money Management Institute In-House

CritMoves

PepsiCo 🇺🇸

***Trace Element** 🇺🇸

BexBrands 🇺🇸

CF Napa Brand Design 🇺🇸

Affinity Creative Group 🇺🇸

CF Napa Brand Design 🇺🇸

Shenzhen Excel Brand Design Consultant Co.,Ltd. 🇨🇳

Lippincott 🇺🇸

Freaner Creative & Design 🇺🇸

Atelier Mistype 🇺🇸

Cepheid One Studio Internal Agency 🇺🇸

Coastlines Creative Group 🇨🇦

Vinko 🇬🇧

Iowa State University – Patrick Finley 🇺🇸

Viva & Co. 🇨🇦

Legis Design 🇺🇸

Bailey Lauerman 🇺🇸

Lisa Sirbaugh Creative 🇺🇸

Brown Advertising and Design, Inc. 🇺🇸

AG Creative Group 🇨🇦

Addison 🇺🇸

Innerspin Marketing 🇺🇸

Legacy79 🇺🇸

Legis Design 🇺🇸

Daichi Takizawa 🇯🇵

Be Someone Design Co. 🇺🇸

HOOK 🇺🇸

UNISAGE 🇭🇰

MiresBall 🇺🇸

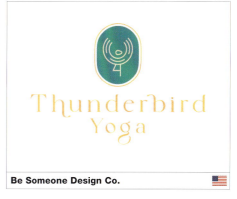

Be Someone Design Co. 🇺🇸

Duas Faces Design

Microsoft, Koto, OO Design, A. Jamet

AuditBoard In-House Design Department

Yijia Xie

***Trace Element**

Tarrant County College Graphic Services

Traction Factory

DLR Group

AuditBoard In-House Design Department

PepsiCo

Big House Studio

Ahoy Studios

Studio DelRey

Anagraphic

MJH Life Sciences

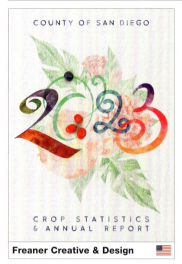

Freaner Creative & Design 🇺🇸

Lisa Sirbaugh Creative 🇺🇸

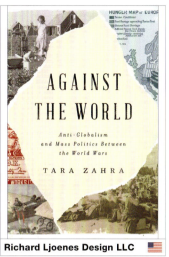

Richard Ljoenes Design LLC 🇺🇸

Faceout Studio 🇺🇸

Studio DelRey 🇧🇷

Faceout Studio 🇺🇸

Planet Propaganda 🇺🇸

Ashley Menezes 🇦🇺

TOPPAN INC. 🇯🇵

Richard Ljoenes Design LLC 🇺🇸

Alison Place 🇺🇸

Freaner Creative & Design 🇺🇸

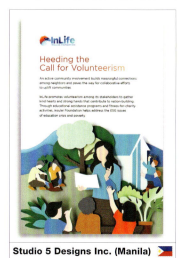

Studio 5 Designs Inc. (Manila) 🇵🇭

Freaner Creative & Design 🇺🇸

Freaner Creative & Design 🇺🇸

Mermaid, Inc. 🇺🇸

Studio Eduard Cehovin 🇸🇮

Goodall Integrated Design 🇨🇦

Teiga, Studio. 🇪🇸

Teiga, Studio. 🇪🇸

Setareh Ghoreishi 🇺🇸

Barlow.Agency 🇦🇺

Keith Kitz Design 🇺🇸

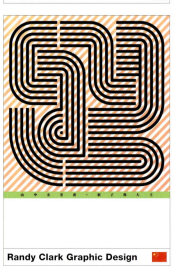

Randy Clark Graphic Design 🇨🇳

Barlow.Agency 🇦🇺

Setareh Ghoreishi 🇺🇸

Legacy79 🇺🇸

Setareh Ghoreishi 🇺🇸

BlackHare Studio 🇺🇸

May & Co. 🇺🇸

Noriyuki Kasai 🇯🇵

Mouser Electronics 🇺🇸

SG Posters

Injun Shin

Setareh Ghoreishi

Barlow.Agency

Freaner Creative & Design

UP-Ideas

Hufax Arts / FJCU

Setareh Ghoreishi

Freaner Creative & Design

Freaner Creative & Design

Freaner Creative & Design

Freaner Creative & Design

Those that stood out continue to push our craft with crisp thinking and imaginative storylines, all within the confines of type, line, scale, and imagery.

Brendán Murphy, *Global Creative Director & Senior Partner, Lippincott*

For designers and the practice of design, Graphis is a symbol of international peer recognition, in addition to valuing the effort of each designer and studio.

Eduardo Aires, *Founder & Art Director, Studio Eduardo Aires*

Credits & Commentary

PLATINUM WINNERS:

20 TESLA: A VIDA E A LOUCURA DO GÊNIO QUE ILUMINOU O MUNDO (ORIGINAL TITLE: TESLA: HIS TREMENDOUS AND TROUBLED LIFE)
Design Firm: Studio DelRey | Designer: Delfin | Client: Editora Globo
Main Contributor: Cover Design and Illustration: Delfin

Assignment: The Brazilian publishers wanted a new cover for this biography of scientist Nikola Tesla, possibly without photographs and with a modern representation. However, the theme of electricity and electric current could not be omitted.
Approach: The font was custom-made and references the visual depiction of electrical circuit components. The book's title, subtitle, and the authors' names were placed in two boxes. Between them is an image of Nikola Tesla appearing in a plasma globe. Tesla's image is mostly represented by lines that pictorially depict lightning, divided into black and white that allude to an alternating current motor. Outside the globe, more rays collide with the walls of the central box. The entire image is supported by the color red, and the book was printed in four colors.
Results: The publishing house approved the visual proposal and the book is performing well. Over the past year, the cover has been remembered for its depiction of Tesla.

21 NARRATIVE DESIGN: A FIFTY YEAR PERSPECTIVE | Design Firm: Studio Hinrichs
Designers: Kit Hinrichs, Dang Nguyen, Chloe Cunningham, Carrie Cheung | Client: Self-initiated
Editors: Kate Bolen, June Lin Umfress | Main Contributor: Kit Hinrichs

Assignment: Collect and organize over a half-century of design and to showcase an array of disciplines from poster campaigns to publication design to environmental graphics.
Approach: The book is organized according to ten ways of telling stories. Each piece includes a thoughtful statement of the thinking that drove the design. The casebound hardcover was printed in full color and a bookplate and slipcase were produced for the limited edition.
Results: The book celebrates a decorated career and curates iconic design over the last half century. It has received compliments from design-conscious audiences worldwide.

22 EPSON CALENDAR SPECTACULAR LIMITED EDITION
Design Firm: The Balbusso Twins | Designers: Anna Balbusso, Elena Balbusso | Client: Epson
Illustrators: Anna Balbusso, Elena Balbusso | Art Director: Gianluca Foli
Graphic Designer: Marco Goran | Print Producer: Opificio Arte Stampata
Main Contributors: Balbusso Twins Artist Duo

Assignment: Artworks created for the Epson calendar Spectacular 2024 signed limited edition. Our work combines two core elements, graphic design and painting, with a clear reference to art history. For the Epson Calendar, we wanted to create a visual narrative with a human focus and with a strong perceptive and emotional impact, enhancing the expressive power of colour.
Approach: The idea came from the sculpture Unique Forms of Continuity in Space by Umberto Boccioni. Geometries, patterns, and circles interact with the human body in motion, creating 'abstract spaces' that stimulate vision. In dance, as in sporting disciplines, the body becomes a spectacle, expressing talent and commitment while overcoming your own limitations. Artworks created using a mixed technique that combines traditional tools with digital.
Results: The series won the SI66 gold medal from the Society of Illustrators of New York.

23 THE REGAL TOUCH PERFUME | Design Firm: Sol Benito | Designer: Vishal Vora
Client: Emper Perfumes | Main Contributor: Sol Benito

Assignment: The client aims to create an exclusive collection of 4 to 5 limited edition perfumes originating from the Middle East. These ultra-premium fragrances should feature designs that go beyond traditional glass bottlesn and incorporate unique, luxurious elements.
Approach: We developed an exquisite concept that elevates the perfume bottle to a new level of luxury. The bottle is encased in an ornate alloy metal jacket. To ensure a cohesive and distinguished aesthetic, the cap is also crafted from high-quality alloy zinc. This combination of materials and craftsmanship creates a stunning presentation.
Results: Result was so amazing that we have added more variant as extension.

24 NEMIROFF LEX VODKA | Design Firm: Stranger & Stranger | Designer: Stranger & Stranger
Client: Nemiroff Vodka Limited | Main Contributor: Stranger & Stranger

Assignment: Reimagine the Lex vodka expression.
Approach: A brand refresh with a new proud and bold bespoke bottle and branding reflecting the brand's indomitable Ukrainian spirit and positioning in the luxury premium vodka segment.

25 LISTENING ROCK GIN | Design Firm: Stranger & Stranger | Designer: Stranger & Stranger
Client: Tenmile Distillery | Main Contributor: Stranger & Stranger

Assignment: The listening rock lies in the hills behind the distillery.
Approach: The listening rock is a place where one can contemplate and focus, perhaps on the local flora that makes up this New York State gin.

26 SDGS MESSAGES TRILOGY
Design Firm: National Kaohsiung University of Science and Technology (NKUST)
Designer: Chong-Wen Chen | Client: NKUST College of Innovation and Design
Main Contributor: Chong-Wen Chen

Assignment: This trilogy promotes the global mission to foster a sustainable environment and society. Using the United Nations' 17 Sustainable Development Goals (SDGs), each poster conveys a unique yet interconnected message. "Design for Tomorrow" advocates for forward-thinking in today's design practices. "Global Commitments" underscores the necessity of international collaboration for enhanced sustainability. "For Lives & Children" calls for a deep empathy for the well-being of all Earth's inhabitants.
Approach: These posters use a single letter from SDG to form three vertical phrases. "Design for Tomorrow" features colored pencils, symbolizing the tools of designers and the college's dedication to teaching sustainable design principles. "Global Commitments" uses fountain pens, emblematic of international agreements and the collective endeavors necessary for a sustainable future. "For Lives & Children" is depicted on wooden road signs amidst diverse plants, signifying the path to sustainability. The presence of endangered Menelaus blue morpho butterflies symbolizes hope that the SDGs will restore their natural habitats.
Results: These newly launched posters will be distributed to international academic and non-profit institutions to promote the College of Innovation and Design at NKUST, aiming to foster potential collaborations in research and design practices.

27 TOLERANCE | Design Firm: Dankook University | Designer: Hoon-Dong Chung
Client: Self-initiated | Main Contributor: Hoon-Dong Chung

Assignment: Tolerance is to embrace difference to be together. In Contrast and Harmony, this work symbolizes the beginning of 'Tolerance' and the ending of 'Conflict' in a integrated form.

28 HAIRSTYLE FIGURE | Design Firm: 33 and Branding
Designer: Xiaowei Zhang | Client: MUQING | Chief Creative Officer: Xiaowei Zhang
Associate Creative Director: Jing Xu | Main Contributor: Xiaowei Zhang

Assignment: MUQING, a timber products company, concentrates on producing wooden furniture. It also sales small wooden goods like combs. However, their combs have low recognition. Therefore, they want us to design a series of creative posters to attract more attention.

Approach: We combined several common hairstyle and combs to create unique Oriental hairstyle figures. There is no doubt that it's an interesting way to display the products.
Results: Sales have increased 46% compared with same period last year.

29 BUTTERFLY EFFECT | Design Firm: EJ Communication Studio | Designer: Eunjin Yu
Client: Information and Communication Technology Division | Main Contributor: Eunjin Yu

Assignment: The butterfly effect is a sensitive dependence on initial conditions in which a slight change in one state can result in significant differences in a later state. Thus, the goal is to warn of the growing threat of plastics that escalates into great fear and devastation.
Approach: The image is of a small change that starts with a single flightless butterfly trapped in plastic that grows into an ecological cascade that poses a substantial environmental risk.
Results: The butterfly and the warning message of the butterfly effect use the metaphor of ecosystem destruction at the center of environmental problems to call for awareness.

GOLD WINNERS:

31 HACIN 30TH ANNIVERSARY BOXED SET | Design Firms: Hacin, Michele Snow
Designers: David Hacin, Emily Neumann, Katie Dayton, Michele Snow | Client: Self-initiated
Print Producer: Puritan Capital | Main Contributor: Michele Snow

Assignment: To celebrate the firm's thirtieth anniversary and rebrand, Hacin, along with designer Michele Snow, created a limited edition boxed set to showcase the studio's work. The set includes three books for Residential, Housing, and Hospitality + Workplace projects, as well as a brochure detailing the firm's process, identity, and services. The goal was to highlight the firm's projects, as well as celebrate the collaborators who helped make them happen.
Approach: Numerous assets were compiled to present a truly cohesive view, including sketches, photography, project narratives, floor plans, diagrams, and material palettes. In-depth reviews of projects and stock, foil, and box construction options took place to ensure that the materials used were cohesive, tactile, structurally sound, and vibrant. The intended message was one of appreciation and gratitude for a firm's history and the collaborators who helped make it possible.
Results: The boxed sets achieved their initial objectives and the firm received many pieces of positive feedback from the recipients.

32 THE STORY OF U | Design Firm: Pendo | Designers: Pendo, Timothy King, Peter Ladd
Client: Unifonic | Director: Don Cleland | Creative Director: Peter Ladd
Copywriters: Ryan Leeson, Samantha Kohn | Project Manager: Yasmina Hashemi
Main Contributors: Timothy King, Peter Ladd

Assignment: Unifonic is an engagement platform that helps businesses connect with customers across mobile apps. The company was expanding and the leadership team knew that maintaining culture was important – especially through a time of rapid growth. The goal was to capture the company story, unpack the culture, and inspire new and existing employees.
Approach: Recognizing "Unifones" are full of pride for their company and their contributions, it was essential to introduce and tell Unifonic's story in a celebratory way. The founders, history, and company values, along with employee quotes and imagery were brought together, celebrating Unifonic's successes and highlighting how their employees are a critical part of their culture.
Results: Revealed at a company-wide launch event, the keepsake piece has become a touchstone for Unifonic and their culture.

33 VICENTE GAJARDO | Design Firm: Studio Eduardo Aires
Designers: Guillermo Zetek, Miguel Almeida, Vasco Castro, Raquel Piteira
Client: Self-initiated | Art Director: Eduardo Aires | Creative Director: Eduardo Aires
Photographer: Jorge Moreira | Main Contributor: Eduardo Aires

Assignment: Vicente Gajardo is a Chilean sculptor. This anthology communicates his entire oeuvre while adding a graphic approach to it and is intended as a eulogy of his work.
Approach: The project began as an idea over a decade ago, and in 2018 it involved a trip through Chile to photograph the public works on site. The photographer, Alexandre Delmar, was able to immerse in the narratives and wait for the best light, taking pictures under the same gaze and artistic direction and giving visual coherence to the entire portfolio.
Results: The outer black case is a symbolic reference to the black granite ever-present in Gajardo's work amd contrasts with the white paper of the cover and book block. Text and images fill each page almost to the edges. Opening a new book demands a manual task: each leaf has to be cut to reveal the content, much like the sculptor carves.The book will then be "sculpted" open, producing a rich texture in the printed fore and top edges.

34 HUED, RACHELLE THIEWES MASTER METALSMITH
Design Firm: Antonio Castro Design | Designer: Antonio Castro H.
Clients: Metals Museum, Rachelle Thiewes | Fabricator: Su-Yin Wong
Main Contributor: Antonio Castro H.

Assignment: Design a book for the retrospective exhibition of Master Metalsmith Rachelle Thiewes at the Metal Museum in Memphis, TN.
Approach: This book includes images of all the work exhibited at the Metal Museum, and it represents Rachelle's body of work for the last 30 years. When she told me the name of the exhibition, Hued, I decided that instead of showing an image of one of her beautiful pieces on the cover, I was going to show a zoomed-in photo of Rachelles's hair, which she dyes in magnificent magentas, blues and greens. Once the book was printed, I designed a beautiful custom-made box for it and had artist Su-Yin Wong take care of the box production.
Results: Overall, the book was a great success; it sold out on opening night.

35 FLUID DIMENSIONS | Design Firm: Jocelyn Zhao Design | Designer: Jocelyn Ziying Zhao
Client: Berkeley Center for New Media | Main Contributor: Jocelyn Ziying Zhao

Assignment: Fluid Dimensions delved into eight dimensions of cyberspace across eight chapters. In the posthuman era, the lines between humans, machines, and nature blur, making our digital identities extensions of our essence. This project encompasses extensive research and a vast array of information and offers a new perspective on the interplay between humans and machines in both physical and virtual realms.
Approach: This book employs three methods to visualize dimensions: Firstly, it employs 3D typography and 3D printing embossment to demonstrate cyberspace's fluidity through both renderings and physical forms on the bookcase. Secondly, it uses the hypercube shape to abstractly represent multidimensionality, the interlocking form serves as chapter dividers. Thirdly, the book adopts generative design for data visualization, graphically depicting social networks based on real data.
Results: Received positive feedback from the client.

36 I LOVE IT WHAT IS IT | Design Firm: Turner Duckworth
Designer: Robert Williams | Client: Phaidon Press | Executive Creative Director: Andy Baron
Chief Creative Officer: Sarah Moffat | Account Services: Katie Monahan
Assistant: Xavier Drudge | Main Contributor: Gyles Lingwood

Assignment: The central theme of the book is the power of instinct in design. In the age of big data and AI, print is the perfect medium to express our passion for creativity. We believe there is still a need for the type of creativity that cannot be reduced to an algorithm. The various perspectives are meant to help our audience understand what the creative process feels like.

Approach: "I love it. What is it?" is a reflection on lessons we've learned over the last 3 decades, alongside thoughts from friends and collaborators. The cover design is a physical expression of the title and theme. The upturned corner rewards your curiosity. The interior emphasizes the snackable nature of the book. Each piece stands on its own but also sits happily with the others.
Results: We've had great press and conversations surrounding the book. The warm reception has meant the world to us, and it has been a joy bringing the brilliant minds of the design industry together. It's also nice to see our work grace the physical page in this digital era.

37 THE EVOLVING WAY: AN HP STORY | Design Firm: Trope Publishing Co.
Designer: Scott Yanzy | Client: HP | Editors: Sam Landers, Sol Sender
Text: Sol Sender, Lindy Sinclair | Research: Heritage Werks | Photographer: Tom Maday
Other: Special Thanks to All the HP Team Members Who Contributed
Main Contributor: Trope Publishing Co.
Assignment: The "HP Way" has attained a kind of mythological status for anyone familiar with the company's history. The Evolving Way was created to celebrate HP's storied history and examine how the HP Way evolves to meet each moment, each challenge, and how its principles continue to shine the light forward.
Approach: Trope editors, writers, and designers were granted exclusive access to archives dating back to the company's origin. Thousands of artifacts, documents, and photographs were reviewed, scrutinized and restored. Hours of interviews with key HP visionaries and team leaders revealed how Bill Hewlett and David Packard's unconventional ideas continue to influence and shape the company today.
Results: Initially conceived as a limited-run token of appreciation for select executive leadership, directors, and partners, HP immediately recognized the book as an opportunity to inform and inspire their broader employee base by ordering thousands of copies to distribute to HP teams and offices worldwide, as well as making it publicly available for sale.

38 NOIR BAR: COCKTAILS INSPIRED BY THE WORLD OF FILM NOIR
Design Firm: Headcase Design | Designers: Paul Kepple, Alex Bruce
Clients: Running Press Book Publishers, Turner Classic Movies | Photographer: Steve Legato
Creative Director: Frances Soo Ping Chow (Running Press) | Art Director: Paul Kepple
Stylist: Kelsi Windmiller | Editor: Cindy Sipala (Running Press) | Author: Eddie Muller
Publisher: Running Press Book Publishers | Main Contributor: Headcase Design
Assignment: "Noir Bar" is a cocktail book by the "Czar of Noir" Eddie Muller—host of TCM's "Noir Alley"—that pairs libations with classic noir films and includes behind-the-scenes anecdotes and insights on film favorites. The book features reproductions of vintage movie posters, film stills, and plenty images of dames, detectives, stiffs, and stiff drinks.
Approach: We wanted to capture the atmosphere of noir films through moody photography, vintage typography, and a limited color palette. The photography integrates props related to plot points from the films and incorporates a dramatic lighting style. The design of the recipe names evokes vintage title cards. The ingredient lists play off end credits via their justified layout and dotted rules. The book is drenched in black, with the posters, yellow captions, and drinks providing the only color. The book is a square trim size when closed, giving a cinematic widescreen proportion when opened.
Results: The author Eddie Mueller—a leading authority on film noir—was thrilled with the results. He appreciated the references to the films, the attention to detail, and felt the book captured the spirit of his content. Sales for the book has been strong and it has been well received by fans, with many specifically pointing out the design.

39 THE LUMBERJILLS | Design Firm: Richard Ljoenes Design LLC
Designer: Richard Ljoenes | Client: Merrow Downs Press | Art Director: Richard Ljoenes
Author: Joanna Foat | Image Sources: Front cover photograph Rekha Garton © Arcangel
Images; back cover photograph: Geoffrey Kuchera © Shutterstock
Main Contributor: Richard Ljoenes Design LLC
Assignment: Create an engaging book cover for this WWII novel. The Lumberjills is inspired by the incredible and heroic true stories of the Women's Timber Corps, a branch of the UK's Women's Land Army. Author Joanna Foat researched and interviewed sixty women who served as Lumberjills in World War II.
Approach: The solution became a stock image featuring two Lumberjills in genuine historical uniforms carrying the Union Jack. The title lock-up features two crossed felling axes and the authentic insignia of the Timber Corps.
Results: The book has performed well and a sequel is in the works.

40 PONYBOY | Design Firm: Richard Ljoenes Design LLC
Designer: Richard Ljoenes | Client: W. W. Norton | Creative Director: Steve Attardo
Art Director: Sarahmay Wilkinson | Editor: Mo Crist | Author: Eliot Duncan
Image Sources: Jacket photographs: © Maria Silent / Trevillion Images; Marcel / Stocksy
Main Contributor: Richard Ljoenes Design LLC
Assignment: Create an engaging book cover for this evocative debut novel of trans-masculinity, addiction, and the pain and joy of becoming.
Approach: The mirror shards design is meant to suggest a fractured self, while hinting at a bit of mayhem, partying and drugs.
Results: The book has performed well and garnered strong reviews.

41 BROKEN SUMMER | Design Firm: Richard Ljoenes Design LLC | Designer: Richard Ljoenes
Client: Amazon Publishing | Photographer: Miki Takahashi | Author: J.M. Lee
Senior Art Director: Jarrod Taylor | 2.Main Contributor: Richard Ljoenes Design LLC
Assignment: Create an engaging book cover for this unforgettable Korean literary thriller about the uncovering of a lie from a childhood summer long ago—a lie that would irreversibly and tragically determine the fates of two families.
Approach: The novel covers the suspicious death of an upper-class girl. An important piece of the story is a painting of a girl who is lying partly submerged in water with small flowers and weeds covering her. The design solution tries to combine these two aspects.
Results: The book has performed well and garnered great reviews.

42 ALL I SEE IS VIOLENCE | Design Firm: Greenleaf Book Group | Designer: Neil Gonzalez
Client: Angie Elita Newell | Art Director: Neil Gonzalez | Main Contributor: Neil Gonzalez
Assignment: Angie Elita Newell brings a poignant retelling of the true story of the 1876 Battle of Little Bighorn and the social upheaval that occurred on the Pine Ridge Reservation in 1972. Cheyenne warrior Little Wolf fights to maintain his people's land and heritage as General Custer leads a devastating campaign against American Indians. A century later, Little Wolf's relation Nancy Swiftfox raises four boys with the help of her father-in-law while facing the economic and social ramifications of this violent legacy.
Approach: The author actually had the idea of using a skull and headdress to show the war being waged against Indigenous Americans. I added a hand drawn text to play into the chaotic violence aspect of the story and run the title along the back of the headdress, leading your eye down to a small figures towards the bottom of the composition.
Results: The author was happy with how the image matched the tone and themes of the book.

43 BROADWAY BUTTERFLY | Design Firm: Richard Ljoenes Design LLC
Designer: Richard Ljoenes | Client: Amazon Publishing | Senior Art Director: Jarrod Taylor
Author: Sara DiVello | Image Sources: Jacket photographs: woman by Sudha Peravali / Arcangel
Images; Art Deco pattern by Daniela Iga / Shutterstock; New York skyline by Charles Phelps
Cushing / ClassicStock | Alamy Stock Photo | Main Contributor: Richard Ljoenes Design LLC
Assignment: Create a book cover for this true-crime novel, based on one of the most notorious unsolved murders of the era, where power, politics, and secrets conspire to bury the truth.
Approach: The solution became a collage attempting to combine New York in the Roaring Twenties, sordid tabloid scandal, and "True Crime Noir".
Results: The book has performed well and has garnered tons of great editorial reviews.

44 WEST HORSLEY PLACE | Design Firm: Rose | Designer: Rose
Client: West Horsley Place | Main Contributor: Rose
Assignment: West Horsley Place is a historic house and estate that helps improve the well-being of people through art, culture, history and nature. Visitors are allowed to explore and discover the house and estate and become part of the next chapter in West Horsley Place's history.
Approach: West Horsley Place's incredible library holds thousands of fascinating stories of its own. We used typography from the many illuminated bookplates as inspiration for the logotype, as well as marbled endpapers to inspire the patterns used throughout the new visual language. The typography is elegant but eccentric and nods to the heritage of the house and estate. By contrast, we recommended they use photographic close-ups of the many beautiful details at West Horsley Place to provide a contemporary counterpoint to the heritage.
Results: Our rebranding coincided with an ambitious renovation programme. Although still a work in progress, it has already grown a loyal audience base with an exciting events programme throughout the year. It has also generated considerable commercial revenue streams through event hire, and film and tv location opportunities.

45 TOLEDO MUSEUM OF ART REBRAND | Design Firm: Lafayette American
Designers: Lafayette American, Asha Cook | Clients: Toledo Museum of Art, Adam Levine,
Gary Gonya, Mark Yappueying, Aly Krajewski, Crystal Phelps
Chief Creative Officer: Toby Barlow | Design Director: Meg Jannott
Senior Designers: Jon Wolfer, Paolo Catalla (Semi:Formal) | Junior Designer: Cecilia Hong
Associate Creative Director: Aidan McKiernan | Strategy Director: Beth Rea
Strategy: Priya Tirtha | Digital Director: Ben Bator | Creative Strategist: Doug James
Project Manager: Vu Nguyen | Web Developer: Madhouse | Account Supervisor: Justin Morley
Account Director: Stephanie McMillan | Main Contributor: Lafayette American
Assignment: The Toledo Museum of Art (TMA) has one of the richest collections of art in the world. TMA came to us with a clear request: A desire to transform while honoring its legacy.
Approach: We answered with a total rebrand, including strategy and a holistic design system. We grounded the rebrand on a strategic platform: The transformative power of art is for all of Toledo. The new TMA logo is a dynamic, multifaceted icon and a symbol of the continual reframing of the history of art while evoking the dynamism of art's emerging future. This is a brand identity that expresses the bold confidence of TMA — moving out into the community, revealing new perspectives, and shaping the future of where museums go next.
Results: TMA has seen increases in year-over-year museum visitation of 20% and year-over-year exhibitions ticket sales have grown 140%. In this same period, social media campaigns have seen a strong year-over-year growth in impressions and engagement.

46 BLANK SPACE: OVERCOMING CREATIVE FEAR | Design Firm: Charmie Shah
Designer: Charmie Shah | Client: Dropbox | Creative Director: Charmie Shah
Production Company: OTHR | Main Contributor: Charmie Shah
Assignment: The objective of this project was to empower design professionals to conquer their fear of the blank page. We aimed to create an experience that fostered exploration and experimentation, reigniting creative freedom. Many designers get hung up on execution over exploration, and this event aimed to break that cycle.
Approach: "Boundless Exploration" became the central theme and was infused into every design element. The logo symbolized fluidity and exploration, and the letters were designed to flow freely. Subtle text blending created a feeling of vastness and openness, and a softer color scheme complemented the logo, further emphasizing the sense of openness and exploration. Instead of traditional titles, badges used "Adobe Creative Types" to categorize participants by creative personalities. The badges featured a minimal, typographic layout printed on reflective metallic glass. A unique stand, subtly cut from wood in the shape of the Dropbox logo, suspended the badges on beaded metal strings. Guests entered through a mirrored entryway displaying the message "Thoughts Become Things." Made from polished metal, it reflected attendees themselves, blurring the lines between observer and participant.
Results: The design was a huge hit! The branding not only looked unique but also served the event's purpose by encouraging participants to embrace their creative spark.

47 DIGIKEY: FROM CULT CLASSIC DISTRIBUTOR TO GLOBAL E-COMMERCE LEADER
Design Firm: Lippincott | Designers: Jenifer Lehker, Thom Finn, Kaito Gengo, Devin Sager,
Victor Rijo, Kevin Grady; Lippincott | Client: DigiKey | Creative Director: Ross West; DigiKey
Strategy: Tim Cunningham, Alexandra Previdi, Sarah Koe; Lippincott | Others: Tim Carroll,
Global Head of Marketing and eCommerce; DigiKey, Eva Hoffman, Senior Designer, Experience,
Innovation & Engineering; Lippincott, Jillian Larson Switts, Director, CX and Digital Technology
Office; DigiKey, Brooks Vigen, Senior Director, Global Strategic Marketing; DigiKey,
Kirsten Fonken, Senior Creative Team Project Manager; DigiKey
Assignment: Known for its exceptional service and cult-like affinity within the design engineer community, DigiKey excels at selling electronic components. They needed a brand to support their aspirations to grow confidently. Lippincott created a new brand purpose and visual identity showcasing their ability to drive progress for designers, buyers, and builders.
Approach: The new visual language is steeped in a modern take on the components DigiKey is known for to express Digikey's technical expertise and the reliability its customers count on. The tagline, We Get Technical, accompanies the logo and accomplishes critical goals: it speaks to DigiKey's expertise, celebrates its role as a member of the community, and provides a rallying cry for customers who proudly own their technical abilities.
Results: It's all led to a bold, fresh identity for DigiKey that brings the brand's most enduring qualities to the surface while positioning them towards a future of growth and possibility.

48 ECO FUSION - BRANDING | Design Firm: Viva & Co.
Designer: Mike Deinum | Client: Eco Fusion | Creative Director: Todd Temporale
Main Contributor: Viva & Co.
Assignment: Eco Fusion is a company based in Ireland that creates high-quality, ultra-low carbon building products. The founders hired Viva & Co. to brand the business as it launched in Europe, which involved the design of its packaging, a new website, and other applications.
Approach: A key focus of the brand is its proprietary technology, so we anchored our approach around the tagline "The Science of Building." This fed into our design process as we looked to communicate this aesthetically while connecting it to the brand's purpose. These focal points needed to be understood throughout the brand's applications, which we accomplished through

a consistent set of visual motifs, a tight typography system, and a considered grid structure.
Results: The result is a modern, integrated brand that effortlessly communicates its value. It is eye-catching while remaining minimal and straightforward.

49 BANDCAMP REBRAND | Design Firm: Lingou Li | Designer: Lingou Li
Client: Bandcamp (Non-commercial) | Main Contributor: Lingou Li
Assignment: Bandcamp is an music community and online record store dedicated to supporting indie music and young artists' career. Often misunderstood as an alternative streaming platform, Bandcamp needs to separate itself from its competitors like Spotify and Soundcloud, communicate its mission better, and attract more listeners and artists to its community.
Approach: Bandcamp underwent a brand refresh that drew inspiration from vintage posters, reminiscent of local record shops. This new brand identity is designed to resonate with its core community, emphasizing the intimate connections between artists and their audiences. The secondary series of posters are designed for artists and music lists on their website. The typography used is more vibrant and expressive, aiming to create a festive atmosphere.
Results: The project received positive feedback from professional peers and was featured in various design competitions and media.

50 MICHI JAPANESE KITCHEN BRANDING | Design Firm: Arcana Academy
Designer: Jay Josue | Clients: Michi Japanese Kitchen, Michiyo Wilson
Executive Creative Directors: Lee Walters, Shane Hutton | Main Contributor: Jay Josue
Assignment: For the 10+ years that Arcana Academy has been open, one thing has remained constant: Michi Japanese Kitchen has been the go to place for a home cooked Japanese meal. The Arcana Academy team has frequented the restaurant at least once a week and have built a strong relationship with the founder and head chef, Michio Wilson.
Approach: We were able to provide nearly 15 logo options for her. This chosen logo represents a traditional Japanese family crest. Its central figure is an evolution of the Skeleton Flower endemic to the Obihiro region of Hokkaido where Michi is from. The logo has 4 petals instead of 5 to symbolize the four values Michi associates with food: Food, Joy, Love, and Harmony. The descriptor indicates a warm, home-style experience.
Results: "The rebrand takes the restaurant to another level," said Michi. "We've had a renewed energy with both existing and new customers. Just last week I had new customers come in that have lived in the neighborhood for over 17 years and just now realized we're here."

51 BAUM | Design Firm: Ermolaev Bureau | Designers: Vlad Ermolaev, Olga Rodina
Client: PZSP | Creative Director: Vlad Ermolaev
Typeface Designers: Vlad Ermolaev, Anton Terekhov, Oleg Macujev
Main Contributor: Ermolaev Bureau
Assignment: PZSP has been building panel houses and housing estates for over 30 years. Now the company has decided to reach a new technological level by purchasing a modern German production line. This allows them to build with a new, improved layout and a variable facade design. Our main task was to create a visual identity to reflect the new construction principle.
Approach: We came up with a name where "BAU" stands for construction and "M" stands for module. We took the rectangle module from PZSP company's old logo to evolve it and use it as the basis for the new BAUM logo. The resulting 4:3 matrix gives us a multiplicity of different letterforms that resemble building structures.
Results: We created a modular principle that gave us a universal tool for branding objects built with the new technology. The typeface matrix allows us to create recognisable letters, each time in a new form, depending on the need and adaptable to the customer's wishes.

52 UNIFONIC REBRAND | Design Firm: Pendo
Designers: Pendo, Jiaan Co, Peter Ladd, Timothy King | Client: Unifonic
Brand Strategy: Don Cleland | Creative Director: Peter Ladd
Copywriter: Ryan Leeson | Project Manager: Yasmina Hashemi
Main Contributors: Jiaan Co, Peter Ladd, Timothy King
Assignment: Unifonic is a platform that helps businesses connect with customers across mobile apps. Previously focused solely in the Middle East, Unifonic wanted to expand globally. The company was also looking to overcome an external perception issue where they were seen only as a regional SMS text technology versus a global messaging platform technology.
Approach: Inspired by the brand idea of "Where conversations connect", we developed a custom wordmark, typography, and graphic system around a waveform concept that connected all touchpoints. Applications included print materials, collateral, tradeshow booth, office environment, culture story, and brand guidelines.
Results: Since launch, the company has expanded across the Middle East and entered the US, with increased staff and office locations, building new partnerships and landing global clients.

53 WERT&CO. BRAND IDENTITY: EVERY CREATIVE'S CAREER FOLLOWS A UNIQUE PATH | Design Firm: Stitzlein Studio | Designers: Joe Stitzlein, Leslie Stitzlein
Client: Wert&Co. | Motion Designer: Nertil Muhaxhiri | Main Contributor: Joe Stitzlein
Assignment: Wert&Co. is the design industry's most trusted search partner. They approached us to evolve their brand identity system.
Approach: Our response was to build on their iconic ampersands while at the same time evolving them for digital and social mediums. We grounded the system in a simple idea: Every designer's journey is unique. To express this, we created a family of 5 hand drawn, unique 3D ampersands that are built with a continuous ribbon of white and orange, reflecting the continuous path of designer's careers.
Results: Wert&Co. has used these assets to redefine their thought leadership articles, website and their social media presence. Their posts have increased engagement dramatically, to as high as 20,000 impressions compared to a few hundred that Wert's posts typically receive.

54 UPSTAIRS | Design Firm: Ron Taft Brand Innovation & Media Arts
Designer: Ron Taft | Client: Divino Restaurant | Photographer: Liv Friis-Larsen
Copywriters: Cliff Einstein, Ron Taft | Main Contributor: Ron Taft
Assignment: Name creation and logo for a highly acclaimed Italian restaurant owned and operated by Goran Milic. A new addition at the top of an inviting stairway was created as an exclusive dining experience to its sophisticated clientele.
Approach: My partner, Cliff Einstein, felt that a beautiful narrative lived in the staircase and came up with UPSTAIRS as the name for this expanded, elevated ambiance. Breaking up the letters into a pair on each step suggests positive upward motion. The simple graphic representation of the stairs gave us an effective visual asset carrying over onto plates, glassware, napkins, etc., further complementing the UPSTAIRS brand visual narrative.
Results: There has been a firestorm of excitement from investors for the new name and identity.

55 7UP ONAM 2023 | Design Firm: PepsiCo | Designer: PepsiCo
Client: Self-initiated | Main Contributor: PepsiCo
Assignment: During Onam, a local harvest festival in the Indian state of Kerala, people gather together to celebrate this major annual event. 7UP® is known for its massive popularity in the region, so in 2024, our team designed a visual identity system and retail toolkit for Onam.
Approach: We created illustrations that brought the joy of the festival to life by representing key

aspects of Onam. We went for a bold, modern illustration style to celebrate the festival's most recognizable elements like marigolds, leaves, and folk dancers of the Kathakali and Puli Kali.
Results: We stayed true to the 7UP® brand color palette while adding in other accents to increase the festive feeling. Our designs were placed across key areas in Kerala on posters, banners, and more. By weaving 7UP® into the fabric of the festival, we crafted a refreshing visual identity system that invites you to celebrate Onam with our zesty lemon-lime soda.

56 7000KM | Design Firm: Z WAVE DESIGN
Designer: Yinan Lyu | Client: Shenzhen 7000KM Trading Co., Ltd
Contributor: Zhongbiao Jiang | Main Contributor: Yinan Lyu
Assignment: 7000KM is an international trading company with operations in major economies. Its name comes from the length of the Silk Road, the world's earliest international trade route.
Approach: Our understanding of international trade and the Silk Road is that it is free, flexible, and friendly like a network spreading out, so we created a logo and visual identity based on a grid system. 7000KM's letters are condensed into a grid, arranged and shuttled so that the logo becomes dynamic and interesting, echoing the freedom and flexibility of trade networks.
Results: The number 0 can also be extended into a "map route" representing trade and the silk road, linking from a starting point to an end point, which strengthens the impression of the brand, enriches the brand's emotional attributes, and helps the brand to develop more quickly.

57 AMIDA BRANDING | Design Firm: Twice2 - Atelier de Graphisme & Typographie
Designer: Johann Terrettaz | Client: AMIDA | Main Contributor: Johann Terrettaz
Assignment: The goal was to use the historic codes of the brand for the new launch of the Swiss brand in the world and its iconic AMIDA Digitrend watch model from the 70s. The atmosphere is deliberately retro-futuristic like the AMIDA Digitrend watches of the time.

58 GANGWON STATE CI | Design Firm: DAEKI and JUN
Designers: Daeki Shim, Hyojun Shim, Junseok Kim
Clients: Gangwon State, Kim Jin-Tae, Kim Yong-Kyun, Bak Ho, Choi Nak-young, Choi In-Sook, Choi Yong-Sun, Shin Kyoung-Cheol, Jang Aeri, Lee Mi-Kyung, Choi Jung-Won, Park Young-Jo
Design Directors: Daeki Shim, Hyojun Shim
Main Contributors: Daeki Shim, Hyojun Shim, Junseok Kim
Assignment: Gangwon State, the second-largest state in South Korea, was underdeveloped due to overlapping regulations. Gangwon State needed to change to gain regional symbolism, build industrial infrastructure, and drive balanced development in South Korea. In 2023, after 628 years, Gangwon State has been reborn as "GANGWON STATE".
Approach: We represented the direction of a growing industrial city moving towards the future with arrows. Simultaneously, we incorporated the letter 'ㄱ' (giyeok), the first letter of the Korean alphabet, Hangeul. The graphic concept of the corporate identity (CI) is "Growth." It emphasizes that GANGWON STATE is a region of Korea that is proud of its history and tradition, and also signifies a positive future for the country that begins here. Beginning with the wordmark design, a comprehensive redesign was undertaken. The redesign was implemented across all Gangwon State institutions and infrastructure, including road signs.
Results: On June 9, 2023, a grand inauguration ceremony took place featuring the new Gangwon State CI. The event was attended by the current President of South Korea, the Governor of Gangwon State, government officials, and citizens.

59 BOMBSHELLS SALON IDENTITY | Design Firm: Lewis Communications
Designer: Robert Froedge | Client: Bombshells Salon | Main Contributor: Robert Froedge
Assignment: Brand a new upscale salon in Nashville.
Approach: Instead of using some of the tired visual tropes like scissors, we decided to consider nice expressive typography and movement that mimicks hair to create the logo.
Results: The client is happy. The designer is happy. Customers are happy.

60 JESSICA NEUMANN PHOTOGRAPHY BRANDING | Design Firm: Lisa Sirbaugh Creative
Designer: Lisa Sirbaugh | Client: Jessica Neumann Photography
Photographer: Jessica Neumann | Sign Fabricator: Graphcom | Production: Chatterbox
Main Contributor: Lisa Sirbaugh Creative
Assignment: Jessica Neumann Photography (JNP) has been an integral part of the DC, Maryland, and Virginia photography community for 15 years. As the studio approaches a milestone anniversary, founder Jessica Neumann embarked on a reevaluation of the JNP business model, its brand, and identity. Working closely with JNP, we explored strategic decisions, creative innovations, and the development of a new visual identity and various brand touchpoints. The goal: elevate the brand and propel the studio towards continued success and distinction.
Approach: JNP's transformative rebrand began with in-depth discussions, discovery, and research. We then crafted a detailed brand brief that encapsulated JNP's objectives, target audience, client experience, and brand mission, vision, and characteristics. The impact was multi-faceted, extending to internal strategy, visual identity, color palette, and more. By aligning every element with the brand brief, we ensured a cohesive and authentic representation of JNP.
Results: The resulting visual identity and brand touchpoints embodies sophistication, luxury, and professionalism. This transformation not only underscores Jessica's brand values but also presents JNP as a distinctive and memorable brand in the photography industry.

61 65TH MONTEREY JAZZ FESTIVAL IDENTITY | Design Firm: *Trace Element
Designer: Jeff Rogers | Client: Monterey Jazz Festival | Creative Director: Jeff Rogers
Account Director: Jenna Snyder | Main Contributor: Jeff Rogers
Assignment: The Monterey Jazz Festival holds the prestigious title of being the longest-running jazz festival globally, showcasing legendary artists within the genre throughout its 60-plus-year history. To maintain its innovative spirit, the festival updates its visual identity annually, ensuring freshness and spontaneity. For the 65th festival, the client sought a versatile visual system that could seamlessly transition from the live event to the digital realm. The goal was to create a captivating online presence to generate excitement and attract new attendees to the festival.
Approach: Given that this festival marked the first full event post-COVID, we aimed to celebrate life and beauty by using abstract flower shapes and a restrained color palette. The highlight was a hand-painted main stage that transformed daily throughout the festival.
Results: The digital advertising campaign exceeded expectations. As anticipation built, tickets for the festival sold out. Audiences were enthralled by the first-ever evolving stage design, adding an extra layer of excitement and delight to the event.

62 2024 CALENDAR LIFE WITH LIGHTS | Design Firm: TOPPAN INC.
Designer: Masahiro Ogawa | Clients: Electric Works Company, Panasonic Corporation
Art Director: Masahiro Aoyagi | Photographer: Atsushi Malta
Print Designer: Daijiro Hasegawa | Main Contributor: Masahiro Aoyagi
Results: This calendar is composed of landscape lighting photographs from around the world taken by Atsushi Maruta. The motifs were selected with an awareness of figurative change, as well as the impression of different lighting colors. UV coated varnish is used on the cover to emphasize the photographic portion, and line drawings of the buildings are applied to the black areas above and below. The title section is accented with silver foil stamping.

63 2024 CALENDAR FUSION NATURE & TECHNOLOGY | Design Firm: TOPPAN INC.
Designer: Masahiro Aoyagi | Client: KOMORI Corporation | Art Director: Masahiro Aoyagi
Artist: Josh Dykgraaf | Print Designer: Riichi Yamaguchi | Main Contributor: Masahiro Aoyagi
Results: Josh Dykgraaf, an Australian photographic illustrator, was selected for this project. High-definition printing is used to express delicate expressions, and a variety of varnishes, including gloss, emboss, and matte, are applied to match the artwork. The header is silk over offset, and the logo is luminescent printing.

64 THE 2024 ARCHITECTURE COLLECTION | Design Firm: David Cercós
Designer: David Cercós | Client: Arkoslight | Main Contributor: David Cercós
Assignment: Catalog for Arkoslight, technical lighting company, in search of purity of forms to create unique, attractive and differentiated products.
Approach: The catalog, through its most iconic products, shows a way of understanding design where light is the element that establishes a dialogue with the space to endure over time.
Results: Each product is presented with a resounding typographic game of contemporary character, conceived in reference to the flexibility of the new designs presented, which gives rise to different distinctive visual motifs. The cover, through its orange-brown color and shiny bronze stamping, reflects the warmth and subtlety of the light that surrounds us on a daily basis.

65 GLOBAL TALENT EXPRESSION | Design Firm: Microsoft Brand Studio
Designer: Microsoft Brand Studio | Client: Self-initiated
Main Contributor: Microsoft Brand Studio
Assignment: We set out to redesign the way Microsoft attracts and retains 250,000+ employees annually. Our prior recruitment system was focused on the functional elements of employment and lacked emotion. So, we changed our approach—inviting talent to imagine the impact they might have at Microsoft and the calling they want to pursue for themselves.
Approach: Our new recruitment system repositions the benefits of working at Microsoft through the lens of the company's mission and focus on social good. To showcase the global impact of one's job, the new system employs a memorable visual metaphor: a catalyst. It represents the scale and potential of one's work at Microsoft. Provocative copy pairs employee opportunity and corporate responsibility.
Results: Open and inviting, the new system visualizes Microsoft's vision and strategy in a personal way, differentiates it from other employers, and communicates company's values and culture clearly and effectively. Research shows the system is working—with increased consideration, preference, and brand love for Microsoft.

66 THE AGE OF INNOCENCE | Design Firm: Wainscot Media
Designers: Trevett McCandliss, Nancy Campbell | Client: Earnshaw's Magazine
Fashion Director: Mariah Walker | Photographer: Zoe Adlersberg | Editor-in-Chief: Michele Silver
Main Contributors: Trevett McCandliss, Nancy Campbell
Assignment: Create an opening spread that features white, classic clothing.
Approach: We chose to create a custom type solution using a Blackletter font that we altered and soft pastel colors to create a dreamy mood.

66 TO THE MAX! | Design Firm: Wainscot Media
Designers: Trevett McCandliss, Nancy Campbell | Client: Footwear Plus Magazine
Photographer: Mark Andrew | Fashion Director: Mariah Walker | Editor-in-Chief: Greg Dutter
Main Contributors: Trevett McCandliss, Nancy Campbell
Assignment: Create an opening spread that features sneakers with big, thick soles.
Approach: We chose to play off the maximum thickness concept by creating a customized type design where some characters get extremely thick and wide.

67 PLAY | Design Firm: Cina Associates | Designer: Michael Cina
Client: The Minneapolis Pickup Basketball Community | Photographer: Eric Melzer
Creative Team: Eric Melzer, Michael Cina, Christopher Bickford | Creative Director: Eric Melzer
Editor: Christopher Bickford | Main Contributors: Eric Melzer, Michael Cina
Assignment: 'The Play Project' is a project created by photographer Eric Melzer that uses art to celebrate neighborhood play and good health. The first chapter was created for a group of pickup basketball players at Peavey Park in Minneapolis, Minnesota. A generous grant allowed for an artistic celebration of the game in the form of a custom tabloid poster book.
Approach: Because celebrating the players was central, designer Michael Cina decided his design efforts shouldn't cover the imagery. Eric and Michael decided that it was important to have a series of uninterrupted posters that were easy for the players to hang frameless. All individual page markings took cues from the photographs they reflected. A simple image numbering system was decided upon that reflected the traditional plate numbers from fine art photography books. Because of the complex layout, the numbers had to count up to 021 and back down to 001 so that when the loose posters were pulled apart, the numbers were consistent.
Results: Each player got a poster book along with a fine art print and a set of custom basketball cards. Free tabloids were also distributed throughout the neighborhood. The poster book is on display at the University of Minnesota's Urban Research and Outreach-Engagement Center as a disassembled set of 21 separate posters.

68 KATS TOOLKIT | Design Firm: Lisa Winstanley Design
Designer: Lisa Winstanley | Client: [copy] KATS | Photographer: After Dark Media
Printer: Allegro Print Singapore | Main Contributor: Lisa Winstanley
Assignment: The [copy] KATS Participatory Design Workshop Toolkit represents our response to ethical challenges within art and design education, specifically addressing issues surrounding visual plagiarism. Our goal was to make discussions on visual plagiarism both informative and enjoyable. After engaging with multiple stakeholders, we identified four significant challenges (differing levels of Knowledge, incorrect Assumptions, Time constraints, and lack of Support), strategically using the term "KATS" to encapsulate them.
Approach: With the brand slogan "Don't Cut Corners," we embody the essence of creative integrity through ethical, creative practice, a philosophy woven into the visual narrative of the brand. Featuring four hands-on activities and a user-friendly maker pack, the kit empowers educators to create solutions collaboratively. The adorable cats play a lead creative role in inviting discussions, and we aim to create a friendly atmosphere that encourages exploratory actions, making the learning experience both enjoyable and impactful.
Results: The [copy] KATS Toolkit is about to embark on a global journey, with participatory design workshops being held in the USA, Europe, and Asia. Our goal is to establish the toolkit as a dynamic catalyst for change in art and design education.

69 DAZZLE JAZZ CLUB: BRANDING, ENVIRONMENTAL GRAPHICS, AND SIGNAGE
Design Firm: ArtHouse Design | Designers: ArtHouse Design, Kevin Penland, Maddie Bonthron, Aaron Hilst, Mikayla Zancanelli | Client: Dazzle Jazz
Design Directors: Marty Gregg, Beth Rosa, Chuck Desmoineaux | Fabricator: ADCON Signs
Main Contributor: ArtHouse Design
Assignment: For nearly 30 years, Dazzle Jazz has been at the core of Denver's music scene. By bridging the past and present through younger generations, Dazzle ensures that the legacy of jazz music continues to live on in Denver.

Approach: The final logo is a visual representation of sound in a chromatic palette, evocative of both a rippling sound wave and a horn bell. We were brought into the build-out process early to integrate the new brand into every aspect of the listening room. The stage and signage are visible from every vantage point, and the rippling soundwave is brought to life as large, illuminated rings. The rings also serve as a captivating backdrop for the artists. Every element was curated to accentuate the history and deliver an unparalleled live music experience.
Results: ArtHouse has garnered outstanding feedback on the impact of the new brand and the environmental design from the ownership team, performers, and audience members alike.

70 PERELMAN PERFORMING ARTS CENTER | Design Firm: Entro
Designers: Entro, Shehrbano Akhtar, Lauren Kuzyk | Client: Perelman Performing Arts Center
Creative Directors: Kevin Spencer, Udo Schliemann | Other: Anna Crider, Partner in Charge
Main Contributor: Entro
Assignment: The vision for the Perelman Performing Arts Center (PAC NYC) began over 20 years ago. To accommodate diverse artistic programs, the three main auditoria can transform into ten different proportions that collectively adopt more than 60 stage-audience arrangements. In addition, PAC NYC differs from many theaters in that it is a vertical experience. The wayfinding needed to allow visitors to understand the vertical configuration of the building.
Approach: We devised a wayfinding strategy and signage program that offers both permanent and flexible elements. This translated into ceiling lights that animate towards the elevators when it's show time, and large-scale illuminated sign elements to capture the patron's attention. Tactile and braille equivalent information is available on all wayfinding signage. Because of the vertical architectural layout, we visually stacked the floor levels at each elevator, added playful graphics, and created meandering illuminated arrows to encourage exploration and orientation. The theater doors are identified by large illuminated numbers that can be turned off when the door is not accessible. We also worked with PAC NYC to ensure that tickets communicate the stair/elevator letter and door number ideal for that person's journey.
Results: We were honored to collaborate on this final public cornerstone of the rebuilt World Trade Center site. As the renowned architectural critic of The New York Times states, "Lower Manhattan could have hardly asked for a more spectacular work of public architecture."

71 GATORADE DREAM COURT GUIZHOU | Design Firm: PepsiCo
Designer: PepsiCo | Client: Self-initiated | Main Contributor: PepsiCo
Assignment: Through collaboration with the NBA, our team transformed a local basketball court in Guizhou, China into an immersive Gatorade experience. This wasn't about just refurbishing concrete and hoops; we had a shared vision to invest in a recreational space that would ignite dreams, build meaningful connections, and foster a sense of local pride.
Approach: This project marked a significant opportunity for the brand to leave a lasting impact. We combined the Gatorade visual identity system with bespoke styles and patterns inspired by the craftsmanship and vibrant local culture of the Bouyei people. We also installed solar-powered lights so the court is illuminated and ready for play, day or night.
Results: Not only was the design a local hit, but the Gatorade Dream Court was also met with significant media excitement. By bringing bold design to the court, basketballs and jerseys, we created a gathering place that reflects the brand values that Gatorade and the NBA share.

72 INTERNATIONAL AFRICAN AMERICAN MUSEUM
Design Firm: Ralph Appelbaum Associates | Designer: Ralph Appelbaum Associates
Client: International African American Museum | Project Director: Luka Kito
Project Manager: Rio Valledor | Main Contributor: Aki Carpenter, Project Oversight
Assignment: The International African American Museum (IAAM) is located on the waterfront site that was the port of arrival for nearly half of all enslaved Africans brought to North America. The museum's design intent was to create an environment that honors the site's history while supporting an array of exhibitions, events, and educational resources.
Approach: The museum's exhibition themes include connections across the African diaspora, the spread of African American culture and influence, and the movements for justice and equality. The narrative flow of the installations were planned around the architecture, with an introductory corridor and orientation theater leading to multimedia displays of South Carolina, Gullah Geechee culture, African roots, and the Atlantic world. Exhibits offer artifacts and works of art juxtaposed with media presentations related to the legacies of slavery and current movements for racial equality, while the Center for Family History provides a resource for the study and advancement of African American genealogy. To develop the interpretive scope of IAAM, it was important to involve not only the museum's leadership and curators, but also the local community and scholarly advisors to ensure history and personal experience was being accurately told while maintaining sensitivities around historical topics.
Results: The New York Times wrote: "If such a museum expands the parameters of history, and this one does, that's a lot. Which, I guess, is why I ended up on a visit awarding it my sincerest accolade: At closing time I didn't want to leave."

73 ARGHAVAN KHOSRAVI: BLACK RAIN | Design Firm: Siena Scarff Design
Designer: Siena Scarff | Client: Rose Art Museum | Main Contributor: Siena Scarff Design
Assignment: To design exhibition graphics for Arghavan Khosravi's first significant museum survey. According to the artist, "contradiction" is one word that sums her work.
Approach: Drawing inspiration from Arghavan's artwork, we created a gradient for the title wall, which blended seamlessly into the blue color of the exhibition walls. We also designed the typography treatment to highlight the artwork.
Results: The exhibition was an success, attracting a significant number of visitors. It was highly acclaimed and received coverage in several renowned publications.

74 ANOTHER YEAR | Design Firm: UP-Ideas | Designer: Mark Braught
Client: Self-initiated | Main Contributor: Mark Braught
Assignment: Image created for agency holiday greeting card based on the theme, "another year."

75 21 COVERS FOR MARGARET ATWOOD'S MASTERPIECES
Design Firm: The Balbusso Twins | Designers: Anna Balbusso, Elena Balbusso
Client: Corriere Della Sera | Graphic Designer: Xxy Studio Milano
Illustrators: Anna Balbusso, Elena Balbusso | Main Contributors: Balbusso Twins Artist Duo
Assignment: Create images for the covers of twenty-one Margaret Atwood's masterpieces collection published by Corriere Della Sera, the first Italian national newspaper.
Approach: The conceptual graphic style of the images was born from our personal artistic research that began many years ago in 2012 when we illustrated The Handmaid's Tale for the UK publisher Folio Society. This amazing project for Corriere Della Sera gave us the opportunity to use our graphic language for novels with visionary and dystopian atmospheres and also for essays, short stories and poems. Our goal was to create powerful, elegant images that arouse curiosity and emotions while avoiding stereotypes.
Results: The images won Best of Show at the 3x3 International Illustration Show.

76 MADOURA'S EMBRACE: THE OCTOPUS FANTASY
Design Firm: Michael Pantuso Design | Designer: Michael Pantuso
Client: Self-initiated | Main Contributor: Michael Pantuso

Assignment: This is the latest addition to my "Mechanical Integration" series, which delves into the realm where organic forms intertwine with mechanical elements.
Approach: Madoura's Embrace is a hand-drawn digital creation, meticulously crafted using Adobe Illustrator. Once the digital rendering reaches its final form, it is then transferred onto a durable metal canvas, ensuring the longevity of the colors and details.
Results: Madoura's Embrace is being produced and will occupy a new gallery space in Chicago.

77 LOOMING DANGER (1-3) | Design Firm: HandMade Monsters
Designer: Mark Borgions | Client: Gallery 1988 | Main Contributor: Mark Borgions
Assignment: Part of an art show celebrating the golden age of Hollywood.
Approach: Giclee prints, depicting three classic Hitchcock characters (Roger Thornhill, Madeleine Elster and Melanie Daniels). Straight to digital illustration (vector > bitmap detail).
Results: Produced in a limited, signed and numbered run on archival paper.

78 GHOST ARMY CONGRESSIONAL GOLD MEDAL AND BRONZE MEDAL
Design Firm: Justin Kunz Art & Design | Designer: Justin Kunz | Client: The United States Mint
Sculptors: John P. McGraw, Phebe Hemphill | Art Director: Joseph Menna
Main Contributor: Justin Kunz
Assignment: The 23rd Headquarters Special Troops and the 3133rd Signal Service Company, Special, known collectively as The Ghost Army, were U.S. Army tactical deception units active during WWII. Their efforts were so effective that they remained classified for decades after the war, and as such, members weren't given any public honors or recognition. The goal of this project was to design a medal to honor the members of the Ghost Army.
Approach: I used the obverse side of the medal to highlight the four different illusions the Ghost Army used: visual, sonic, radio, and special effects. For the reverse side, I opted for a graphic, type-based solution, which features their unique patch emblems. I drafted a fitting inscription to honor the Ghost Army, including a list of the places where they served, and used this text to fill the remaining space of the design. The stars represent members of the Ghost Army who were wounded or killed in action, that they may not be forgotten.
Results: I received an email from the U.S. Mint's Office of Design Management informing me that, "the Secretary [of the Treasury] has officially selected your designs for the obverse and reverse of the Ghost Army Congressional Gold Medal." On March 21, 2024, the Ghost Army Congressional Gold Medal was unveiled and awarded to the recipients at a ceremony at the U.S. Capitol in Washington. There were numerous articles reporting the event, and Brigham Young University interviewed me about my experiences designing the medal.

79 OPPO FIND N3 | Design Firm: Media.Work
Designers: Sergey Shurupov, Kirill Makhin, Daniil Makhin, Alexandra Vorobeva, Roman Eltsov, Denis Semenov, Dmitry Ponomarev, Artur Gadzhiev, Aleksei Komarov, Vasily Zinchuk
Client: OPPO | Creative Director: Igor Sordokhonov | Art Director: Dmitry Ponomarev
Producers: Alexandra Kotova, Andrey Sukhoruchkin | Main Contributor: Media.Work
Assignment: OPPO is renowned primarily for its smartphones. They entrusted us with the task of producing the wallpapers to establish the main visual direction for their Find N3 Flip and Find N3 phones. We created an elegant feather composition capturing the refined curves and details of the foldable phones. The wallpapers symbolize the harmony between technology and aesthetics while integrating with the essence of OPPO's innovative design philosophy.
Approach: We explored many combinations of shapes, colours and textures to find the delicate balance between naturalness and digital abstraction. The next step was to explore the composition. The main feature of the new series is the new camera system, which has a circular shape, so we integrate round forms into the digital wallpaper. Since we were creating a moving wallpaper, it was important to incorporate animation that would work with perfect precision when the phone opened. Our task was to bring the existing composition alive and to give the movement nuance and elegance, emphasising the sense of flowing lines and naturalistic forms.
Results: This was a huge worldwide OPPO campaign presenting the best foldable smartphones.

80 2023 PUBLIC ART FUND PARTY INVITATION | Design Firm: Ahoy Studios
Designers: Connie Koch, Denise Sommer, Lucia del Zotto | Client: Public Art Fund
Main Contributors: Connie Koch, Denise Sommer
Assignment: The Public Art Fund (PAF) brings dynamic contemporary art to a broad audience in New York City. When PAF approached us to collaborate on their 2023 fundraising party, our aim was to once again create a stunning piece that would excite the New York art world and help raise funds for PAF's extraordinary projects.
Approach: PAF collaborated with an event designer who was inspired by an urban jungle in spring, emphasizing overgrowth and mystery. We sought to convey this atmosphere in the invitation. Featuring four fold flaps, the envelope created an unwrapping experience that enhanced the mysterious theme. Inside, the invitation card was held by a die-cut leaf pattern, casting beautiful shadows and interacting with the pattern printed on the card. This interplay embodied the event's essence and offered invitees a glimpse of what to expect.
Results: The event was a resounding success, bringing together the New York art community to support innovative artists who share their ideas and visions through PAF's initiatives.

81 COPILOT ICON | Design Firm: Microsoft Design Studio | Designer: Microsoft Design Studio
Client: Self-initiated | Main Contributor: Microsoft Design Studio
Assignment: The technology landscape is changing in the era of AI, so it was critical for Microsoft to create a meaningful symbol for Copilot, a new AI-powered product integrated across the Microsoft product suite to enhance productivity and creativity. The Copilot icon needed to reflect both Copilot's capabilities and its relationship to users as well as fit into the existing Microsoft icon ecosystem.
Approach: Designers across all of Microsoft came together to collaborate on the icon. The form captures two speech bubbles in a cyclical conversation. The central forward slash signals the interaction between people, their files, and beyond. And finally, the color reflects the vibrancy of the Microsoft brand ecosystem, its scale, and flexibility of use across offerings.
Results: The icon had immediate adoption across the company, integrated into products, comms, and at events with positive response to the intentionality behind the symbol.

82 GAMESQUARE LOGO | Design Firm: Arcana Academy | Designer: Jay Josue
Client: Gamesquare | Executive Creative Directors: Lee Walters, Shane Hutton
Account Executive: Kensy Kenna | Main Contributor: Jay Josue
Assignment: We were propositioned to help rebrand Gamesquare, an e-sports and media company. Additionally we were to strategize and manage their web presence. The Company's mission is to make it easier for global brands and esports communities to play together. It was our job to make sure that the Creative spoke to that.
Approach: We developed 8 different logos and how each would rest on a business card and social handles for round 1. Round two took 3 of the 8 favorites and showed an in-depth color exploration. The selected logo has been the visual motif of the brand since its change over. From a design standpoint, we created the logo to have a classic "sports team" feel. We gave the brand strong colors that would also be at home on a sports team. The look and feel for Social Media and Press Releases is reminiscent of overlays from live sportscasts or player promos to further

integrate the tone of the brand with the familiar iconography of professional sports.
Results: The company is very happy with the logo, branding, and social media presence.

82 CURATING AND THE COMMONS LOGO | Design Firm: Big House Studio
Designers: Jiayu Ma, Linlan Li | Clients: Independent Curators International, Scott Campbell
Art Director: Gaozhe Li | Project Manager: Yu Lin
Assignment: Create a logo for Curating and the Commons, a public curatorial conference produced by Independent Curators International (ICI) in partnership with EXPO Chicago.
Approach: The logo emphasizes the letter "C" with lines that create distinct sections, representing the spaces within the enclosure. The bold, simple design ensures the logo remains versatile across various media, from header images to program guides.
Results: This visual identity enhanced signage, header images, program guides, the conference presentation booth, and more. Additionally, a tote bag with the logo provided participants with a memorable keepsake, encapsulating the ideas and discussions shared during the conference.

82 LA PERNÍA BEER | Design Firm: El Paso, Galería de Comunicación
Designer: Álvaro Pérez | Client: José R. Garcia | Creative Directors: Álvaro Pérez, Curra Medina
Main Contributor: El Paso, Galería de Comunicación
Assignment: La Pernía BEER is a popular craft beer fair hosted in the Palencia's Mountain, Spain. Where else can you try dozens of delicious craft beers, savor pairings with traditional products from the mountains of Palencia and enjoy excellent live music... surrounded of a nature landscape? It is not surprising that attendees come from all over to enjoy this fair and its natural character in a wild and characterful environment.
Approach: Our challenge was to find the balance between nature and tradition, imagination and solidity, craftsmanship and character... with the bear and beer as the absolute protagonists. We worked to mix all this in a simple, solid and attractive logo.
Results: The logo design has worked very well, and our client is really satisfied. All fair attendees love the t-shirts and other merchandising where the logo is the main element.

82 BIRCHDEN VINEYARDS LOGO | Design Firm: Idle Hands | Designer: André de Waal
Client: Birchden Vineyards | Main Contributor: André de Waal
Assignment: Logo for Birchden Vineyards.
Approach: The logo incorporates several elements that hold special meaning for the owners. The European finch, native to their area, is prominently featured. The key symbolizes new beginnings, with its silhouette revealing their farmhouse and a rising sun within the lock area. Additionally, the four circles represent the four partners of the wine farm.

82 ORYX OUTDOOR CLOTHING | Design Firm: Mischievous Wolf | Designer: Phil Marshall
Client: OpSec | Account Management: Dawn Wilson | Main Contributor: Phil Marshall
Assignment: The project goals for ORYX, an extreme outdoors clothing brand under the umbrella of OpSec, are multifaceted. Firstly, the aim is to cultivate a deep sense of belonging within the explorer and climbing community. Secondly, ORYX aims to carve out a distinct niche within the market. By fostering a supportive, authentic relationship with its community, ORYX seeks to become an integral part of their journey.
Approach: The process began with extensive research into the target audience's preferences, desires, and aspirations, leading to the identification of two distinct layers within the explorer community. Layer one encompassed enthusiasts drawn to mountain ranges like the Tian Shan, The Andes, and The Alps, while layer two comprised those seeking even greater challenges such as the Himalayas and The Karakoram. The logo design incorporated elements symbolic for each. The outer triangle was crafted to resemble K2 with jagged peaks reminiscent of The Alps forming its snow cap. Within this framework, an upward inner arrow was integrated. The brand name served as the basecamp, anchoring the brand's unwavering support for every explorer

83 EAT DRINK SLEEP RUN / HEART LOGO | Design Firm: Daichi Takizawa
Designer: Daichi Takizawa | Client: Runtrip, Inc. | Art Director: Daichi Takizawa
Main Contributor: Daichi Takizawa
Assignment: Runtrip, Inc. is a comprehensive service company that makes running enjoyable by allowing runners to post their running routes, track their times, and share running information. One of their best-selling items is a T-shirt that says, "EAT DRINK SLEEP RUN." For this project, I was responsible for designing the logo for a charity version of this T-shirt.
Approach: For runners, "eating, drinking, sleeping, and running" form the baseline of happiness. However, children from impoverished backgrounds cannot enjoy this "baseline of happiness." Therefore, a project was started to donate a portion of the T-shirt sales to organizations supporting children in poverty. I expressed various forms of happiness and love starting from running with a multifaceted heart.
Results: The T-shirts sold well, and a limited edition was also released.

83 TWO OLIVES & A TWIST LOGO | Design Firm: Arcana Academy
Designer: Daniel Pettit | Clients: Two Olives & A Twist, Clark Germain
Executive Creative Directors: Lee Walters, Shane Hutton | Account Executive: Mia Germain
Main Contributor: Daniel Pettit
Assignment: Client approached Arcana Academy to create a logo that incorporates the company name, Two Olives & a Twist, and evokes their industry, Music. The goal was to create a logo that quickly and succinctly communicated their brand without additional context.
Approach: The team experimented with various designs, aiming for an elegant and meaningful integration. The successful concept featured a musical note with an olive forming the base and a lemon twist as the top, achieving a harmonious and distinctive collaboration between the client's affection for martinis and business of music production.
Results: Client positively received all renditions presented in the first round, narrowing in on one design, requesting alternates, and ultimately settling on the original rendition. The logo is now in use across the clients' properties and well received by their own target custmers.

83 NEPHI WESTERN FEDERAL CREDIT UNION LOGO | Design Firm: Tielemans Design
Designer: Anton Tielemans | Client: Nephi Western Federal Credit Union
Main Contributor: Anton Tielemans
Assignment: To create a memorable identity for the Nephi Western Federal Credit Union, which has never effectively established any type of cohesive image in its community.
Approach: With established competing banks in the community and their well known brands, it was deemed necessary to establish a memorable identity for this community Credit Union. A bold and striking symbol that communicates strength and confidence in the form of the letter "N" is the prominent shape. Forward leaning, forward thinking, modern services all combine in the icon with the top left corner completing the shape suggesting the letter "W".
Results: The logo is unique in its presentation that combines two letters in one and is easily adaptable in all applications including stationery and signage, digital usage and clothing.

84 NEW YORK PAVEMENTS | Design Firm: Reggie London | Designer: Paul Brooking
Client: New York Pavements | Chief Creative Director: Paul Brooking
Photographer: Paul Brooking | Account Director: Jeremy Duncan
Main Contributor: Reggie London

Assignment: New York Pavements are a band with a long name. They needed a symbol that was simple, distinct and could represent the artist in situations without the full wording. In keeping with the style of the band it needed to be sophisticated and uniquely identifiable.
Approach: The solution of kerning the initials 'NYP' into a simple, elegant logotype was chosen as a strong, memorable icon becoming a device which worked well from a small digital file in social posts to carrier bags and labels on vinyl records.
Results: The logo was used online and in print and became an iconic identity for the band.

84 REBEL CHEF LOGO DESIGN | Design Firm: LERMA/ | Designer: Andrew Hensley
Client: Rebel Dreads Corp, LLC. | Advertising Agency: LERMA/ | Art Director: Andrew Hensley
Executive Creative Director: Brian Linder | Copywriter: Brooke Betik
Senior Account Director: Jennifer Estorga | Main Contributor: LERMA/
Assignment: This logo redesign was part of a larger brand revamp for Rebel Chef that. The goal was to develop a logo that made the product stand out on the shelf – the competitors in the CBD wellness category have developed a see of sameness that all feels very ignorable.
Approach: We knew two things needed to come through visually: Rebellion and gastronomy. Chef is passionate about the intersection of the culinary world and the growing CBD wellness industry, so we landed on a visual marriage of the two. We arranged knives into the shape of a marijuana leaf, keeping the design sleek in appearance but substantial in meaning.
Results: There has been substantial positive feedback in response to the new logo. After the adoption of the logo on all branded assets, we saw a 393.6% increase in sales.

84 AEROSPIKE LOGO | Design Firm: Traina | Designer: Joe Ross
Client: Aerospike | Graphic Designer: Joe Baglow | Chief Creative Director: Mark Gallo
Account Director: Jeselyn Andrews | Main Contributor: Joe Ross
Assignment: Aerospike's business was at an inflection point. Their previous brand and way of speaking about the company didn't reflect their growth and maturation. They came to Traina seeking a new brand position and identity to differentiate them from competitors—and signal to the market that Aerospike had redefined what the category could expect from a database.
Approach: Aerospike's new logo mark features dynamic line continuation to form an iconic rocket shape, thematically tying back to the brand's name. The angular shape of the rocket complements the brand's initial letter A, while the overall aesthetic geometry of the mark references the database's technical industry. The bold word mark anchors nicely across the baseline of the rocket's fins, and the triangular after burn juts out to perfectly align with the descender of the 'p'. Finally, the "deep space blue" hue is a nice contrast to the bright "sun yellow," which deliver an aspirational, uplifting aesthetic in sync with the brand's values and goals.
Results: The new brand was just launched publicly, but its initial introduction at Aerospike's annual Sales Kickoff Meeting was nothing short of triumphant. Everyone was excited by the potential of the new brand to amplify their sales efforts.

84 FLAMING6 LOGOMARK | Design Firm: Mermaid, Inc. | Designer: Sharon Lloyd McLaughlin
Client: Flaming6 | Web Developer: Bart McLaughlin | Main Contributor: Sharon Lloyd McLaughlin
Assignment: Flaming6 is a new AA group based in NYC. We aimed to support this group by creating a distinctive name and branding for them. The challenge was to develop a name and logo that would resonate with its members, embodying the transformative journey of recovery.
Approach: We based our creative strategy on the metaphor of the phoenix rising from the ashes. This concept led to the name "Flaming6," reflecting not only the transformative spirit of the group but also the time of their meetings: 6:00 PM. The logo design featured a dramatic flame with the numeral '6' integrated seamlessly, its top tapering into a point that mirrored the flame's shape, symbolizing the ignition of a new, empowered life through recovery.
Results: The Flaming6 AA Group loved it, feeling that it perfectly captured them. It created a sense of belonging and identity among its members. Most importantly, it made them smile.

84 MADISON NIGHTMARES IDENTITY | Design Firm: Planet Propaganda
Designer: Laura Gang | Client: Madison Nightmares | Executive Creative Director: Dana Lytle
Main Contributor: Laura Gang
Assignment: Planet Propaganda was tapped to create an identity for the first-ever professional women's softball team in Madison, WI. The client wanted something that felt more elevated than traditional sports logos while still having the flexibility to evoke fun and whimsy.
Approach: Derived from Madison lore about a spirit horse that would appear near where the softball stadium sits today, Night Mares is a concept elegantly delivering on the client ask. Rooted in Madison, the name has a playful double meaning, delivering a fun attitude and competitive edge. The logomark features a horse whose mane meets the moon to create a softball. Five feathers serve as a reminder of the five lakes that comprise its home turf.
Results: The new logo and name debuted with a well-attended launch event at the Orpheum Theatre. Drawing fans from near and far, the launch event created a positive buzz surrounding the new team's name and look. With the first season officially getting underway, the Night Mares have already sold out of merchandise, well before the first pitch is even thrown.

85 CL!KS DIGITAL IDENTITY | Design Firm: Studio Hinrichs
Designers: Kit Hinrichs, Taylor Wega | Client: CL!KS Digital
Project Manager: June Lin Umfress | Main Contributor: Kit Hinrichs
Assignment: The assignment was to create an identity for an influencer marketing agency that projects boldness, creativity, and inclusivity. The identity package should include a logo, distinctive color palette, and typographic system.
Approach: The logo leverages the power of the exclamation point to mark the collaboration between CL (Cat Lincoln) and KS (Kristy Sammis). The exclamation point takes the space of the omitted "i," which only appears when speaking CL!KS ("clicks") Digital's name aloud.
Results: The client loved both the impact of the exclamation point and the typographic system that was recommended to them.

85 OCTOPUS GARDEN PRESCHOOL TRADEMARK | Design Firm: *Trace Element
Designer: Jeff Barfoot | Client: Octopus Garden Preschool | Creative Director: Jeff Barfoot
Chief Creative Officer: Jeff Barfoot | Illustrators: Octopus Garden Preschoolers
Account Director: Lindsey Phaup | Main Contributor: Jeff Barfoot
Assignment: The Octopus Garden preschool, Montessoriesque in nature, asked for a new logo that encapsulated the hands-on approach they take to learning and the warm vibe of the school.
Approach: That simple input inspired us to create a simple and charming solution that interpreted the "hands-on" bit quite literally. We took a child's handprint, turned it upside down, and added a little happy face to create an octopus. We enlisted the preschoolers themselves to help by having them make handprintss. We combined several of them to create the final logo.
Results: The logo was an instant hit. As soon as we showed it in the initial concept presentation, we heard gasps and "awww"s – everyone in the room knew that it was "the one."

85 MAZE LOGO | Design Firm: Johann Terrettaz
Designer: Johann Terrettaz | Client: MAZE | Main Contributor: Johann Terrettaz
Assignment: Logo for a creator and organizer of Art Fairs
Approach: Original typography.
Results: Create a logo that expresses the playful side of the mazes of the Art Salons.

85 SHAKIRA PASTRY LOGO | Design Firm: MiresBall
Designer: David Alderman | Client: Shakira Pastry
Creative Director: John Ball | Main Contributors: John Ball, David Alderman
Assignment: Shakira Pastry is a beloved Middle-Eastern bakery based in San Diego, California, that wanted to expand–both to a bigger physical location as well as by reaching a wider audience with online sales. They needed an identity that reflected the high quality of their sweet confections, while retaining the traditional feel of a family-run shop.
Approach: The identity is anchored by an "S" that suggests the thin sheets of phyllo dough used to create Shakira's baklava. Typography and color combine to add richness, warmth, and flavor.
Results: "We're thrilled with the outcome. Their team captured our essence, transforming it into a visual identity that speaks to our customers. The new design not only reflects our work and quality but also sets us apart in the competitive food market. It was great to work with a team that was on board with our vision, blending our ideas with their expertise." – Ronnie Sleman, Operations Manager, Shakira Pastry

85 SEXELS | Design Firm: Shadia Design | Designer: Shadia Ohanessian
Client: SEXELS | Main Contributor: Shadia Ohanessian
Assignment: SEXELS are a rock band that are heavy on the ROCK side! They needed a logo to reflect their sound and themselves.
Approach: I created a typographic solution with the 'X' acting as the axe/guitar.
Results: The band love their new logo/image and all promotions for their up coming gigs. The support and positive response has been fantastic.

86 RAFFLES BOSTON'S SIGNATURE RESTAURANT, AMAR: MENUS
Design Firm: Toolbox Design | Designer: Alice Zeng | Client: Raffles Hotels and Resorts
Creative Director: Niko Potton | Account Manager: Christina Hamdon
Assignment: Raffles Hotels and Resorts, one of the world's most legendary hotel brands, opened its first North American property in Boston, MA. In each location, Raffles tells a story of place, history, and global significance, and nowhere are these experiences more exquisitely defined than through signature food and beverage offerings. Toolbox was entrusted with creating the hotel's signature restaurant's brand identity and development.
Approach: Toolbox travelled to Boston to meet with chef George Mendes and the Raffles hotel team and collect the intel needed to build the brand strategy. Back in Vancouver, the Toolbox team distilled the findings into categories and defined strategy, language, naming, tone, manner, and design ideation to push the project into exciting, unoccupied space. After many discussions with the Boston team, a name and concept were chosen: Amar, Modern Portuguese, a brand of fiery ardor and salty seas. Menu and collateral design were crafted and once the brand was approved, the core elements were refined and produced in a final format. When all design items were approved, print production began. Materials including wrapped linen with custom copper foil stamping and branded graphic prints were coordinated and managed through Toolbox's Vancouver studio with local Boston specialist production partners.
Results: In its inaugural year, Amar captivated the Boston and global culinary scene, earning accolades such as month-long reservation waitlists and prestigious rankings among Time Out's Best Boston Restaurants. It took the first spot on Condé Nast's list of best Boston restaurants, with the heading "The kind of obsessive attention to detail that a Raffles hotel demands".

87 SONGHUA RIVER RICE | Design Firm: 33 and Branding
Designer: Xiaowei Zhang | Client: Suyuan Food Group | Associate Creative Director: Jing Xu
Chief Creative Officer: Xiaowei Zhang | Main Contributor: Xiaowei Zhang
Assignment: Songhua River Rice is a high-end rice product from Suyuan Food Group. With the Chinese Spring Festival approaching, we designed a beautifully packaged rice product as gifts to customers. The overall design needs to echo the festive atmosphere of the Spring Festival while highlighting traditional cultural elements and auspicious good meaning.
Approach: "Koi" in Chinese tradition has the meaning of more than one year, good luck. We take "Koi" as the main shape and extract the elements of water, light and earth into it, and redesign the traditional cultural language to form a visual language. At the same time, the main visual color is extracted, which is perfectly combined with the pattern to achieve the purpose of complementing the overall visual effect. We use pearlescent paper to better highlight the smoothness and texture, and use laser cutting technology so that the fish scale slightly turned up, making the whole package more three-dimensional beautiful.
Results: This eye-catching unique packaging combines creativity, aesthetics, and beautiful symbolism, leaving a deep impression on customers, enhancing their liking for the brand, and helping the brand complete a successful marketing campaign.

88 WAIKULU DISTILLERY OHANA RESERVE
Design Firm: CF Napa Brand Design | Designer: CF Napa Brand Design
Client: Waikulu Distillery | Main Contributor: CF Napa Brand Design
Assignment: Design the packaging for Waikulu Distillery's new spirit, Ohana Reserve.
Approach: The design needed to continue the Hawaiian sensibility and traditional tequila inspiration of the original packaging while communicating the elevated quality of the new offering.
Results: We utilized a custom bottle design with a variable pebble texture, reminiscent of the specialty bottles used by luxury tequila producers. The teal gradient transports the imbiber to the tropical waters of Maui and was complemented by a metallic blue foil stamping for the icon. The black label gave a gravitas to the package, creating clear differentiation from the core spirit's cream label and a cue to the super premium quality of Ohana Reserve.

89 DILMAH ELIXIR OF CEYLON TEA | Design Firm: Pavement | Designer: Michael Hester
Client: Dilmah Ceylon Tea Company | Main Contributor: Michael Hester
Assignment: Dilmah Elixir of Ceylon Tea is made from only natural tea extracts produced from 100% pure Ceylon tea. Since its founding, Dilmah has always championed quality and ethics in tea production, and pioneered the concept of single-origin teas. With this dedication in mind, the Elixir of Ceylon Tea were redesigned to better attract tea enthusiasts and mixologists. A custom flask-style bottle was crafted featuring a lion, a cherished symbol of both Sri Lanka and Ceylon tea, within a tea garden. The finalized look spoke to the product's authenticity and origin, while better positioning the product to captivate bartenders worldwide.
Approach: Create a bottle design intended to attract mixologists from around the globe.
Results: This was a successful product launch for the client.

90 PIRES & TURNER | Design Firm: Studio Eduardo Aires
Designers: Miguel Almeida, Joana Teixeira | Client: Pires and Turner Wines
Creative Director: Eduardo Aires | Art Director: Eduardo Aires
Photographer: Óscar Almeida | Main Contributor: Eduardo Aires
Assignment: Pires & Turner Escolha is a Vinho Verde wine at the heart of the Douro valley in Portugal. Owners Becky Turner and João Pires wanted a fresh take on wine label design.
Approach: In the predominantly granite soil of Quinta de Alvites, the Avesso grape variety evolves to reveal a particular freshness and minerality. Quinta de Alvites vineyards inspired the Pires & Turner Escolha label. In the label design, the profile of the land is articulated with the name of the wine, combining the surnames of its founders. The simplified geometry of the

terraces embraces a "metric hyphenation" of the Pires & Turner, enhancing a contemporary attitude towards this iconic feature of Douro vineyards.
Results: The striking outline of the label, the typographical composition and the subtlety of the embossed text appear distinctive in the region's wine label landscape.

91 PICCOLA NOCE | Design Firm: CF Napa Brand Design
Designer: CF Napa Brand Design | Client: Vinoce Vineyards
Main Contributor: CF Napa Brand Design
Assignment: Develop a new line of approachable wines for Vinoce Vineyards.
Approach: The brand was called Piccola Noce, Italian for "little nut"—a nod to their winery name, Vinoce —a portmanteau meaning "wine nut".
Results: CF Napa drew a stylized walnut as the main graphic of the label. The script was inspired by the Vinoce wordmark, but with additional flourishes and flairs to capture the brand's laid-back, modern Italian bistro vibe. The contrast of the toothy white paper and the brightly colored graphics gave the front label a clean, pop-art feel; keeping with the artistic, boutique sensibility that Vinoce Vineyards is known for.

92 SUNSHINE PUNCH | Design Firm: Sandstrom Partners
Designer: Trevor Thrap | Client: B.A.R. Brands | Project Manager: Kelly Bohls
Main Contributor: Sandstrom Partners
Assignment: Branding and packaging for a first of its kind, new-to-market orange creme cocktail. Both beverage and package won top prize at the Wine and Spirits Wholesalers Association competition and is now expanding distribution to retail shelves across multiple states.
Approach: The custom glass bottle has an orange peel textured surface and a vivid orange tint. Inspired by poolside and beach party drinking, it's a bottle of delicious fun even if the weather doesn't always cooperate. The orange, cream and blue color palette create a sunny moment, despite the typically poor lighting at most spirits retailers.

93 SHAN XI
Design Firm: Shenzhen Excel Brand Design Consultant Co., Ltd. | Designer: Kuanfu Wu
Client: SHAN XI | Main Contributor: Shenzhen Excel Brand Design Consultant Co., Ltd.
Assignment: The wine label adopts the shape of traditional Chinese ceremonial flowers, symbolizing respect and traditional values. Through careful design, it showcases its magnificent charm in simple lines. This design reflects the Shanxi brand's love for nature and respect for traditional culture. At the same time, the shape of the wine label is also the same as that of a clear bottle, reflecting the brand's commitment to environmental protection.

94 STAGS LEAP DISTRICT WINEGROWERS | Design Firm: CF Napa Brand Design
Designer: CF Napa Brand Design | Client: Stags Leap District Winegrowers
Main Contributor: CF Napa Brand Design
Assignment: Stags Leap District Winegrowers came to CF Napa with a unique proposition – to create the packaging design for 1 wine that unites all the wineries in Stags Leap District.
Approach: Each of the 16 wineries of the world-famous Stags Leap District contributed 2021 Cabernet Sauvignon from their most prestigious lots to create one ultra-premium blend that unites and forges the paramount representation of the AVA.
Results: CF Napa was inspired by the symbol of the Stags Leap District and drew the antlers of a 16-point buck – 1 point representing each of the wineries. The antlers were delicately embossed to create texture for every detail of the illustration. The names of the wineries were listed along the bottom of the label.

95 CHRONICLE SERIES: COGNAC & RUM | Design Firm: Omdesign
Designer: Diogo Gama Rocha | Client: The Auld Alliance | Main Contributor: Omdesign
Assignment: Omdesign was invited to create and produce the luxurious and timeless packaging for The Auld Alliance's Chronicle Series, led by Emmanuel Dron. The starting point was to transform the consumer experience into a luxurious ritual during an aspirational moment. This series introduces different spirits, with the initial releases being a Rum and a Cognac. Chronicle serves as a symbol for the moment of spirits' reverence, crafted exclusively for The Auld Alliance, an acclaimed company recognized for its quality offerings and limited editions.
Approach: This series is contained in 3-liter "demijohn" bottles which aims to transport discerning drinkers to Paradise through a unique "à la pipette" experience. The Cognac bottle makes a striking impact. The front incorporates various techniques to highlight the exclusive nature of this edition. The high-quality walnut wood case features custom decoration on the front, varying based on the specific barrel each bottle carries. The brand's symbol is drawn in low relief on top, and the packaging is adorned with silver pieces. Inside, a hidden compartment lined tells the project's story and protects the exclusive pipette. The Rum decanter also commands attention with its high structure. Screen printing decorates the front, and a silver medal enhances the bottle's magnificent image. The fully adorned bottle neck and powerful bartop feature a pattern reflecting the brand's identity. The walnut wood packaging opens like a temple and is covered in black leather with the "A" printed in silver screen printing. The numbering and project's designation are engraved on the outside, and The Auld Alliance's symbol is featured in an extruded silver piece. Similar to the Cognac case, the pipette niche is concealed on the back for safe transport and protection.
Results: Both editions double as displays, with designated places for various elements to assist during the serving moment. The Chronicle Series concept was conceived to enhance the luxurious experience for the consumer. Numerous design elements were meticulously crafted to facilitate the serving moment when using The Auld Alliance's exclusive pipette.

96 PANTALONES TEQUILA ORGANICO | Design Firm: Sandstrom Partners
Designer: Steve Sandstrom | Client: Pantalones Tequila | Project Manager: Robin Olson
Main Contributor: Sandstrom Partners
Assignment: Branding and packaging for an organic tequila developed for and inspired by Matthew McConaughey and his wife Camila Alves. Matthew named it Pantalones, which in Spanish means pants, but also is used colloquially as "guts." The two wanted to avoid the often serious approach to tequila and to have the most "fun with your pants on."
Approach: The front label features the finely tooled art of western style leather goods and also reflects the patches on the back of denim jeans. The custom bottle has a concave back that's comfortable in hand as well as easy to fit in a saddle bag. It is offered in Blanco, Reposado and Añejo versions and labeled accordingly.
Results: The brand has just launched and is being supported by the McConaugheys in a number of lighthearted videos and promotions.

97 REVIVALIST GARDEN GIN | Design Firm: Sandstrom Partners
Designers: Trevor Thrap, Steve Sandstrom | Client: Botanery Barn Distillery
Project Manager: Robin Olson | Main Contributor: Sandstrom Partners
Assignment: Brand design and packaging for an American gin that is made using botanicals grown by the distillers and from other sources around the world. The distillery is located in an old dairy barn in rural Pennsylvania, on acreage suitable for growing some of the herbs and ingredients used in making the gin. The assignment also included designing an identity for the distillery, and developing a vision for their tasting room and bistro.

Approach: The bottle is tinted matte green with a screen-printed front label and a kraft paper back label. The closure is custom made to look, feel and weigh like a garden hose bib, with an antiqued brass finish. The closure is a threaded screw top rather than a cork so one has to turn the faucet to open the bottle.
Results: Although the cost to produce the package was a serious financial commitment for the client, their board and investors, all agreed it was an outstanding solution for such a competitive category. The package won "Best of Show" from the American Craft Spirits Association.

98 THE REVEREND SOUR MASH WHISKEY | Design Firm: Sandstrom Partners
Designer: Steve Sandstrom | Client: Call Family Distillers | Illustrator: Steven Noble
Project Manager: Kelly Bohls | Main Contributor: Sandstrom Partners
Assignment: Brand design and packaging for an American sour mash whiskey produced by descendents of Reverend Daniel Call, a Tennessee preacher, farmer, grocer, and distiller in the mid 1800s. He took in an orphan named Jasper "Jack" Daniel as a young boy, and years later introduced him to the business of making whiskey. The two became partners in a distillery in Lynchburg, until Reverend Dan chose to honor his congregation when they sided with the Temperance movement and sold his interests in the business to Jack. The Reverend's descendants however, continued to distill for decades after. The Call family has released this sour mash whiskey using the original methods as a tribute to American whiskey heritage.
Approach: The front label features the Reverend's story and is written in the style of a St. James bible. The page and typography also reference an old bible in layout. The edges of the label are gold foil stamped as a nod to the gold-tipped pages of vintage bibles.
Results: Recently launched in January 2024, the distribution was limited to only a few states, but success is creating opportunities for broader distribution.

99 AQUATICA | Design Firm: CF Napa Brand Design | Designer: CF Napa Brand Design
Client: Aquatica Distilling | Main Contributor: CF Napa Brand Design
Assignment: Aquatica Distilling came to CF Napa to develop the name, packaging, logo, and custom bottle for their premium craft American Gin inspired by California and the Pacific Ocean's influence on agriculture. Distilled and bottled in Northern California, the Gin had notes of fresh lemon, orange, and just a touch of brininess.
Approach: The name Aquatica was developed by CF Napa to connote water, evoking the magic of the Pacific Coast.
Results: For the custom bottle, CF Napa created a shape that was unique in the gin category, and the distinctive light aqua-blue hue of the bottle further supported the name and story. The back of the bottle was embellished with a custom deboss of California Pacific Coast ocean floor topography. When viewed through the front of the bottle, the refraction of light gives depth to the multi-level deboss. The custom closure was a replica of a boat tie-off, complete with knotted rope. The wordmark, icon, and linear topographic map lines added to the nautical, ocean-inspired theme of the package.

100 HOTEL TANGO PRIDE 2023 | Design Firm: Young & Laramore
Designers: Derek Hulsey, Baker Wright | Client: Hotel Tango Distillery
Executive Creative Director: Bryan Judkins | Creative Director: Scott King
Senior Art Director: Derek Hulsey | Senior Designer: Allison Tylek
Account Director: Dave Theibert | Senior Account Executive: Sam Hanes
Artist: Jun Ioneda | Main Contributor: Jun Ioneda
Assignment: Hotel Tango welcomes all. And that spirit is exemplified in their support of the LGBTQIA+ community. Every year, they celebrate Pride Month by releasing a special, limited-edition bottle design for their craft Vodka. For every bottle sold, they donate $1 to the Modern Military Associate of America, the nation's largest organization of LGBTQIA+ service members, military spouses, veterans, their families, and allies. This year, Y&L collaborated with Brazilian artist Jun Ioneda to create a design that captures the idea of "Fervo é Luta," a saying in Brazil among the LGBTQIA+ community that loosely translates to "To party is to fight/resist"—a reminder to be strong and serious about the struggle, but also to enjoy life at its best. The result is a joyous spirit in every sense of the word—one that lives on the bottle and beyond.

100 CHRONICLE WHISKY | Design Firm: Omdesign | Designer: Diogo Gama Rocha
Client: The Auld Alliance | Main Contributor: Omdesign
Assignment: Omdesign went to the origins of Scotch Whisky to give life to Chronicle. The starting point was motivated by the exclusivity of a single cask that carries the spirit of a unique beverage born from the adversity of time and extreme conditions faced during its several decades of aging. The careful creation of this project represents and honors its heritage. This edition is an ode to the time-lapse through historical and remarkable spirits, as well as the origins of Whisky itself. Omdesign developed the whole concept around the idea of preserving and carrying the history of aging and maturing this nectar. Chronicle is also a symbol of the unique moment of spirits' worship, created for The Auld Alliance.
Approach: Chronicle was developed in three distinct parts. The interior of the exclusive decanter gains the shape of the auld ("old", in ancient Scottish) cask, and is crafted from the wooden stripes and staves that make up a whisky cask. This design allows for a 360° view of the intricately molded interior, introducing new levels of detail and dynamism. The bottleneck, with a see-through effect on the cork stopper glass ring, is inspired by the oldest bottle of Whiskey, dating back to the 18th-19th century. The distinct internal shape were crafted to capture the essence of this remarkable project. To enhance its innovation further, this special edition is enriched with striking reflections, textures, and contrasts, thanks to the incorporation of silver components, the Scottish tweed fabric, and the glass elements. To pay homage to the terroir, Omdesign resorted to noble fine papers and challenging printing techniques. At its base, there are supports that carry the pipette and its pump during shipping, but also the bartop support. The transport case was conceived to serve as both a protective case but also an ornament. Covered in black leather on the outside and in tweed fabric on the inside, the exquisite exterior case is locked by a brown leather belt. It evokes the elegance of editions that hold jewelry and works of art, with its Alcantara base enhancing the uniqueness of this whisky.
Results: The Chronicle Whisky concept was conceived with a focus on elevating the luxurious experience for the consumer. Numerous design elements were meticulously crafted to elevate the tasting moment and the serving ritual. These include the remarkable pipette and its pump, the support for the pipette and bartop, as well as the functionality of the display, which opens to facilitate whisky service using The Auld Alliance's exclusive pipette.

101 LAGG SINGLE MALT RANGE | Design Firm: Stranger & Stranger
Designer: Stranger & Stranger | Client: Isle of Arran Distillers Ltd.
Main Contributor: Stranger & Stranger
Assignment: A new distillery offering smokey, peated Scotch from the Isle of Arran.
Approach: There are a few peated whiskeys out there already but non seemed singleminded, so we thought there was an opportunity for our client to be able to visually own peat. We used peat as print blocks, we painted with it, we even made fonts using it. Peat is black so a monochrome palette seemed appropriate and the custom bottle features an outline of the island topography.
Results: The pack stands out from the sea of competition and leaps off the shelf from 20 feet away so, not surprisingly, it's been a big hit.

102 KAMORA REDESIGN | Design Firm: Cue | Designer: Matt Erickson
Client: Phillips Distilling Co. | Creative Director: Alan Colvin | Main Contributor: Cue
Assignment: Kamora crafts a rich coffee liqueur to honor ancient Mayan tradition. Made with authentic Mexican coffee, the product had a loyal following, but lacked energy and a strong presence on shelf. We were tasked with invigorating the brand to challenge category convention and reposition it with younger consumers to compete with its main competitor, Kahlúa.
Approach: The new high-energy solution codifies Kamora's historical visual brand elements, including Mayan step pyramid iconography, vibrant red and rich coffee tones, gold patterning that draws inspiration from the sun, and a strong wordmark. An expanded portfolio architecture was developed to support growth with innovative new products and recipes.
Results: The updated system elevates brand equities, respectfully and authentically. A modern expression created to expand the brand's appeal to new audiences. Interest in Kamora's offerings has increased, especially with its new innovation expressions.

103 ROSHAMBO WINE LABEL | Design Firm: Michael Schwab Studio
Designer: Michael Schwab | Client: Share a Splash Wine Co.
Main Contributor: Michael Schwab
Assignment: Evoke an alluring, timeless image that beckons the curious wine shopper.
Approach: We created a vintage tone that looked as if it could have been printed on old paper from 'who knows how long ago'. The name along with the illustrations has a bit of 'sense of humor' - and we wanted to invoke the attitude of that silly, mysterious kids game, ROSHAMBO.
Results: The client is very happy, excited and proud of the design.

104 LEROUX REDESIGN | Design Firm: Cue | Designer: Matt Erickson
Client: Phillips Distilling Co. | Creative Director: Alan Colvin | Main Contributor: Cue
Assignment: Leroux is a storied brand with more than a century of history. Over the years, the brand became fragmented, losing its presence and credibility on shelf. Our charge was to strengthen Leroux's brand expression and reputation for innovative products.
Approach: This new brand expression honors equity of the past while adding credibility to the portfolio. The new Identity adds refinement with filigree and brand iconography, and the packaging system features illustrative flavor cues to elevate its repertoire of home bar options. Much of the brand's equity is rooted in the its Jezynowka Polish Blackberry Brandy, featuring a jolly Polish character, and accompanied by language touting its heritage: "Made specially to the Polish taste." We elevated the Polish character's role as spokesperson for the brand, named him "Jez," and gave him a unique personality.
Results: The identity system was developed to accommodate a wide range of brand expressions, on premise and off, on primary and secondary packaging, in social media and other applications. With new tools to activate, the brand is able to more fully engage consumers.

105 KINGSMARK WINE LABEL | Design Firm: Vanderbyl Design
Designers: Michael Vanderbyl, Tori Koch | Client: Kingsmark Wine
Creative Director: Michael Vanderbyl | Main Contributor: Michael Vanderbyl
Assignment: Kingsmark is crafted in accordance with the highest standards of Kosher wine. The first Kosher wine from renowned winemakers Philippe Melka and Maayan Koschitzky of Atelier Melka. Kingsmark is five generations of family vision brought to fruition.

106 THE LIBRARY COLLECTION | Design Firm: Omdesign
Designer: Diogo Gama Rocha | Client: Kopke | Main Contributor: Omdesign
Assignment: Kopke, the oldest Port wine house, has launched "The Library Collection," which aims to honor and celebrate the journey by this renowned producer since 1638. Omdesign developed the concept, design and entire production of this special collection. Composed by three differentiating nectars united by Port wine – a Very Very Old Tawny, a Vermouth and a Quinine, made at the beginning of the 20th century –, this combination stands out for its uniqueness and unparalleled character.
Approach: The project was conceived with the purpose of elevating the brand's assets and going further in the art of creating unique combinations. Inspired by Kopke's exclusivity, values and identity, Omdesign recreated iconic elements, resulting in an original, aspirational and unique work. With a book concept and using noble materials and distinct finishes, every detail of "The Library Collection" invites connoisseurs to discover and absorb the full potential of the Douro and Kopke. From the book-shaped case to the fontain pen and the original inkwell, from the cover and spine to the striped wooden cradle, to the signed and numbered certificates that attest the authenticity of the wines and the booklet that presents them, every detail has been meticulously elaborated to ensure that the story continues to be written. Omdesign was also responsible for all communication materials, including photography and video, which illustrate the story, process and details of this unique edition. The Leça da Palmeira agency not only designed and produced the different media materials, but was also responsible for the development of the naming, concept, storytelling and narrative. This new milestone seeks to continue the path of the drop of ink that writes the future of this art.
Results: Omdesign delved into Kopke's extensive wine and book library to bring this project to life. We reinterpreted old labels and concentrated the prestige and character of almost four centuries of history in a timeless work.

107 STONESTREET BOURBON | Design Firm: Chad Michael Studio
Designer: Chad Makerson Michael | Clients: Stonestreet Whiskey, Jackson Family Wines
Photographer: Red Productions | Main Contributor: Chad Michael Studio
Assignment: To develop the a purebred brand and bespoke bottle designed for renowned winemakers Jackson Family Wines and proprietor Chris Jackson, which would mark the company's inaugural venture into the spirit category. A 5-year Kentucky Straight Bourbon, it draws inspiration from the Jackson family's extensive history in horse breeding and racing, spanning decades. Prominently emblazoned on the bottle's shoulder is the iconic "V" for victory emblem, a symbol that has adorned their jockeys' silks for generations. "A bourbon in the pursuit of victory."
Approach: To visually tell the story of the Jackson's family horse racing history and combine it with that of the world of Bourbon in a premium way. The package design, from bespoke glass to packaging, takes cues from the character of the two worlds while integrating their families iconic 'V' for victory mark and subtle cues from items like their mare barn, horseshoes, and the gold racing trophies that are peppered throughout the family's property.
Results: The presented client designed is reflected in the final product photography. A heroic bottle of strength and hardiness shouldered with the Jackson jockey 'V' for victory with a glass based mimicking that of a pedestal as if the bottle is a trophy in of itself.

108 GODAWAN - THE 100 SERIES | Design Firm: Butterfly Cannon
Designer: Butterfly Cannon | Client: Diageo India | Main Contributor: Butterfly Cannon
Assignment: Rajasthan's state bird, the Great Indian Bustard or 'Godawan', is critically endangered. Targeted at a new emerging class of affluent and conscious Indian consumers, the goal of the Godawan 100 Series was to create "A Rare Whisky To Save A Rare Species" which would raise the profile of the plight of the Godawan birds and raise funds for their conservation.
Approach: The Godawan 100 Series is an ultra-limited edition drop of 100 uniquely designed bottles of rare, Indian single malt whisky. Each bottle is a one-of-a-kind piece of art, metic-

ulously hand-etched with 100 unique illustrations of the last living Godawan birds. Layered, FSC-certified labels with recycled content evoke the exquisite craft of the birds' homeland of Rajasthan. The Godawan wordmark blooms from a foil blocked horizon line. A serene, sandstone colour palette with vibrant pops of colour captures the life and soul of Rajasthan. Hand-dipped wax caps bring artisanal luxury and act as a seal of quality and symbol of conservation. Finally, bespoke hand-crafted cases up-cycled from the distillery's old whisky casks emphasise the beauty & rarity of both the bird and the whisky.
Results: Sold through a high-profile auction, The 100 Series has raised the profile of the plight of the Godawan birds. Proceeds from the auction raised an additional ₹10 Million to go towards ongoing conservation efforts.

109 BELVEDERE 10 VODKA | Design Firm: Stranger & Stranger
Designer: Stranger & Stranger | Client: LVMH | Main Contributor: Stranger & Stranger
Assignment: Create a super luxe tier for the longstanding Belvedere vodka brand.
Approach: As most really expensive vodka is sold in clubs we really wanted this bottle to be a celebratory table piece. Its crystalline structure is ten levels tall, and the white glass reflects the spirit's purity and standout in a darkened environment. Its chiseled facets give a diamond-like sparkle – a nod to the precious organic Diamond Rye used to make the spirit.

110 PIN DROP RUM, AGED 10 YEARS | Design Firm: Sandstrom Partners
Designer: Steve Sandstrom | Client: Pin Drop Rum | Project Manager: Robin Olson
Illustrator: Howell Golson | Main Contributor: Sandstrom Partners
Assignment: Pin Drop is a distinct, award-winning blended rum distilled in The Bahamas and aged 10 years in former bourbon barrels. The colors of the brand relate to the colors of the Bahamian national flag. The goddess figure in the crest is actually a portrait of one of the partners in the company. The package has received local appreciation in the country as it visually relates to the history, culture and pride of the islands.
Approach: The custom bottle is made of black glass with ACL applied labels and a de-bossed seal on the back, and custom cork closure.
Results: The brand has been launched with expansion plans for the UK and USA.

111 ZI SHI QI XIN
Design Firm: Shenzhen Excel Brand Design Consultant Co., Ltd. | Designer: Kuanfu Wu
Client: ZI SHI QI XIN | Main Contributor: Shenzhen Excel Brand Design Consultant Co., Ltd.
Assignment: The design refines the features of ancient Chinese architecture. It aims to express respect for traditional culture and show the beauty of Chinese architecture.

112 CONFESSION® STRAIGHT BOURBON WHISKEY
Design Firm: Thoroughbred Spirits Group | Designer: Benjamin Carr
Client: Burnt Church Distillery | Production Artist: Jamie Berwick
Account Director: Kristin Shirtz | Main Contributor: Benjamin Carr
Assignment: Burnt Church Distillery entrusted us with developing CONFESSION® Chapter 1: Original Sin - the first in a series of Straight Bourbon Whiskeys.
Approach: The client expressed their desire to make their own Confession: "We didn't make this bourbon. While we never intended to bottle and sell bourbon we didn't craft, the need to slow the run on our aging inventory overruled our sense of moral authority in this space". We aimed to convey this transparency in a lighthearted manner, focusing on a bold ecclesiastic design with a non-traditional bottle shape and premium labeling.
Results: Sean Watterson, co-founder of Burnt Church Distillery, stated: "We are excited to introduce this whiskey to the world. The Thoroughbred design team did a great job of bringing our vision to life for this brand through premium finishing details and luxury look and feel. The process of bringing Confession to life was more fun than we anticipated so stay tuned for more chapters in this tell-all story where you can expect transparency and premium brown liquid."

113 IRLANDÉS TEQUILA BRANDING | Design Firm: Duffy & Partners
Designers: Joe Duffy, Joseph Duffy | Client: Irlandés Tequila | Main Contributor: Duffy & Partners
Assignment: Irlandés Tequila honors the brave soldiers of the Irish San Patricios Battalion who traveled to Mexico in 1847 to fight alongside Los Niños Héroes. Irlandés is the first tequila inspired by Ireland. It is symbolic of these two unlikely forces fighting to defend the flag of Mexico in the battle at Churubusco in 1847. This brand's promise is, The Spirit that Unites. The goal of this project is to make that promise come to life.
Approach: During the battle, Francis O'Connor was anointed by a Mexican priest with holy water that O'Connor had carried with him from a sacred well in his motherland. It is this water from that exact same source that Irlandés Tequila is made. The artistry of the brand's identity unites the Irish Claddagh ring with the rich, blue agave from the Los Altos region. The iconic three leaf clover instantaneously says, this tequila has Irish roots. The 50 red drops represent the blood shed from the 50 battalion soldiers. The colors of the Irish and Mexican flags, so closely related, serve as the perfect framework for our story.
Results: Irlandés was formally launched on St Patrick's Day, 2024. Currently the brand is in three markets: New York, California and Connecticut. A groundswell movement has begun. Those who hear the story and taste the liquid all want to unite with this spirit.

114 ROBERT'S NO. 1 AMERICAN DRY GIN | Design Firm: CF Napa Brand Design
Designer: CF Napa Brand Design | Client: Oak House Distillery
Main Contributor: CF Napa Brand Design
Assignment: Oak House Distillery came to CF Napa to create the design for their Robert's line of gins. In addition to classic styles of gin, Oak House planned to distill more inventive gins with an influence of traditionally Asian botanicals.
Approach: The packaging needed to match their more contemporary approach to gin. The first gin to launch was the No. 1 American Dry Gin – a new age gin with a floral-forward flavor profile. Drawing on the client's affinity for abstract illustrations and Asian design, CF Napa created a custom illustration for each gin.
Results: The artwork includes stylized representations of the lavender, lemongrass, and makrut lime notes that give the gin its flavor. Embossed and gold foil details bring a tactile element to the label and contribute to the futuristic sensibility of this contemporary gin.

115 MARY JANE | Design Firm: Next Brand | Designer: Michele Bush
Client: Monks Gin | Main Contributor: Next Brand
Assignment: To develop a range extension into one of the world's first hemp based gins.
Approach: The focus was to instil some subtle indicators as to the flavour profile (hemp). The hemp leaf and name (Mary Jane) along with the green colour way proved to be enough.
Results: A truly successful launch. Monks Mary Jane has broken into a number of countries where it continues to sell well.

116 GALLIVANTER GIN | Design Firm: Chad Michael Studio
Designer: Chad Makerson Michael | Client: Itinerant Spirits
Photographer: Red Productions | Main Contributor: Chad Michael Studio
Assignment: To develop and design a new Australian Gin from name, bespoke bottle, to package design that evoked wanderlust in a bottle in a simply but elegant way.

Approach: Gallivanter Gin embodies the spirit of adventure, tailored for intrepid travelers. Its' tagline, "The Horizon Awaits," perfectly encapsulates its essence. At the core of Gallivanter Gin lies the unique fusion of wild botanicals and volcanic spring waters, creating an unforgettable flavor reminiscent of an epic journey. The bespoke glass design of Gallivanter Gin is a reflection of the brand's free-from-restraint attitude and the free-spirited individuals who embrace the unknown. It's more than just gin; it's a companion for those who chase horizons and revel in the thrill of the journey.

Results: The brand release in Australia was a success! The first run, limited bottling, sold out at the event and the client is currently ramping up their production for Gallivanter.

117 VANSETTER VODKA | Design Firm: Chad Michael Studio
Designer: Chad Makerson Michael | Client: Itinerant Spirits
Main Contributor: Chad Michael Studio

Assignment: Develop a new Vodka brand for a new Australian distillery that included custom bottle, closure, and full package design. The brand needed to pays tribute to Itinerants Spirits' distillers and the historic railway grounds on which the distillery was built.

Approach: The strategy was to be fully inspired by both the industrial aesthetic of the distillery and also the historic 'Vansetter' which was a title given to those who unloaded baggage and did a brunt of the grueling work at railways. The design was to be incredible strong, blue collar yet refined, and calloused. The feeling of hard work need to come through in full force as it is both a reflection of the distillery but also the distiller's who make it.

Results: The results bore a quite unexpected brand and package design. The bespoke bottle was inspired by large rivets and threading found in the distillery paired with a overall shape inspired by a travel thermos. This alongside the "grain yellow" colored palette and use of woodcut illustration in the small badges present on label felt like it arrived at the right station.

118 THREEQUEL WINE | Design Firm: Vanderbyl Design
Designers: Michael Vanderbyl, Tori Koch | Client: Threequel
Main Contributor: Michael Vanderbyl

Assignment: Label for Threequel Wine.

Approach: To make the name memorable, a rebus was designed to act as the brand identifier.

118 LIKKLE MORE | Design Firm: THERE IS STUDIO | Designers: Sean Freeman, Eve Steben
Clients: Likkle More Chocolate, Nadine Burie | Creative Director: Eve Steben
Producer: Eve Steben | Typography Design: Sean Freeman | Copywriter: Eve Steben
Main Contributors: Sean Freeman, Eve Steben

Assignment: We were commissioned by Likkle More to design their packaging & oversee the brand's creative direction. The packaging had to feel luxurious, visually stand out, be cost effective, and accommodate its founder's relentless explorations of new aromatic pairings. The project involved designing a collection of illustrations oozing tropical vibes, as a tribute to Jamaica's natural beauty & vibrant culture - also communicating the brand ecological values.

Approach: The use of labels on black blank boxes links the design dots between maximising visual impact and lowering environmental impact, allowing flexibility with small batches on demand, and eliminating packaging waste. The materials were selected for a luxury yet sustainable feel. Using colourful botanical illustration & abstract fluid shapes, paired with gold foil & classic typography, the labels bring the product to life as exotic pieces of art.

Results: The small collection rapidly expanded to larger series of unique designs. Likkle More Chocolate has gained global attention in the luxury chocolate scene, being invited to join international craft chocolate events around the world. The colourful bars are gaining a cocoa cult following, sold in local Jamaican boutiques, luxury hotels, premium gift & fine food shops, and the national duty free - as well as around the Caribbean, North America & Europe.

119 DILWORTH COFFEE PACKAGING | Design Firm: The Republik
Designers: Matt Shapiro, Dylan West, Luke Rayson | Client: Dilworth Coffee
Creative Director: Robert Shaw West | Art Director: Matt Shapiro
Main Contributor: Robert Shaw West

Assignment: A coffee brand with more than 30 years of history, Dilworth Coffee roasts beans with a mission to provide the perfect cup of coffee. We created packaging that appealed to coffee shops and customers who like their coffee a certain way. Or not. If it feels right it is right.

Approach: The packaging reflects the travels of Dilworth to find the perfect cup.

120 PACKAGING MADE FROM BAGASSE | Design Firm: 33 and Branding
Designer: Xiaowei Zhang | Client: BIOHYALUX | Chief Creative Officer: Xiaowei Zhang
Associate Creative Director: Jing Xu | Main Contributor: Xiaowei Zhang

Assignment: Sugarcane is the largest sugar raw material in China, with an annual output of over 100 million tons. About 50% of the fiber of bagasse can be used for papermaking. Due to technology, site, cost and other reasons, a large number of bagasse were burned, resulting in waste of resources and environmental pollution.

Approach: BIOHYALUX recycles bagasse into product packaging. The bagasse is made into a round inner package by the technology of extraction and semi-automatic wet pressing, which makes it reasonable to place and convenient to carry. In addition to the high compatibility of product concepts and packaging materials, we extract [30] [60] from the product features of [30 days skin improvement process, 60 days food grade shelf life], and use digital structure to skillfully integrate the use stages of 1, 2, 3 into visual recognition. In the process of production, the problem of extracting impurities from bagasse and stamping the screen on the arc wall of the outer package was overcome and achieved success.

Results: In the double 11 pre-sale activity, the product won the favor of consumers with its environmental protection concept, further enhancing the goodwill of the brand.

121 PEPSI GLOBAL REDESIGN | Design Firm: PepsiCo | Designer: PepsiCo
Client: Self-initiated | Main Contributor: PepsiCo

Assignment: Pepsi is a brand in perpetual motion, and its 125-year history of meeting the moment meant it was time for its visual identity system to evolve once again. By embracing the same challenger mindset Pepsi is known for, we created a new look that connects our cola brand's storied heritage with our bold vision for what's to come.

Approach: Before taking on the first evolution of the Pepsi visual identity in 14 years, we had to first dive into the brand's legendary history. From there, we charted our course toward a fresh look and feel and began to thoughtfully test and transform the Pepsi type, palette, and logomark. We also sought to unlock more flexibility for Pepsi to move between physical and digital spaces. Timely and timeless, the new Pepsi logo and visual identity system are more than a refresh. We introduced an electric blue and the black of Pepsi Zero Sugar to our cola's classic colors alongside a modern, custom typeface that reflects the brand's confidence.

Results: The revitalized and distinct design introduces movement and animation into the visual system with a new signature blue and black "pulse." The wordmark and globe combine to take on every touchpoint, from packaging to equipment to fashion. Grounded in our ambition to create more moments of unapologetic enjoyment, the fresh look and feel of Pepsi is bigger and bolder in every way. Our global Pepsi redesign made a splash, attracting the attention of TODAY, Fast Company, AdWeek, and many more.

122 DREAM OM | Design Firm: Omdesign | Designer: Diogo Gama Rocha
Client: Self-initiated | Main Contributor: Omdesign

Assignment: In the cyclical dance of life, a simple seed holds the power to inspire and drive the evolution of humanity. Since 1998, we, at Omdesign, have transformed our ideas, like golden grain of wheat, into a timeless blend of excellence, consistency, and determination. Our mission is to continue this cycle while patiently nurturing the seed and witnessing its fruition. DREAM OM continues our commitment to sustainability, while emphasizing the importance of minimizing our impact on the earth and connecting with the fundamental aspects of life. From bread to whisky, it invites us to share moments of union and to enhance relationships, while catch attention for the need of pro-environmental initiatives our generations need to take.

Approach: We took a reusable glass jar and adorned it with cork, on the stopper and on the neck-collar, that also works as a jar coaster. The outside packaging was drawn and built without glue and only with embossing and printing. The jar comes with a wood-free paper label made from 15% by-product from barley processing. The remaining paper contains 40% post-consumer recycled fibres and 45% virgin wood pulp. We adorned DREAM OM with a game of embossing and debossing all over the paper sleeve. To avoid single-use items, the bottom carries a reusable drop stopper. Inside, there are wheat seeds with a jiffy growblock and an instructional scheme that invites you to begin this life cycle, turning the bottle upside down and removing the drop stopper at the base to germinate them and to witness its admirable growth. Then, turn the jar over again and enjoy the Single Malt Scotch Whisky it carries. When empty, adorn it with a harvested wheat cob so you can contemplate it for another 25 years.

Results: Our DREAM OM has an ecological message for all of our clients and partners. It gathers recycled, reusable, recyclable and plant-based materials in a call-to-action small piece. But it goes further; it is an invitation to continue growing. The Portuguese cork of 100% sustainable provenance, the reusable whisky mini-bottle and drop stopper, alongside the plant-based papers and cardboards only embrace the crucial warning for the present and future generations, to not stop the eco-friendly drop.

123 CY BIOPHARMA | Design Firm: Play
Designers: Play, Chandler Reed, Dylan Wells, Marcio Flausino | Client: Cy Biopharma
Executive Creative Director: Casey Martin | Creative Directors: Kyle Lee Beck, Mathew Foster
Design Directors: Kelly Scheurich, Ellis Latham-Brown, Rosie Bloom, Owen Cramp
Director: Lindsay McMenamin | Senior Designers: Simon Blackensee, Claire Whitman
Interactive Designer: Jaime Patino-Calvo | Motion Designers: David Kopidlansky, Xiaoxue Meng
Copywriter: David Schermer | Main Contributor: Play

Assignment: Cy is an emerging leader in the biopharmaceutical industry with a focus on researching and developing psilocybin-derived drug therapies for treating chronic pain more safely and effectively. They approached our studio to develop their brand identity and website to attract future investors and establish their presence as a player in the rapidly growing world of psychedelic research. The work had to speak to an audience that's at home in the highly technical world of biochemistry and other hard sciences. But as with any complex product, we knew the way to win was to appeal to the emotional part of the brain at least as much as the rational. Not unlike Cy's drugs, we knew we had to make the audience feel something.

Approach: Cy is a brand that's experimenting with molecules derived from psilocybin mushrooms. We knew we needed to embrace that but in a smartly elegant way. We eventually arrived in this world of fuzzy, neon-tinged, amorphous shapes grounded by Swiss design grids and sharp, clean typography. The idea of auras was the basis for the gradient color system. Cy pharmaceuticals come from the natural world, so we derived the color palette from sea, sky, and land. We were also inspired by the visual language of scientific journals and lab reports. That's how we landed on the simplicity of the Univers typeface and the underlying grids.

Results: Cy website traffic increased after the launch. The redesign helped Cy secure additional funding. Our work also gained the attention of the esteemed design blog, Brand New. They featured it in a very glowing review.

124 BURJ AL SHIEKH PERFUME | Design Firm: Sol Benito | Designer: Vishal Vora
Client: Emper Perfumes | Main Contributor: Sol Benito

Assignment: Client wanted create an iconic perfume concept originated from UAE which comes across as a souvenir product.

Approach: This exquisite design features a transparent cap that houses a detailed miniature of the Burj Khalifa. The bottle itself is adorned with luxurious gold and silver metal accents. Every element mirrors the architectural brilliance and modern elegance of the Burj Khalifa. This perfume bottle is more than just a fragrance holder; it is a stunning souvenir, capturing the essence of Dubai's skyline. Each spray delivers a scent as captivating as the city itself, making it a perfect keepsake and symbol of luxury.

125 CAFÉ OLIMPICO - HERITAGE TIN
Design Firm: STNMTL (Station Montréal Design Bureau) | Designer: Ibraheem Youssef
Client: Café Olimpico | Graphic Designer: Febryan Nur | Design Director: Ibraheem Youssef
Product Photographer: Aabid Youssef | Copywriter: Adriana Palanca
Main Contributor: John Vannelli

Assignment: For anyone visiting Montréal, there's 3 things on everyone's must do list: Montréal Bagels from St. Viateur Bagels, Smoked Meat from Schwartz's, and Coffee from Café Olimpico. Opened in 1970, Café Olimpico has grown to where people worldwide visit to savor traditional Italian Espresso, a one-of-a-kind family vibe, and an atmosphere that makes you feel at home. How do we capture all of that history in a coffee tin?

Approach: The Limited edition Café Olimpico Heritage Tin is a nod to the traditional Vintage Style Italian Coffee tins that are found in every Nonna's Kitchen Shelf. This Tin not only is an exceptional work of art, but every single inch is crafted based on existing architectural and interior details from and within Olimpico. We literally took everything that made the cafe, and put it in a tin, in traditional Italian Fashion.

Results: Available at all three of Café Olimpico locations across Montréal, since it's launch the Coffee Tin is the best selling product, loved by tourists from all over the world that are eager to take a piece of Montreal & Olimpico home with them.

126 DORITOS SOLID BLACK 2023 | Design Firm: PepsiCo | Designer: PepsiCo
Client: Self-initiated | Main Contributor: PepsiCo

Assignment: As part of SOLID BLACK®, our ongoing DORITOS® initiative that supports Black innovators and changemakers, we've scaled our annual limited edition series into a collaboration-driven platform that amplifies Black artists. For the third DORITOS® SOLID BLACK® series, we commissioned Mz. Icar, an anonymous interdisciplinary arts collective composed primarily of Black women, to create the artwork for our limited-edition packaging.

Approach: Mz. Icar centered their artwork around the concept of thriving. They described it as "hope for the present and future." We then extended the artwork by Mz. Icar to a complete visual identity system that brought the piece's palette and graphics to packaging design, an influencer kit, and merchandise. The iconic DORITOS® triangle inspired the kit's pyramid shape and its luxe stationery that highlights how each of our 2023 Changemakers is igniting positive change and making a bold social impact.

Results: 2023 marks the third year of SOLID BLACK® which was funded by the PepsiCo Foundation. Each non-profit leader received a $50k donation for their organization, plus resources such as leadership development, coaching, and media and cultural exposure.

127 COMMONHOUSE ALEWORKS REBRAND | Design Firm: HOOK
Designer: Brett Tighe | Client: Commonhouse Aleworks
Creative Director: Brady Waggoner | Main Contributor: Brett Tighe
Assignment: Nestled in the heart of vibrant Park Circle, Commonhouse Aleworks is a neighborhood brewery celebrated for its diverse beer selection, live music scene, and welcoming atmosphere. The brand craved a cohesive look that would elevate its standing from a modest, craft brewery to a consistent big-name powerhouse.
Approach: We designed packaging with a unified layout that uses bold colors to signal different flavors: An element that would make the brand easy to locate in the beer aisle. Park Circle is the uniquely planned community where Commonhouse Aleworks is centrally located. Aerials of the iconic neighborhood proudly tie the brewery to the community which has made it a popular, inclusive meeting space. We creatively strategized to help the client's budget get a massive bang for its buck, from inventive packaging to a surprising group costume stunt.
Results: The packing is easily recognizable. Free news coverage during the area's biggest event.

128 CASABELLA | Design Firm: Sol Benito | Designer: Vishal Vora
Client: Emper Perfumes | Main Contributor: Sol Benito
Assignment: The client seeks to create an exclusive, limited edition feminine perfume that transcends traditional glass bottle design. This ultra-luxurious product aims to incorporate unique and innovative elements, ensuring it stands out in the global market. The design should reflect its high-end nature and appeal to discerning consumers worldwide.
Approach: We developed a concept that exudes elegance and uniqueness. The bottle is encased in a stenciled gold metal jacket. To complement this, we designed an ornate round ball cap, which features a hanging tassel. This combination of details creates a visually stunning and highly original presentation. "CASABELLA" thus embodies a perfect blend of opulence and creativity, making it a standout piece in the world of high-end perfumes.

128 CIOCCOLATO | Design Firm: STNMTL (Station Montréal Design Bureau)
Designers: Naylar Youssef, Ibraheem Youssef | Clients: Café Olimpico, État de Choc.
Product Photographer: Aabid Youssef | Design Director: Ibraheem Youssef
Main Contributors: John Vannelli, Maud Gaudreau
Assignment: Our design studio collaborated with Café Olimpico, a beloved Montreal coffeehouse, and chocolatier État de Choc to create a chocolate that truly embodies heritage and craftsmanship. Drawing inspiration from traditional vintage Italian chocolate packaging, the goal was to create an exquisite creation that pays homage to the rich cultural tapestry of Italy.
Approach: We created a packaging design that captures the essence of vintage Italian packaging aesthetics, featuring intricate details and classic motifs. The meticulous artistry in the design ensures that each chocolate bar is not just a treat for the palate, but also a visual feast, invoking memories of Italy's rich heritage. The final design was loved by both clients, and captured both the history and aesthetically nature of Italian vintage design and the clean sleek modernity and classical nature of the art of chocolate making.
Results: Within two days of launching, the first batch of chocolates was sold out. Since then, multiple batches have been produced and subsequently sold out as well within days.

129 MARGARET RIVER NATURAL SPRING WATER | Design Firm: Dessein
Designer: Leanne Balen | Client: Margaret River Natural Spring Water
Photographer: Geoff Bickford | Account Manager: Tracy Kenworthy
Main Contributor: Leanne Balen
Assignment: Margaret River Natural Spring Water (MRNSW) embodies the enchanting essence of its origin in southwest Western Australia. The brand celebrates this magical setting capturing the region's purity and sustainability.
Approach: Our approach emphasizes the natural beauty of the region, using a simple colour palette of pure, clean blues. Printed on silver label stock, the labels catch and reflect light, mirroring the shimmering waters and changing hues of the sky. This accentuates the brand's logo and illustrative elements. The packaging reinforces MRNSW's commitment to sustainability, being bottled in 100% recycled PET bottles. This emphasis on authenticity and environmental responsibility resonates with consumers seeking a genuine, eco-friendly hydration option.
Results: Early sales of the redesigned 1.5L bottles demonstrated a 25% increase in sales. This success underscores the effectiveness of the branding strategy in capturing the regions essence, communicating it to consumers, driving both engagement and sales.

130 NUTRITION EXPRESS | Design Firm: CollierGraphica
Designer: Steve Collier | Client: Nutrition Express | Photographer: Hal Lott
Main Contributor: Steve Collier
Assignment: Design a full line of new packaging for products of a homeopathy nature that would reflect the quality and effectiveness of the products.
Approach: Research the area of homepathy products and develop a look and identity to establish Nutrition Express as a leader in it's field.
Results: The product line was well received and it was a success.

131 UTOPIAN COFFEE | Design Firm: Pavement | Designer: Michael Hester
Client: Utopian Coffee | Main Contributor: Teagan White
Assignment: Utopian Coffee was founded by a backpacking vagabond who fell in love with coffee-producing countries. Today, this has evolved into an intentional commitment to invest in and learn from coffee producers first hand. To capture this unwavering promise, Utopian's branding and packaging design were evolved into a vibrant representation of the sources of their coffees. Colorful full-bleed illustrations of surrealistic flora and fauna replaced Utopian's previous stark blue identity, and the logotype was given a modest evolutionary facelift.
Approach: We wanted to capture the ecosystems and environment from which the coffees were souced with our creative solution.
Results: The redesign allowed the client to expand nationally outside of its native Ft. Wayne, Indiana market and stand brightly amongst its third-wave coffee counterparts.

132 GENESIS MOTORS G90 GIFTING CAMPAIGN
Design Firm: Premier Communications Group | Designer: Randy Fossano
Client: Genesis Motors | Art Director: Mike Fossano | Production Artist: Maria Kowalski
Main Contributor: Corey Wheeler
Assignment: The 2023 Genesis G90 luxury full-size sedan embodies luxury in both design and performance, complemented by Genesis' premium Priority One customer service. Our package design includes insets for the candles, placards with descriptions of each scent and a custom-branded matchbox. Our purpose was to leave a mark on the customer by giving them the ability to evoke a true sensory experience both on and off the road.
Approach: Premier led the creative process, crafting high-end gifts for early G90 buyers. The initial 100 owners of the G90 received a gift that included a letter from Genesis Chief Operating Officer Claudia Marquez and a set of Bang & Olufsen Beoplay headphones.

Results: Following the positive reception from the first 100 Priority One G90 owners with the headphones gift set, we were tasked with creating a second concept to appeal to a wider group of G90 owners. This led to the creation of 1,000 gift sets that featured custom silk fabric with a grille-inspired design and eucalyptus sprigs, alongside scented candles and a branded matchbox. These quickly demonstrated its success, prompting us to produce an additional 1,000 sets.

133 DORITOS PRIDE ALL YEAR | Design Firm: PepsiCo
Designer: PepsiCo | Client: Self-initiated | Main Contributor: PepsiCo
Assignment: For the 2023 Doritos Pride All Year campaign release throughout Latin America, Doritos wanted to show that there's only one kind of future–a wholly inclusive one. By amplifying the voice, exposure, and platform of Pride, Doritos makes a statement that being your authentic self deserves to be celebrated, all year round.
Approach: While this may be a brand story, it's also more importantly a global conversation. That's why, when creating a new visual identity, we knew we had to take the brand purpose to a new level. Our first priority was recruiting a diverse alliance of individuals to advise on the project direction. These people, alongside an array of NGOs, helped shape our creative vision.
Results: We sought to create a visual representation of how Doritos sees society. We did this by including lively, vibrant, and excited individuals reflecting the Doritos ethos - "to live boldly!" The illustration style reflected kinetic energy. By not relying heavily on text, we were able to communicate via visual craftsmanship that lends itself to the maxim of expressing yourself without fear. This year, Doritos Pride All Year have been met with excitement. For Valentine's Day 2023, the digital campaign results included a 43% positive sentiment, 31% of users responding to the question of "what was the craziest thing they did for love" on social media, and 21% users tagged friends to further engage with the content. Doritos' long history of supporting LGBTQ+ people and causes has continually helped to drive positive cultural shifts, and Doritos Pride All Year continues this trajectory.

134 WRAPPING THE OPPORTUNITY OF A LIFETIME — 1963 FERRARI 250 GTO S/N 3765GT PRESENTED BY RM SOTHEBY'S
Design Firms: Affinity Creative Group, Kabookaboo
Designers: Kabookaboo, Affinity Creative Group | Client: RM Sotheby's
Main Contributors: Kabookaboo, Affinity Creative Group
Assignment: Kabookaboo + Affinity Creative Group embarked on a mission to design and craft a meticulously targeted direct marketing piece to captivate the attention of affluent individuals beyond the realm of Automobilia. This endeavor demanded not just creativity, but a profound understanding of their desires, aspirations, and discerning tastes. Our aim? Curate an experience that not only acknowledges their elevated status but celebrates their individuality with unparalleled finesse and exclusivity.
Approach: Our team crafted a marketing piece that stands out amidst the noise, capturing attention and fostering a sense of immediate connection. Central to this approach is the inclusion of incredible elements and meticulous attention to detail, such as personalized letters, a brochure containing auction information, beautiful historical pictures, and details about the car's history. Additionally, the marketing piece featured an iPad containing photography of the car as well as the "Don't Blink" promotional/teaser video, both filmed and produced by us.
Results: By delivering a personalized and bespoke marketing piece, we increased the likelihood of engaging affluent individuals and fostering long-term relationships. This exceptional marketing piece set the tone for a campaign that would culminate in a historic moment, as the Ferrari went on to become the most expensive ever sold at auction.

134 EPICURE POPCORN TINS | Design Firm: Neiman Marcus Brand Creative
Designers: Stephen Arevalos, Alyse Lanier, Donna Davis | Client: Self-initiated
Design Lead: Alyse Lanier | Design Director: Lori Dibble | Chief Creative Officer: Nabil Aliffi
Design Manager: Stephen Arevalos | Production Manager: Rhoda Gonzales
Production Artist: Donna Davis | Printer: Royal Summit | Account Manager: Aurora Chavez
Main Contributors: Stephen Arevalos, Alyse Lanier
Assignment: Each year, we are challenged to create packaging for our epicure items that captures the joy of the holiday season. This year, we created geometric patterns that express the exuberance of the festivities with designs inspired by the facets of fine jewels and strings of holiday lights that have a hint of Art Deco and Art Nouveau to tie into the idea of traditions while still looking thoroughly fresh and modern. We paired seasonal colors with gold, rendered them all in metallics, and used gradations to give them interest and depth. We finished with fonts chosen to clearly identify the products while also adding an appropriate flourish.

135 CARIBOU COFFEE LA MINITA PEABERRY | Design Firm: Cue | Designer: Matt Erickson
Client: Caribou Coffee | Creative Director: Alan Colvin | Main Contributor: Cue
Assignment: La Minita Peaberry is a rare, vibrant coffee, the result of Caribou Coffee's decades-long partnership with Hacienda La Minita. We were tasked with creating a new identity and packaging to resonate with the place, and get credit for this special relationship.
Approach: The packaging creates a sense of place with an illustrative approach that captures the feel of the Hacienda and Tarrazu Valley in Costa Rica. Premium touches of metallic gold signal the special grade of the crop. The elevated treatment is paired with hand-touched elements and the words "hand-picked with care."
Results: The response to the packaging was very positive. The La Minita Peaberry packaging helped to elevate the Caribou Coffee portfolio with premium coffee credential.

136 FUTURE | Design Firm: Tsushima Design | Designer: Hajime Tsushima
Client: Osaka Poster Fest | Main Contributor: Hajime Tsushima
Assignment: This is a poster for an exhibition. The theme is the future. This exhibition will be held as a virtual exhibition and a real exhibition. The real exhibition was held at the Osaka University of Arts Gallery from November 27th to December 1st, 2023.
Approach: In the future, the latest technologies such as space exploration, artificial intelligence, and virtual reality will become crucial elements. Reflecting diversity and inclusivity, the design imagines various cultures, races, genders, abilities, and more.
Results: The real exhibition was visited by many. The virtual exhibition is currently being held.

137 MONSIEUR SPADE | Design Firm: ARSONAL | Designer: ARSONAL
Clients: AMC, AMC+ | Illustrator: Michael Koelsch | Others: Ed Sherman, VP Brand & Design, Mark Williams, EVP Creative, Nancy Hennings, VP Production Brand & Design
Main Contributors: ARSONAL, AMC, AMC+
Assignment: Monsieur Spade shows the beloved detective, Sam Spade, in a completely new light. To reflect that, we needed to find a unique approach for the art. He is no longer the hardened detective he once was, so we also wanted to display the character's vulnerability in the art.
Approach: Instead of leaning into traditional noir visuals, we created a hand-painted portrait of Det. Spade unlike we've ever seen him - naked and completely vulnerable.
Results: The final piece was well received by the client and filmmakers, and has received accolades including being chosen for the cover of the Communication Arts Illustration cover.

138 CYCLE | Design Firm: Elevate Design | Designer: Kelly Salchow MacArthur
Client: Self-initiated | Main Contributor: Kelly Salchow MacArthur

Assignment: As a citizen designer, I aspire to catalyze environmental empathy and action through my work. At any moment in time, we are within a cycle of conservation or extinction.
Approach: Foraged local flora and fauna provide the subject matter for the photography, knotted into a tangle, which initiates the continual circular reading direction.
Results: The viewer's instinct is challenged in the sequence of reading, as if the format could be rotated and conservation could become dominant over extinction.

139 THE ROOSTER TEASER KEY ART | Design Firm: Barlow.Agency
Designer: Barlow.Agency | Client: Thousand Mile Productions | Main Contributor: Barlow.Agency
Assignment: To promote feature film 'The Rooster,' our objective was to craft a captivating and enigmatic image that alludes to a recurring motif in the storyline—the ping pong ball.
Approach: Utilizing on-set unit photography, we skillfully manipulated the image to feature the film's recurring motif—a ping pong ball held by the rooster's head. This deliberate alteration imbues the picture with an unsettling yet intriguing tease for the forthcoming feature film.
Results: Emerging as a client favorite during our presentation, this project is now being internally rolled out in preparation for the wide release of the film.

140 AMERICAN HORROR STORY: DELICATE S12 | Design Firm: ARSONAL
Designer: ARSONAL | Client: FX Network | Photographer: Frank Ockenfels
Others: Stephanie Gibbons, Creative Director/President, Creative, Strategy & Digital Marketing, Michael Brittain, Creative Director / SVP Print Design, Todd Russell, VP Print Design, Alvaro Masa, Director, Design, Sarin Markarian, Director Print Design, Laura Handy, Project Director, Print Design, Claudia Traina, Jr. Project Manager, Print Design, Lisa Lejeune, Production Director, Print Design | Main Contributors: ARSONAL, FX Network
Assignment: "Delicate," the 12th season of American Horror Story, delves into the psychological terror of pregnancy. Kim Kardashian, who plays an absolutely terrifying publicist, is a big part of this season. Because of this, FX's goal for the key art was to portray Kim in a way that she has never been showcased before.
Approach: Our creative challenge was to find a balance between presenting a strikingly beautiful piece of character art and adding a disturbing visual element of Kim as a spider. Our artistic direction naturally went to incorporating the web in her hair and subtly enhancing Kim's eyelashes to resemble spider legs. These additions accompanied with Kim's sensual intrigue and the overall dark palette resulted in a great addition to the collection of iconic artworks of all the past AHS seasons.
Results: Both FX and Kim loved how the final artwork came together, and it was featured throughout the marketing campaign and promotions.

141 DISARMED SHORT FILM KEY ART | Design Firm: Barlow.Agency
Designer: Barlow.Agency | Client: Last One Standing Productions
Main Contributor: Barlow.Agency
Assignment: We aimed to portray a woman grappling with PTSD from gun violence and self-sabotaging mental health stemming from a robbery while hinting at the climactic twist.
Approach: Constrained by budget, we lacked access to photography talent. Undeterred, we crafted a compelling image using stock photography, skilfully manipulating elements like reversing elements of the gun and hands. We ended with a captivating image that encapsulates the narrative of self-sabotage and becoming one's own worst enemy in the context of gun violence, our mission was to distill these complex themes into a singular, evocative image.
Results: The artwork made its debut on social media, significantly boosting promotion for the upcoming film and contributing to its acceptance into various short film festivals worldwide.

142 THE HEARTBEAT OF MEXICO | Design Firm: Legacy79 | Designer: Genaro Solis Rivero
Client: Department of Modern Languages and Cultures at Baylor University
Main Contributor: Genaro Solis Rivero
Assignment: The project aimed to design a poster to promote a Mariachi Masterclass and performance for the Department of Modern Languages and Cultures at Baylor University.
Approach: The solution was to combine the shape of the heart with a guitar. The guitar illustration was rendered by folklore birds interlacing the guitar strings, a homage to folklore and handcraft artists in Mexico. At the same time, the strings form a visual rhythm while metaphorically discovering the heartbeat of Mexico and the music.
Results: The organizing party received the poster exceptionally well. They reported that the class succeeded and that the poster helped attract more people within their targeted audience.

143 GENFEM CAMPAIGN | Design Firm: Studio XXY | Designer: Yuqin Ni
Client: Bizarrely Basic | Main Contributor: Yuqin Ni
Assignment: The struggle for women's rights has been a long and difficult one. In this campaign, we want to explore what is most needed in the feminist movement in the current situation and how design and creativity can contribute to it as designers.
Approach: GENFEM is a creative framework that unites women by enabling feminist activists to advocate for their rights through multifaceted practices. GEN stands for both "generation" and "generative" recognizing the diversity of experiences and perspectives within feminist movements and generating innovative ideas and adaptable approaches. This poster series conducted several experiments about visuals and methodology about how feminism could be practiced in to convey and collect different ideas and messages.

144 PLASTIC KILLS | Design Firm: Sun Design Production
Designers: Xian Liyun, Liang Gang | Client: Marine Environment Management Department of the Ministry of Ecology and Environment of China | Main Contributor: Xian Liyun
Assignment: The problem of plastic in our oceans and coasts is not new. This poster aims to warn of the ever-growing threat of plastic.
Approach: The visual impact was emphasized with a scary and powerful image of a shark made of plastic to scare us. The informative text is represented by an additional image of a shark's fin to break up the layout.
Results: Among the many environmental issues, this is one of the most effective and relatable campaign posters for a topic that should directly affect our lives.

145 SAVING ANIMALS FROM EXTINCTION (SAFE PROGRAM)
Design Firm: Fallano Faulkner & Associates | Designer: Frank Fallano
Client: Associations of Zoos & Aquariums | Photographers: Frank Fallano, Greg Lepera, Reid Park Zoo, Daniel Hilliard, Roger Sweeney, Palm Beach Zoo, Thom Benson, Jennifer D., Candice Rennels, Roshan Patel, Smithsonian, Matt Igleski, Michelle Steinmeyer
Main Contributor: Frank Fallano - Design/illustration/Photography
Assignment: Create a series of posters featuring animals in the association's SAFE program (Saving Animals From Extinction). The client's creative requirements included the additional capability of member institutions to brand the posters with their logo and offer it for their own sales and promotional efforts and a style inspired by vintage travel posters of the 1930s-40s.
Approach: Taking the travel posters as inspiration, we created posters, one for each endangered species selected. The client provided some reference photography and we used some of our own existing images as well as images shot specifically for the project. Each image was created using a number of techniques–. In addition, the series was tied together with some

common elements–distant horizon lines with changing angles of view, breaking the frame boundary with elements to enliven the composition, and treating a few items as flat graphic shapes to evoke the vintage posters mentioned in the client's brief.
Results: This group of additional posters is new and research data has not yet been compiled.

146 INNER LIGHT | Design Firm: Carmit Design Studio | Designer: Carmit Makler Haller
Client: Poster Every Day 2024 International Design Poster Exhibition
Main Contributor: Carmit Design Studio
Assignment: Invitation to "Poster Every Day 2024 International Design Poster Exhibition."
Approach: Works on the theme of Inner light through graphic layout and typography treatments.
Results: Online and physical exhibitions during summer 2024.

147 HUMAN SHADOW ETCHED IN STONE | Design Firm: Tsushima Design
Designer: Hajime Tsushima | Client: Japan Graphic Designers Association Hiroshima
Main Contributor: Hajime Tsushima
Assignment: This is a poster for the Peace Poster Exhibition held every year in Hiroshima.
Approach: The human shadow etched in stone symbolizes the devastating impact of the atomic bombs on Hiroshima and Nagasaki. These shadows serve as a lasting testament to the suffering and sacrifice of the survivors. The horrors of the atomic bomb emphasize the urgency of nuclear disarmament and the importance of abolishing nuclear weapons.
Results: Many people visited this peace poster exhibition.

148 IMAGERY OF 4 CONSONANTS | Design Firm: Dankook University
Designer: Hoon-Dong Chung | Client: 'TYPE TEXT KOREA' Typography Poster Exhibition
Main Contributor: Hoon-Dong Chung
Assignment: This experimental poster is designed for the 'TYPE TEXT KOREA' Typography Poster Exhibition which took place in Warsaw, Poland.
Approach: Transforming 4 consonants in the Korean alphabet into 3D imagery.

149 FARGO | Design Firm: ARSONAL | Designer: ARSONAL | Client: FX Network
Others: Stephanie Gibbons, Creative Director/President, Creative, Strategy & Digital Marketing, Michael Brittain, Creative Director / SVP Print Design, Rob Wilson, VP Print Design, Sarin Markarian, Director Print Design, Laura Handy, Project Director, Print Design, Lisa Lejeune, Production Director, Print Design | Main Contributors: ARSONAL, FX Network
Assignment: For the 5th installment of the series, Fargo revisits Joel and Ethan Coen's original 1996 movie, and this time, the fictional "true story" revolves around the wife of the car salesman. The goal for the campaign was to highlight how extreme and bizarre the characters are as well as to showcase the contrast of qualities that exists within their personalities.
Approach: It was important to be iconic and to keep consistency with past campaigns. To achieve this, we pulled iconography from the story that symbolizes and communicates the tone of this season which contrasts a crime drama with high stakes and a comedy.
Results: The art successfully exhibits the quirkiness of the characters with an underlying sense of drama. The figurine art in particular was a bit hit, receiving a lot of buzz.

150 LEGALLY BLONDE | Design Firm: Andrewsobol.com | Designer: Andrew Sobol
Client: Theatre at the Mill | Main Contributor: Andrew Sobol
Assignment: Design a poster and accompanying a social media campaign (not featured here) for a production of Legally Blonde.
Approach: Challenge: Create an original poster and digital campaign that doesn't rehash the clichés often used for previous theatre productions or the films adaptations (e.g., purses, dogs, plaid, blonde hair, etc.). I focused on using a high-heel shoe and a pen as symbols for the main character—a strong, dynamic woman protagonist.
Results: The combination of the poster and digital campaign drew crowds to the run of the show.

151 FARGO | Design Firm: ARSONAL | Designer: ARSONAL | Client: FX Network
Others: Stephanie Gibbons, Creative Director/President, Creative, Strategy & Digital Marketing, Michael Brittain, Creative Director / SVP Print Design, Rob Wilson, VP Print Design, Sarin Markarian, Director Print Design, Laura Handy, Project Director, Print Design, Lisa Lejeune, Production Director, Print Design | Main Contributors: ARSONAL, FX Network
Assignment: For the 5th installment of the series, Fargo revisits Joel and Ethan Coen's original 1996 movie, and this time, the fictional "true story" revolves around the wife of the car salesman. The goal for the campaign was to highlight how extreme and bizarre the characters are as well as to showcase the contrast of qualities that exists within their personalities.
Approach: It was important to be iconic and to keep consistency with past campaigns. To achieve this, we pulled iconography from the story that symbolizes and communicates the tone of this season which is a contrast between a crime drama with high stakes and a comedy.
Results: The art successfully exhibits the quirkiness of the characters with an underlying sense of drama. The figurine art in particular was a bit hit, receiving a lot of buzz.

152 ARTIFICIAL INTELLIGENCE: FRIEND OR FOE?
Design Firm: Goodall Integrated Design | Designer: Derwyn Goodall
Client: Borderless Graphic Designer's Group Artificial Intelligence International Competition
Main Contributor: Derwyn Goodall
Assignment: Create a poster suggesting the dangers and advantages of artificial intelligence.
Approach: Artificial Intelligence, Friend or Foe? Opportunity or Unmitigated Disaster? Generative AI and large language models (LLMs) will reshape how we live, work and do business. How do we navigate the opportunity and uncertainty? Will it enhance our lives? (arrow up) or be a catastrophe? (arrow down).
Results: Excellent results from colleagues and clients.

153 FOLHA DE SALA | Design Firm: 1/4 Studio
Designers: Ana Mota, Jorge Araújo | Client: Galeria Ocupa!
Creative Directors: Ana Mota, Jorge Araújo | Main Contributor: 1/4 Studio
Assignment: Commissioned by Galeria Ocupa! and Sput&nik the Window, for the exhibit "Folha de Sala" by Rui Mota. The exhibition is made up of what the artist called "extroverted objects" that can expand the concept of Sculpture beyond their limits. The brief was: to create an image that, like the exhibition, could expand the concept of itself beyond its limits.
Approach: We used the room sheet as the "image" and layered it onto itself, creating an "optical spatial" composition. Taking the title into consideration, we came up with the core idea of "a room sheet about a room sheet about a room sheet about a room sheet." This conveyed several aspects of the exhibition.

154 LOVE AT FIRST SIGHT | Design Firm: ARSONAL | Designer: ARSONAL | Client: Netflix
Copywriter: Netflix | Other: Emily Cheng, Manager Films Creative Marketing (Netflix)
Main Contributors: ARSONAL, Netflix
Assignment: After missing her flight from New York to London, Hadley meets Oliver in a chance encounter at the airport. A long night on the plane together passes in the blink of an eye but upon landing at Heathrow, the pair are separated and finding each other in the chaos seems impossible. Will fate intervene to transform these seatmates into soul mates?

Approach: We used unit photography to create a caught moment between the two leads. We utilized the negative space in the art for the copy line to sell the concept of the film and really highlight the scale and proposition. Additionally, we brought some personality in the title treatment font, so it didn't feel too serious. This allowed us to keep the imagery clean and simple.
Results: The poster created a lot of buzz, as it evoked a feeling of nostalgia and excitement around the release, both for those who had read the book, as well as fans of rom-coms.

155 EMPATHY | Design Firm: Code Switch | Designer: Jan Šabach
Client: The Golden Bee Biennale | Main Contributor: Jan Šabach
Assignment: Poster for the Global Empathy category for the international poster competition.
Approach: "A healed femur is the earliest sign of civilization." This quote by Margaret Mead was a conceptual foundation for this popster. The idea of helping others is an embodiment of empathy. The fine line of the letter E written in elegant script visually cuts the bone creating a dramatic contrast while the colorful flowers blooming from the letterform are a symbol of hope.

156 YOU CREATE TOMORROW | Design Firm: One Design Company
Designer: David Sieren | Client: Self-initiated | Main Contributor: David Sieren
Assignment: This is a typographic poster series designed to spur action within communities, prompting viewers to engage and share perspectives regarding how individual actions and observations can benefit their surroundings. Custom type maximizes the white space, creating a blank canvas that invites viewers to contribute their thoughts and ideas in response to a series of prompts. Large-scale typography also equates to less ink coverage, which lowers the cost of printing in high quantity for mass distribution. The work was initially installed as part of the Chicago's Tomorrow, Today exhibition in Chicago's West Loop. 250 posters were given away for free for individuals to use, distribute, and install within their own communities. Digital versions of the posters are available for download and distribution.

157 FALL | Design Firm: HEHE DESIGN | Designer: Wu Qixin
Client: FALL | Main Contributor: Wu Qixin
Assignment: Becky and Hunter are a pair of besties who are so committed to taking adventures. One day, after they climbed a 610-meter-high TV tower, they were accidentally trapped at the top. Facing with severe weather and a lack of supplies, they had to manage to survive at a dizzying height. In the poster, the "l" of "Fall" was stretched high, and the images with a theme of "falling" were filled next to the letters in the margin, forming a close connection between the letters and images, which is also a special image structure.

158 "LIVE" IS A FOUR-LETTER WORD | Design Firm: Steiner Graphics
Designer: Rene V. Steiner | Client: Self-initiated | Main Contributor: Rene V. Steiner
Assignment: The number four symbolizes solidity, wholeness, and universality. The intersectionality of the cross moving in four directions and yet returning to a centre is an obvious metaphor. Four letter words that embody proactive intention can make a similar statement — "love" "look" "feel" "fuse". The verb "live" also has four letters and in a way embodies all of the others. The goal of this poster series was to communicate this dynamic in an abstract form.
Approach: Using yellow and light blue as base colours symbolizing dynamism and optimism played with layered visual themes evoked by the four-letter words chosen.
Results: The initial presentation of the series on social media platforms elicited a very positive response and stimulated dialogue on the dynamics of proactive living.

159 STOP WAR | Design Firm: Tsushima Design | Designer: Hajime Tsushima
Client: Taiwan Poster Design Association | Main Contributor: Hajime Tsushima
Assignment: This poster is for the Taiwan Poster Design Association Annual Exhibition. The theme was STOP and to think about the various challenges we are facing. The design visually appeals to the destructive reality of war while conveying the importance of peace and hope.
Approach: I want to appeal to the emotions of the viewer with simple, powerful messages and impressive visuals. I hope this poster will encourage people to take action to choose peace.
Results: We hope tho convey the importance of peace and contribute to stopping war.

160 FUTURE? | Design Firm: Carmit Design Studio | Designer: Carmit Makler Haller
Client: Osaka Poster Fest | Main Contributor: Carmit Design Studio
Assignment: I got an invitation from Osaka, Japan, to take part in the Osaka Poster Fest, 2023: Future exhibition. I decided to focus on Artificial Intelligence. It's everywhere. Everyone is talking about it, and it's here to stay. Hence, we should better adapt to it. Will it fix humanity's problems? Or will it conjure new dilemmas? I can't help but wonder who is at the helm. Will ill it be the machine ruling us at the end? Only time, or Future, will tell.
Approach: The poster is displaying an AI environment by using algorithms as textures, AI functions and current platforms along with a textured nervous system inside the typeface. The layout suggests a chart overloaded with data. The general color palette is of a warm and optimistic future yet the question mark on the last letter suggests a doubtful one.
Results: Displayed for a week at the Osaka Poster Fest, 2023: Future exhibition.

161 FAKE NEWS | Design Firm: Gallery BI | Designer: Byoung il Sun
Client: National Human Rights Commission of the Republic of Korea
Artist: Byoung il Sun | Main Contributor: Byoung il Sun
Assignment: This poster is a cautionary message about fake news, which causes enormous mental and material damage. The poster aims to call attention and care for our neighbors from fake news creators, media, social media, etc. that are created in dark and secret places.
Approach: The idea is that a lot of the negative news starts in dark places. The design uses objects such as hooded jackets, dark, cat's eyes, and newspapers to create a visual impact, absorb the gaze, and call for our conscience against fake news.
Results: The poster attracted a lot of eyes and attention. At the very least, the idea and composition were judged to be a new and creative approach to generate interest and empathy.

162 ADAPT | Design Firm: Elevate Design | Designer: Kelly Salchow MacArthur
Client: Self-initiated | Main Contributor: Kelly Salchow MacArthur
Assignment: Visualize two forces affecting and displacing each other.
Approach: Each panel is created through a combination of a paper square and a laser etched aluminum square. These pairings fold along a continual axis that cuts across the series, with the black aluminum at the left edge, and the yellow imagery at the right.
Results: The word ADAPT is created with geometric lines in coordination with the arcs that expands across the series. Text throughout indicate ways to consider or frame these implications. Dichotomies are integrated on the final panel. Humankind and ecosystems are past the point of sustainability, now in the realm of adaptation.

162 HOUSE OF THE DRAGON | Design Firm: ARSONAL | Designer: ARSONAL
Client: HBO | Main Contributors: ARSONAL, HBO
Assignment: Following King Aegon II's coronation and the death of Lucerys Targaryen, S2 follows the 'Greens' and the 'Blacks' as the "Dance of the Dragons" truly begins. The desire to amass larger armies and more strongholds divides our main characters, leading them down separate paths where battles await.

Approach: This was a stunty billboard that ran during Coachella, promoting fans to choose #teamgreen or #teamblack. The idea was to incorporate provocative copy ("ALL MUST CHOOSE") and ground it in the look/feel and iconography from the series.
Results: This stunt board generated a lot of excitement towards the upcoming second season.

163 NO COUNTRY FOR OLD MEN | Design Firm: Collective Turn | Designer: Jinyoung Kim
Client: Self-initiated | Chief Strategy Officer: Hanna Lee | Main Contributor: Jinyoung Kim
Assignment: The primary goal is to raise social awareness about the poverty issue among the elderly in South Korea and to highlight the severity of an aging society. According to the latest OECD report, South Korea has the worst elderly poverty rate among OECD countries, and the situation is worsening as the country ages rapidly.
Approach: We aimed to emphasize that all of us could someday become elderly, and without change, anyone could end up in such a state of poverty. To this end, the image created centers on an elderly person standing alone on a barren landscape. The elder's dress is made from black crows and their feathers, utilizing the traditional Korean symbol of death and misfortune. Crows flying around hint at a bleak future. This image aims to deliver the message in a powerful and visually striking manner, stirring emotions and fostering empathy among the public.
Results: We aim to enhance awareness of the elderly poverty issue and stimulate social dialogue. Additionally, it intends to pressure policymakers to actively address and seek long-term solutions to this problem. We hope that this image will spark societal concern and serve as a catalyst for strengthening sustainable support and protective policies for the aging population.

164 WINTER WOODLAND ANIMALS | Design Firm: Studio A | Designer: Antonio Alcalá
Client: US Postal Service | Illustrator: Katie Kirk | Main Contributor: Antonio Alcalá
Assignment: The Winter Woodland Animals stamps celebrate four species that make their homes in North America. Among the most familiar of wildlife, deer, rabbits, owls, and foxes connect us to the natural beauty of the winter season.
Approach: The whimsical, graphic illustrations of an antlered brown and white deer, a rust-colored fox, a snow-colored rabbit, and a bright-eyed owl celebrate four species that make their homes in the woodlands of North America. Art director Antonio Alcalá designed the stamps with Katie Kirk who illustrated them using geometric shapes of bold, solid color. Each animal appears with details of its habitat in winter such as a full or crescent moon, snow-covered trees, holly branches with berries, and delicate snowflakes. The illustrations were created digitally.
Results: US postage stamp distributed nationally.

164 WOMEN'S SOCCER | Design Firm: Studio A | Designer: Antonio Alcalá
Client: US Postal Service | Illustrator: Noah MacMillan | Main Contributor: Antonio Alcalá
Assignment: Soccer is the most popular sport in the world. In the United States, women's soccer has gained a firm foothold in sports and popular culture. Despite this, women's athletic programs were all but invisible on college and university campuses for decades, receiving very little of the funding and none of the recognition of their male counterparts.
Approach: This new Forever® stamp celebrates women's soccer in the United States. The stamp artwork depicts a female soccer player in action, walloping a ball with a side volley. Illustrator Noah MacMillan used simplified shapes and bold colors to convey the high energy and fast motion of the sport. The somewhat grainy rendering lends a timeless quality to the design, evoking not just a single all-star athlete or era but the entire legacy of women's soccer.
Results: US postage stamp distributed nationally.

165 CHIEF STANDING BEAR | Design Firm: Derry Noyes | Designer: Derry Noyes
Client: US Postal Service | Typographer: Derry Noyes | Main Contributor: Thomas Blackshear II
Assignment: This stamp honors Chief Standing Bear (ca 1829–1908), a Native American who, in 1879, won a landmark court ruling that determined a Native American was a person under the law with an inherent right to life, liberty, and the pursuit of happiness.
Approach: The stamp features a portrait of Chief Standing Bear by Thomas Blackshear II based on a black-and-white photograph taken of Standing Bear in 1877. Art director Derry Noyes designed the stamp.
Results: Exquisite original artwork honoring Standing Bear, a Ponca Chief.

166 TADAO ANDO EXHIBITION BRANDING | Design Firm: Zhiyi Zhu
Designer: Zhiyi Zhu | Client: Self-initiated | Main Contributor: Zhiyi Zhu
Assignment: This project aims to embody Tadao Ando's architectural interplay of light and shadow through the beauty of customized typefaces with a clean layout.
Approach: Customized typographies for this branding projects, start with calligraphy and ends up with those two modern, memorizable and natural feels fonts. One typeface embodies the luminosity and darkness of his work. Body copy typeface integrated the raw concrete dots.
Results: The combination of customized typeface with a clean layout represents Tadao Ando's fusion of precision and artistry, a hallmark of his architectural ethos.

SILVER WINNERS:

168 MAKE YOUR HOLIDAY A MASTERPIECE
Design Firms: Microsoft Brand Studio, McCann New York, O0 Design
Designers: Microsoft Brand Studio, McCann New York, O0 Design | Client: Microsoft
Main Contributors: Microsoft Brand Studio, McCann New York

168 THE FUTURE IS NUCLEAR, 2023: BRUCE POWER ANNUAL REVIEW AND ENERGY REPORT | Design Firm: Bruce Power Creative Strategy
Designers: Erin Grandmaison RGD, Jessica Hillis | Client: Self-inititated
Writers: Tim McKay, Kate Bagshaw | Photographers: Francis Lodaza, Riley Snelling
Main Contributor: Bruce Power

168 YSLETA DEL SUR PUEBLO 2022 YEAR-END REPORT
Design Firm: Anne M. Giangiulio Design | Designer: Anne M. Giangiulio
Clients: Ysleta del Sur Pueblo, Helix Solutions | Printer: Tovar Printing, El Paso, TX, USA
Main Contributor: Ysleta del Sur Pueblo

168 GNOME WITH THE CHROME | Design Firm: Traction Factory
Designer: David Brown | Client: Snap-on Tools | Creative Director: Tom Dixon
Design Director: David Brown | Art Director: Paul Bartlett | Copywriter: Jack Rice
Director of Photography: CJ Foeckler | Set Designer & Props: Burt Gross
Production Artist: Jenni Wierzba | Project Manager: Pam Sallis
Account Director: Shannon Egan | Main Contributor: Paul Bartlett

168 BLACKROCK 2022 ANNUAL REPORT | Design Firm: Addison
Designer: Nick Schmitz | Client: BlackRock | Creative Director: Richard Colbourne
Account Director: Lauren DeAngelis | Main Contributor: Nick Schmitz

168 RAR SEEN BY... | Design Firm: Atelier Nunes e Pā, Lda
Designer: Atelier Nunes e Pā, Lda | Client: RAR - Sociedade de Controle Holding, S.A.
Main Contributor: Atelier Nunes e Pā, Lda

168 MSK ANNUAL REPORT 2022 | Design Firm: Memorial Sloan Kettering
Designer: Kristin Glick | Client: Self-initiated | Creative Director: Randi Press
Editor: Toni Rumore | Chief Marketing Officer: Erin McDonough
Vice President of Marketing: Ami Schmitz | Managing Director: Katie Boyle Sobolik

169 LIFE LESS SCARY - BILLBOARD SERIES | Design Firm: Dunn&Co.
Designers: Stephanie Morrison, Cris Trespando, Cody Davis
Client: Grow Financial Federal Credit Union | Chief Creative Director: Troy Dunn
Creative Director: Max Dempster | Copywriter: Michala Jackson
Art Director: Mitchell Goodrich | Account Supervisor: Rachel Jensen
Account Executive: Anna Butler | Main Contributor: Stephanie Morrison

169 THERE'S ALWAYS A PLAN B | Design Firm: Design by OOF
Designer: Design by OOF | Client: Braga 25 Portuguese Capital of Culture
Art Director: Cláudio Rodrigues | Copywriter: Carolina Lapa | Photographer: Lais Pereira
Video: Neva Films | Main Contributor: Design by OOF

169 TRO ESSEX MUSIC GROUP ANNIVERSARY BOOKLET
Design Firm: C&G Partners LLC | Designers: Chris Mills, C&G Partners LLC
Client: TRO Essex Music Group | Creative Directors: Maya Kopytman, C&G Partners LLC
Lead Designers: Maya Kopytman, C&G Partners LLC | Photographer: Sabrina Asch
Product Photographers: Peter Philbin, Brilliant | Printer: Brilliant
Writers: Katherine Ostien, TRO Essex Music Group
Content Developers: Katherine Ostien, TRO Essex Music Group
Partners: Maya Kopytman, C&G Partners LLC
Main Contributors: C&G Partners LLC, TRO Essex Music Group

169 JOHNNY CASH: THE LIFE IN LYRICS | Design Firm: Headcase Design
Designers: Paul Kepple, Alex Bruce | Clients: Voracious, Little Brown
Creative Director: Mario Pulice (Voracious, Little Brown) | Art Director: Paul Kepple
Design Manager: Kirin Diemont (Voracious, Little Brown) | Authors: Johnny Cash, Mark Stielper
Editors: Mike Szczerban (Voracious, Little Brown), Karen Landry (Voracious, Little Brown)
Publishers: Voracious, Little Brown | Production: Nyamekye Waliyaya (Voracious, Little Brown)
Contributor: John Carter Cash | Main Contributor: Headcase Design

169 ART CATALOGUE FOR DAMIEN HIRST "TO LIVE FOREVER (FOR A WHILE)"
EXHIBIT | Design Firm: Teikna Design | Designer: Claudia Neri | Client: Rizzoli International
Assistant: Elisa Stagnoli | Typeface: Bluu Next by Jean-Baptiste Morizot and Julien Imbert
Main Contributor: Claudia Neri

169 WE IMITATE SLEEP TO IMITATE DISSENT | Design Firm: Studio Castrodale
Designer: Elise Castrodale | Client: FADO Performance Art Centre
Main Contributor: Emily DiCarlo

169 PAIRS: A BOOK OF PHOTOGRAPHS
Design Firm: Schatz Ornstein Studio | Designers: Alex Spacher, Howard Schatz
Client: Lawrence Richard Publishing | Retouching: John Early
Main Contributors: Photographer, Howard Schatz. Editor, Beverly Ornstein

169 THE EXILED | Design Firm: Studio XXY | Designer: Yuqin Ni
Client: Bizarrely Basic | Main Contributor: Yuqin Ni

170 LÁSKA JE KURVA A JINÉ POVÍDKY (TRANSLATION FROM CZECH: LOVE IS A
WHORE AND OTHER SHORT STORIES) | Design Firm: Code Switch
Designer: Jan Šabach | Client: Paseka Publishing House | Art Director: Vojta Sedláček
Main Contributor: Jan Šabach

170 OUTDOOR INTERIORS | Design Firm: Studio Castrodale
Designer: Elise Castrodale | Client: Lannoo | Main Contributor: Juliet Roberts

170 30 YEARS VHM | Design Firm: Atelier Nunes e Pã, Lda
Designer: Atelier Nunes e Pã, Lda | Client: VHM – Coordenação e Gestão de Projectos, Lda
Main Contributor: Atelier Nunes e Pã, Lda

170 CURRENT: LA FOOD | Design Firm: Still Room Studio
Designers: Jessica Fleischmann, Taylor Miles Hopkins, Evelena Ruether
Client: City of Los Angeles Department of Cultural Affairs | Editors: Deirdre O'Dwyer,
Marina Belozerskaya | Publisher: City of Los Angeles Department of Cultural Affairs
Photographers: Panic Studio LA, Asuka Hisa, Harry Gamboa Jr., Justin Jackson (J3 Collection)
Contributors: Asuka Hisa, Teena Apeles, Jess Arndt, Dr. LeRonn P. Brooks, Sarah Cooper,
Jesse Connuck, Suzy Halajian, Pablo Heiguera, Michael Ned Holte, Harry Gamboa Jr.,
Daniel Gerwin, Arisha Fatima Haq, India Mandelkern, Aurora Tang, Alena Williams,
Maxwell Williams | Others: Lead Curators: Asuka Hisa; Jamillah James. Curatorial Advisors:
Lauren Mackler; Diana Nawi; Marco Rios
Main Contributors: Still Room Studio, Jessica Fleischmann

170 BACKSTAGE | Design Firm: Studio Eduardo Aires
Designers: Rita Borges, Miguel Almeida, Raquel Piteira, Joana Teixeira, Anastasiia Potapenko
Client: Self-initiated | Creative Director: Eduardo Aires | Art Director: Eduardo Aires
Photographer: João Pedro Azevedo | Main Contributor: Eduardo Aires

170 A CERTAIN MAGICAL INDEX: THE OLD TESTAMENT OMNIBUS EDITION
Design Firm: Yen Press | Designer: Andy Swist | Client: Yen On
Art Director: Wendy Chan | Editors: Kurt Hassler, Ivan Liang | Main Contributor: Andy Swist

171 THE WEST TEXAS POWER PLANT THAT SAVED THE WORLD REVISED EDITION
Design Firm: Texas Tech University Press | Designer: Hannah Gaskamp
Client: Self-initiated | Main Contributor: Hannah Gaskamp

171 SHAKE IT UP, BABY! | Design Firm: Faceout Studio | Designer: Elisha Zepeda
Client: Pegasus Books | Main Contributors: Faceout Studio, Elisha Zepeda

171 ORDINARY SOIL | Design Firm: Greenleaf Book Group | Designer: Jared Dorsey
Client: Alex Woodard | Art Director: Neil Gonzalez | Main Contributor: Jared Dorsey

171 COME NOVEMBER | Design Firm: Greenleaf Book Group | Designer: Neil Gonzalez
Client: Scott Lord | Art Director: Neil Gonzalez | Main Contributor: Neil Gonzalez

171 PEPSICO DESIGN X RIZZOLI DESIGN BOOK 2023 | Design Firm: PepsiCo
Designer: PepsiCo | Client: Self-initiated | Main Contributor: PepsiCo

171 THE BELLY OF THE WHALE | Design Firm: Texas Tech University Press
Designer: Hannah Gaskamp | Client: Self-initiated | Main Contributor: Hannah Gaskamp

171 THE WAR ON PRICES | Design Firm: Faceout Studio | Designer: Molly von Borstel
Client: Cato Institute | Main Contributors: Faceout Studio, Molly von Borstel

171 CHASING THE PANTHER | Design Firm: Richard Ljoenes Design LLC
Designer: Richard Ljoenes | Client: HarperCollins Publishers | Creative Director: Belinda Bass
Art Director: Belinda Bass | Author: Carolyn Pfeiffer | Photographers: Jacket photographs:
portrait of Carolyn by Jens Peter Bloch; Gian Lorenzo Bernini's The Rape of Proserpina statue:
Wikimedia; Hollywood sign by Michele Falzone / Getty Images; all others by Shutterstock: film
reel by Steve Collender, Union Jack by Savvapanf Photo, flowers by Tanafortuna, pyramids by
romeovip_md, Fiat by ermess. Author photograph © Rick Guest | Publisher: Matt Baugher
Main Contributor: Richard Ljoenes Design LLC

171 A DREAM IN WHICH I AM PLAYING WITH BEES
Design Firm: Texas Tech University Press | Designer: Hannah Gaskamp
Client: Self-initiated | Main Contributor: Hannah Gaskamp

172 THE LEAVING SEASON | Design Firm: Richard Ljoenes Design LLC
Designer: Richard Ljoenes | Client: W. W. Norton | Creative Director: Steve Attardo
Author: Kelly McMasters | Image Sources: Jacket photographs: siekierski.photo / Shutterstock
(top); Polina Plotnikova / Getty Images (middle); Ryan DeBerardinis / Shutterstock (bottom)
Art Director: Sarahmay Wilkinson | Editor: Jill Bialosky
Main Contributor: Richard Ljoenes Design LLC

172 FRANK'S SHADOW | Design Firm: Greenleaf Book Group | Designer: Cameron Stein
Client: Doug McIntyre | Art Director: Neil Gonzalez | Main Contributor: Cameron Stein

172 THE EDGE ROVER | Design Firm: Texas Tech University Press
Designer: Hannah Gaskamp | Client: Self-initiated | Main Contributor: Hannah Gaskamp

172 WEED RULES | Design Firm: Faceout Studio | Designer: Tim Green
Client: University of California Press | Main Contributors: Faceout Studio, Tim Green

172 CRUX | Design Firm: Richard Ljoenes Design LLC | Designer: Richard Ljoenes
Client: Troutpond Creative Partners | Art Director: Richard Ljoenes
Image Sources: Cover art/photographs: pig anatomical chart © http://www.anatomicalprints.
com; wrist © Simone Wave/Stocksy; all remaining images by Shutterstock; barn © Christiane
Godin; man in blizzard © Andrei Stepanov; scars © Nata Vilman and © ajisai13. Author
photograph by Meredith Coe Photography | Author: Robert Hamilton
Main Contributor: Richard Ljoenes Design LLC

172 SHRIMPING WEST TEXAS | Design Firm: Texas Tech University Press
Designer: Hannah Gaskamp | Client: Self-initiated | Main Contributor: Hannah Gaskamp

172 THE POLICING MACHINE | Design Firm: Faceout Studio
Designer: Spencer Fuller | Client: University of Chicago Press
Main Contributors: Faceout Studio, Spencer Fuller

172 NIGHT TRAIN TO NASHVILLE | Design Firm: Faceout Studio | Designer: Spencer Fuller
Client: HarperCollins Christian Publishing | Main Contributors: Faceout Studio, Spencer Fuller

172 FOLLOW THE ARTIST: 20 YEARS OF CALARTS CENTER FOR NEW
PERFORMANCE | Design Firm: Still Room Studio
Designers: Jessica Fleischmann, Taylor Miles Hopkins
Client: CalArts Center for New Performance | Printer: Ofset Yapimevi
Editors: George Lugg, Travis Preston, Deirdre O'Dwyer | Proofreader: Phoebe Kaufman
Main Contributors: Still Room Studio, Jessica Fleischmann

173 IRENE SOLÀ | Design Firm: Anagraphic | Designer: Anna Farkas
Client: Magvető | Main Contributor: Anna Farkas

173 WALLS: THE REVIVAL OF WALL DECORATION | Design Firm: Studio Castrodale
Designer: Elise Castrodale | Client: Lannoo | Main Contributor: Laura May Todd

173 LAIL VINEYARDS BRAND BOOK | Design Firm: Vanderbyl Design
Designers: Michael Vanderbyl, Tori Koch | Client: Lail Vineyards
Main Contributor: Michael Vanderbyl

173 THE BOOK, FALL 2023 | Design Firm: Neiman Marcus Brand Creative
Designers: Stephen Arevalos, Morgan Baldwin, Mary Covington, Lisa Garcia, Jessica Oviedo
Client: Self-initiated | Chief Creative Officer: Nabil Aliffi | Design Director: Lori Dibble
Art Director: Devin Hall | Design Manager: Stephen Arevalos | Printer: MILANI
Stylists: Kim Stanley, Stephanie Quadri, Allison Wilt | Director of Photography: Tim Flannery
Senior Creative Service Director: Erica Mouzoukos | Production Manager: Sharon Murway
Production: Janet Newcomer, Brooke Helm, Albert Dombroski
Director of Project Management: Erica Mouzoukos | Account Managers: Jessica Edwards,
Taylor Sicking | Main Contributors: Stephen Arevalos, Morgan Baldwin, Mary Covington,
Lisa Garcia, Jessica Oviedo

173 BADACSONY | Design Firm: Anagraphic | Designer: Anna Farkas
Client: Ábel Szalontai | Main Contributors: Anna Farkas, Ábel Szalontai

173 EMBALADO EM 9/4/21 | CONSUMIR ATÉ 12/11/22 | Design Firm: 1/4 Studio
Designers: Ana Mota, Jorge Araújo | Client: Galeria Ocupa!
Creative Directors: Ana Mota, Jorge Araújo | Main Contributor: 1/4 Studio

173 MABEE FOUNDATION COFFEE TABLE BOOK | Design Firm: Spire Agency
Designer: Lexi Palmer | Client: The J.E. & L.E. Mabee Foundation
Chief Creative Officer: Kimberly Tyner | Associate Creative Director: Jason James
Senior Designer: Tyler Fonville | Account Supervisor: Julia Cardali | Writer: Nick Reese
Painting: ColorMark | Main Contributor: Spire Agency

173 Y HANYU YUZURU PHOTO BOOK | Design Firm: Kojima Design Office Inc.
Designer: Toshiyuki Kojima | Client: The Sports Nippon Newspapers
Creative Group Head: Yuji Takahashi | Creative Directors: Yutaka Nagakubo, Yoshiki Kogaito
Art Director: Toshiyuki Kojima | Photographer: Yoshiki Kogaito | Producer: Kenichi Tanaka
Main Contributor: Toshiyuki Kojima

174 RAFFI'S SUPERPOWERS | Design Firm: Studio Hinrichs
Designers: Kit Hinrichs, Taylor Wega | Client: Joline Godfrey | Printer: Beon Printing
Project Manager: June Lin Umfress | Main Contributor: Kit Hinrichs

174 CROWN, CLOAK, AND DAGGER | Design Firm: Faceout Studio
Designer: Spencer Fuller | Client: Georgetown University Press
Main Contributors: Faceout Studio, Spencer Fuller

174 RAQIB SHAW: BALLADS OF EAST AND WEST | Design Firm: Siena Scarff Design
Designer: Siena Scarff | Client: Isabella Stewart Gardner Museum
Main Contributor: Siena Scarff Design

174 FASHION KILLA | Design Firm: Faceout Studio | Designer: Tim Green
Client: Simon & Schuster | Main Contributors: Faceout Studio, Tim Green

174 LUCKY RED | Design Firm: Faceout Studio | Designer: Tim Green
Client: Penguin Random House | Main Contributors: Faceout Studio, Tim Green

174 KILLING GRACE | Design Firm: Greenleaf Book Group | Designer: Laurie MacQueen
Client: Peter Prichard | Art Director: Neil Gonzalez | Main Contributor: Laurie MacQueen

174 EXPERIENCE DESIGN: A PARTICIPATORY MANIFESTO | Design Firm: Erica Holeman
Designer: Erica Holeman | Client: Yale University Press | Author: Abraham Burickson
Editors: Alison Hagge, Katherine Boller | Project Manager: Rachel Faulise
Main Contributor: Abraham Burickson

174 GREATNESS OF SPIRIT: STORIES OF LOVE, COURAGE, AND SERVICE
Design Firm: Gentry Press OPC | Designer: Gentry Press OPC
Client: Ramon Magsaysay Award Foundation | Author: Maria Cristina Batungbacal Encarnacion
Graphic Designers: Saumya Goyal, Ponsang Tamang, Danyel Maxin Adam Santos
Main Contributor: Atharva Sudarshan Barapatre

175 WHISKAS | Design Firm: Elmwood London | Designer: Elmwood London
Client: Mars Petcare | Executive Creative Director: Kyle Whybrow | Design Lead: Jay Bates
Design Director: Paul O'Brien | Senior Designers: Mimi Van Helfteren, Matt Churchill,
Andrea Maiuri, Jack Bannerman, Sam Povey | Senior Account Director: Charlotte Bennett
Animator: Doug Brown | Others: Senior Account Manager: Lily Lyth, Head of 2D and 3D
Animation: Oli Minchin, Head of Client Partnerships: Sheila Buchet
Main Contributor: Elmwood London

175 OLLION REBRAND | Design Firm: Matchstic
Designers: Gray Hauser, Brian Paul Nelson, Christian Thompkins, John Bowles | Client: Ollion
Creative Director: Blake Howard | Design Director: Brittany Blankenship
Strategy: Tracy Clark, Mitchell Ditto | Project Manager: Melissa Kruse
Copywriter: Cameron Leberecht | Main Contributor: Gray Hauser

175 AEROSPIKE REBRAND | Design Firm: Traina | Designer: Joe Ross
Client: Aerospike | Chief Creative Director: Mark Gallo | Graphic Designer: Joe Baglow
Illustrator: Dmitrii Kharchenko | Motion Designer: Chris Hylton
Web Designers: Lidia Santoyan, Jacob Martinez | Brand Strategy: Matt Bachmann
Account Director: Jeselyn Andrews | President: David Traina | Main Contributor: Joe Ross

175 KEYWORDS STUDIOS BRAND REFRESH | Design Firm: Studio Pgerossi
Designers: Peter Gregory, Emilio Rossi | Client: Keywords Studios
Brand Strategy: John Flannery | Chief Marketing Officer: Liz Corless
Main Contributor: Studio Pgerossi

175 ALLAWAY BRAND | Design Firm: Traina | Designer: Mark DeRose | Client: Allaway
Chief Creative Director: Mark Gallo | Graphic Designer: Carlo Palazzolo
Web Designer: Lidia Santoyan | Brand Strategy: Sandra Rivera, Megan Kapalla
Naming & Writing Manager: Megan Kapalla | Web Developer: Cory Dobson
Account Director: Jeselyn Andrews | President: David Traina | Main Contributor: Mark DeRose

175 DVLP MEDICINES | Design Firm: One Design Company
Designers: Aimee Lehto Schewe, Jessica Checkeroski, David Gutierrez
Client: DVLP Medicines | Content Strategist: Melinda Benoit | Developer: Mike McMillan
Project Management: Kristen Romaniszak | Main Contributor: David Sieren

175 CHROMA | Design Firm: RedPeak Global | Designer: Stacey Chun Yu
Client: Chroma ATE Inc. | Chairman: Silvia Yu | Account Director: Raychard Huang
Account Manager: Lea Chien | Strategy: Lucas Suor Yves Willery, Yiyi Huang
Main Contributors: Stacey Chun Yu, Chris Chung

175 THE AA | Design Firm: Elmwood London | Designer: Elmwood London | Client: The AA
Executive Creative Director: Kyle Whybrow | Design Director: Paz Martinez Capuz
Senior Designers: Matt Churchill, Mike Preston, Vyara Zlatilova
Strategy Director: Esther Hastings | Senior Account Director: Paul Waters
Others: Creative Lead: Ryan Brown, Chief Provocation Officer: Greg Taylor, Head of 2D and 3D
Animation: Oli Minchin | Main Contributor: Elmwood London

176 RAIN BIRD REBRAND | Design Firm: Matchstic | Designer: Brian Paul Nelson
Client: Rain Bird | Design Director: Blake Howard | Strategy: Mitchel Ditto
Copywriter: Cameron Leberecht | Main Contributor: Meghan Murray

176 THE ENCINITAN HOTEL & SUITES | Design Firm: Innerspin Marketing
Designer: Innerspin Marketing | Client: The Encinitan Hotel & Suites
Executive Creative Director: Colin Schur | Senior Art Director: Davina Roshansky Victor
Account Director: Alyna Choi | Copywriter: Zach Links | Web Developer: 3ite Nine Studios
Project Director: Gloria Yi | President: Elcid Choi | Main Contributor: Innerspin Marketing

176 THE TOOTH CO. BRAND IDENTITY & WEBSITE | Design Firm: Test Monki
Designer: Test Monki | Client: The Tooth Co. | Main Contributor: Test Monki

176 MOORELAND HOUSE VISUAL IDENTITY | Design Firm: Hacin
Designers: David Hacin, Emily Neumann | Clients: Sea-Dar Real Estate, CNW Capital Partners
Main Contributors: Rob Clocker, Eduardo Serrate, Isabelle Carey, Kim Boutwell, Sophie Mailhot

176 TENSURE REBRAND | Design Firm: Matchstic | Designer: Cody Bass | Client: Tensure
Creative Director: Blake Howard | Design Director: Brittany Blankenship | Strategy: Kirby Carol
Copywriter: Cameron Leberecht | Project Manager: Lauren Hood | Main Contributor: Cody Bass

176 ESPAZO ISAURA GÓMEZ | Design Firm: Teiga, Studio.
Designer: María Toucedo Cal | Client: Concello de Tomiño | Creative Director: Xosé Teiga
Art Directors: María Toucedo Cal, Xosé Teiga | Graphic Designer: María Toucedo Cal
Main Contributor: Teiga, Studio.

177 MILWAUKEE ADMIRALS AUTISM ACCEPTANCE | Design Firm: Traction Factory
Designer: Brandon Tushkowski | Client: Milwaukee Admirals | Creative Director: David Brown
Art Director: Brandon Tushkowski | Copywriter: Tom Dixon | Photographer: Scott Paulus
Production Artist: Jenni Wierzba | Project Coordinator: Abby Willner
Account Directors: Shannon Egan, Scott Bucher | Main Contributor: Brandon Tushkowski

177 MN8: YOU GOT POWER | Design Firm: Thackway McCord
Designers: Steve Clarke, Tim Woolliscroft | Client: MN8 Energy
Executive Creative Director: Kat McCord | Creative Director: Steve Clarke
Senior Designer: Tim Woolliscroft | Brand Strategy: Jonathan Paisner
Photographers: Melanie Dunea, Dave Burk | Main Contributor: Thackway McCord

177 GOLDBUG BRANDING | Design Firm: Lafayette American
Designer: Lafayette American | Client: GoldBug | Main Contributor: Lafayette American

177 OPEN HAND AND GOOD MEASURE MEALS REBRAND | Design Firm: Matchstic
Designer: Christian Thompkins | Client: Open Hand | Creative Director: Blake Howard
Project Manager: Melissa Kruse | Main Contributor: Meghan Murray

177 KINETIC | Design Firm: One Design Company
Designers: Ryan Paule, Hannah Cormier, Erick Morales, Mike Phillips | Client: Kinetic
Developer: Karly Hoffman | Account Director: Danielle Pierre
Project Manager: Kristen Romaniszak | Main Contributor: David Sieren

177 UMANZOR LAUNDRY MANAGEMENT | Design Firm: Rolando Castillo
Designer: Rolando Castillo | Clients: Carlos Umanzor, Melissa Umanzor
Main Contributor: Rolando Castillo

178 YULIN TOFU VISUAL IDENTITY | Design Firm: Big House Studio
Designers: Linlan Li, Jiayu Ma | Client: Yulin Tofu | Art Director: Gaozhe Li
Main Contributors: Linlan Li, Jiayu Ma

178 BOMBARDIER: PILOTING A NEW FUTURE FOR BUSINESS AVIATION
Design Firm: Lippincott | Designers: Michael Guerin, Brendan Murphy, Lizzie Harris,
Jeroen Sikma, Will Ferguson, Devin Sager | Clients: Bombardier, Ève Laurier, Maria Pagano
Strategy: Rose Baki, Emily Guilmette, Amanda Abell, Rocky Lam

178 LIVING THE AVANT-GARDE—THE TRITON COLLECTION FOUNDATION
Design Firm: Phillips Marketing Department | Designers: Tirso Montan, Stephanie Chin,
Christine Knorr, James Reeder | Client: Self-initiated
Creative Directors: Martin Schott, Mark Mayer | Chief Marketing Officer: Amy Wexler
Marketing Manager: Anna Ivy | Project Managers: Ally Mintz, Chris Ward
Head of Proposals: Nathan Bendavid | Main Contributor: Phillips

178 WECAN KIDS CLUB: VISUAL BRAND IDENTITY DESIGN
Design Firm: Whimsical Studio | Designer: Jang Won Lee | Client: Wecan Kids Club
Creative Director: Jang Won Lee | Photographer: Jang Won Lee
Location: Suite B109, 78, Gosanja-ro 32-gil, Dongdaemun-gu, Seoul, South Korea
Main Contributor: Jang Won Lee

178 SAN ANTONIO STOCK SHOW & RODEO – 75TH ANNIVERSARY IDENTITY
Design Firm: San Antonio Stock Show & Rodeo | Designer: Anthony Welborn
Client: Self-initiated | Main Contributor: Anthony Welborn

178 FENTON THIS IS THE LIFE | Design Firm: House of Current
Designers: Jenny Park, Koble Delmer | Client: Hines | Creative Director: Wendy Lowden
Art Director: Wendy Lowden | Photography: Scott Lowden Photography
Production Manager: Scott Brannon | Account Manager: Stefanie Demoff
Account Director: Lisa Maloof | Main Contributors: House of Current, Wendy Lowden

178 DRG BRANDING SERIES | Design Firm: BrandTuitive | Designer: Hannah Platte
Client: DRG | Art Director: Dimitri Scheblanov | Main Contributor: Dimitri Scheblanov

178 HALLØJ | Design Firm: Sidecar | Designer: Griffin Orser
Client: Stauning Whisky | Art Director: Lauren Juenger

179 LINDSAY SIU BRANDING | Design Firm: Here Be Monsters
Designer: Jocelyn Wong | Client: Lindsay Siu
Creative Directors: Matt Bielby, Tony Hird | Account Director: Chris Raedcher
Main Contributors: Jocelyn Wong, Tony Hird, Matt Bielby

179 TRULIOO REBRAND | Design Firm: Pendo | Designers: Pendo, Timothy King, Peter Ladd
Client: Trulioo | Creative Director: Peter Ladd | Art Director: Murray Falconer
Brand Strategy: Don Cleland | Copywriter: Ryan Leeson | Illustrators: Jamie Portch, Rory Doyle
Photographer: Grant Harder | Project Managers: Erica Jonsson, Yasmina Hashemi
Main Contributors: Timothy King, Peter Ladd

179 EXPO2027 BRAND IDENTITY | Design Firm: SVIDesign
Designers: Sasha Vidakovic, Joey Lau | Clients: Government of Serbia, BIE - Bureau
International des Expositions | Architect: Fenwick Irribaren Architects
Brand Creative: Sasha Vidakovic | Brand Strategy: Andjelko Trpkovic
Content Designer: Dorijan Kulundzija | Creative Director: Sasha Vidakovic
Design Director: Ian Houghton | Strategy: Publicis Serbia | Typography Design: Sasha Vidakovic
User Experience Architect: Dorijan Kulundzija | User Experience: Galerija 12

179 LUX REBRAND | Design Firm: Pendo | Designers: Pendo, Timothy King, Peter Ladd
Client: Lux Insights | Creative Director: Peter Ladd | Art Director: Jiaan Co
Copywriter: Ryan Leeson | Brand Strategy: Don Cleland | Illustrator: Irena Gajic
Photographer: Grady Mitchell | Project Manager: Erica Jonsson
Main Contributors: Timothy King, Peter Ladd

179 ABSURD / AGAINST BEAUTY | Design Firm: Univisual SRL
Designers: Gaetano Grizzanti, Giancarlo Tosoni | Client: ABSURD Group S.r.l. Società Benefit
Main Contributors: Gaetano Grizzanti, Giancarlo Tosoni

179 THE PLAYLIST | Design Firm: Krit Design Club | Designers: Vincent Tanvis,
Gandhi Gultom, Natasya Christabel, Frederick Austin, Raven Ashley | Client: Self-initiated

179 UÍMA - ECOSSISTEMA FLUVIAL | Design Firm: PMDESIGN
Designer: Paulo Marcelo | Client: Município de Santa Maria da Feira | Photographer: Vânia Costa
Motion Designer: Rui Silva | Illustrators: Luís Taklim, Anyforms | Main Contributor: Paulo Marcelo

179 PORTUGUESE GOVERNMENT NEW VISUAL IDENTITY
Design Firm: Studio Eduardo Aires | Designers: Tiago Campeã, Miguel Almeida, Raquel Piteira,
Joana Teixeira, Anastasiia Potapenko | Client: Government of Portugal
Creative Director: Eduardo Aires | Art Director: Eduardo Aires
Photographers: Óscar Almeida, Nuno Moreira, Diana Quintela | Main Contributor: Eduardo Aires

180 DEVDAY | Design Firm: Play | Designers: Play, OpenAI
Client: OpenAI | Main Contributor: Play

180 BUILDING SUCCESS TOGETHER: REDEFINING AMG'S BRAND OF PARTNERSHIP
Design Firm: Sequel Studio | Designer: Alban Oroz | Client: AMG
Executive Creative Director: Wendy Blattner | Creative Director: David Phan
Brand Strategy: Alex Reid | Managing Director: Brian Crooks | Web Designer: Jesse Wong
Production Manager: Michael Steinhofer | Production Artist: Lora Ewing
Project Managers: Jennifer Vazquez, Stephanie Subervi | Main Contributor: Alban Oroz

180 CYNERGY™ SERIES RATCHET LAUNCH | Design Firm: Traction Factory
Designer: Mike Basse | Client: Snap-on Tools | Design Director: David Brown
Art Director: Mike Basse | Copywriters: S.J. Barlament, Tom Dixon
Production Artist: Jenni Wierzba | Project Managers: Liz Wilson, Pam Sallis
Account Director: Shannon Egan | Main Contributor: Mike Basse

180 BANKABOX BRANDING | Design Firm: Lisa Sirbaugh Creative
Designer: Lisa Sirbaugh | Client: Bankabox | Main Contributor: Lisa Sirbaugh Creative

180 FICCT BRANDING PROJECT | Design Firm: Balloon Inc.
Designer: Ryo Shimizu | Client: Osaka University | Art Director: Ryo Shimizu
Main Contributor: Balloon Inc.

180 HOWDY PEDIATRIC DENTAL STUDIO BRAND IDENTITY | Design Firm: Test Monki
Designer: Test Monki | Client: Howdy Pediatric Dental Studio | Main Contributor: Test Monki

180 CONFRONTING DESIGN | Design Firm: One Design Company | Designer: Kyle Meyer
Client: Chicago Graphic Design Club | Main Contributor: David Sieren

180 BRAND IDENTITY FOR YY PROJECT | Design Firm: Claire Zou
Designer: Claire Zou | Client: YY Project | Main Contributor: Claire Zou

181 OES BE PREPARE EMERGENCY DISASTER FULL ADVERTISING CAMPAIGN
Design Firm: Freaner Creative & Design | Designer: Ariel Freaner
Clients: San Diego County Office of Emergency Services, Daniel Vasquez
Art Director: Ariel Freaner | Digital Artist: Ariel Freaner | Main Contributor: Ariel Freaner

181 THE GREEN BOAT | Design Firm: Next Brand | Designer: Jessica Havea
Client: The Green Boat | Creative Director: Heather Selsick | Strategy Director: Lee Selsick
Main Contributor: Next Brand

181 THE ROYAL PARKS HALF | Design Firm: Rose | Designer: Rose
Client: The Royal Parks Half | Main Contributor: Rose

181 YOUTUBE MUSIC RECAP 2022 | Design Firms: Google, YouTube Music
Designer: Minkwan Kim | Client: Self-initiated | Creative Director: Gabriela Namie
Art Director: Minkwan Kim | Animator: Minkwan Kim | Copywriter: Colleen Clark
Interactive Designer: Mike Brand | Main Contributor: Minkwan Kim

181 RED CROSS BINATIONAL DONATION CAMPAIGN
Design Firm: Freaner Creative & Design | Designer: Ariel Freaner
Clients: Red Cross of Tijuana, Jorge Astiazaran | Creative Director: Ariel Freaner
Creative Production Partner: Ariel Mitchell Freaner | Digital Artist: Ariel Freaner
Editor: Fernanda Freaner | Main Contributor: Ariel Freaner

181 CASINOS.COM REBRAND | Design Firm: Matchstic | Designer: Cody Bass
Client: Casinos.com | Creative Director: Blake Howard | Design Director: Meghan Murray
Copywriter: Cameron Leberecht | Project Manager: Lauren Hood
Strategy: Dee Boyle | Main Contributor: Sean Jones

181 FROM COLORFUL TO COLOR-THOUGHTFUL
Design Firms: Microsoft Brand Studio, FranklinTill, Pantone
Designers: Microsoft Brand Studio, FranklinTill, Pantone | Client: Microsoft
Main Contributors: Microsoft Brand Studio, FranklinTill, Pantone

181 CROSSBOUNDARY GROUP BRANDING | Design Firm: Ahoy Studios
Designers: Connie Koch, Denise Sommer, Denis Kuchta, Paulina Raczkowska
Client: CrossBoundary Group | Main Contributors: Connie Koch, Denise Sommer

182 WAYZGOOSE 2023 | Design Firm: Go Welsh | Designers: Craig Welsh, Jenna Flickinger
Clients: Hamilton Wood Type & Printing Museum, Stephanie Carpenter, Erin Beckloff
Creative Director: Craig Welsh | Main Contributor: Go Welsh

182 ASSEMBLED MEDIA | Design Firm: Next Brand
Designer: Ashley Menezes | Client: Assembled Media | Creative Director: Lee Selsick
Strategy Director: Lee Selsick | Main Contributor: Next Brand

182 PRAZA CULTURA BRANDING | Design Firm: Teiga, Studio.
Designer: Xosé Teiga | Client: Concello de Tomiño
Creative Director: Xosé Teiga | Art Directors: Xosé Teiga, Maria Toucedo Cal
Graphic Designers: Maria Toucedo Cal, Xosé Teiga | Main Contributor: Teiga, Studio.

182 OPTICAT | Design Firm: C&G Partners LLC | Designer: Maya Kopytman
Client: Optica | Creative Directors: Maya Kopytman, C&G Partners LLC
Art Directors: Maya Kopytman, C&G Partners LLC | Animator: Rui Li
Assistant Designers: Maya Zimmer, Gabriele Schies, Melinda Sekela, Nike Adewumi
Illustrator: Joao Miranda | Main Contributor: C&G Partners LLC

182 BUTTERFLY SUPERHIGHWAY | Design Firm: Lafayette American
Designer: Lafayette American | Client: Self-initiated | Main Contributor: Lafayette American

182 ADS AND THE CITY: OUT-OF-HOME EVENT BRANDING | Design Firm: Claire Zou
Designer: Claire Zou | Client: The Advertising Club of New York | Main Contributor: Claire Zou

182 QUASTELLA BRANDING PROJECT | Design Firm: Balloon Inc.
Designer: Ryo Shimizu | Client: Quastella Inc. | Main Contributor: Balloon Inc.

182 INDUSTRIAL AUTOMATION CLOCK AD | Design Firm: Mouser Electronics
Designer: Mouser Electronics Creative Design Team | Client: Self-initiated
Main Contributor: Mouser Electronics Creative Design Team

183 OBSERVATIONS | Design Firm: CutlerBremner | Designer: Scott Bremner
Client: Self-initiated | Main Contributor: Craig Cutler

183 AMERICAN COLLEGE OF THE BUILDING ARTS BROCHURE
Design Firm: Not William | Designer: Rich Wallace | Client: American College of the Building Arts
Creative Director: Rich Wallace | Art Director: Rich Wallace | Copywriter: Rich Wallace
Photographer: Will Martinez | Main Contributor: Rich Wallace

183 TEKNION KIOSK BROCHURE | Design Firm: Vanderbyl Design
Designers: Michael Vanderbyl, Tori Koch | Client: Teknion | Main Contributor: Michael Vanderbyl

183 BUTTERFIELD & ROBINSON BROCHURE | Design Firm: Viva & Co.
Designer: Todd Temporale | Client: Butterfield & Robinson
Illustrators: Frank Viva, Greg Clarke | Writer: Frank Viva | Main Contributor: Viva & Co.

183 VHS MAGAZINE | Design Firm: Gastdesign | Designer: Wolfgang Gast
Client: VHS Langenfeld/Rhld. | Main Contributor: Wolfgang Gast

183 A WORLD OF CLUBS AND FENCES | Design Firm: White & Case LLP
Designer: Caroline Caldwell | Client: Self-initiated | Creative Director: Kim Robak
Art Director: Karolina Pietrynczak | Brand Creative: Robin McLoughlin
Illustrator: Kotryna Zukauskaite | Printing: Noel Tocci, TocciMade
Production Manager: Lillian Martinez | Main Contributor: Caroline Caldwell

184 2024 ARTIENCE CALENDAR "ART+SCIENCE" | Design Firm: TOPPAN INC.
Designer: Masahiro Aoyagi | Client: artience Co., Ltd. | Main Contributor: Masahiro Aoyagi

184 2024 CALENDAR CITYSCAPES -MEMORIES- | Design Firm: TOPPAN INC.
Designer: Masahiro Aoyagi | Client: Obayashi Corporation | Photographer: Sohei Nishino
Print Designer: Kazuya Tanaka | Main Contributor: Masahiro Aoyagi

184 CALENDAR 4 KEEPS | Design Firm: BEKAR HAUS D.O.O.
Designers: Alira Hrabar Bekar, Dušan Bekar | Client: HRVATSKA POŠTANSKA BANKA
Main Contributors: Alira Hrabar Bekar, Dušan Bekar

184 BRIDGES OF PROGRESS (SEVENTY YEARS OF PIONEERING AND TRAILBLAZING)
Design Firm: Studio 5 Designs Inc. (Manila) | Designer: Ermil Carranza | Clients: Alcantara Group
of Companies, Sylvia Duque, Anna Alcantara | Creative Director: BG Hernandez
Account Director: Marily Oroco | Main Contributor: Studio 5 Designs Inc. (Manila)

184 CENTRAL MARKET FOODIE TRADING CARDS | Design Firm: *Trace Element
Designer: Jeff Barfoot | Client: Central Market | Chief Creative Officer: Jeff Barfoot
Copywriter: Plot Twist Creativity | Printer: Ussery Printing | Paper: Clampitt Paper
Account Director: Anna Mertz | Account Management: Kasey Cooley
Main Contributor: Jeff Barfoot

184 NARI WARD – HOME OF THE BRAVE CATALOG AND EXHIBITION DESIGN
Design Firm: Ahoy Studios | Designers: Connie Koch, Denise Sommer, Denis Kuchta,
Hannah Ying | Client: Vilcek Foundation | Artist: Nari Ward | Writer: Erica Moiah James
Main Contributors: Connie Koch, Denise Sommer

185 SNAP-ON TOOLS CATALOG | Design Firm: Traction Factory | Designer: Mike Basse
Client: Snap-on Tools | Creative Director: Tom Dixon | Art Director: Mike Basse
Design Director: David Brown | Director of Photography: Kevin Netz
Copywriters: Tom Dixon, Kirk Ruhnke | Production Artist: Jenni Wierzba
Account Director: Shannon Egan | Agency: Traction Factory | Project Manager: Pam Sallis
Retouching: Benny DeLaHunt | Main Contributor: Mike Basse

185 BEJEWELED MAILER | Design Firm: Neiman Marcus Brand Creative
Designer: Lisa Garcia | Client: Self-initiated | Art Director: Devin Hall
Design Director: Lori Dibble | Chief Creative Officer: Nabil Aliffi | Copywriter: Kate Watson
Editors: JoAnne Crist, Katy Richardson | Production Manager: Sharon Murway
Main Contributors: Lisa Garcia, Devin Hall

185 THE MODERNS THAT MATTER: SARASOTA 100 PUBLICATION
Design Firm: Studio Craig Byers | Designer: Craig Byers | Client: Architecture Sarasota
Main Contributor: Craig Byers

185 SCAD ADMISSION CATALOG 2023-24 | Design Firm: Savannah College of Art & Design
Designers: Savannah College of Art & Design, Jen Young Hammer | Client: Self-initiated
Executive Creative Director: Chris Miller | Creative Director: Hadley Stambaugh
Associate Creative Director: Jen Young Hammer | Senior Art Director: Jennifer McCarn
Director of Photography: Siobhan Bonnouvrier | Photo Director: Chris Ambrose
Senior Designer: Jinna Lee | Editors: Jeffery Catron, Chantel Britton | Contributor: Emma Hatch
Photographers: Aman Shakya, Allison Smith, Yani Pedroza, Colin Gray
Retouchers: Scott Newman, Jarred Joly | Studio: Alex Neumann | Print Producer: Erin Williams
Producers: Anna Robertson, Jenny Upperman, Adam Williams, Trey Vereen
Writers: Matthew McNab, Michelle Ray, Sarah Kramer, Kendall McKinnon, Emily King
Main Contributor: Savannah College of Art & Design

185 SCAD ACADEMIC CATALOG 2022-23 | Design Firm: Savannah College of Art & Design
Designer: Andy Yanchunis | Client: Self-initiated | Agency: Savannah College of Art & Design
Executive Creative Director: Chris Miller | Senior Art Director: Jennifer McCarn
Art Director: Savannah College of Art & Design | Lead Designer: Jen Young Hammer
Senior Designer: Jinna Lee | Director of Photography: Siobhan Bonnouvrier
Photo Director: Chris Ambrose | Photographers: Hadley Stambaugh, Colin Gray, Allison Smith,
Aman Shakya, Chia Chong, Nick Thomsen, Justin Chan, Santiago Vega
Photo Retouching: Scott Newman, Jarred Joly, Taylor Franco | Studio: Alex Neumann
Writers: Tiara Hodges, Matthew McNab | Producers: Jenny Upperman, Trey Vereen, Ryan King
Contributors: Hannah Jakubowski, Emma Hatch
Main Contributor: Savannah College of Art & Design

185 MATERIALIZING MEMORY | Design Firm: Lingou Li | Designer: Lingou Li
Client: Self-initiated | Main Contributor: Lingou Li

186 MAKE THIS YEAR THE GREATEST. | Design Firm: Nikkeisha, Inc.
Designer: Ayaka Kawamata | Client: Self-initiated | Creative Director: Hiroyuki Nakamura
Art Director: Hiroyuki Nakamura | Copywriter: Keika Katsumata | Illustrator: Ayaka Kawamata
Main Contributor: Nikkeisha, Inc.

186 OUR COMMITMENTS | Design Firms: Microsoft Brand Studio, Microsoft Design Studio
Designers: Microsoft Brand Studio, Microsoft Design Studio | Client: Self-initiated
Main Contributors: Microsoft Brand Studio, Microsoft Design Studio

186 HONKI FACTORY VISUAL IDENTITY | Design Firm: Daichi Takizawa
Designer: Daichi Takizawa | Client: Honki Factory Co., Ltd | Art Director: Daichi Takizawa
Typeface Designer: Daichi Takizawa | Main Contributor: Daichi Takizawa

186 2023 WHITE & CASE PARTNER HOLIDAY CELEBRATION PROGRAM COVER
Design Firm: White & Case LLP | Designer: Dawn Jasper | Client: Self-initiated
Main Contributor: Dawn Jasper

186 REIMAGINE ACTION: LET'S PUT AI TO WORK FOR THE PLANET
Design Firms: Microsoft Brand Studio, Koto Studio, O0 Design, Alexis Jamet
Designers: Microsoft Brand Studio, Koto Studio, O0 Design, Alexis Jamet | Client: Microsoft
Main Contributors: Microsoft Brand Studio, Koto Studio

186 PAPA JOHNS ESG REPORT | Design Firm: Addison | Designer: JG Debray
Client: Papa Johns | Creative Director: Kevin Barclay | Strategy: Russ Kuhner
Main Contributor: JG Debray

187 HIGH FIBER | Design Firm: McCandliss and Campbell
Designers: Trevett McCandliss, Nancy Campbell | Client: Footwear Plus Magazine
Creative Directors: Trevett McCandliss, Nancy Campbell | Photographer: Trevett McCandliss
Editor-in-Chief: Greg Dutter | Stylist: Mariah Walker | Main Contributor: Trevett McCandliss

187 GENERATION NEXT | Design Firm: McCandliss and Campbell
Designers: Trevett McCandliss, Nancy Campbell | Client: Earnshaw's Magazine
Editor-in-Chief: Michele Silver | Fashion Director: Mariah Walker
Photographer: Zoe Adlersberg | Main Contributors: Trevett McCandliss, Nancy Campbell

187 A PERFECT KEN | Design Firm: Wainscot Media
Designers: Nancy Campbell, Trevett McCandliss | Client: Footwear Plus Magazine
Editor-in-Chief: Greg Dutter | Photographer: Mark Andrew | Fashion Director: Mariah Walker
Main Contributors: Nancy Campbell, Trevett McCandliss

187 BLUE CRUSH | Design Firm: McCandliss and Campbell
Designers: Nancy Campbell, Trevett McCandliss | Client: Footwear Plus Magazine
Editor-in-Chief: Greg Dutter | Fashion Director: Mariah Walker
Photographer: Trevett McCandliss | Main Contributors: Nancy Campbell, Trevett McCandliss

187 NEW WAVE | Design Firm: Wainscot Media
Designers: Nancy Campbell, Trevett McCandliss | Client: Footwear Plus Magazine
Editor-in-Chief: Greg Dutter | Fashion Director: Mariah Walker
Photographer: Mark Andrew | Main Contributors: Nancy Campbell, Trevett McCandliss

187 SUNSHINE SUPERSTARS | Design Firm: Wainscot Media
Designers: Trevett McCandliss, Nancy Campbell | Client: Earnshaw's Magazine
Editor-in-Chief: Michele Silver | Fashion Director: Mariah Walker
Photographer: Zoe Adlersberg | Main Contributors: Trevett McCandliss, Nancy Campbell

188 GLOBAL CLIMATE ACTION SURVEY 2023 | Design Firm: Gensler Research Institute
Designers: Laura Latham, Lela Johnson, Minjung Lee | Client: Self-initiated
Main Contributors: Laura Latham, Lela Johnson, Minjung Lee

188 ZACH WEISS IS EVERYWHERE | Design Firm: Wainscot Media
Designers: Trevett McCandliss, Nancy Campbell | Client: MR Magazine
Editor-in-Chief: Karen Alberg Grossman | Editor: John Russel Jones
Photographer: Krista Schlueter | Stylist: Michael Macko
Main Contributors: Trevett McCandliss, Nancy Campbell

188 LEX MAGAZINE 2023 | Design Firm: Code Switch
Designer: Jan Šabach | Client: Thomas R. Kline School of Law at Drexel University
Creative Director: Brian Crooks | Art Director: Jan Šabach
Managing Editor: Nancy J. Waters | Proofreader: Purnell Cropper
Additional Title: Dean: Daniel M. Filler | Main Contributor: Jan Šabach

188 WAYFARE MAGAZINE ISSUES 1, 2, 3 | Design Firm: TopoGraphic Studio
Designer: Cole Melanson | Client: Faith Matters Foundation
Associate Creative Director: Douglas Thomas | Editor: Zachary Davis
Artists: Sarah Winegar, Jorge Cocco, Steph Johnsen | Main Contributor: Cole Melanson

188 OES PERSONAL DISASTER PLAN | Design Firm: Freaner Creative & Design
Designer: Ariel Freaner | Client: San Diego County Agricultural Weights and Measures
Art Director: Ariel Freaner | Digital Artist: Ariel Freaner | Main Contributor: Ariel Freaner

**188 LET'S GET THERE GETTING 2 ZERO - SAN DIEGO COUNTY DECARBONIZATION
FRAMEWORK** | Design Firm: Freaner Creative & Design
Designer: Ariel Freaner | Client: San Diego County Land Use & Environment
Art Director: Ariel Freaner | Digital Artist: Ariel Freaner | Main Contributor: Ariel Freaner

189 THE RISE IN U.S. GUN VIOLENCE | Design Firm: Kathy Mueller Design, LLC
Designer: Kathy Mueller | Client: The Public Policy Lab at Temple University
Main Contributor: Kathy Mueller

189 DEGREES OF SUCCESS | Design Firm: Kathy Mueller Design, LLC
Designer: Kathy Mueller | Client: The Public Policy Lab at Temple University
Main Contributor: Kathy Mueller

189 SOCRATES IS DEAD | Design Firm: Randy Clark Graphic Design
Designer: Randy Clark | Client: Spark | Main Contributor: Randy Clark

189 EYE OPENER SESSIONS CAMPAIGN | Design Firm: Truth Collective
Designer: Matt McKeveny | Client: Association of Schools and Colleges of Optometry (ASCO)
Creative Strategist: Josh Coon | Senior Designer: Ruth Rossi | Strategy: Ken McVeagh
Writers: Alyssa Davis, Julie Clementi | Project Manager: Ashley Stoller
Account Director: Jennifer Piper | Main Contributor: Matt McKeveny

189 ART THINKING & DESIGN THINKING
Design Firm: Kiyoung An Graphic Art Course Laboratory | Designer: Kiyoung An
Client: KINDAI University | Design Director: Kiyoung An
Main Contributor: KINDAI University

189 COOPERATION ACTIVITIES FOR GA COURSE'S "TEAM EXPO 2025"
Design Firm: Kiyoung An Graphic Art Course Laboratory | Designer: Kiyoung An
Client: KINDAI University | Art Director: Kiyoung An
Main Contributor: KINDAI University

189 WALK ACROSS ITALY WITH CSU! | Design Firm: Gravdahl Design
Designer: John Gravdahl | Client: International Programs at Colorado State University
Copywriter: John Gravdahl | Photographer: John Gravdahl
Main Contributor: John Gravdahl

190 MAKE PRIDE | Design Firms: Microsoft Brand Studio, Sterling, O0 Design, Atypic
Designers: Microsoft Brand Studio, Sterling, O0 Design, Atypic | Client: Microsoft
Main Contributors: Microsoft Brand Studio, Sterling

190 THE ECONOMIC JUSTICE PARTNERSHIP BRAND IDENTITY
Design Firm: Elmwood New York | Designer: Elmwood New York
Client: The Economic Justice Partnership | Main Contributor: Elmwood New York

190 FAYETTEVILLE STATE UNIVERSITY POSTER CAMPAIGN
Design Firm: The Republik | Designer: Brad Magner | Client: Fayetteville State University
Creative Directors: Brad Magner, Robert Shaw West | Art Directors: Matt Shapiro, Dallas West
Account Executives: Kirk deViere, Vanessa Nguyen | Copywriter: Dwayne Fry
Photographer: Tyler Northrup | Main Contributor: Robert Shaw West

190 THE BREEZE | Design Firm: Airspace | Designers: Jill Ayers, Rachel Einsidler
Client: Hudson Companies | Creative Director: Jill Ayers | Senior Designer: Rachel Einsidler
Fabricator: Drive2 | Main Contributor: Airspace

190 LYFT EAST COAST HEADQUARTERS | Design Firm: Airspace
Designers: Jill Ayers, Rachel Einsidler | Client: Lyft | Creative Director: Jill Ayers
Senior Designer: Rachel Einsidler | Architect: Studios Architecture
Fabricator: Applied Image | Main Contributor: Airspace

190 HYATT CENTRIC GAOXIN XI'AN ART MURALS | Design Firm: Jansword Design
Designer: Jansword Zhu | Client: Hyatt | Art Director: Jansword Zhu | Artist: Jansword Zhu
Assistant Designers: Sola Wang, Ma Deqiang, Wang Yuan, Huang Dacheng, Zhang Ruize,
Zhou Lejia | Architect: Kuma Kengo | Interior Designer: Lauwis Ricky (Zinta)
Account Director: Jinn Liu | Main Contributor: Jansword Zhu

190 DESIGNED BY DATA | Design Firm: Asterisk | Designer: Asterisk
Client: NI | Main Contributor: Asterisk

190 NICE-PAK HEADQUARTERS | Design Firm: Airspace
Designers: Jill Ayers, Rachel Einsidler | Client: Nice-Pak
Creative Director: Jill Ayers | Fabricator: Design Communications Ltd.
Project Manager: Rachel Einsidler | Main Contributor: Airspace

191 PIER 57 | Design Firm: Airspace | Designers: Jill Ayers, Rachel Einsidler, Branson Kellen,
Daniel Berja | Client: Jamestown | Creative Director: Jill Ayers | Fabricator: Drive21
Project Director: Rachel Einsidler | Main Contributor: Airspace

191 PEPSI 125 DINER | Design Firm: PepsiCo | Designer: PepsiCo
Client: Self-initiated | Main Contributor: PepsiCo

191 JUNIOR ACHIEVEMENT: FREE ENTERPRISE CENTER | Design Firm: 3D-Identity
Designer: Andon Malone | Client: Junior Achievement Rocky Mountain
Senior Designer: Abigail Knab | Project Manager: Hillary Brubaker | Main Contributor: 3D-Identity

191 VETERINARY DIAGNOSTIC LABORATORY DONOR WALL
Design Firm: Bailey Lauerman | Designer: Sarah Northcutt
Client: College of Veterinary Medicine at Iowa State University | Design Director: Jim Ma
Chief Creative Officer: Carter Weitz | Production Manager: Gayle Adams
Account Director: Liz Urbaniak | Main Contributor: Sarah Northcutt

191 650 TOWNSEND WAYFINDING AND ENVIRONMENTAL GRAPHICS
Design Firm: Volume Inc. | Designer: Volume Inc.
Client: Beacon Capital | Main Contributor: Volume Inc.

191 DEVDAY | Design Firm: Play | Designers: Play, OpenAI
Client: OpenAI | Main Contributors: Play, OpenAI

191 BMO PLACE | Design Firm: Entro
Designers: Entro, Gerald Querubin, Donna Lui, Rachel Wallace, Paolo Emili
Client: Bank of Montreal (BMO) | Creative Directors: Udo Schliemann, Jacqueline Tang
Project Director: Rob Daly | Research: Vedran Dzebic
Other: Rae Lam Fox, Partner-in-Charge | Main Contributor: Entro

191 ST. FRANCIS COLLEGE | Design Firm: Airspace | Designers: Jill Ayers, Rachel Einsidler,
Branson Kellen, Daniel Berja | Client: St. Francis College | Creative Director: Jill Ayers
Fabricators: Duggal, L&M Signs | Project Manager: Rachel Einsidler | Main Contributor: Airspace

192 THE MODERNS THAT MATTER: SARASOTA 100 EXHIBITION
Design Firm: Studio Craig Byers | Designer: Craig Byers | Client: Architecture Sarasota
Illustrator: John Pirman Illustration | Main Contributor: Craig Byers

192 PRESENCE OF PLANTS IN CONTEMPORARY ART | Design Firm: Siena Scarff Design
Designer: Siena Scarff | Client: Isabella Stewart Gardner Museum
Photographer: Images courtesy Isabella Stewart Gardner Museum, Boston
Main Contributor: Siena Scarff

192 PELLIER PARK INTERPRETIVE PROGRAM | Design Firm: Volume Inc.
Designer: Volume Inc. | Client: The City of San Jose | Creative Director: Adam Brodsley
Main Contributor: Volume Inc.

192 RICHARD GILDER CENTER FOR SCIENCE, EDUCATION, AND INNOVATION
Design Firm: Ralph Appelbaum Associates | Designer: Ralph Appelbaum Associates
Client: American Museum of Natural History | Project Manager: Matt Krupanski
Main Contributor: Ralph Appelbaum Associates

192 INVISIBLE WORLDS PRE-SHOW
Design Firm: American Museum of Natural History - Exhibitions Department
Designer: American Museum of Natural History | Client: Self-initiated
Art Director: Catharine Weese | Design Director: Michael Meister
Exhibition Designer: Cine Ostrow | Graphic Designer: Nicole Fox
Photo Editor: Jose Ramos | Project Coordinator: Ron Demetrio | Writer: Laura Moustakerski
Project Managers: Katherine Browning, Dina Langis | Senior Vice President: Lauri Halderman
Others: Sasha Nemecek, Director of Exhibition Interpretation, Melissa Posen, Senior Director of
Exhibition Operations, Antonia Gabor, Assistant Director of Graphics Production
Main Contributor: American Museum of Natural History - Exhibitions Department

192 THE SECRET WORLD OF ELEPHANTS
Design Firm: American Museum of Natural History - Exhibitions Department
Designers: American Museum of Natural History, Eleanor Kung, Nicole Fox, Ron Demetrio,
Rayna Weingord | Client: Self-initiated | Art Director: Catharine Weese
Senior Vice President: Lauri Halderman | Graphic Implementation Coordinator: Ron Demetrio
Exhibition Designer: Cine Ostrow | Design Director: Michael Meister
Photo Editor: Jose Ramos | Project Manager: Dina Langis | Illustrator: Rayna Weingord
Writers: Martin Schwabacher, Margaret Dornfield, Allison Hollinger, Willow Lawson

Others: Assistant Director of Graphic Production: Antonia Gabor, Curator: Ross MacPhee, Senior Director for Exhibition Operations: Melissa Posen
Main Contributor: American Museum of Natural History - Exhibitions Department

193 "UPROOTED: AN AMERICAN STORY" | Design Firm: C&G Partners LLC
Designer: Jonathan Alger | Client: The California Museum | Project Coordinator: Kevin Samaya
Project Manager: Laura Grady | Main Contributor: C&G Partners LLC

193 WHAT A WONDERFUL WORLD | Design Firm: C&G Partners LLC
Designers: Jonathan Alger, Chris Mills | Client: The Louis Armstrong House Museum
Architects: Sara Caples, Everado Jefferson | Interactive Designer: Potion Design
Fabricator: Art Guild | Project Manager: Shuyler Nazareth | Main Contributor: C&G Partners LLC

193 LOUIS V. GERSTNER, JR. COLLECTIONS CORE
Design Firm: American Museum of Natural History - Exhibitions Department
Designer: American Museum of Natural History | Client: Self-initiated
Art Director: Catharine Weese | Graphic Designers: Rayna Weingord, Eleanor Kung
Senior Vice President: Lauri Halderman | Graphic Implementation Coordinator: Ron Demetrio
Project Managers: Katherine Browning, Dina Langis | Writers: Margaret Dornfield, Stuart Fox,
Allison Hollinger, Emily Hoff, Martin Schwabacher | Photo Editor: Jose Ramos
Others: Debra Everett-Lane, Associate Director of Gilder Exhibit Content; Sasha Nemecek,
Director of Exhibition Interpretation; Antonia Gabor, Assistant Director of Graphic Production;
Melissa Posen, Senior Director of Exhibitions Operations
Main Contributor: American Museum of Natural History - Exhibitions Department

193 SUSAN AND PETER J. SOLOMON FAMILY INSECTARIUM
Design Firm: American Museum of Natural History - Exhibitions Department
Designer: American Museum of Natural History | Client: Self-initiated
Art Director: Catharine Weese | Graphic Designers: Rayna Weingord, Eleanor Kung
Senior Vice President: Lauri Halderman | Project Managers: Katherine Browning, Dina Langis
Graphic Implementation Coordinator: Ron Demetrio | Photo Editor: Jose Ramos
Writers: Debra Everett-Lane, Allison Hollinger, Emily Hoff, Martin Schwabacher
Others: Debra Everett-Lane, Associate Director of Gilder Exhibit Content; Sasha Nemecek,
Director of Exhibition Interpretation; Antonia Gabor, Assistant Director of Graphic Production;
Melissa Posen, Senior Director of Exhibitions Operations; Hazel Davies, Director of Live Exhibits
Main Contributor: American Museum of Natural History - Exhibitions Department

193 50 YEARS GERMANY IN THE UNITED NATIONS EXHIBIT | Design Firm: Ahoy Studios
Designers: Connie Koch, Denise Sommer, Giulia Zoavo, Patricia Schuh
Client: Permanent Mission of Germany to the United Nations
Main Contributors: Connie Koch, Denise Sommer

193 STATE STREET: A NEW CHAPTER FOR A STORIED FINANCIAL INSTITUTION
Design Firm: Lippincott | Designers: Jenifer Lehker, James Atkins, Aurelio Saiz, Victor Rijo,
Devin Sager, Kaito Gengo, Charlotte Sunnen, Kishen Pujara, Labelle Chang, Kevin Grady
Client: State Street | Chief Marketing Officer: Brenda Tsai; State Street
Creative Director: Patrick Gray; State Street | Design Director: Joseph Kowan; State Street
Others: Daniel Johnston, Partner, Experience, Innovation, & Engineering; Lippincott, Hillary
Gove, Brand and Design Program Manager; State Street, Raja Singh, Head of Creative Services;
State Street, Josh Mason, Digital Strategy and Delivery; State Street, Shivakumar Basavaraju,
Digital Services and Publishing; State Street, Eric Garulay, Content Strategy and Development;
State Street

**193 STORI: BUILDING STABILITY AND CONFIDENCE FOR LATAM'S UNBANKED
MILLIONS** | Design Firm: Elmwood New York | Designer: Elmwood New York
Client: Stori Card | Illustrator: Luis Santiesteban

193 RE-IMAGINING CFA INSTITUTE | Design Firm: Elmwood New York
Designer: Elmwood New York | Client: CFA Institute

194 REVITALIZING PAUL HOBBS WINERY'S PACKAGING FOR MODERN EXCELLENCE
Design Firm: Affinity Creative Group | Designer: Affinity Creative Group
Client: Paul Hobbs Winery | Main Contributor: Affinity Creative Group

194 RED LOCKS IRISH WHISKEY | Design Firm: Duffy & Partners
Designers: Joe Duffy, Joseph Duffy | Client: Red Locks Irish Whiskey
Main Contributor: Duffy & Partners

194 MENIN D. BEATRIZ | Design Firm: Omdesign | Designer: Diogo Gama Rocha
Client: Menin Douro Estates | Main Contributor: Omdesign

194 BLACK CHALK STILL WINE | Design Firm: Chase Design Group
Designers: Peter Hawkins, Sarahna Drury, Jordan Cox | Client: Black Chalk Wine
Production: Simon Ward | Main Contributor: Chase Design Group

194 TOKYO SPICE GIN
Designer: Chikako Oguma | Client: Tokyo Hachioji Distillery
Creative Director: Shintaro Nakazawa | Main Contributor: Chikako Oguma

194 THE HONEY THIEF | Design Firm: Idle Hands | Designer: André de Waal
Client: Black Elephant Vintners & Co. | Creative Director: André de Waal
Copywriter: André de Waal | Illustrator: André de Waal | Main Contributor: André de Waal

194 ACIDITY TRIP PACKAGING DESIGN
Design Firm: Affinity Creative Group | Designer: Affinity Creative Group
Client: Acidity Trip Wines | Main Contributor: Affinity Creative Group

194 SAINAS PACKAGING | Design Firm: Teiga, Studio. | Designer: Maria Toucedo Cal
Client: Sainas | Creative Director: Xosé Teiga | Art Directors: Maria Toucedo Cal, Xosé Teiga
Graphic Designer: Maria Toucedo Cal | Copywriter: Maria Toucedo Cal
Creative Strategist: Maria Toucedo Cal | Main Contributor: Teiga, Studio.

194 ETERNO VERANO TEQUILA | Design Firm: HOOK
Designer: Trish Ward | Client: Grain and Barrel Spirits
Creative Director: Brady Waggoner | Main Contributor: Trish Ward

195 TOMMARROW BI | Design Firm: DAEKI and JUN
Designers: Daeki Shim, Hyojun Shim, Junseok Kim
Clients: Tommarrow (CEO Seung Hyun Won), Gangwon Institute of Design Promotion (GIDP),
Choi In-Sook, Choi Yong-Sun, Shin Kyoung-Cheol, Jang Aeri, Lee Mi-Kyung, Choi Jung-Won,
Seong Yeong-Shin, Park Young-Jo | Art Directors: Daeki Shim, Hyojun Shim
Creative Directors: Daeki Shim, Hyojun Shim
Main Contributors: Daeki Shim, Hyojun Shim, Junseok Kim

195 DOLMIO | Design Firm: Elmwood London | Designers: Elmwood London, Emily Morris
Client: Mars | Executive Creative Director: Craig Barnes | Design Lead: Jay Bates
Design Directors: David Walsh, Paul O'Brien | Senior Designer: Sam Povey
Associate Creative Director: Ben Dolman | Account Director: Eleanor Westwood
Others: Creative Lead: Ryan Brown, Chief Provocation Officer: Greg Taylor, Head of 2D and 3D
Animation: Oli Minchin | Main Contributor: Elmwood London

195 WILD TONIC REBRAND | Design Firm: HOOK | Designer: Trish Ward
Client: Wild Tonic | Chief Creative Director: Brady Waggoner | Art Director: Brett Tighe
Illustrator: Chris Engler | Main Contributor: Trish Ward

195 OAK CLIFF BREWING CO. PACKAGING | Design Firm: *Trace Element
Designer: Jeff Rogers | Client: Oak Cliff Brewing Co. | Account Director: Jenna Snyder
Creative Director: Jeff Rogers | Chief Creative Officer: Jeff Barfoot
Main Contributor: Jeff Rogers

195 HORIZON ORGANIC BRAND REFRESH | Design Firm: Elmwood New York
Designers: Elmwood New York, Horizon Organic | Client: Horizon Organic
Main Contributor: Elmwood New York, Horizon Organic

195 REVL FRUITS BRAND IDENTITY
Design Firm: Elmwood New York | Designer: Elmwood New York | Client: Revl Fruits
Photographers: Leslie Grow, Sarah Anne Ward | Main Contributor: Elmwood New York

195 LAVAZZA CHINA COFFEE PACKAGING | Design Firm: *Trace Element
Designer: Jeff Rogers | Client: Lavazza | Chief Creative Officer: Jeff Barfoot
Account Director: Anna Mertz | Main Contributor: Jeff Rogers

195 ADAMUS SIGNATURE EDITION 2023 | Design Firm: Omdesign
Designer: Diogo Gama Rocha | Client: Adamus | Main Contributor: Omdesign

196 ACT FOR LIFE. | Design Firms: PEACE Inc., Fujimino Design | Designer: Lee Giltae
Client: Earth Corporation | Creative Director: Yoshihiro Kojima | Director: Mayuko Nakata
Advertising Agency: SO NICE Inc. | Project Manager: Takashi Ikeda | Illustrator: Kenta Kaido
Writer: Fujimino Design | Producer: Risa Mishima | Videographer: Masahito Tatsutomi
Main Contributor: Earth Corporation

196 ANSWER THE IF CAMPAIGN
Design Firm: Cepheid One Studio Internal Agency | Designer: Kirsten Olivet | Client: Self-initiated
Additional Titles: Varun Suneja, Senior Commercial Marketing Manager, India, Bryan Turner,
Senior Marketing Manager, Hospitals, Melanie Stillings, Senior Manager Marketing
Communications, Jared Tipton, Vice President Corporate Communications, Kristin Bialaszewski,
Director of Creative Strategy, Nichole Treeter, Product Management Director, Respiratory,
Amparo Davila, Senior Product Manager, Respiratory, Jamie Aaronson, Senior Content
Marketing Manager, Americas, Nadia Schnack, Senior Digital Marketing Manager,
North America, Isabelle Demange, Marketing Manager, France, Julie Ung-Hoi, Digital Marketing
Manager, Andrew Farrell, Marketing Manager, US Hospitals, Viloshni Govender,
Solutions Marketing Manager, Beatriz Pane, Senior Manager, Marketing, LATAM
Main Contributor: Cepheid One Studio Internal Agency

196 THE YEAR OF THE DRAGON | Design Firm: Gravdahl Design
Designer: John Gravdahl | Client: Self-initiated | Main Contributor: John Gravdahl

196 SPREADING THE WARM FUZZIES | Design Firm: Spire Agency
Designer: Lexi Palmer | Client: Self-initiated | Writer: Mike Stopper
Chief Creative Officer: Kimberly Tyner | Associate Creative Director: Jason James
Printing: ColorMark | Account Supervisor: Julia Cardali | Main Contributor: Spire Agency

196 EASTER BLESSINGS | Design Firm: Darkhorse Design, LLC | Designer: Robert Talarczyk
Client: Self-initiated | Copywriter: Nancy Trezise | Photographer: Robert Talarczyk
Artist: Robert Talarczyk | Main Contributor: Robert Talarczyk

**196 JOHANN TERRETTAZ - TWICE2 - ATELIER DE GRAPHISME & TYPOGRAPHIE
GREETINGS CARD** | Design Firm: Twice2 - Atelier de Graphisme & Typographie
Designer: Johann Terrettaz | Client: Self-initiated | Main Contributor: Johann Terrettaz

196 FLOWERS OF THE PHILIPPINES: A SELECTION OF BOTANICAL ILLUSTRATIONS
Design Firm: Gentry Press OPC | Designer: Gentry Press OPC
Client: ASEAN Centre for Biodiversity | Illustrator: Gizzele Delos Santos-Eustaquio
Author: Domingo A. Madulid | Main Contributor: Gizzele Delos Santos-Eustaquio

197 CORRIDA | Design Firm: Štorkán | Designer: Rudolf Štorkán
Client: Self-initiated | Main Contributor: Štorkán

197 TENDER EMBRACE | Design Firm: ArtCenter College of Design
Designer: William Johnstone | Client: Self-initiated | Main Contributor: William Johnstone

197 AUTISM: THE INVISIBLE SPECTRUM | Design Firm: Studio Holden
Designer: Whitney Holden | Client: Self-initiated | Main Contributor: Whitney Holden

197 #TWOCOLORCHARACTER | Design Firm: HandMade Monsters
Designer: Mark Borgions | Client: Self-initiated | Main Contributor: Mark Borgions

197 SLACKTOBERFEST ILLUSTRATIONS | Design Firm: Spire Agency
Designer: Alex Flores | Client: Slack Davis Sanger | Senior Designer: Alex Flores
Chief Creative Officer: Kimberly Tyner | Associate Creative Director: Jason James
Account Supervisor: Julia Cardali | Main Contributor: Spire Agency

197 CAFÉ D'OURO "O PIOLHO" | Design Firm: Duas Faces Design
Designer: Cristiana Rodrigues | Client: Café Ancora d'Ouro | Creative Director: Sérgio Duarte
Account Executive: Ana Monteiro | Photographer: Sérgio Ferreira
Illustrator: Cristiana Rodrigues | Main Contributor: Sérgio Duarte

198 CITY PULSE 2023: THE FUTURE OF CENTRAL BUSINESS DISTRICTS
Design Firm: Gensler Research Institute | Designers: Laura Latham, Minjung Lee, Lela Johnson
Client: Self-initiated | Main Contributors: Minjung Lee, Lela Johnson, Laura Latham

198 GLOBAL WORKPLACE SURVEY 2024
Design Firm: Gensler Research Institute | Designers: Laura Latham, Minjung Lee, Lela Johnson
Client: Self-initiated | Main Contributors: Minjung Lee, Lela Johnson, Laura Latham

198 GLOBAL WORKPLACE SURVEY COMPARISON 2023
Design Firm: Gensler Research Institute | Designers: Laura Latham, Minjung Lee, Lela Johnson
Client: Self-initiated | Main Contributors: Minjung Lee, Lela Johnson, Laura Latham

198 THE RETURN OF THE CITY: A 2024 RETROSPECTIVE OF THE CITY PULSE
Design Firm: Gensler Research Institute | Designers: Laura Latham, Minjung Lee, Lela Johnson, Jennifer Knotts | Client: Self-initiated | Main Contributors: Minjung Lee, Lela Johnson, Jennifer Knotts, Laura Latham

198 SLACKTOBERFEST INVITATION | Design Firm: Spire Agency | Designer: Alex Flores
Client: Slack Davis Sanger | Chief Creative Officer: Kimberly Tyner
Associate Creative Director: Jason James | Senior Designer: Alex Flores | Writer: Mike Stopper
Account Supervisor: Julia Cardali | Main Contributor: Spire Agency

198 MONROE COMMUNITY COLLEGE FOUNDATION GOLD STAR GALA INVITATIONS
Design Firm: Dixon Schwabl + Company | Designer: Jewel Mastrodonato
Client: Monroe Community College Foundation | Executive Creative Director: Marshall Statt
Chief Creative Officer: Mark Stone | Production Manager: Bob Charboneau
Printers: Andy Schenkel, Rick Moll, Sealong Bermudez, Cindy West | Preprinter: Stephanie Miller
Copywriter: Nick Guadagnino | Account Executive: Mel Brand
Account Director: Amanda Maxim | Main Contributor: Jewel Mastrodonato

198 CRYSTAL BRIDGES LETTERHEAD | Design Firm: *Trace Element
Designer: Dana Nixon | Client: Crystal Bridges Museum of American Art
Chief Creative Officer: Jeff Barfoot | Creative Directors: Dana Nixon, Katie Kitchens
Account Director: Jenna Snyder | Main Contributor: Dana Nixon

198 TRINITY EPISCOPAL CATHEDRAL STATIONERY | Design Firm: Lightner Design
Designer: Connie Lightner | Client: Trinity Episcopal Cathedral | Art Director: Connie Lightner
Logo Designer: Connie Lightner | Main Contributor: Connie Lightner

199 TECHFOUNDRY IDENTITY | Design Firm: SML Design
Designers: Vanessa Ryan, Wendy Cho, Gerson Mena Murcia | Client: TechFoundry
Main Contributor: Vanessa Ryan

199 MUSICNOTES LOGO | Design Firm: Planet Propaganda
Designer: Laura Gang | Client: Musicnotes | Art Director: Casey Christian
Executive Creative Director: Dana Lytle | Main Contributor: Laura Gang

199 PHILIP HANSON HISS AWARD IDENTITY | Design Firm: Studio Craig Byers
Designer: Craig Byers | Client: Architecture Sarasota | Main Contributor: Craig Byers

199 ALLAWAY LOGO | Design Firm: Traina | Designer: Mark DeRose
Client: Allaway | Graphic Designer: Carlo Palazzolo | Chief Creative Officer: Mark Gallo
Account Director: Jeselyn Andrews | Main Contributor: Mark DeRose

199 SEEDING TRADE | Design Firm: Next Brand | Designer: Lee Selsick
Client: Australia Africa Chamber of Commerce | Illustrators: Liezel Liebenberg, Lee Selsick
Main Contributor: Next Brand

199 SPUDNIK PRESS LOGO | Design Firm: Riesling Dong | Designer: Riesling Dong
Client: Spudnik Press | Main Contributor: Riesling Dong

199 COMMON GRACE POTTERY LOGO | Design Firm: Lewis Communications
Designer: Robert Froedge | Client: Common Grace Pottery | Main Contributor: Robert Froedge

199 REVITALIZED BRAND IDENTITY OF QWALE | Design Firm: Ruiqi Sun Design
Designer: Ruiqi Sun | Client: Qwale | Main Contributor: Ruiqi Sun

199 FITTBUZZ | Design Firm: 33 and Branding | Designer: Xiaowei Zhang
Client: FITTBUZZ | Chief Creative Officer: Xiaowei Zhang | Design Director: Jing Xu
Main Contributor: Xiaowei Zhang

199 PULITZER ON THE ROAD | Design Firm: Columbia University | Designer: G.D. Allen
Client: The Pulitzer Prizes | Photographer: Jeffrey Schifman

199 MABEE FOUNDATION 75TH ANNIVERSARY LOGO | Design Firm: Spire Agency
Designer: Alex Flores | Client: The J.E. & L.E. Mabee Foundation
Chief Creative Officer: Kimberly Tyner | Associate Creative Director: Jason James
Senior Designer: Alex Flores | Account Supervisor: Julia Cardali | Main Contributor: Spire Agency

199 WATERSAFE MKE | Design Firm: Traction Factory | Designer: David Brown
Client: Milwaukee Fire Department | Design Director: David Brown
Production Artist: Jenni Wierzba | Project Coordinator: Abby Willner
Account Directors: Shannon Egan, Scott Bucher | Main Contributor: David Brown

200 SALONA YACHTS | Design Firm: Stjepko Rošin
Designer: Stjepko Rošin | Client: Salona Group Ltd.

200 SAN DIEGO TIJUANA INTERNATIONAL JAZZ FESTIVAL | Design Firm: MiresBall
Designers: John Ball, David Alderman | Client: San Diego Tijuana International Jazz Festival
Creative Director: John Ball | Main Contributors: John Ball, David Alderman

200 ACCESSOLOGY LOGO | Design Firm: RedCape
Designer: Mark Allen | Client: Accessology | Main Contributor: Mark Allen

200 SUNCOAST MARKET FOOD CO-OP LOGO | Design Firm: MiresBall
Designer: David Alderman | Client: SunCoast Market Food Co-op
Creative Director: John Ball | Main Contributors: John Ball, David Alderman

200 JMG TALLER DE FORJA Y AFILADO | Design Firm: El Paso, Galería de Comunicación
Designer: Álvaro Pérez | Client: JMG Taller de Forja y Afilado | Creative Directors: Álvaro Pérez,
Curra Medina | Main Contributor: El Paso, Galería de Comunicación

200 POSSIBILITY PARTNERS LOGO | Design Firm: Angelique Markowski
Designer: Angelique Markowski | Client: Possibility Partners LLC
Main Contributor: Angelique Markowski

200 RESTORATIVE HOUSING LOGOMARK | Design Firm: Mermaid, Inc.
Designer: Sharon Lloyd McLaughlin | Client: Restorative Housing
Digital Director: Bart McLaughlin | Main Contributor: Sharon Lloyd McLaughlin

200 KEEPER ICON AND WORDMARK | Design Firm: Partners + Napier
Designer: Rob Hopkins | Client: Keepr | Chief Creative Director: Rob Kottkamp
Project Manager: Tom Murphy | Creative Group Head: Katy Collar
Creative Director: Kira Csakany | Main Contributor: Kira Csakany

200 OCEANSIDE MUSIC LOGO | Design Firm: AG Creative Group
Designer: Stewart Jung | Client: Parksville & District Musical Association
Director of Brand Marketing: Annabelle Cormack | Main Contributor: Stewart Jung

200 TATC LOGO | Design Firm: Yanguan | Designer: Xie Yanguang
Client: Tmall Autocare Tuning Center | Main Contributor: Xie Yanguang

200 TIJUANA RED CROSS 80° ANNIVERSARY
Design Firm: Freaner Creative & Design | Designer: Ariel Freaner
Clients: Red Cross of Tijuana, Jorge Astiazaran | Main Contributor: Ariel Freaner

200 A.S.M.D. LOGO | Design Firm: A.S.M.D. Creations | Designer: Louis Yiu
Client: Self-initiated | Main Contributor: Louis Yiu

201 KABOB SHACK LOGO | Design Firm: Tielemans Design | Designer: Anton Tielemans
Client: Kabob Shack | Main Contributor: Anton Tielemans

201 SAG HARBOR PRESS LOGO | Design Firm: Camilart
Designer: Camilla Marstrand Golden | Client: Sag Harbor Press
Main Contributor: Camilla Marstrand Golden

201 METAHUB LOGO | Design Firm: UNISAGE | Designer: Chak Kin Jeff Poon
Client: Wenzhou-Kean University | Main Contributor: Chak Kin Jeff Poon

201 CHEWTON CEMETERY LOGO | Design Firm: Roger Archbold | Designer: Roger Archbold
Client: Chewton General Cemetery | Main Contributor: Roger Archbold

201 CLUBE DE MINIGOLFE DO PORTO | Design Firm: Duas Faces Design
Designer: Sérgio Duarte | Client: André Campos | Account Executive: Ana Monteiro

201 DOC LOGO | Design Firm: Level Group
Designers: Jennifer Bernstein, Eva Beckendorf | Client: DOC
Art Director: Eva Beckendorf | Creative Directors: Jennifer Bernstein, Nick Hubbard
Main Contributor: Level Group

201 FIRST DISTRICT MECHANICAL LOGO | Design Firm: AG Creative Group
Designer: Stewart Jung | Client: First District Mechanical | Creative Director: Stewart Jung
Main Contributor: AG Creative Group

201 QUINCE FLOWERS LOGO | Design Firm: Goodall Integrated Design
Designer: Derwyn Goodall | Client: Quince Flowers | Main Contributor: Derwyn Goodall

201 NATURE'S EARTH PRODUCTS LOGO | Design Firm: Kevin Woods Creative
Designer: Kevin Woods | Client: Nature's Earth Products | Main Contributor: Kevin Woods

201 BANKABOX LOGO | Design Firm: Lisa Sirbaugh Creative
Designer: Lisa Sirbaugh | Client: Bankabox | Main Contributor: Lisa Sirbaugh Creative

201 PATTERN
Design Firm: Hyungjookim Designlab | Designers: Hyungjoo A. Kim, Evan Olinger
Client: Print Bay in the John Martinson Honors College at Purdue University
Art Director: Hyungjoo A. Kim | Main Contributor: Hyungjoo A. Kim

201 JIRRAHLINGA LOGO | Design Firm: Roger Archbold | Designer: Roger Archbold
Client: Jirrahlinga Wildlife Sanctuary | Main Contributor: Roger Archbold

202 FOR THE BIRDS: THE BIRDSONG PROJECT | Design Firm: SMOG Design, Inc.
Designers: Jeri Heiden, John Heiden | Clients: National Audubon Society, The Birdsong Project
Creative Team: Michael Pontecorvo, Samantha Uzbay, Amanda Chiu
Producers: Randall Poster, Rebecca Reagan, Lee Ranaldo, Elliot Bergman, Stewart Lerman
Print Producers: Kate Dear - GZNA / Memphis Record Pressing
Artists: John James Audubon, Adun Lund Alvestad, Dan Attoe, Sabrina Bosco, Ed Burkes, Brian
Calvin, Thomas Campbell, Roz Chast, Penny Davenport, Howard Fonda, Barrie Goshko, Hugo
Guinness, Florence Hutchings, Chris Johanson, Elsa Kuhn / In Felt We Trust, Igor Moritz, Jeff
Olsson, Hannah Ricke, Danny Romeril, Simone Shubuck, Amy Tan
Main Contributor: SMOG Design, Inc.

202 THE ABYSS EP | Design Firm: Now Now | Designers: Adam Ferry, John Solarz
Client: Tenet Recordings | Digital Artist: Tiago Marinho | Main Contributor: Now Now

202 NIMA SMISLA - BALANS (LP) | Design Firm: Primoz Zorko
Designer: Primoz Zorko | Client: Balans | Creative Director: Primoz Zorko
Art Director: Primoz Zorko | Photographer: Marijo Zupanov | Fashion Director: Jan Brovc
Main Contributor: Primoz Zorko

202 CRAFT CLASS | Design Firm: Charmie Shah | Designer: Charmie Shah
Client: Dropbox | Creative Director: Charmie Shah | Production Company: OTHR
Main Contributor: Charmie Shah

202 NON-SOLO SARANG VINYL COVER | Design Firm: Shantanu Suman
Designer: Shantanu Suman | Client: Non-Solo | Art Director: Manoj Kurian Kallupurackal
Main Contributor: Shantanu Suman

202 ACCENTS OF LOVE | Design Firm: Rozi Zhu | Designer: Rozi Zhu
Client: Vivian Fang Liu | Digital Artist: Xizhe Wang | Main Contributors: Rozi Zhu, Xizhe Wang

202 JOYSTICK JAZZ VOL. 2 | Design Firm: HandMade Monsters
Designer: Mark Borgions | Client: iam8bit | Main Contributor: Mark Borgions

203 MIRINDA PLUS RESTAGE | Design Firm: Pepsico | Designer: Pepsico
Client: Self-initiated | Main Contributor: Pepsico

203 PEPSI X SPOTIFY CAN DESIGN + INFLUENCER KIT | Design Firm: Pepsico
Designer: Pepsico | Client: Self-initiated | Main Contributor: Pepsico

203 TK MULLIGAN | Design Firm: CF Napa Brand Design | Designer: CF Napa Brand Design
Client: TK Mulligan | Main Contributor: CF Napa Brand Design

203 MANHATTAN COFFEE ROASTERS | Design Firm: Pavement | Designer: Michael Hester
Client: Manhattan Coffee Roasters | Main Contributor: Michael Hester

203 LAVOSH, BISCUITS AND CRACKERS | Design Firm: Dessein
Designer: Tracy Kenworthy | Client: Knutsford Gourmet | Stylist: Leanne Balen
Photographer: Geoff Bickford | Main Contributor: Tracy Kenworthy

203 PURE LOVE | Design Firm: Next Brand | Designer: Ashley Menezes
Client: Loving Earth | Creative Director: Heather Selsick | Main Contributor: Next Brand

204 NORTHCROSS IRISH WHISKEY | Design Firm: Pavement | Designer: Michael Hester
Client: Latitude Beverage Company | Main Contributor: Michael Hester

204 ISLE OF RAASAY GIN | Design Firm: Stranger & Stranger | Designer: Stranger & Stranger
Client: R&B Distillers LTD | Main Contributor: Stranger & Stranger

204 ICE LAKE
Design Firm: Shenzhen Excel Brand Design Consultant Co., Ltd. | Designer: Kuanfu Wu
Client: Ice Lake | Main Contributor: Shenzhen Excel Brand Design Consultant Co., Ltd.

204 BOYD & BLAIR SPIRITS PACKAGING | Design Firm: Our Man In Havana
Designer: Chris Duggan | Client: Boyd & Blair | Executive Creative Director: Andrew Golomb
Creative Director: Sylve Rosen-Bernstein | Managing Director: Lacey Gardner
Account Supervisor: Violet Herzfeld | Account Executive: Ruby Gumenick
Associate Creative Director: Lisa Alban | Head of Production: Aisling Bodkin
Main Contributor: Our Man In Havana

204 MEDAL ONE
Design Firm: Shenzhen Excel Brand Design Consultant Co., Ltd. | Designer: Kuanfu Wu
Client: Medal One | Main Contributor: Shenzhen Excel Brand Design Consultant Co., Ltd.

204 REINTERPRETING OLD SOUL
Design Firm: Affinity Creative Group | Designer: Affinity Creative Group
Client: Oak Ridge Winery | Main Contributor: Affinity Creative Group

204 HYPOTHESIS | Design Firm: CF Napa Brand Design
Designer: CF Napa Brand Design | Client: Roots Run Deep
Main Contributor: CF Napa Brand Design

204 TURKS HEAD | Design Firm: CF Napa Brand Design
Designer: CF Napa Brand Design | Client: Main Line Wine Company
Main Contributor: CF Napa Brand Design

204 REBROOK CELLARS | Design Firm: CF Napa Brand Design
Designer: CF Napa Brand Design | Client: Rebrook Cellars
Main Contributor: CF Napa Brand Design

205 GLENGLASSAUGH HIGHLAND SINGLE MALT SCOTCH WHISKY
Design Firm: Stranger & Stranger | Designer: Stranger & Stranger
Client: Brown-Forman Corporation | Main Contributor: Stranger & Stranger

205 THE HEARACH SCOTCH WHISKY | Design Firm: Stranger & Stranger
Designer: Stranger & Stranger | Client: Isle of Harris Distillers Ltd.
Main Contributor: Stranger & Stranger

205 AUTHENTICO ORGANIC TEQUILA PACKAGING DESIGN
Design Firm: Affinity Creative Group | Designer: Affinity Creative Group
Client: Freshie | Main Contributor: Affinity Creative Group

205 GIULIO STRACCALI | Design Firm: CF Napa Brand Design
Designer: CF Napa Brand Design | Client: Palm Bay International
Main Contributor: CF Napa Brand Design

205 HEAD HIGH WINES SHORELINE SERIES
Design Firm: CF Napa Brand Design | Designer: CF Napa Brand Design
Client: Head High Wines | Main Contributor: CF Napa Brand Design

205 ELEMENT[AL] WINES | Design Firm: Stranger & Stranger
Designer: Stranger & Stranger | Client: Bogle Vineyards & Winery
Main Contributor: Stranger & Stranger

206 NEVERSTILL WINES | Design Firm: Stranger & Stranger
Designer: Stranger & Stranger | Client: Bayberry Lane Investors
Main Contributor: Stranger & Stranger

206 STARWARD AUSTRALIAN WHISKEY | Design Firm: Stranger & Stranger
Designer: Stranger & Stranger | Client: New World Whisky Distillery Pty Ltd
Main Contributor: Stranger & Stranger

206 FORCE & GRACE - BRAND CREATION | Design Firm: forceMAJEURE
Designers: Michelle Mak, Tim Devereaux, Meilyn Wedge | Client: Deutsch Family Wine & Spirit
Main Contributor: Neil Grundy

206 BEELU FOREST DISTILLING CO. SAPROCK | Design Firm: Harcus Design
Designer: Galima Akhmetzyanova | Client: Beelu Forest Distilling Co.
Creative Director: Annette Harcus | Photographer: Stephen Clarke
Main Contributor: Harcus Design

206 COTERRA WINES | Design Firm: Pavement | Designer: Michael Hester
Client: Cote West Winery | Main Contributor: Michael Hester

206 OLD MOUT | Design Firm: Elmwood London | Designer: Elmwood London
Client: Heineken | Executive Creative Director: Kyle Whybrow
Design Directors: Tim Wood, Paolo Orazietti | Account Manager: Hannah Griffiths
Account Director: Amy Elliot | Other: Head of 2D and 3D Animation: Oli Minchin
Main Contributor: Elmwood London

206 SCORPION ROSÉ | Design Firm: Lafayette American | Designer: Lafayette American
Client: Self-initiated | Main Contributor: Lafayette American

206 ELECTRIFYING ELEGANCE: FORCE AND GRACE SIZZLE KITS
Design Firm: Affinity Creative Group | Designer: Affinity Creative Group
Client: Deutsch Family Wine & Spirit | Main Contributor: Affinity Creative Group

207 2023 MCCAFÉ HOLIDAY CUPS | Design Firm: Boxer Brand Design
Designers: Diana Samper (SVP, Group Creative Director), Ross Knezovich (Associate Creative
Director) | Client: McDonald's USA | Production Artist: Meg Meyers
Senior Account Director: Lisa Burgess | Account Supervisor: Brian Torbik
Photographer: Megan Luckett | Main Contributor: Boxer Brand Design

207 NOT TOO SWEET CRAFT SODA REBRANDING, BRAND IDENTITY, PACKAGING
Design Firm: Toolbox Design | Designers: Alice Zeng, Rachel Sanvido | Client: Not Too Sweet
Account Manager: Heather Dowinton | Creative Director: Niko Potton

207 AMANATSU CANDY | Design Firm: Legis Design | Designer: Mayumi Kato
Client: Hirano Farm | Main Contributor: Legis Design

207 EL CADEJO COFFEE PACKAGING | Design Firm: Subin Yun
Designer: Subin Yun | Client: Self-initiated | Main Contributor: Subin Yun

207 NOTHING FOR THE HOLIDAYS | Design Firm: Here Be Monsters
Designer: Jocelyn Wong | Client: Self-initiated | Creative Directors: Matt Bielby, Tony Hird
Account Directors: Chris Raedcher, Nicole Steward | Copywriter: Matt Bielby
Main Contributors: Matt Bielby, Tony Hird, Jocelyn Wong

207 BATH & BODY WORKS AAPI CANDLE COLLECTION
Design Firm: Bath & Body Works | Designer: Kenneth Chiem | Client: Self-initiated
Art Director: Michiyo Nelson | Main Contributor: Kenneth Chiem

207 SINTEN COFFEE ROASTERY PACKAGING DESIGN | Design Firm: A.S.M.D. Creations
Designer: Louis Yiu | Client: SinTen Coffee Roastery
Main Contributors: A.S.M.D. Creations, SinTen Coffee Roastery

207 AIN'T NORMAL COFFEE | Design Firm: Pavement
Designer: Michael Hester | Client: Ain't Normal Cafe | Main Contributor: Bud Snow

208 QUAKER BOWL OF GROWTH | Design Firm: Pepsico
Designer: Pepsico | Client: Self-initiated | Main Contributor: Pepsico

208 LAYS DUNGEONS AND DRAGONS | Design Firm: Pepsico
Designer: Pepsico | Client: Self-initiated | Main Contributor: Pepsico

208 NEIMAN MARCUS HOLIDAY GIFT BOXES
Design Firm: Neiman Marcus Brand Creative
Designers: Stephen Arevalos, Morgan Baldwin, Alyse Lanier | Client: Self-initiated
Chief Creative Officer: Nabil Aliffi | Design Director: Lori Dibble
Project Manager: Shane Danos | Illustrators: Morgan Baldwin, Alyse Lanier
Design Manager: Stephen Arevalos | Main Contributor: Stephen Arevalos

208 BIT-O-HONEY REBRAND | Design Firm: Young & Laramore
Designer: Zac Neulieb | Client: Spangler Candy | Executive Creative Director: Trevor Williams
Illustrator: Zac Neulieb | Main Contributor: Zac Neulieb

208 NO. 8 | Design Firm: Pavement | Designer: Michael Hester
Client: No. 8 Health | Main Contributor: Michael Hester

208 RICE PACKAGING | Design Firm: Legis Design
Designer: Mayumi Kato | Client: Ikeda Farm | Main Contributor: Mayumi Kato

209 FRITO LAY SUPER BOWL LVII COMPOSTABLE BAGS 2023
Design Firm: PepsiCo | Designer: PepsiCo | Client: Self-initiated | Main Contributor: PepsiCo

209 NATUCHIPS REDESIGN | Design Firm: PepsiCo | Designer: PepsiCo
Client: Self-initiated | Main Contributor: PepsiCo

209 YONI | Design Firm: Dessein | Designer: Tracy Kenworthy | Client: Yoni Pleasure Palace
Photographer: Geoff Bickford | Main Contributor: Tracy Kenworthy

209 POSH EAU DE PARFUM BY CAMARA | Design Firm: Sol Benito
Designer: Vishal Vora | Client: Elite Brands | Main Contributor: Sol Benito

209 AAVRANI UPDATED BRANDING AND NEW HAIR CARE LINE
Design Firm: Dear Fellow Design Studio | Designer: Emily Funck
Clients: Aavrani, Nancy Lan, Rooshy Roy, Samantha Strauss | Art Director: Courtney Spencer
Photographer: Lauren Juratovac | Stylists: Liz Mydlowski, Astrid Terrazas
Digital Artist: Vanessa Rojo de la Vega | Production: Serena Nappa
Main Contributor: Emily Funck

209 PACKAGING SYSTEM POLARAMIN | Design Firm: Tangram Strategic Design
Designer: Bianca Garavaglia | Client: Bayer | Art Director: Enrico Sempi

210 THE FUTURE OF AI: HOW WILL AI CHANGE INDUSTRIES?
Design Firm: Namseoul University | Designer: Mi-Jung Lee | Client: Ministry of Science and ICT
Professor: Mi-Jung Lee | Main Contributor: Mi-Jung Lee

210 HARMONY LGBT-POSTER CAMPAIGN | Design Firm: The Republik
Designer: Matt Shapiro | Clients: Harmony LGBT, Allied Chamber of Commerce
Creative Director: Matt Shapiro | Art Director: Matt Shapiro | Copywriter: Dwayne Fry
Main Contributor: Robert Shaw West

210 GOD | Design Firm: HEHE DESIGN | Designer: Wu Qixin
Client: GOD | Main Contributor: Wu Qixin

210 RAISING KANAN | Design Firm: ARSONAL | Designer: ARSONAL | Client: STARZ
Others: Whitney Abeel – SVP, Originals and Digital Marketing, Roxana Munoz – (Former)
Director, Originals Marketing, Sherelle Penalosa – Manager, Originals Marketing
Main Contributors: ARSONAL, STARZ

210 PRAY FOR PEACE | Design Firm: Dalian RYCX Design | Designer: Zhongjun Yin
Client: Mankind | Creative Director: Zhongjun Yin | Main Contributor: Zhongjun Yin

210 BE LIE VE (DON'T BELIEVE THE LIES) | Design Firm: Goodall Integrated Design
Designer: Derwyn Goodall | Client: Self-initiated | Main Contributor: Derwyn Goodall

210 HAPPY 200TH BIRTHDAY ANTON BRUCKNER
Design Firm: Goodall Integrated Design | Designer: Derwyn Goodall
Client: Self-initiated | Main Contributor: Derwyn Goodall

210 TRUE DETECTIVE NIGHT COUNTRY | Design Firm: ARSONAL
Designer: ARSONAL | Client: HBO Max | Photographer: Dan Winters
Other: HBO MAX ORIGINALS MARKETING | Main Contributors: ARSONAL, HBO Max

210 THE DESERT SAID DANCE TEASER KEY ART | Design Firm: Barlow.Agency
Designer: Barlow.Agency | Client: Mojave Pictures | Main Contributor: Barlow.Agency

211 UNFROSTED | Design Firm: ARSONAL
Designer: ARSONAL | Client: Netflix | Photographer: John P. Johnson / Netflix
Others: Missy Rawnsley (Netflix) Creative Marketing, Javier Crespo (Netflix) Creative Marketing
Main Contributors: ARSONAL, Netflix

211 AMBROSIUS: ALBUM RELEASE CONCERT POSTER | Design Firm: Braley Design
Designer: Michael Braley | Client: Ambrosius | Main Contributor: Michael Braley

211 THE LIONESS WITHIN | Design Firm: Sagon-Phior
Designers: Glenn Sagon, Peter Stougaard | Client: Casillas Inc.
Art Director: Peter Stougaard | Main Contributor: Glenn Sagon

211 PAPA JOHNS ESG POSTERS | Design Firm: Addison | Designer: JG Debray
Client: Papa Johns | Creative Director: Kevin Barclay | Copywriters: Kevin Barclay, JG Debray
Illustrator: JG Debray | Strategy: Russ Kuhner | Main Contributor: JG Debray

211 SAINAS POSTERS | Design Firm: Teiga, Studio.
Designer: Xosé Teiga | Client: Sainas | Art Directors: María Toucedo Cal, Xosé Teiga
Creative Director: Xosé Teiga | Copywriters: María Toucedo Cal, Xosé Teiga
Photographer: Fernando Maselli | Main Contributor: Teiga, Studio.

211 COP28 | Design Firm: Tsushima Design | Designer: Hajime Tsushima
Client: Emirates International Poster Festival | Main Contributor: Hajime Tsushima

211 BARBARA STAUFFACHER SOLOMON | Design Firm: Keith Kitz Design
Designer: Keith Kitz | Client: Self-initiated | Main Contributor: Keith Kitz

211 ZETA POSTER ANNIVERSARY HISTORY AND TIMELINE
Design Firm: Freaner Creative & Design | Designer: Ariel Freaner | Client: ZETA Weekly
Art Director: Ariel Freaner | Digital Artist: Ariel Freaner | Main Contributor: Ariel Freaner

211 TRUE DETECTIVE NIGHT COUNTRY | Design Firm: ARSONAL
Designer: ARSONAL | Client: HBO Max | Photographer: Dan Winters
Other: HBO MAX ORIGINALS MARKETING | Main Contributors: ARSONAL, HBO Max

212 SOLAR ECLIPSE | Design Firm: May & Co. | Designer: Douglas May
Client: Self-initiated | Main Contributor: Douglas May

212 AS AVES CAPITALS | Design Firm: Duas Faces Design
Designer: Sérgio Duarte | Client: Pixbee | Art Director: Sérgio Duarte
Illustrator: Cristiana Rodrigues | Motion Designer: Tiago Cardoso
Photographer: Jorge Costa | Account Executive: Ana Monteiro
Producers: Pedro Magano, Pedro Sá | Main Contributor: Daniel Sousa

212 RELIGULOUS | Design Firm: HEHE DESIGN | Designer: Wu Qixin
Client: RELIGULOUS | Main Contributor: Wu Qixin

212 PROMOTING RUEFF SCHOOL POSTERS
Design Firm: Do Kim Design | Designer: Do Gyun Kim
Client: Rueff School at Purdue University | Main Contributor: Do Gyun Kim

212 RED CROSS 80° ANNIVERSARY POSTER SERIES
Design Firm: Freaner Creative & Design | Designer: Ariel Freaner
Clients: Red Cross of Tijuana, Jorge Astiazaran | Main Contributor: Ariel Freaner

212 ECLIPSE ADVERTISING ADS CAMPAIGN | Design Firm: Freaner Creative & Design
Designer: Ariel Freaner | Clients: Fujitsu Ten, Eclipse Mobile Entertainment
Art Director: Ariel Freaner | Main Contributor: Ariel Freaner

212 TOXIC SOCIETY LEAVES TOXIC SCARS
Design Firm: Carmit Design Studio | Designer: Carmit Makler Haller | Client: Self-initiated
Photographer: Naked Woman Photo by Adobe Stock | Design Lead: Carmit Makler Haller
Digital Artists: Carmit Makler Haller / Carmit Design Studio, Jorge Gamboa / Mal De Ojo
Main Contributor: Carmit Design Studio

213 DESIGN FOR TOMORROW 2023 | Design Firm: Goodall Integrated Design
Designer: Derwyn Goodall | Client: The Earth International Poster Art Festival in Taiwan
Main Contributor: Derwyn Goodall

213 URINETOWN: THE MUSICAL | Design Firm: Chemi Montes Design
Designer: Chemi Montes | Client: Department of Performing Arts at American University
Main Contributor: Chemi Montes

213 RACHMANINOFF 150 | Design Firm: Braley Design
Designer: Michael Braley | Clients: The Golden Bee Biennale, Self-initiated
Main Contributor: Michael Braley

213 MINNESOTA TWINS HISTORY POSTER | Design Firm: DLR Group
Designer: Jovaney Hollingsworth | Client: Minnesota Twins
Main Contributor: Jovaney Hollingsworth

213 TIPPING POINT | Design Firm: Elevate Design | Designer: Kelly Salchow MacArthur
Client: Self-initiated | Main Contributor: Kelly Salchow MacArthur

213 BELIEVE | Design Firm: HEHE DESIGN | Designer: Wu Qixin
Client: HUMAN | Main Contributor: Wu Qixin

213 KEY THE BOYS SHORT FILM KEY ART | Design Firm: Barlow.Agency
Designer: Barlow.Agency | Client: Stefan Hunt Films | Main Contributor: Barlow.Agency

213 FESTIVAL DE IDEIAS (FESTIVAL OF IDEAS) | Design Firm: Studio DelRey
Designer: Delfin | Client: Conexão Quilombo Amarais Hub | Main Contributor: Delfin

213 INTERVIEW WITH THE VAMPIRE S2 | Design Firm: ARSONAL
Designer: ARSONAL | Client: AMC | Photographer: Pari Dukovic
Others: Ed Sherman, VP Brand & Design, Mark Williams, EVP Creative, Nancy Hennings,
VP Production Brand & Design | Main Contributors: ARSONAL, AMC

214 ZETA 42 YEARS ANNIVERSARY POSTER | Design Firm: Freaner Creative & Design
Designer: Ariel Freaner | Client: ZETA Weekly | Creative Director: Ariel Freaner
Art Director: Ariel Freaner | Digital Artist: Ariel Freaner | Main Contributor: Ariel Freaner

214 STUDY ABROAD WITH CSU! | Design Firm: Gravdahl Design
Designer: John Gravdahl | Client: Colorado State University | Main Contributor: Gravdahl Design

214 CLIMATE ACTION 2023 | Design Firm: Goodall Integrated Design
Designer: Derwyn Goodall | Client: Emirates International Poster Festival
Main Contributor: Derwyn Goodall

214 SUMMER 2023 | Design Firm: John Sposato Design & Illustration
Designer: John Sposato | Client: Self-inititated | Main Contributor: John Sposato

214 THE LOVE YOU TAKE/MAKE | Design Firm: Symbiotic Solutions
Designer: Chris Corneal | Client: Self-inititated | Main Contributor: Chris Corneal

214 ACCOUNTABILITY | Design Firm: Randy Clark Graphic Design
Designer: Randy Clark | Client: Self-inititated | Photographer: Tyler Merbler
Main Contributor: Randy Clark

214 CENTRAL MARKET CATCH HATCH CAMPAIGN | Design Firm: *Trace Element
Designer: Cristina Moore | Client: Central Market | Chief Creative Officer: Jeff Barfoot
Creative Director: Jeff Barfoot | Associate Creative Director: Cristina Moore
Copywriter: Plot Twist Creativity | Animator: Cody Rubino | Account Director: Anna Mertz
Account Manager: Kasey Cooley | Illustrator: Cristina Moore | Main Contributor: Cristina Moore

214 DILWORTH COFFEE POSTER CAMPAIGN
Design Firm: The Republik | Designer: Matt Shapiro | Client: Dilworth Coffee
Creative Directors: Robert Shaw West, Matt Shapiro | Copywriters: Dwayne Fry, Neil Hinson
Art Directors: Robert Shaw West, Matt Shapiro | Main Contributor: Robert Shaw West

215 GOD OF CARNAGE | Design Firm: Andrewsobol.com | Designer: Andrew Sobol
Client: Theatre at the Mill | Main Contributor: Andrew Sobol

215 EKODA METAVERSE INNOVATION | Design Firm: Noriyuki Kasai
Designer: Noriyuki Kasai | Client: Nihon University College of Art
Main Contributor: Noriyuki Kasai

215 BORDERLESS | Design Firm: Andrea Szabó | Designer: Andrea Szabó
Client: Association of Hungarian Fine and Applied Artists | Main Contributor: Andrea Szabó

215 LA DESIGN FESTIVAL 2023: DESIGN FOR THE PEOPLE
Design Firm: Braley Design | Designer: Michael Braley | Client: LA Design Festival 2023
Illustrator: Kate Davis | Main Contributor: Michael Braley

215 FULL. HALF. | Design Firm: Bailey Lauerman | Designer: Gayle Adams
Client: Lincoln Track Club | Chief Creative Officer: Carter Weitz | Creative Director: Casey Stokes
Production Manager: Gayle Adams | Account Supervisor: Emma Gallagher
Printer: Regal Printing | Main Contributor: Casey Stokes

215 RED CROSS CORPORATE CAMPAIGN POSTER SERIES
Design Firm: Freaner Creative & Design | Designer: Ariel Freaner
Clients: Red Cross of Tijuana, Jorge Astiazaran | Digital Artist: Ariel Freaner
Main Contributor: Ariel Freaner

215 THE HATMAKER'S WIFE | Design Firm: Code Switch | Designer: Jan Šabach
Client: The Theatre Department at the University of Massachusetts-Amherst
Main Contributor: Jan Šabach

215 CORRUPTION | Design Firm: Spotco NYC | Designer: Nicky Lindeman
Client: Lincoln Center Theater | Illustrator: Mirko Ilic | Main Contributor: Mirko Ilic

215 BOBI WINE | Design Firm: ARSONAL | Designer: ARSONAL | Client: NGC
Others: Chris Spencer - EVP, Creative, Brian Everett - VP Design, Mariano Barreiro - Design
Director, Brandon Kessler - Senior Manager, Consumer Marketing, Maricruz Merlo - Project
Manager | Main Contributors: ARSONAL, NGC

216 DELTA DINER BRANDING | Design Firm: Traction Factory | Designer: Matt Lemke
Client: Delta Diner | Creative Director: David Brown | Design Director: David Brown
Art Director: Matt Lemke | Copywriter: Tom Dixon | Production Artist: Jenni Wierzba
Project Manager: Liz Wilson | Account Director: Shannon Egan | Main Contributor: Matt Lemke

216 RACHMANINOFF 150 | Design Firm: Code Switch | Designer: Jan Šabach
Client: The Golden Bee Biennale | Main Contributor: Jan Šabach

216 WHERE YOU READ | Design Firm: Studio Lorenzetti
Designer: Katherine Lorenzetti | Client: Detroit Public Library | Photographer: Marco Lorenzetti
Camera: 8x10 Deardorff | Main Contributor: Katherine Lorenzetti

216 CENTRAL MARKET PASSPORT PORTUGAL | Design Firm: *Trace Element
Designers: Dana Nixon, Stephanie Williams | Client: Central Market
Chief Creative Officer: Jeff Barfoot | Creative Director: Dana Nixon
Associate Creative Director: Cristina Moore | Production: Dave Basden
Animator: Cody Rubino | Copywriter: Plot Twist Creativity | Account Director: Anna Mertz
Account Manager: Kasey Cooley | Illustrator: Stephanie Williams
Main Contributor: Dana Nixon

216 RED CROSS | Design Firm: Freaner Creative & Design
Designer: Ariel Freaner | Clients: Red Cross of Tijuana, Jorge Astiazaran
Main Contributor: Ariel Freaner

216 ZETA 2022 ADVERTISING POSTER | Design Firm: Freaner Creative & Design
Designer: Ariel Freaner | Client: ZETA Weekly | Creative Director: Ariel Freaner
Art Director: Ariel Freaner | Digital Artist: Ariel Freaner | Main Contributor: Ariel Freaner

216 NEW YORK TIMES PROMO | Design Firm: John Sposato Design & Illustration
Designer: John Sposato | Client: New York Times | Art Director: Minh Uong
Main Contributor: John Sposato

217 DDP DNA: DESIGN & ART | Design Firm: DAEKI and JUN
Designers: Daeki Shim, Hyojun Shim | Clients: Seoul Metropolitan Government, Se-Hoon Oh,
Dongdaemun Design Plaza (DDP), Seoul Design Foundation, Kyung-Don Rhee, Jin-bae Park,
Yun-hee Kim, Juyi Yoo, Sujeong Kim, Hyewon Lee, Jinsil Oh
Creative Directors: Daeki Shim, Hyojun Shim | Art Directors: Daeki Shim, Hyojun Shim
Main Contributors: Daeki Shim, Hyojun Shim

217 INFOCUS GRAPHIC + DIGITAL DESIGN GRADUATION 2022–2023: KEY VISUALS
Design Firm: L.S. Boldsmith | Designer: Leila Singleton | Client: InFocus Film School
Main Contributor: Leila Singleton

217 UNFROSTED | Design Firm: ARSONAL | Designer: ARSONAL | Client: Netflix
Others: Missy Rawnsley (Netflix) Creative Marketing, Javier Crespo (Netflix) Creative Marketing
Main Contributors: ARSONAL, Netflix

217 TDH COOKBOOK | Design Firm: Tom, Dick & Harry Creative
Designer: Stacey Chapman | Client: Self-initiated | Copywriter: Joel Thomas

217 414 DAY PROMOTION | Design Firm: Traction Factory | Designer: David Brown
Client: Milwaukee Admirals | Design Director: David Brown | Art Director: Eric Taggart
Copywriter: Tom Dixon | Production Artist: Jenni Wierzba | Project Manager: Liz Wilson
Account Director: Shannon Egan | Agency: Traction Factory | Main Contributor: Eric Taggart

217 TIJUANA ILUMINADA MUGS - PROMOTIONAL ITEMS
Design Firm: Freaner Creative & Design | Designer: Ariel Freaner | Client: City of Tijuana
Art Director: Ariel Freaner | Agency: Freaner Creative & Design | Main Contributor: Ariel Freaner

217 COFFEE WRISTBAND | Design Firm: HANYUE DESIGN STUDIO
Designer: Hanyue Song | Client: I'M NOT A BARISTA
Image Source: I'M NOT A BARISTA | Main Contributor: Hanyue Song

218 AMMI NYC | Design Firm: Shantanu Suman | Designer: Shantanu Suman
Client: Jimmy Rizvi | Interior Designer: Shaila Rizvi | Main Contributor: Shantanu Suman

218 TRUTH BE TOLD, | Design Firm: One Design Company
Designers: Stacey Donaldson, Nick Rissmeyer, Amy Xu | Clients: Study Hotels, Truth Be Told
Account Director: James Johnston | Project Manager: Stacey Shintani
Content Strategist: Bianca Smith | Main Contributor: David Sieren

218 NEIMAN MARCUS GIFT NOTECARD | Design Firm: Neiman Marcus Brand Creative
Designers: Stephen Arevalos, Morgan Baldwin | Client: Self-initiated
Chief Creative Officer: Nabil Aliffi | Design Director: Lori Dibble Printer: MetroVCS
Project Manager: Shane Danos | Production Manager: Rhoda Gonzales
Illustrator: Morgan Baldwin | Design Manager: Stephen Arevalos
Main Contributor: Stephen Arevalos

218 CANADA POST WILLIE O'REE STAMP | Design Firm: Underline Studio
Designers: Claire Dawson, Ritu Kanal, Laura Rojas, Yasaman Fakhr | Client: Canada Post
Art Directors: Fidel Peña, Claire Dawson | Illustrator: Mike McQuade
Photographer: Philip Cheung | Printer: Colour Innovations | Main Contributor: Underline Studio

218 LOVE (2023) | Design Firm: Kessler Design Group | Designer: Ethel Kessler
Client: US Postal Service | Illustrator: Chris Buzelli | Main Contributor: Ethel Kessler

218 THINKING OF YOU | Design Firm: Journey Group | Designer: Greg Breeding
Client: US Postal Service | Illustrator: Ellen Surrey | Main Contributor: Greg Breeding

219 RUTH BADER GINSBURG | Design Firm: Kessler Design Group | Designer: Ethel Kessler
Client: US Postal Service | Artist: Michael J. Deas | Main Contributor: Ethel Kessler

219 SNOW GLOBES | Design Firm: Derry Noyes | Designer: Derry Noyes
Client: US Postal Service | Artist: Gregory Mancheess | Main Contributor: Derry Noyes

219 COCA-COLA SOUTHWEST BEVERAGES SAN ANTONIO MURAL
Design Firm: *Trace Element | Designer: Jeff Rogers | Client: Coca-Cola Southwest Beverages
Chief Creative Officer: Jeff Barfoot | Account Director: Katherine Scoggin
Main Contributor: Jeff Rogers

219 LIFE LESS SCARY - ALPHABET | Design Firm: Dunn&Co. | Designer: Mitchell Goodrich
Client: Grow Financial Federal Credit Union | Creative Director: Stephanie Morrison
Chief Creative Officer: Troy Dunn | Main Contributor: Mitchell Goodrich

219 LABORATÓRIO DA PAISAGEM WEBSITE | Design Firm: Design by OOF
Designer: Design by OOF | Client: Laboratório da Paisagem | Copywriter: Carolina Lapa
Main Contributor: Design by OOF

219 IPARK 87 WEBSITE | Design Firm: Mermaid, Inc. | Designer: Sharon Lloyd McLaughlin
Client: iPark 87 | Web Developer: Bart McLaughlin | Marketing Manager: Lauren Calabria
Main Contributor: Sharon Lloyd McLaughlin

PLATINUM FILM/VIDEO WINNERS:
221 DESIGNING PEACE: ORIGAMI DOVE | Design Firm: Studio Hinrichs
Designers: Kit Hinrichs, Taylor Wega | Client: Museum of Craft and Design
Artists: Linda Mihara, Paper Tree | Videographers: Rob Villanueva, RVSF Inc.
Main Contributors: Kit Hinrichs
Assignment: To create an inspirational video and image for the exhibition "Designing Peace" at the Museum of Craft and Design (which ran from October 7, 2023 – February 4, 2024) which could extend beyond the experience of visiting the exhibit.
Approach: The white dove is a symbol of peace. The large, folded origami dove is the major piece of art you see as you walk in and on the exhibition's promotional pieces.
Results: The client was thrilled with the artwork and the video (they even adapted a variation of the image for their children's learning program) and it was a successful exhibition.

221 SKINCEUTICALS BRAND ASSETS | Design Firm: Media.Work
Designers: Denis Semenov, Roman Eltsov, Daniil Makhin, Kirill Makhin, Sergey Shurupov, Alexandra Vorobeva, Aleksei Komarov, Vasily Zinchuk, Artur Gadzhiev | Client: SkinCeuticals
Creative Director: Igor Sordokhonov | Art Director: Dmitry Ponomarev
Producers: Alexandra Kotova, Andrey Sukhoruchkin | Main Contributor: Media.Work
Assignment: Proclaiming its mission to improve skin health backed by science, SkinCeuticals invited us to create a series of visualizations showcasing the brand's core message. Integrating the unique benefits of the products and their medical-tool effect, we tried to communicate the essential tenets based on research and innovation.
Approach: Relying on a bold statement that puts science at the center of the story, we aimed to connect the power points of medical procedure, innovation, and product benefit. In drawing a strong visual thread between these components, we developed a set of metaphors to demonstrate a clear commitment to research and evidence-based validity. With the formulas of the brand's primary products in our arsenal, we dedicated ourselves to an extensive visual exploration to highlight the uniqueness and active action of each of them but staying within a consistent visual language of the entire series. Each of the featured products has a particular benefit as smoothing and tightening, reducing redness and lowering skin inflammation, plumping and contouring. To creatively capture these peculiarities, we tried to combine our artistic interpretation with the real products' impact on the skin.

GOLD FILM/VIDEO WINNERS:
222 PLAYSTATION PRODUCTIONS BRANDING IDENTITY | Design Firm: Media.Work
Designers: Daniil Makhin, Kirill Makhin, Roman Eltsov, Dmitry Ponomarev, Sergey Shurupov, Denis Semenov, Artur Gadzhiev, Roman Kuzminykh, Tatyana Balyberdina, Anna Reshetnikova, Vasily Zinchuk, Aleksei Komarov, Alexandra Vorobeva | Client: PlayStation Studios
Creative Directors: Igor Sordokhonov, Maxim Zhestkov | Project Manager: Zhenya Zolotova
Producers: Alexandra Kotova, Andrey Sukhoruchkin | Main Contributor: Media.Work
Assignment: In 2019, Sony Interactive Entertainment launched a new company division dedicated to adapting games for cinematography. Ahead of the premiere of the Uncharted movie, PlayStation Productions invited us to create an opening animation for the brand's identity.
Approach: Developing the visual appearance of the figures, our task was to convey their personality and depth of expression. We focused on the deep tones of the original PlayStation blue color, allowing us to create a sense of space and the possibilities it opens up. The third creative challenge of the project was dedicated to light, which leads us through the entire video. Playing with the silhouettes of the characters, the beams of light pass through them, illuminating their meaningfulness and futuristic nature.

Results: The new identity was presented along with the world premiere of the Uncharted movie. Furthermore, it was unveiled on the company's official YouTube and Instagram channels, gathering more than a million views and thousands of comments.

222 FAYETTEVILLE STATE UNIVERSITY - ANYTHING REALLY CAN HAPPEN
Design Firm: The Republik | Designer: Matt Shapiro | Client: Fayetteville State University
Creative Directors: Brad Magner, Matt Shapiro | Art Directors: Dallas West, Matt Shapiro
Copywriter: Dwayne Fry | Account Executives: Kirk deViere, Vanessa Nguyen
Main Contributor: Robert Shaw West
Assignment: Fayetteville State University (FSU) is a historic HBCU with a 150+ year legacy, but is often viewed as a North Carolina system school serving a regional population.
Approach: In reality, FSU was a bright shining light covered by a basket - with vitality and relevance for the next generation of doers. Are You In?
Results: The campaign was instrumental in setting enrollment records for FSU.

222 DROPSHOP | Design Firm: Phillips Marketing Department
Designer: Daniel Brokstad | Client: Self-initiated | Creative Directors: Martin Schott, Mark Mayer
Chief Marketing Officer: Amy Wexler | Digital Director: Andy Ellis
Motion Designer: Daniel Shutt | Main Contributor: Phillips
Assignment: Phillips auctioneers launched Dropshop, a digital platform offering limited-edition releases in partnership with artists, collaborators, and brands. The goal was to design an impactful brand identity, including a logo sting.
Approach: The logo sting features a unique type motion sequence, revealing one letter after another, resolving in DROPSHOP. The 3D letterforms were constructed to morph from one letter shape to another. The aim was to evoke a feeling of a futuristic/virtual retail setting with the letters appearing like architecture, to become an evergreen logo animation.
Results: The launch of Dropshop attracted great media attention and achieved commercial success, sometimes with lightning-fast sell-outs.

223 "DON'T BLINK" TEASER — 1963 FERRARI 250 GTO S/N 3765GT PRESENTED BY RM SOTHEBY'S | Design Firms: Affinity Creative Group, Kabookaboo
Designers: Affinity Creative Group, Kabookaboo | Client: RM Sotheby's
Main Contributors: Affinity Creative Group, Kabookaboo
Assignment: RM Sotheby's aimed to ignite a wave of anticipation and fascination, setting the scene for a truly monumental auction. The challenge was clear: devise a teaser video that would serve as the catalyst, sparking widespread interest from Monterey to New York City.
Approach: The approach was multifaceted, beginning with a 'Don't Blink' teaser video that aimed to evoke a sense of urgency and curiosity. It was a calculated blend of mystery and excitement, setting the stage for a journey that would unfold over months, from the reveal at the Monterey Car Week in August 2023 to the pinnacle auction in New York City in November 2023.
Results: The impact exceeded all expectations, sparking a frenzy of interest and engagement. The video set the tone for a campaign that would culminate in a historic moment, as the Ferrari went on to become the most expensive ever sold at auction.

223 VOLVO SAFETY IN MIND | Design Firm: Media.Work
Designers: Sergey Shurupov, Daniil Makhin, Kirill Makhin, Denis Semenov, Artur Gadzhiev, Aleksei Komarov, Roman Eltsov, Alexandra Vorobeva, Vasily Zinchuk | Client: Volvo
Creative Director: Igor Sordokhonov | Art Director: Dmitry Ponomarev
Producers: Alexandra Kotova, Andrey Sukhoruchkin | Main Contributor: Media.Work
Assignment: Redefining the importance of safety and emotions for the entire automotive industry, Volvo has developed Safety in Mind. We collaborated with AKQA to create a set of animations depicting the range of sensations that affect drivers on a daily basis.
Approach: With "Does how you feel affect how you drive" as one of the main headlines, our aim was to create a visual interpretation of the emotional impact on driving. Inspired by the gradient illustration, we imagined that such a pattern could serve as the perfect illustration. Having a tendency to stretch and generate a complex shape in a single sweep, the gradients spread, and take on the form of the unique narratives of the driving experience.

223 NIKE INVINCIBLE 3 | Design Firm: Media.Work
Designers: Roman Eltsov, Denis Semenov, Sergey Shurupov, Alexandra Vorobeva, Aleksei Komarov, Artur Gadzhiev, Kirill Makhin, Daniil Makhin, Vasily Zinchuk
Client: Nike | Creative Director: Igor Sordokhonov | Art Director: Dmitry Ponomarev
Producers: Andrey Sukhoruchkin, Alexandra Kotova | Music: Artem Markaryan
Sound: Artem Markaryan | Model Maker: Lubov Lobanova | Main Contributor: Media.Work
Assignment: Nike asked us to imagine ways to describe the shoe's innovative cushioning. Connecting the playful world and the benefits of reality, we present all possible pillowy incarnations, visualizing a sense of complete softness, cloudiness, and comfort on the foot.
Approach: Gathering a combination of soft materials, we extend them to surround the space. Balancing between reality and the exaggerated world, we caught a wave of playfulness and super-cush softness to capture the new benefits. To find the right approach to visualize the keywords of the campaign, we experimented with a variety of shapes, textures, and movement. The soft details fill the space and reveal all the features and benefits of the world of cushions.
Results: The first announcement post on Instagram garnered over a million likes and was one of the most successful posts on the @nike and @nikerunning accounts.

SILVER FILM/VIDEO WINNERS:
224 FAYETTEVILLE STATE UNIVERSITY - WE COULD USE YOUR HELP
Design Firm: The Republik | Designer: Matt Shapiro | Client: Fayetteville State University
Creative Directors: Brad Magner, Matt Shapiro | Art Directors: Dallas West, Matt Shapiro
Copywriter: Dwayne Fry | Account Executives: Kirk deViere, Vanessa Nguyen
Main Contributor: Robert Shaw West

224 COVID-19 3D MEDICAL ANIMATION | Design Firm: MJH Life Sciences
Designers: Alysa Braga, Timothy Vernile, Tatiana Holt | Client: Self-initiated
Main Contributor: Alysa Braga

224 PATIENT STORIES | Design Firm: MJH Life Sciences
Designer: Erin Hughes | Client: CURE | Main Contributor: Erin Hughes

224 HUMAN SHADOW ETCHED IN STONE | Design Firm: Tsushima Design
Designer: Hajime Tsushima | Client: Japan Graphic Designers Association Hiroshima
Main Contributor: Hajime Tsushima

224 BEAT THE PEAKS | Design Firm: B&W Studio | Designers: Lee Bradley, Scott Cockerham, Declan Byrne | Client: Self-intiated | Main Contributor: Lee Bradley

224 RED CROSS BINATIONAL DONATION CAMPAIGN
Design Firm: Freaner Creative & Design | Designer: Ariel Freaner
Clients: Red Cross of Tijuana, Jorge Astiazaran | Editor: Fernanda Freaner
Creative Production Partner: Ariel Mitchell Freaner | Main Contributor: Ariel Freaner

DESIGNERS

LEAD, SENIOR, GRAPHIC, JUNIOR DESIGNERS

DESIGN DIRECTORS, LEADS

CREATIVE DIRECTORS/ASSOCIATE, CHIEF, EXECUTIVE CREATIVE DIRECTORS

ART DIRECTORS/SENIOR ART DIRECTORS

ASSISTANT DESIGNERS

DIRECTORS/DIRECTORS OF PHOTOGRAPHY/PHOTO, FASHION DIRECTORS

PHOTOGRAPHY/PHOTOGRAPHERS/PRODUCT PHOTOGRAPHERS/PHOTO RETOUCHING, EDITORS/RETOUCHERS/RETOUCHING

IMAGE SOURCES

ANIMATORS/MOTION DESIGNERS/VIDEO/VIDEOGRAPHERS/ARTISTS/DIGITAL ARTISTS

CONTENT, EXHIBITION, INTERACTIVE, LOGO, PRINT, SET, TYPEFACE DESIGNERS/TYPOGRAPHERS/TYPOGRAPHY DESIGN/TYPEFACE

WEB DESIGNERS/WEB DEVELOPERS/USER EXPERIENCE/USER EXPERIENCE ARCHITECTS

ILLUSTRATORS

AUTHORS/COPYWRITERS/PUBLISHERS/EDITORS-IN-CHIEF/EDITORS

CONTRIBUTORS

PRODUCTION/HEADS OF PRODUCTION/PRODUCTION ARTISTS, COMPANIES, MANAGERS

ACCOUNT DIRECTORS, EXECUTIVES, MANAGEMENT, SERVICES, SUPERVISORS

PROJECT DIRECTORS/PROJECT MANAGERS/PROJECT MANAGEMENT/PROJECT COORDINATORS

PRODUCERS

PLATINUM

33 and Branding
www.33andbranding.com
Room 112, Building 30,
Andersen Garden
Hongxia Road,
Chaoyang District, Beijing
100024
China
Tel +86 0042 1868
will@33andbranding.com

Dankook University
www.dankook.ac.kr
Room 317, College of Arts, 126
Jukjeon, Suji Yongin Gyeonggi
448-701
South Korea
Tel +82 10 9117 0517
finvox3@naver.com

EJ Communication Studio
www.gallerybi.com
105-902, 15 Geumho-ro
Seongdong-gu, Seoul 04740
South Korea
Tel +82 10 3842 4238
eunjiniker@naver.com

Media.Work
www.media.work
453 S. Spring St., Ste. 400,
PMB 102
Los Angeles, CA 90013
United States
Tel +1 813 502 7416
alexandra@media.work

**National Kaohsiung University of
Science and Technology (NKUST)**
www.eng.nkust.edu.tw
No. 58, Shenzhong Road
Kaohsiung 82444
Taiwan
Tel +886 915 626 327
cwc2022@nkust.edu.tw

Sol Benito
www.solbenito.com
1515-16 Ghanshaym Enclave,
Link Road
Kandivali, Mumbai,
Maharashtra 400067
India
Tel +91 099 6786 4864
solbenitoinfo@gmail.com

Stranger & Stranger
www.strangerandstranger.com
68 Greenpoint Ave.
Brooklyn, NY 11222
United States
Tel +1 212 625 2441
nyc@strangerandstranger.com

Studio DelRey
www.studiodelrey.com.br
Rua Uruguaiana 1237 CJ 32
Campinas,
São Paulo 13026-002
Brazil
Tel +55 11 979 50 4999
studiodelrey@gmail.com

Studio Hinrichs
www.studio-hinrichs.com
2064 Powell St.
San Francisco, CA 94133
United States
Tel +1 415 543 1776
reception@studio-hinrichs.com

The Balbusso Twins
www.balbussotwins.myportfolio.
com
Milan, Lombardy
Italy
Tel +1 212 333 2551
balbusso.twins@gmail.com

GOLD

***Trace Element**
www.traceelement.com
6125 Luther Lane, #123
Dallas, TX 75225
United States
Tel +1 469 644 1023
kasey.cooley@traceelement.com

1/4 Studio
www.quarterstudio.pt
Estrada da Circunvalação
12115 Cave, Porto 4250-155
Portugal
Tel +351 223 166 278
hello@quarterstudio.pt

33 and Branding
www.33andbranding.com
Room 112, Building 30,
Andersen Garden
Hongxia Road,
Chaoyang District, Beijing
100024
China
Tel +86 0042 1868
will@33andbranding.com

Affinity Creative Group
www.affinitycreative.com
1155 Walnut Ave.
Mare Island, CA 94592
United States
Tel +1 707 562 2787
ella@affinitycreative.com

Ahoy Studios
www.ahoystudios.com
456 Broadway, 3rd Floor
New York, NY 10013
United States
Tel +1 212 645 0565
denise@ahoystudios.com

Andrewsobol.com
www.andrewsobol.com
1120 Wickham Court
Naperville, IL 60540
United States
Tel +1 312 909 0588
andrew.sobol@elmhurst.edu

Antonio Castro Design
www.acastrodesign.net
El Paso, TX
United States
antcastro@utep.edu

Arcana Academy
www.arcanaacademy.com
13323 Washington Blvd., Ste. 301
Los Angeles, CA 90066
United States
Tel +1 310 279 5024
newbusiness@arcanaacademy.
com

ARSONAL
www.arsonal.com
3524 Hayden Ave.
Culver City, CA 90232
United States
Tel +1 310 815 8824
info@arsonal.com

ArtHouse Design
www.arthousedenver.com
2373 Central Park Blvd., Ste. 204
Denver, CO 80238
United States
Tel +1 303 892 9816
info@arthousedenver.com

Barlow.Agency
www.barlow.agency
1-5 Woodburn St., Studio A3a
Redfern, NSW 2016
Australia
hello@barlow.agency

Big House Studio
www.bighousestudio.com
6115 S. University Ave., Unit 6
Chicago, IL 60637
United States
Tel +1 773 707 0668
maddiema@bighousestudio.com

Butterfly Cannon
www.butterflycannon.com
Holborn Tower,
137-144 High Holborn
London WC1V 6PL
United Kingdom
Tel +44 203 384 4572
jon.davies@butterflycannon.com

Carmit Design Studio
www.carmitdesign.com
2208 Bettina Ave.
Belmont, CA 94002
United States
Tel +1 650 283 1308
carmit@carmitdesign.com

CF Napa Brand Design
www.cfnapa.com
2787 Napa Valley and
Corporate Drive
Napa, CA 94558
United States
Tel +1 707 265 1891
cfnapa@cfnapa.com

Chad Michael Studio
www.chadmichaelstudio.com
515 S. Manus Drive
Dallas, TX 75224
United States
Tel +1 972 302 5198
chad@chadmichaelstudio.com

Charmie Shah
www.charmieshah.com
285 Ave. C, Apt. 11F
New York, NY 10009
United States
Tel +1 646 309 3080
charmieshah2109@gmail.com

Cina Associates
www.cinaassociates.com
1101 Stinson Blvd.
Minneapolis, MN 55413
United States
Tel +1 201 272 7666
eric@ericmelzer.com

Code Switch
www.codeswitchdesign.com
262 Crescent St.
Northampton, MA 01060
United States
jansabach@mac.com

Collective Turn
www.instagram.com/jinyoungk
im.official
4F, 2, Ttukseom-ro 30-gil,
Gwangjin-gu
Seoul 05085
South Korea
Tel +82 10 8061 0828
coltv.turn.j@gmail.com

CollierGraphica
www.colliergraphica.com
2715 Chenevert St.
Houston, TX 77004
United States
Tel +1 713 894 0061
scollier44@gmail.com

Cue
www.designcue.com
520 Nicollet Mall, Ste. 500
Minneapolis, MN 55402
United States
Tel +1 612 465 0030
info@designcue.com

DAEKI and JUN
www.b-d-b.xyz
Hannamdong Yongsan-gu
Seoul 04418
South Korea
win.daekiandjun@gmail.com

Daichi Takizawa
www.daichitakizawa.com
ARKHOUSE #213,
17-6 Wakamatsu-cho
Shinjuku-ku, Tokyo 162-0056
Japan
Tel +81 80 5172 9358
takizawa.d.517@gmail.com

Dankook University
www.dankook.ac.kr
Room 317, College of Arts, 126
Jukjeon, Suji Yongin Gyeonggi
448-701
South Korea
Tel +82 10 9117 0517
finvox3@naver.com

David Cercós
www.davidcercos.com
Padre Viñas 16
Valencia 46019
Spain
Tel +34 696 011 108
estudio@davidcercos.com

Derry Noyes
www.photoassist.com
3891 Newark St. NW, D484
Washington, DC 20016
United States
Tel +1 202 276 2832
shandwerger@photoassist.com

Dessein
www.dessein.com.au
130 Aberdeen St.
Northbridge Perth, WA 6003
Australia
Tel +61 892 280 661
geoff@dessein.com.au

Duffy & Partners
www.duffy.com
323 Washington Ave. N, Ste. 200
Minneapolis, MN 55401
United States
Tel +1 612 327 7921
bduffy@duffy.com

**El Paso, Galería de
Comunicación**
www.elpasocomunicacion.com
c. Sagunto, 13
Madrid 28010
Spain
Tel +34 91 594 2248
elpaso@elpasocomunicacion.
com

Elevate Design
www.elevatedesign.org
2600 Roseland Drive
Ann Arbor, MI 48103
United States
Tel +1 734 827 4242
salchow@msu.edu

Entro
www.entro.com
135 W. 26th St., Floor 12
New York, NY 10001
United States
Tel +1 416 368 6988
valerie@entro.com

Ermolaev Bureau
www.ermolaevbureau.com
I. Chavchavadze Ave., N 37
Tbilisi 0162
Georgia
Tel +99 559 500 2681
vlad@ermolaevbureau.com

Fallano Faulkner & Associates
www.fallano.com
19 S. Stricker St.
Baltimore, MD 21223
United States
Tel +1 410 945 2092
ffallano@fallano.com

Gallery BI
www.gallerybi.comr
91 Daehak-ro, Seonghwan-eup,
Seobuk-gu
Cheonan-si,
Chungcheongnam-do
South Korea
Tel +82 41 580 2000
sunbi155@naver.com

Goodall Integrated Design
www.goodallintegrated.com
35 Tyrrel Ave.
Toronto, ON M6G 2G1
Canada
Tel +1 416 435 3653
derwyn@goodallintegrated.com

Greenleaf Book Group
www.greenleafbookgroup.com
PO Box 91869
Austin, TX 78709
United States
Tel +1 512 891 6100
lmacqueen@greenleafbookgroup.
com

Hacin
www.hacin.com
500 Harrison Ave., Studio 4F
Boston, MA 02118
United States
Tel +1 617 426 0077
media@hacin.com

HandMade Monsters
www.handmademonsters.com
Van Schoonbekestraat 75
Antwerp B-2018
Belgium
Tel +32 475 70 89 64
mark.borgions@handmademon-
sters.com

Headcase Design
www.headcasedesign.com
428 N. 13th St., #5F
Philadelphia, PA 19123
United States
Tel +1 215 840 1142
pkepple@headcasedesign.com

HEHE DESIGN
www.vcg.com
No. 41 Jian'an St., Nanhu Road,
Wuchang District
Wuhan City,
Hubei Province 430000
China
Tel +1 507 245 1101
art008.hi@163.cm

HOOK
www.hookusa.com
522 King St.
Charleston, SC 29403
United States
Tel +1 843 853 5532
trish@hookusa.com

Idle Hands
www.idlehands.co.za
6a Noordhoek Main Road,
Noordhoek
Cape Town, Western Cape 7985
South Africa
Tel +27 837 599 771
andre@idlehands.co.za

Jocelyn Zhao Design
www.jocelynzhao.com
25 Park Lane S, Apt. 3010
Jersey City, NJ 07310
United States
Tel +1 626 592 5210
jocelynzhaodesign@gmail.com

Justin Kunz Art & Design
www.justinkunz.com
1227 E. 10th St. S
Lindon, UT 84042
United States
Tel +1 949 419 7849
jk@justinkunz.com

Kabookaboo
www.kabookaboo.com
2222 Ponce de Leon, Ste. 07-112
Coral Gables, FL 33134
United States
Tel +1 305 569 9154
info@kabookaboo.com

Lafayette American
www.lafayetteamerican.com
5000 Grand River Ave.
Detroit, MI 48208
United States
Tel +1 313 757 2720
doug.patterson@mac.com

Legacy79
www.legacy79.com
816 Camaron St., Ste. 2.02
San Antonio, TX 78212
United States
Tel +1 210 508 0225
genaro@legacy79.com

LERMA/
www.lermaagency.com
409 N. Houston St., Ste. 700
Dallas, TX 75202
United States
Tel +1 214 681 3920
marmstrong@lermaagency.com

Lewis Communications
www.lewiscommunications.com
2030 1st Ave. N
Birmingham, AL 35203
United States
Tel +1 205 980 0774
ryan@lewiscommunications.com

Lingou Li
www.lingou.org
413 Waldo Ave., Unit 206
Pasadena, CA 91101
United States
Tel +1 626 567 2173
lingouvisuals@gmail.com

Lippincott
www.lippincott.com
499 Park Ave.
New York, NY 10022
United States
Tel +1 212 521 0000
christina.clemente@lippincott.
com

Lisa Sirbaugh Creative
www.lisasirbaughcreative.com
31 W. Patrick St., Ste. 209
Frederick, MD 21701
United States
Tel +1 301 788 6455
lisa@lisasirbaugh.com

Lisa Winstanley Design
www.lisawinstanley.com
62J Nanyang View 02-17
639668
Singapore
Tel +83 437 608
lwinstanley@ntu.edu.sg

Media.Work
www.media.work
453 S. Spring St., Ste. 400,
PMB 102
Los Angeles, CA 90013
United States
Tel +1 813 502 7416
alexandra@media.work

Mermaid, Inc.
www.mermaidnyc.com
479 W. 152nd St., Studio 1B
New York, NY 10031
United States
Tel +1 212 337 0707
sharon@mermaidnyc.com

Michael Pantuso Design
www.pantusodesign.com
820 S. Thurlow St.
Hinsdale, IL 60521
United States
Tel +1 312 318 1800
michaelpantuso@me.com

Michael Schwab Studio
www.michaelschwab.com
108 Tamalpais Ave.
San Anselmo, CA 94960
United States
Tel +1 415 257 5792
carolyn@michaelschwab.com

Michele Snow
www.michele-snow.com
Boston, MA
United States
msmichelesnow@gmail.com

Microsoft Brand Studio
www.microsoft.com
3900 148th Ave.
Redmond, WA 98052
United States
Tel +1 425 638 7777
kaitlin.butcher@microsoft.com

Microsoft Design Studio
www.microsoft.com
3900 148th Ave.
Redmond, WA 98052
United States
Tel +1 425 638 7777
kaitlin.butcher@microsoft.com

MiresBall
www.miresball.com
2605 State St.
San Diego, CA 92103
United States
Tel +1 619 234 6631
marketing@miresball.com

Mischievous Wolf
www.mischievouswolf.com
Dominions House, 23-25 St.,
Augustine's Parade
Bristol BS1 4UL
United Kingdom
Tel +44 117 235 6900
phil@mischievouswolf.com

Neiman Marcus Brand Creative
www.neimanmarcus.com
1618 Main St.
Dallas, TX 75201
United States
stephenarevalos@gmail.com

Next Brand
www.nextbrand.design
10 Charles St.
South Melbourne, VIC 3205
Australia
Tel +61 424 253 716
lee@nextbrand.com.au

Omdesign
www.omdesign.pt
Rua de Vila Franca,
54 - Leça da Palmeira
Matosinhos 4450-802
Portugal
Tel +351 229 982 960
comunicacao@omdesign.pt

One Design Company
www.onedesigncompany.com
230 W. Superior St., Ste. 700
Chicago, IL 60654
United States
Tel +1 312 602 3335
info@onedesigncompany.com

Pavement
www.pavementsf.com
420 3rd St., Ste. 240
Oakland, CA 94607
United States
Tel +1 917 558 3985
hester.mike@yahoo.com

Pendo
www.pendo.ca
201-402 W. Pender St.
Vancouver, BC V6B 1T6
Canada
Tel +1 604 398 8822
hello@pendo.ca

PepsiCo
www.design.pepsico.com
350 Hudson St., 2nd Floor
New York, NY 10014
United States
Tel +1 646 681 5095
emily.ford.contractor@pepsico.
com

Phillips Marketing Department
www.phillips.com
432 Park Ave.
New York, NY 10022
United States
Tel +1 917 753 7486
mschott@phillips.com

Planet Propaganda
www.planetpropaganda.com
605 Williamson St.
Madison, WI 53703
United States
Tel +1 608 256 0000
smeuer@planetpropaganda.com

Play
www.play.studio
520 Hampshire St., #213
San Francisco, CA 94110
United States
Tel +1 714 235 9119
ops@play.studio

Premier Communications Group
www.premiercg.com
612 E. 4th St.
Royal Oak, MI 48067
United States
Tel +1 248 320 5306
gfossano@premiercg.com

Ralph Appelbaum Associates
www.raai.com
88 Pine St.
New York, NY 10005
United States
Tel +1 212 334 8200
caseylynn@raai.com

Reggie London
www.reggielondon.co.uk
6 Upper Butts
Brentford, Middlesex TW8 8DA
United Kingdom
Tel +44 079 6131 6876
paul@reggielondon.co.uk

Richard Ljoenes Design LLC
www.richardljoenes.com
4792 McKinley Drive
Boulder, CO 80303
United States
Tel +1 917 407 2400
richard.ljoenes@gmail.com

**Ron Taft Brand Innovation
& Media Arts**
www.rontaft.com
2934 Beverly Glen Circle, #372
Los Angeles, CA 90077
United States
Tel +1 310 339 2442
ron@rontaft.com

Rose
www.rosedesign.co.uk
The Old School,
70 St. Marychurch St.
London SE16 4HZ
United Kingdom
Tel +44 020 7394 2800
hello@rosedesign.co.uk

Sandstrom Partners
www.sandstrompartners.com
808 SW. 3rd Ave., #610
Portland, OR 97204
United States
Tel +1 503 248 9466
jack@sandstrompartners.com

Shadia Design
www.shadiadesign.com.au
419 Magill Road
St. Morris, Adelaide, SA 5068
Australia
Tel +61 040 971 5075
shadia@shadiadesign.com.au

**Shenzhen Excel Brand Design
Consultant Co., Ltd.**
Yidasheng Building, 3rd Floor,
Wuhe Ave. and S. 5th,
Longgang District
518129 Shenzhen
China
Tel +86 755 8282 1024
695938757@qq.com

Siena Scarff Design
www.sienascarff.com
302 Harvard St.
Cambridge, MA 02139
United States
Tel +1 857 756 8372
siena@sienascarff.com

Sol Benito
www.solbenito.com
1515-16 Ghanshaym Enclave,
Link Road
Kandivali, Mumbai,
Maharashtra 400067
India
Tel +91 099 6786 4864
solbenitoinfo@gmail.com

Steiner Graphics
www.renesteiner.com
The Merchandise Building
155 Dalhousie St., Ste. 1062
Toronto, ON M5B 2P7
Canada
Tel +1 416 792 6969
rene@steinergraphics.com

Stitzlein Studio
www.stitzstudio.com
336 W. Poplar Ave.
San Mateo, CA 94402
United States
Tel +1 650 703 6920
jstitzlein@gmail.com

STNMTL (Station Montréal Design Bureau)
www.stnmtl.com
5413 Boul Saint-Laurent,
Ste. 204, Buzzer #350
Montreal, QB H2T 1S5
Canada
Tel +1 514 242 0286
ib@stnmtl.com

Stranger & Stranger
www.strangerandstranger.com
68 Greenpoint Ave.
Brooklyn, NY 11222
United States
Tel +1 212 625 2441
nyc@strangerandstranger.com

Studio A
www.studioa.com
1019 Queen St.
Alexandria, VA 22314
United States
Tel +1 703 684 7729
info@studioa.com

Studio Eduardo Aires
www.eduardoaires.com
Alexandre Braga, N94-1E
Porto 4000-049
Portugal
Tel +351 226 169 080
mail@eduardoaires.com

Studio Hinrichs
www.studio-hinrichs.com
2064 Powell St.
San Francisco, CA 94133
United States
Tel +1 415 543 1776
reception@studio-hinrichs.com

Studio XXY
California
United States
yuqindesign@gmail.com

Sun Design Production
No. 9, Fuqiang Road,
Jiaojiang District
Taizhou City,
Zhejiang Province 318000
China
Tel +86 61 188 5860 8587
1023484137@qq.com

The Balbusso Twins
www.balbussotwins.myportfolio.com
Milan, Lombardy
Italy
Tel +1 212 333 2551
balbusso.twins@gmail.com

The Republik
www.therepublik.com
1700 Glenwood Ave.
Raleigh, NC 27608
United States
Tel +1 919 956 9400
 hello@therepublik.com

THERE IS STUDIO
www.sean-eve.com
94 Park Grove Road
Leytonstone, London E11 4PU
United Kingdom
Tel +44 075 7246 0707
eve@thereis.co.uk

Thoroughbred Spirits Group
www.tbspirits.com
5321 Woodland Ave.
Woodland Springs, IL 60558
United States
Tel +1 312 809 8202
jb@tbspirits.com

Tielemans Design
www.tielemansdesign.com
1535 Roughrider Circle
Henderson, NV 89014
United States
Tel +1 702 946 5511
anton@tielemansdesign.com

Toolbox Design
www.toolboxdesign.com
304-1228 Hamilton St.
Vancouver, BC V6B 6L2
Canada
Tel +1 778 322 7474
victoria@toolboxdesign.com

TOPPAN INC.
www.toppan.com/en
9F, 1-3-3, Suido Bunkyo-ku
Tokyo 112-8531
Japan
Tel +81 3 5840 2192
mescal@mac.com

Traina
www.wearetraina.com
10680 Treena St., Ste. 520
San Diego, CA 92131
United States
Tel +1 619 567 7100
awards@wearetraina.com

Trope Publishing Co.
www.trope.com
1757 N. Kimball Ave., Ste. 103B
Chicago, IL 60647
United States
Tel +1 312 330 5080
info@trope.com

Tsushima Design
www.tsushima-design.com
1-17-204, 1-17, Matsukawa-cho,
Minami-ku
Hiroshima 7320826
Japan
Tel +81 82 567 5586
info@tsushima-design.com

Turner Duckworth
www.turnerduckworth.com
375 Hudson St., Level 8
New York, NY 10014
United States
Tel +1 212 463 2400
xavier.drudge@turnerduckworth.com

Twice2 - Atelier de Graphisme & Typographie
www.twice2.ch
15-17 Rue Saint-Laurent
Geneva 1207
Switzerland
Tel +41 794 589 073
johan@twice2.ch

UP-Ideas
www.up-ideas.com
740 Ashley Laine Walk
Lawrenceville, GA 30043
United States
Tel +1 770 912 3120
roger.sawhill@gmail.com

Vanderbyl Design
www.vanderbyl.com
511 Tokay Lane
St. Helena, CA 94574
United States
Tel +1 415 543 8447
michael@vanderbyl.com

Viva & Co.
www.vivaandco.com
584 Jones Ave.
Toronto, ON M4J 3H3
Canada
Tel +1 416 923 6355
info@vivaandco.com

Wainscot Media
www.mccandlissandcampbell.com
433 N. Windsor Ave.
Brightwaters, NY 11718
United States
Tel +1 631 252 3527
mcandcstudio@gmail.com

Young & Laramore
www.yandl.com
407 Fulton St.
Indianapolis, IN 46202
United States
Tel +1 317 264 8000
awards@yandl.com

Z WAVE DESIGN
www.houlangdesign.com
B5-535, Fantasia Fortune Plaza,
No. 3 Shihua Road,
Futian Bonded Area
Shenzhen, Guangdong 518000
China
Tel +86 075 5239 64097
hlsj@houlangdesign.com

Zhiyi Zhu
www.juziey.com
14727 Roosevelt Ave., Floor 1
Flushing, NY 11354
United States
Tel +1 646 288 8206
juziey.z@gmail.com

SILVER

***Trace Element**
www.traceelement.com
6125 Luther Lane, #123
Dallas, TX 75225
United States
Tel +1 469 644 1023
kasey.cooley@traceelement.com

1/4 Studio
www.quarterstudio.pt
Estrada da Circunvalação
12115 Cave, Porto 4250-155
Portugal
Tel +351 223 166 278
hello@quarterstudio.pt

33 and Branding
www.33andbranding.com
Room 112, Building 30,
Andersen Garden
Hongxia Road,
Chaoyang District,
Beijing 100024
China
Tel +86 0042 1868
will@33andbranding.com

3D-Identity
www.3d-identity.com
2501 Blake St.
Denver, CO 80202
United States
Tel +1 303 471 4334
lduits@workplaceelements.com

A.S.M.D. Creations
www.asmdtw.com
2F, No. 2, Guanqian Road,
Zhongzheng Dist.
Taipei 100
Taiwan
Tel +886 097 226 0318
louis.asmdtw@gmail.com

Addison
www.addison.com
48 Wall St., 9th Floor
New York, NY 10005
United States
Tel +1 617 335 5522
acrosson@addison.com

Affinity Creative Group
www.affinitycreative.com
1155 Walnut Ave.
Mare Island, CA 94592
United States
Tel +1 707 562 2787
ella@affinitycreative.com

AG Creative Group
www.agcreative.ca
100-2250 Boundary Road
Burnaby, BC V5M 3Z3
Canada
Tel +1 604 559 1411
stew@agcreative.ca

Ahoy Studios
www.ahoystudios.com
456 Broadway, 3rd Floor
New York, NY 10013
United States
Tel +1 212 645 0565
denise@ahoystudios.com

Airspace
www.airspace.nyc
41 Flatbush Ave.
Brooklyn, NY 11217
United States
Tel +1 917 593 5200
jill@airspace.nyc

Alexis Jamet
www.alecsi.com
Montreuil, Île-de-France
France
jamet.alexis@gmail.com

American Museum of Natural History - Exhibitions Department
www.amnh.org
Central Park West at 79th St.
New York, NY 10024
United States
Tel +1 212 769 5453
rdemetrio@amnh.org

Anagraphic
www.anagraphic.hu
Attila út 105.
Budapest 1012
Hungary
Tel +36 1 202 0555
anagraphic@anagraphic.hu

Andrea Szabó
www.andreaszabo.hu
Andrássy út 69-71
Budapest 1062
Hungary
Tel +36 20 356 8436
szaboandreaetel@gmail.com

Andrewsobol.com
www.andrewsobol.com
1120 Wickham Court
Naperville, IL 60540
United States
Tel +1 312 909 0588
andrew.sobol@elmhurst.edu

Angelique Markowski
www.cargocollective.com/angelique
markowski/About-me
Brookline, MA
United States
Tel +1 617 834 5730
angeliquemarkowski@gmail.com

Anne M. Giangiulio Design
www.annegiangiulio.com
500 W. University Ave.
El Paso, TX 79968
United States
Tel +1 915 222 1134
annegiangiulio@gmail.com

ARSONAL
www.arsonal.com
3524 Hayden Ave.
Culver City, CA 90232
United States
Tel +1 310 815 8824
info@arsonal.com

ArtCenter College of Design
www.artcenter.edu
1700 Lida St.
Pasadena, CA 91103
United States
Tel +1 626 396 2200
wjohnstone@inside.artcenter.edu

Asterisk
www.asteriskdesign.com
1710 Houston St.
Austin, TX 78756
United States
Tel +1 512 371 1618
pam@asteriskdesign.com

Atelier Nunes e Pã, Lda
www.ateliernunesepa.pt
Rua de Fez
143 Oporto 4150-329
Portugal
Tel +35 122 619 8310
administracao@ateliernunese-
pa.pt

Atypic
www.atypiccraft.com
1307 W. Morehead St., Ste. 102
Charlotte, NC 28208
United States
Tel +1 704 447 7190
info@atypiccraft.com

B&W Studio
www.bandwstudio.co.uk
No. 8 The Square
Farnley Business Park
Farnley LS21 2QF
United Kingdom
hello@bandwstudio.co.uk

Bailey Lauerman
www.baileylauerman.com
1299 Farnam St., 9th Floor
Omaha, NE, 68102
United States
Tel +1 402 514 9400
sfaden@baileylauerman.com

Balloon Inc.
www.lloon.jp
Kita-ku Ohfuka-cho 3-1
Grand Front Osaka Knowledge
Capital 8F
Osaka-fu, Osaka 530-0011
Japan
Tel +81 6 7167 6109
info_b@lloon.jp

Barlow.Agency
www.barlow.agency
1-5 Woodburn St., Studio A3a
Redfern, NSW 2016
Australia
hello@barlow.agency

Bath & Body Works
www.bathandbodyworks.com
13700 Joaquin Lane
Cerritos, CA 90703
United States
Tel +1 562 308 0594
kennethchiem@gmail.com

BEKAR HAUS D.O.O.
www.bekar.haus
Ksaverska Cesta 55
Zagreb, Grad Zagreb 10000
Croatia
Tel +385 919 841 739
info@bekar.haus

Big House Studio
www.bighousestudio.com
6115 S. University Ave., Unit 6
Chicago, IL 60637
United States
Tel +1 773 707 0668
maddiema@bighousestudio.com

Boxer Brand Design
www.boxerbranddesign.com
345 N. Morgan St., Ste. 1000
Chicago, IL 60607
United States
Tel +1 312 614 4600
hello@boxerbranddesign.com

Braley Design
www.braleydesign.com
750 Shaker Drive, #202
Lexington, KY 40504
United States
Tel +1 415 706 2700
braley@braleydesign.com

BrandTuitive
www.brandtuitive.com
1460 Broadway
New York, NY 10036
United States
Tel +1 646 790 5707
emma.brenard@brandtuitive.com

Bruce Power Creative Strategy
www.brucepower.com
3394 Bruce County Road, #20
Tiverton, ON N0G 2T0
Canada
Tel +1 519 525 5493
erin.grandmaison@gmail.com

C&G Partners LLC
www.cgpartnersllc.com
116 E. 16th St., Floor 10
New York, NY 10003
United States
Tel +1 212 532 4460
sehba@cgpartnersllc.com

Camilart
www.camilart.com
945 W. End Ave., 11A
New York, NY 10025
United States
Tel +1 646 319 1368
info@camilart.com

Carmit Design Studio
www.carmitdesign.com
2208 Bettina Ave.
Belmont, CA 94002
United States
Tel +1 650 283 1308
carmit@carmitdesign.com

**Cepheid One Studio
Internal Agency**
www.cepheid.com
904 Caribbean Drive
Sunnyvale, CA 94089
United States
Tel +1 303 898 2522
kirsten.olivet@cepheid.com

CF Napa Brand Design
www.cfnapa.com
2787 Napa Valley and
Corporate Drive
Napa, CA 94558
United States
Tel +1 707 265 1891
cfnapa@cfnapa.com

Charmie Shah
www.charmieshah.com
285 Ave. C, Apt. 11F
New York, NY 10009
United States
Tel +1 646 309 3080
charmieshah2109@gmail.com

Chase Design Group
www.chasedesigngroup.com
99 Pasadena Ave., #9
South Pasadena, CA 91030
United States
Tel +1 323 668 1055
lastudio@chasedesigngroup.com

Chemi Montes Design
www.graphis.com/portfolios/
chemi-montes
4400 Massachusetts Ave. NW,
Katzen Bdg. 101
Washington, DC 20011
United States
Tel +1 202 885 1671
cmontes@american.edu

Chikako Oguma
#1403 1-10-22 Nakameguro
Meguro-ku, Tokyo 153-0061
Japan
Tel +81 90 6045 2037
koguma75@gmail.com

Claire Zou
www.clairezou.art
4427 Purves St., 12E
Long Island City, NY 11101
United States
Tel +1 917 843 6822
clairezoudesign@gmail.com

Code Switch
www.codeswitchdesign.com
262 Crescent St.
Northampton, MA 01060
United States
jansabach@mac.com

Columbia University
www.columbia.edu
116th and Broadway
New York, NY 10027
United States
Tel +1 917 882 2925
geoffrey@gdallen.com

CutlerBremner
www.cutlerbremner.com
19835 Montau Drive
Topanga, CA 90290
United States
Tel +1 310 990 6642
scott@scott-bremner.com

DAEKI and JUN
www.b-d-b.xyz
Hannamdong Yongsan-gu
Seoul 04418
South Korea
win.daekiandjun@gmail.com

Daichi Takizawa
www.daichitakizawa.com
ARKHOUSE #213,
17-6 Wakamatsu-cho
Shinjuku-ku, Tokyo 162-0056
Japan
Tel +81 80 5172 9358
takizawa.d.517@gmail.com

Dalian RYCX Design
www.rycxcn.com
A6-12, No. 419 Minzheng St.,
Shahekou District 116021
Dalian Liaoning
China
Tel +86 1552 4796 568
rycxcn@163.com

Darkhorse Design, LLC
www.darkhorsedesign-usa.com
8 Whitefield Lane
Lancaster, PA 17602
United States
Tel +1 717 844 2888
roberttalarczyk@mac.com

Dear Fellow Design Studio
www.dearfellow.com
4671 Bradley Court
Doylestown, PA 18902
United States
Tel +1 267 987 2637
courtney-spencer@dearfellow.co

Derry Noyes
www.photoassist.com
3891 Newark St. NW, D484
Washington, DC 20016
United States
Tel +1 202 276 2832
shandwerger@photoassist.com

Design by OOF
www.oof.pt
Av. D. Afonso Henriques 170
Guimarães, Braga 4810-431
Portugal
Tel +351 253 419 025
geral@oof.pt

Dessein
www.dessein.com.au
130 Aberdeen St.
Northbridge Perth, WA 6003
Australia
Tel +61 892 280 661
geoff@dessein.com.au

Dixon Schwabl + Company
www.dixonschwabl.com
1595 Moseley Road
Victor, NY 14564
United States
Tel +1 585 383 0380
bob_c@dixonschwabl.com

DLR Group
www.dlrgroup.com
7290 W. 133rd St.
Overland Park, KS 66213
United States
Tel +1 402 975 9510
awells@dlrgroup.com

Do Kim Design
www.dokimdesign.com
West Lafayette, IN
United States
Tel +1 765 496 3271
dokimdesign@gmail.com

Duas Faces Design
www.duasfaces.net
Rua Barata Feyo,
140 - 2º Andar - Escritório 2.5
Porto, Porto 4250-076
Portugal
Tel +35 191 245 2123
duasfaces.design@gmail.com

Duffy & Partners
www.duffy.com
323 Washington Ave. N, Ste. 200
Minneapolis, MN 55401
United States
Tel +1 612 327 7921
bduffy@duffy.com

Dunn&Co.
www.dunn-co.com
202 S. 22nd St.
Tampa, FL 33605
United States
Tel +1 813 350 7990
dunn@dunn-co.com

**El Paso, Galería de
Comunicación**
www.elpasocomunicacion.com
c. Sagunto, 13 Madrid
Madrid 28010
Spain
Tel +34 91 594 2248
elpaso@elpasocomunicacion.
com

Elevate Design
www.elevatedesign.org
2600 Roseland Drive
Ann Arbor, MI 48103
United States
Tel +1 734 827 4242
salchow@msu.edu

Elmwood London
www.elmwood.com
7 Gee St.
London EC1V 3RD
United Kingdom
Tel +44 020 7637 0884
alex.ehrensperger@elmwood.
com

Elmwood New York
www.elmwood.com
598 Broadway, 10th Floor
New York, NY 10012
United States
Tel +1 912 713 4170
meg.beckum@elmwood.com

Entro
www.entro.com
135 W. 26th St., Floor 12
New York, NY 10001
United States
Tel +1 416 368 6988
valerie@entro.com

Erica Holeman
www.ericaholeman.com
2228 Longwood Drive
Carrollton, TX 75010
United States
Tel +1 918 899 7629
erica.holeman@unt.edu

Faceout Studio
www.faceoutstudio.com
414 W. Washington Ave., Ste. B
Sisters, OR 97759
United States
Tel +1 541 323 3220
torrey@faceoutstudio.com

forceMAJEURE Design
www.forcemajeure.design
219 36th St.
Brooklyn, NY 11232
United States
Tel +1 212 625 0708
rmahieu@forcemajeure.design

FranklinTill
www.franklintill.com
Studio C003A,
Lighthouse Studios
89a Shacklewell Lane
London E8 2EB
United Kingdom
info@franklintill.com

Freaner Creative & Design
www.freaner.com
113 W. G St., #650
San Diego, CA 92101
United States
Tel +1 619 870 4699
arielfreaner@freaner.com

Fujimino Design
www.fujimino-d.jp
Japan
s.iitsuka@4peace.co.jp

Gastdesign
www.gastdesign.de
Feldstr. 14
Hürtgenwald, 52393
Germany
Tel +49 015 77 28 71 899
info@gastdesign.de

Gensler Research Institute
www.gensler.com
1700 Broadway, #400
New York, NY 10019
United States
Tel +1 212 492 1400
minjung_lee@gensler.com

Gentry Press OPC
www.gentrypress.com
6/F, Cyber One Building,
11 Eastwood Ave.
Eastwood City Cyberpark,
Barangay Bagumbayan
Quezon City, Metro Manila 1110
The Philippines
Tel +63 917 811 7251
rpd@gentrypress.com

Go Welsh
www.gowelsh.com
987 Mill Mar Road
Lancaster, PA 17601
United States
Tel +1 717 898 9000
cwelsh@gowelsh.com

Goodall Integrated Design
www.goodallintegrated.com
35 Tyrrel Ave.
Toronto, ON M6G 2G1
Canada
Tel +1 416 435 3653
derwyn@goodallintegrated.com

Google
www.about.google
1600 Amphitheatre Parkway
Mountain View, CA 94043
United States
Tel +1 650 253 0000
press@google.com

Gravdahl Design
www.gravdahldesign.com
C138 Clark Building
Colorado State University
Fort Collins, CO 80523
United States
john.gravdahl@colostate.edu

Greenleaf Book Group
www.greenleafbookgroup.com
PO Box 91869
Austin, TX 78709
United States
Tel +1 512 891 6100
lmacqueen@greenleafbookgroup.
com

Hacin
www.hacin.com
500 Harrison Ave., Studio 4F
Boston, MA 02118
United States
Tel +1 617 426 0077
media@hacin.com

HandMade Monsters
www.handmademonsters.com
Van Schoonbekestraat 75
Antwerp B-2018
Belgium
Tel +32 475 70 89 64
mark.borgions@handmademon-
sters.com

HANYUE DESIGN STUDIO
www.hysong.me
592 Mill Creek Lane, Apt. 301
Santa Clara, CA 95054
United States
Tel +1 408 416 8700
hysong950203@gmail.com

Harcus Design
www.harcus.com.au
3/46 Foster St., Surry Hills
Sydney, NSW 2010
Australia
Tel +61 413 059 848
annette@harcus.com.au

Headcase Design
www.headcasedesign.com
428 N. 13th St., #5F
Philadelphia, PA 19123
United States
Tel +1 215 840 1142
pkepple@headcasedesign.com

HEHE DESIGN
www.vcg.com
No. 41 Jian'an St., Nanhu Road,
Wuchang District
Wuhan City,
Hubei Province 430000
China
Tel +1 507 245 1101
art008.hi@163.cm

Here Be Monsters
www.herebemonsters.ca
111 W. Broadway, Ste. 203
Vancouver, BC V5Y 1P4
Canada
Tel +1 778 986 8801
tony@herebemonsters.ca

HOOK
www.hookusa.com
522 King St.
Charleston, SC 29403
United States
Tel +1 843 853 5532
trish@hookusa.com

House of Current
www.houseofcurrent.com
154 Krog St., Ste. 160
Atlanta, GA 30307
United States
Tel +1 404 816 0094
sbrannon@houseofcurrent.com

Hyungjookim Designlab
www.hyungjookimdesign.com
552 W. Wood St.
West Lafayette, IN 47907
United States
Tel +1 765 409 1039
hakim@purdue.edu

Idle Hands
www.idlehands.co.za
6a Noordhoek Main Road,
Noordhoek
Cape Town, Western Cape 7985
South Africa
Tel +27 837 599 771
andre@idlehands.co.za

Innerspin Marketing
www.innerspinmarketing.com
360 N. Pacific Coast Highway,
Ste. 2000
El Segundo, CA 90245
United States
Tel +1 213 529 0805
gloria@innerspinmarketing.com

Jansword Design
www.janswordzhu.com
Wangjing Soho T3-A1703,
Chaoyang District
Beijing, BJ 100015
China
Tel +86 185 0114 0171
jansword.zhu@gmail.com

Johann Terrettaz
www.twice2.ch
15-17 Rue Saint-Laurent
Geneva 1207
Switzerland
Tel +41 794 589 073
johan@twice2.ch

**John Sposato Design
& Illustration**
www.johnsposato.carbonmade.
com
179 Hudson Terrace
Piermont, NY 10968
United States
Tel +1 845 300 7591
johnsposatodesign@gmail.com

Journey Group
www.journeygroup.com
418 4th St. NE
Charlottesville, VA 22902
United States
Tel +1 434 961 2500
gregb@journeygroup.com

Kathy Mueller Design, LLC
www.kmuellerdesign.com/home
Philadelphia, PA
United States
kmueller@temple.edu

Keith Kitz Design
www.keithkitz.com
1945 Commonwealth Ave.
Boston, MA 02135
United States
Tel +1 857 321 0957
keith.kitz@gmail.com

Kessler Design Group
www.kesslerdesigngroup.com
5225 Pooks Hill Road, Apt. 619 N
Bethesda, MD 20814
United States
Tel +1 301 907 3233
info@kesslerdesigngroup.com

Kevin Woods Creative
www.kevinwoodscreative.com
3105 Shadow Green Lane
Lakeland, TN 38002
United States
Tel +1 901 229 2797
kevin@kevinwoodscreative.com

**Kiyoung An Graphic Art
Course Laboratory**
www.kindai.ac.jp
3-4-1 Kowakae
Higashiosaka, Osaka 577-8502
Japan
Tel +81 6 6721 2332
aky6815@hotmail.com

Kojima Design Office Inc.
www.kojimadesign.jp
2-1-30, Etchujima
Koto-Ku, Tokyo 135-8517
Japan
Tel +81 3 3820 0641
kogaito-y@sponichi.co.jp

Koto Studio
www.koto.studio
1st Floor, The Works, Koto
127-131 Great Suffolk St.
London SE1 1PP
United Kingdom
dave@koto.studio

Krit Design Club
www.behance.net/Kritdc
Jl Bougenville C, No. 3, Antapani
Bandung, West Java 40291
Indonesia
Tel +65 8195 1005
kritdesignclub@gmail.com

L.S. Boldsmith
www.leilasingleton.com
Vancouver
Canada
leila@leilasingleton.com

Lafayette American
www.lafayetteamerican.com
5000 Grand River Ave.
Detroit, MI 48208
United States
Tel +1 313 757 2720
doug.patterson@mac.com

Legis Design
273 Ramona Ave.
Sierra Madre, CA 91024
United States
legis@pa2.so-net.ne.jp

Level Group
www.levelnyc.com
270 Jay St., Ste. 11-I
Brooklyn, NY 11201
United States
Tel +1 212 594 2522
jennifer@levelnyc.com

Lewis Communications
www.lewiscommunications.com
2030 1st Ave. N
Birmingham, AL 35203
United States
Tel +1 205 980 0774
ryan@lewiscommunications.com

Lightner Design
www.linkedin.com/in/conniel-
ightner
atlightnerdesign
9730 SW. Cynthia St.
Beaverton, OR 97008
United States
Tel +1 503 641 6351
cklightner@comcast.net

Lingou Li
www.lingou.org
413 Waldo Ave., Unit 206
Pasadena, CA 91101
United States
Tel +1 626 567 2173
lingouvisuals@gmail.com

Lippincott
www.lippincott.com
499 Park Ave.
New York, NY 10022
United States
Tel +1 212 521 0000
christina.clemente@lippincott.
com

Lisa Sirbaugh Creative
www.lisasirbaughcreative.com
31 W. Patrick St., Ste. 209
Frederick, MD 21701
United States
Tel +1 301 788 6455
lisa@lisasirbaugh.com

Matchstic
www.matchstic.com
437 Memorial Drive SE, Unit A7
Atlanta, GA 30312
United States
Tel +1 770 203 1236
marketing@matchstic.com

May & Co.
www.mayandco.com
6316 Berwyn Lane
Dallas, TX 75214
United States
Tel +1 214 536 0599
dougm@mayandco.com

McCandliss and Campbell
www.mccandlissandcampbell.
com
433 N. Windsor Ave.
Brightwaters, NY 11718
United States
Tel +1 917 326 1843
mcandcstudio@gmail.com

McCann New York
www.mccannny.com
622 3rd Ave.
New York, NY 10017
United States
Tel +1 646 865 2000
contact.ny@mccann.com

Memorial Sloan Kettering
www.mskcc.org
633 3rd Ave., 2nd Floor,
Marketing & Communication
New York, NY 10017
United States
Tel +1 646 227 3140
glickk@mskcc.org

Mermaid, Inc.
www.mermaidnyc.com
479 W. 152nd St., Studio 1B
New York, NY 10031
United States
Tel +1 212 337 0707
sharon@mermaidnyc.com

Microsoft Brand Studio
www.microsoft.com
3900 148th Ave.
Redmond, WA 98052
United States
Tel +1 425 638 7777
kaitlin.butcher@microsoft.com

Microsoft Design Studio
www.microsoft.com
3900 148th Ave.
Redmond, WA 98052
United States
Tel +1 425 638 7777
kaitlin.butcher@microsoft.com

MiresBall
www.miresball.com
2605 State St.
San Diego, CA 92103
United States
Tel +1 619 234 6631
marketing@miresball.com

MJH Life Sciences
www.mjhlifesciences.com
2 Commerce Drive
Cranbury, NJ 08512
United States
Tel +1 609 716 7777
jparadizova@mjhlifesciencescom

Mouser Electronics
www.mouser.com
1000 N. Main St.
Mansfield, TX 76063
United States
Tel +1 817 804 3816
jennifer.k@mouser.com

Namseoul University
www.nsu.ac.kr
91 Daehak-ro, Seonghwan-eup,
Seobuk-gu
Cheonan-si,
Chungcheongnam-do
South Korea
Tel +82 41 580 2000
mijung6@nate.com

Neiman Marcus Brand Creative
www.neimanmarcus.com
1618 Main St.
Dallas, TX 75201
United States
stephenarevalos@gmail.com

Next Brand
www.nextbrand.design
10 Charles St.
South Melbourne, VIC 3205
Australia
Tel +61 424 253 716
lee@nextbrand.com.au

Nikkelsha, Inc.
www.nks.co.jp
Akasaka K-Tower,
1-2-7 Motoakasaka
Minato-ku, Tokyo 1070051
Japan
Tel +81 70 1467 3197
hr.nakamura@nks.co.jp

Noriyuki Kasai
www.instagram.com/kasai.
noriyuki_design
2-42-1 Asahigaoka-Ku
Nerima-ku, Tokyo 1768525
Japan
Tel +81 090 3432 3112

Not William
www.richwallace.myportfolio.
com
Berkeley Heights, NJ
United States
Tel +1 718 207 3285
wallacerich1@gmail.com

Now Now
www.nownow.io
1201 Keosauqua Way
Des Moines, IA 50309
United States
Tel +1 515 451 5192
adam@nownow.io

O0 Design
www.ozero.design
Kyiv
Ukraine
krupa@ozero.design

Omdesign
www.omdesign.pt
Rua de Vila Franca,
54 - Leça da Palmeira
Matosinhos 4450-802
Portugal
Tel +351 229 982 960
comunicacao@omdesign.pt

One Design Company
www.onedesigncompany.com
230 W. Superior St., Ste. 700
Chicago, IL 60654
United States
Tel +1 312 602 3335
info@onedesigncompany.com

Our Man In Havana
www.omihnyc.com
55 Washington St., Ste. 453
Brooklyn, NY 11201
United States
Tel +1 646 453 7517
haldavies@omihnyc.com

Pantone
www.pantone.com
590 Commerce Blvd.
Carlstadt, NJ 07072
United States
Tel +1 866 726 8663

Partners + Napier
www.partnersandnapier.com
1 S. Clinton Ave., Ste. 400
Rochester, NY 14607
United States
Tel +1 585 454 1010
katy.collar@partnersandnapier.
com

Pavement
www.pavementsf.com
420 3rd St., Ste. 240
Oakland, CA 94607
United States
Tel +1 917 558 3985
hester.mike@yahoo.com

PEACE Inc.
www.4peace.co.jp
3F No. 21 Arai Building,
1-20-6 Ebisu Minami
Shibuya-ku, Tokyo 150-0022
Japan
Tel +81 080 3120 2982
s.iitsuka@4peace.co.jp

Pendo
www.pendo.ca
201-402 W. Pender St.
Vancouver, BC V6B 1T6
Canada
Tel +1 604 398 8822
hello@pendo.ca

PepsiCo
www.design.pepsico.com
350 Hudson St., 2nd Floor
New York, NY 10014
United States
Tel +1 646 681 5095
emily.ford.contractor@pepsico.
com

Phillips Marketing Department
www.phillips.com
432 Park Ave.
New York, NY 10022
United States
Tel +1 917 753 7486
mschott@phillips.com

Planet Propaganda
www.planetpropaganda.com
605 Williamson St.
Madison, WI 53703
United States
Tel +1 608 256 0000
smeuer@planetpropaganda.com

Play
www.play.studio
520 Hampshire St., #213
San Francisco, CA 94110
United States
Tel +1 714 235 9119
ops@play.studio

PMDESIGN
www.pmdesign.pt
R. Travanca Cima
570 Santa Maria da Feira
4520-819
Portugal
Tel +351 914 066 898
mail@pmdesign.pt

Primoz Zorko
www.primozzorko.com
Puhova 1
Ljubljana 1000
Slovenia
Tel +386 4029 1733
primoz311@gmail.com

Ralph Appelbaum Associates
www.raai.com
88 Pine St.
New York, NY 10005
United States
Tel +1 212 334 8200
caseylynn@raai.com

Randy Clark Graphic Design
www.randyclark.myportfolio.com
88 Daxue Road, Ouhai District
Wenzhou, Zhejiang
China
Tel +86 5775 5870 000
randyclarkmfa@icloud.com

RedCape
www.markallendesign.myport
folio.com
1154 Point Vista Road
Hickory Creek, TX 75065
United States
Tel +1 469 525 5985
markallendesign@gmail.com

RedPeak Global
www.red-peak.com
Level 21, Ste. C, No. 7,
Xinyi Road, Section 5
Taipei 110
Taiwan
Tel +88 628 101 6216
hello@red-peak.com

Richard Ljoenes Design LLC
www.richardljoenes.com
4792 McKinley Drive
Boulder, CO 80303
United States
Tel +1 917 407 2400
richard.ljoenes@gmail.com

Riesling Dong
www.rieslingd.com
Chicago, IL
United States
Tel +1 312 219 1822
rieslingd@gmail.com

Roger Archbold
www.rogerarchbold.com
PO Box 327
Chewton, VIC 3451
Australia
roger@rogerarchbold.com

Rolando Castillo
www.rolandocastillo.info
1410 Columbia Drive
Glendale, CA 91205
United States
Tel +1 818 568 4445
rolandocastillodesign@gmail.
com

Rose
www.rosedesign.co.uk
The Old School,
70 St. Marychurch St.
London SE16 4HZ
United Kingdom
Tel +44 020 7394 2800
hello@rosedesign.co.uk

Rozi Zhu
www.rozi.design
New York, NY
United States
hello@rozi.fun

Ruiqi Sun Design
www.richaelsun.webflow.io
Jersey City, NJ
United States
sunruiqi0224@gmail.com

Sagon-Phior
www.sagon-phior.com
2107 Sawtelle Blvd.
Los Angeles, CA 90025
United States
Tel +1 310 260 1000
glenn.sagon@sagon-phior.com

**San Antonio Stock Show
& Rodeo**
www.sarodeo.com
PO Box 200230
San Antonio, TX 78220
United States
Tel +1 210 225 5851
anthony@sarodeo.com

**Savannah College of Art
& Design**
www.scad.edu
P.O. Box 3146
Savannah, GA 31402
United States
Tel +1 912 525 6830
awards@scad.edu

Schatz Ornstein Studio
www.howardschatz.com
31 W. 21st St., No. 2N
New York, NY 10010
United States
Tel +1 212 334 6667
contact@howardschatz.com

Sequel Studio
www.sequelstudio.com
12 W. 27th St., 15th Floor
New York, NY 10001
United States
Tel +1 212 994 4320
msteinhofer@sequelstudio.com

Shantanu Suman
www.shantanusuman.com
3401 N. Tillotson Ave., AJ 401
Art & Journalism Building
Muncie, IN 47306
United States
Tel +1 352 792 5100
sumanshantanu@gmail.com

**Shenzhen Excel Brand Design
Consultant Co., Ltd.**
Yidasheng Building, 3rd Floor,
Wuhe Ave. & S. 5th,
Longgang District
518129 Shenzhen
China
Tel +86 755 8282 1024
695938757@qq.com

Sidecar
www.sidecardrinks.com
33 Irving St.
New York, NY 10003
United States
Tel +1 201 925 4767
hello@sidecardrinks.com

Siena Scarff Design
www.sienascarff.com
302 Harvard St.
Cambridge, MA 02139
United States
Tel +1 857 756 8372
siena@sienascarff.com

SML Design
www.smldesign.com.au
1 Kent Lane
Prahran, VIC 3181
Australia
Tel +40 381 4001
vanessa@smldesign.com.au

SMOG Design, Inc.
www.smogdesign.com
2353 Moreno Drive
Los Angeles, CA 90039
United States
Tel +1 323 356 6189
jeri@smogdesign.com

Sol Benito
www.solbenito.com
1515-16 Ghanshaym Enclave,
Link Road
Kandivali, Mumbai,
Maharashtra 400067
India
Tel +91 099 6786 4864
solbenitoinfo@gmail.com

Spire Agency
www.spireagency.com
5055 Keller Springs Road,
Ste. 510
Dallas, TX 75001
United States
Tel +1 214 477 2097
awards@spireagency.com

Spotco NYC
www.behance.net/Mirkollic
41 Union Square W., Room 824
New York, NY 10003
United States
Tel +1 212 481 9737
studio@mirkoilic.com

Sterling
www.sterlingbrands.com
720 California St., 2nd Floor
San Francisco, CA 94108
United States
Tel +1 415 427 1200
hello@sterlingbrands.com

Still Room Studio
www.still-room.com
2169 Lemoyne St.
Los Angeles, CA 90026
United States
Tel +1 323 663 5446
info@still-room.com

Stjepko Rošin
www.stjepko.com
EU - HR, 21000 Split
Marina Držića 12
Croatia
stjepko.rosin@gmail.com

Storkan
www.balvanatelier.cz
Budynska 14
Praha, CZ 16500
Czech Republic
Tel +420 721 7519 11
rudolfstorkan@gmail.cz

Stranger & Stranger
www.strangerandstranger.com
68 Greenpoint Ave.
Brooklyn, NY 11222
United States
Tel +1 212 625 2441
nyc@strangerandstranger.com

Studio 5 Designs Inc. (Manila)
www.studio5designsph.net
Unit 3022,
Beacon Residences - Tower 3
Chino Roces Ave.,
Legaspi Village
Makati City 1229
The Philippines
Tel +63 917 885 5507
marilyo@yahoo.com

Studio Castrodale
www.castrodale.com
Toronto, ON
Canada
elise@castrodale.com

Studio Craig Byers
www.studiocraigbyers.com
4609 Del Sol Blvd.
Sarasota, FL 34243
United States
Tel +1 917 597 4388
byers.craig@gmail.com

Studio DelRey
www.studiodelrey.com.br
Rua Uruguaiana 1237 CJ 32
Campinas, São Paulo 13026-002
Brazil
Tel +55 11 979 50 4999
studiodelrey@gmail.com

Studio Eduardo Aires
www.eduardoaires.com
Alexandre Braga, N94-1E
Porto 4000-049
Portugal
Tel +351 226 169 080
mail@eduardoaires.com

Studio Hinrichs
www.studio-hinrichs.com
2064 Powell St.
San Francisco, CA 94133
United States
Tel +1 415 543 1776
reception@studio-hinrichs.com

Studio Holden
www.studio-holden.com
505 Yucca Drive
Denton, TX 76209
United States
Tel +1 817 522 2339
me@whitney-holden.com

Studio Lorenzetti
www.katherinelorenzetti.com
3467 Greentree Road
Bloomfield Township, MI 48304
United States
Tel +1 248 224 9306
katherine.lorenzetti@gmail.com

Studio Pgerossi
www.pgerossi.co.uk
20 Copse Hill
London SM2 6AD
United Kingdom
Tel +44 77 6765 2098
topeterossi@gmail.com

Studio XXY
California
United States
yuqindesign@gmail.com

Subin Yun
www.syun20.myportfolio.com/
work
15 W. 61st St., PH1B
New York, NY 10023
United States
Tel +1 510 963 8895
ysb042697@gmail.com

SVIDesign
www.svidesign.com
124 Westbourne Studios
242 Acklam Road
London W10 5JJ
United Kingdom
Tel +44 20 7524 7808
studio@svidesign.com

Symbiotic Solutions
www.people.cal.msu.edu/corneal
Dewitt, MI 48820
United States
Tel +1 517 355 7612
corneal@msu.edu

Tangram Strategic Design
www.tangramsd.it
Viale Michelangelo Buonarroti,
10/C
Novara 28100
Italy
Tel +39 0321 35 662
esempi@tangramsd.it

Teiga, Studio.
www.xoseteiga.com
Avd. da Barca 18
Bajo Poio Pontevedra 36163
Spain
Tel +60 715 5211
xoseteiga@gmail.com

Teikna Design
www.teikna.com
Via San Vito
6 Milan 20123
Italy
Tel +39 02 3651 5524
claudia@teikna.com

Test Monki
www.testmonki.com
10800 Gosling Road, #131898
Spring, TX 77393
United States
Tel +1 281 323 4903
suzy@testmonki.com

Texas Tech University Press
www.ttupress.org
2310 70th St., Apt. 244
Lubbock, TX 79412
United States
Tel +1 512 470 6235
hdgaskamp@gmail.com

Thackway McCord
www.thackwaymccord.com
138 Grand St., Studio 4ER
New York, NY 10013
United States
Tel +1 646 262 3409
kat@thackwaymccord.com

The Republik
www.therepublik.com
1700 Glenwood Ave.
Raleigh, NC 27608
United States
Tel +1 919 956 9400
hello@therepublik.com

Tielemans Design
www.tielemansdesign.com
1535 Roughrider Circle
Henderson, NV 89014
United States
Tel +1 702 946 5511
anton@tielemansdesign.com

Tom, Dick & Harry Creative
www.tdhcreative.com
350 W. Erie St., 2nd Floor
Chicago, IL 60654
United States
Tel +1 773 308 4432
dyang@tdhcreative.com

Toolbox Design
www.toolboxdesign.com
304-1228 Hamilton St.
Vancouver, BC V6B 6L2
Canada
Tel +1 778 322 7474
victoria@toolboxdesign.com

TopoGraphic Studio
www.colemelanson.com
1816 W. 1010 N
Provo, UT 84604
United States
Tel +1 801 850 4944
colemelanson@gmail.com

TOPPAN INC.
www.toppan.com/en
9F, 1-3-3, Suido Bunkyo-ku
Tokyo 112-8531
Japan
Tel +81 3 5840 2192
mescal@mac.com

Traction Factory
www.tractionfactory.com
247 S. Water St.
Milwaukee, WI 53204
United States
Tel +1 414 944 0900
tf_awards@tractionfactory.com

Traina
www.wearetraina.com
10680 Treena St., Ste. 520
San Diego, CA 92131
United States
Tel +1 619 567 7100
awards@wearetraina.com

Truth Collective
www.truthcollective.com
25 Russell St.
Rochester, NY 14607
United States
Tel +1 585 690 0844
awards@truthcollective.com

Tsushima Design
www.tsushima-design.com
1-17-204, 1-17, Matsukawa-cho,
Minami-ku
Hiroshima 7320826
Japan
Tel +81 82 567 5586
info@tsushima-design.com

**Twice2 - Atelier de Graphisme
& Typographie**
www.twice2.ch
15-17 Rue Saint-Laurent
Geneva 1207
Switzerland
Tel +41 794 589 073
johan@twice2.ch

Underline Studio
www.underlinestudio.com
247 Wallace Ave., 2nd Floor
Toronto, ON M6H 1V5
Canada
Tel +1 416 341 0475
studiomanager@underlinestudio.
com

UNISAGE
www.hkposhan.com/jeffpoon
Lot 1187 DD76,
San Uk Tsai Village
Tan Chuk Hang,
Sha Tau Kok Highway,
Fanling, N.T. 000000
Hong Kong
Tel +86 155 5870 1930
cpoon@kean.edu

Univisual SRL
www.identitymarks.it
Via Lepanto 1
Milano 20125
Italy
Tel +39 335 836 7976
info@identitymarks.it

Vanderbyl Design
www.vanderbyl.com
511 Tokay Lane
St. Helena, CA 94574
United States
Tel +1 415 543 8447
michael@vanderbyl.com

Viva & Co.
www.vivaandco.com
584 Jones Ave.
Toronto, ON M4J 3H3
Canada
Tel +1 416 923 6355
info@vivaandco.com

Volume Inc.
www.volumesf.com
725 Filbert St.
San Francisco, CA 94133
United States
Tel +1 415 503 0800
eric@volumesf.com

Wainscot Media
www.mccandlissandcampbell.
com
433 N. Windsor Ave.
Brightwaters, NY 11718
United States
Tel +1 631 252 3527
mcandcstudio@gmail.com

Whimsical Studio
www.whimsical-studio.com
E-3/6-ho, 12th Floor,
20 Jangchungdan-ro
13-gil Jung-gu Seoul 04563
South Korea
Tel +82 50 6759 5801
hello@whimsical-studio.com

White & Case LLP
www.whitecase.com
1221 Ave. of the Americas
New York, NY 10020
United States
Tel +1 212 763 1757
rob.reade@whitecase.com

Yanguan
www.yanguandesign.com
5-405 Jingteng Jiayuan,
Jingteng Road
Yuhang District, Hangzhou,
Zhejiang 311121
China
Tel +86 187 6776 7115
375773266@qq.com

Yen Press
www.yenpress.com
150 W. 30th St., 6th Floor
New York, NY 10001
United States
Tel +1 917 929 2906
design@yenpress.com

Young & Laramore
www.yandl.com
407 Fulton St.
Indianapolis, IN 46202
United States
Tel +1 317 264 8000
awards@yandl.com

YouTube Music
www.music.youtube.com
901 Cherry Ave.
San Bruno, CA
United States
Tel +1 650 253 0001
thisisminkim@gmail.com

269 WINNERS BY COUNTRY

Visit Graphis.com to view the work within each country, state, or province.

Graphis Titles

Poster Annual 2025

GraphisPosterAnnual2025

2024
Hardcover: 256 pages
200-plus color illustrations

Trim: 8.5 x 11.75"
ISBN: 978-1-954632-33-2
US $ 75

Awards: Graphis presents 12 Platinum, 100 Gold, 418 Silver awards, and 90 Honorable Mentions.
Platinum-winning Instructors: Atelier Bundi AG, CollierGraphica, Dankook University, dGwaltneyArt, Freaner Creative, Gallery BI, João Machado Design, Katarzyna Zapart, Melchior Imboden, Skolos-Wedell, The Union Design Company, and THERE IS STUDIO.
Content: Explore the stories behind the designs with insightful commentary from Platinum and Gold-winning talents, who share their creative processes and the inspiration behind their award-winning work. This beautiful hardcover book is a visual feast, showcasing full-page, full-color images of Platinum-winning designs alongside Gold and Silver winners. With Honorable Mentions listed, every piece of exceptional work is celebrated.

New Talent Annual 2024

GraphisNewTalentAnnual2024

2024
Hardcover: 256 pages
200-plus color illustrations

Trim: 8.5 x 11.75"
ISBN: 978-1-954632-29-5
US $ 75

Awards: Graphis presents 13 Platinum, 132 Gold, 587 Silver, and 858 Honorable Mentions.
Platinum-winning Instructors: Rob Clayton, Simon Johnston, Stephen Serrato, Ming Tai, David Tillinghast, HyoJun Shim, Peter Bergman, Nathan Savage, Billy Magbua, Justin Colt, Natasha Jen, Richard Mehl, William Meek
Content: The New Talent 2024 Annual presents award-winning work submitted by teachers and students of prominent schools, who are dedicated to shaping the next generation of graphic designers. Platinum winners share their creative process, providing valuable insights and inspiration for aspiring creatives. A special section that revisits the Platinum-winning works from the past decade, offering a unique lens on the evolution of creative excellence.

Photography Annual 2024

GraphisPhotographyAnnual2024

2024
Hardcover: 256 pages
200-plus color illustrations

Trim: 8.5 x 11.75"
ISBN: 978-1-954632-28-8
US $ 75

Awards: Graphis presents 12 Platinum, 102 Gold, and 216 Silver awards, along with 54 Honorable Mentions.
Platinum Winners: Craig Cutler, Lindsey Drennan, Jonathan Knowles, James Minchin, Artem Nazarov, Peter Samuels, Howard Schatz, John Surace, and Paco Macias Velasco.
Content: This book is full of exceptional work by our masterful judges, our Platinum, Gold, and Silver award winners, and our Honorable Mentions. It also includes a retrospective on our Platinum 2014 Photography winners, a list of international photography museums and galleries, and an In Memoriam list of photographers who have passed away this past year. The digital copy has an extra 52 pages of additional content for you to peruse.

Advertising Annual 2024

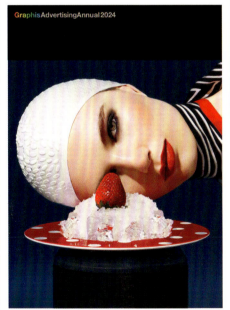

GraphisAdvertisingAnnual2024

2024
Hardcover: 224 pages
200-plus color illustrations

Trim: 8.5 x 11.75"
ISBN: 978-1-954632-25-7
US $ 75

Awards: Graphis presents 15 Platinum, 61 Gold, and 99 Silver awards, along with 14 Honorable Mentions.
Platinum Winners: ARSONAL, Brunner, Célie Cadieux, Extra Credit Projects, Freaner Creative & Design, PangHao Art Studio, Partners + Napier, PETROL Advertising, ReThink, Rhubarb, SJI Associates, Sukle Advertising, and SUPERFY.
Content: This Annual includes amazing Platinum, Gold, and Silver Award-winning print and video advertisements from well-established firms and agencies. Honorable Mentions are also presented. Also featured in the annual is a selection of award-winning work from the competition judges and our yearly In Memoriam list of the advertising talent we've lost over the last year.

Packaging 10

GraphisPackaging10

2022
Hardcover: 240 pages
200-plus color illustrations

Trim: 8.5 x 11.75"
ISBN: 978-1-954632-12-7
US $ 75

Awards: Graphis presents 12 Platinum, 100 Gold, 204 Silver, and 249 Honorable Mentions for innovative work in product packaging.
Platinum Winners: Michele Gomes Bush (Next), Chad Roberts (Chad Roberts Design Ltd.), XiongBo Deng (Shenzhen Lingyun Creative Packaging Design Co., Ltd.) and Lu Chen (Xiaomi), Vishal Vora (Sol Benito), Mattia Conconi (Gottschalk+Ash Int'l), and Frank Anselmo (New York Mets), Ivan Bell (Stranger & Stranger), Brian Steele (SLATE), and the team at PepsiCo Design & Innovation.
Content: This book contains award-winning packaging from the judges, as well as international Platinum, Gold, and Silver-winning packaging designs from designers and design firms from around the world. Honorable Mentions are presented, and a feature of award-winning work from our Packaging 9 Annual is also included.

Narrative Design: Kit Hinrichs

2023
Hardcover: 248 pages
200-plus color illustrations

Trim: 9 x 12"
ISBN: 978-1-954632-03-5
US $ 65

Narrative Design: A Fifty-Year Perspective is a collection of over 50 years of work from the obsessive graphic designer Kit Hinrichs. To the legendary AIGA medalist, author, teacher, and collector, design is the business of telling a story. It's not just about communicating a product or a corporate ethos—it's about contributing to the collective culture of storytelling. Presented in the book are not individual case studies but rather categories of work and graphic approaches to assignments that have wowed clients and dazzled viewers. The work is arranged to communicate Hinrichs' creative thinking, which always leads to a unique and effective solution to any design conundrum.

Books are available at graphis.com/publications